Alfred Stieglitz

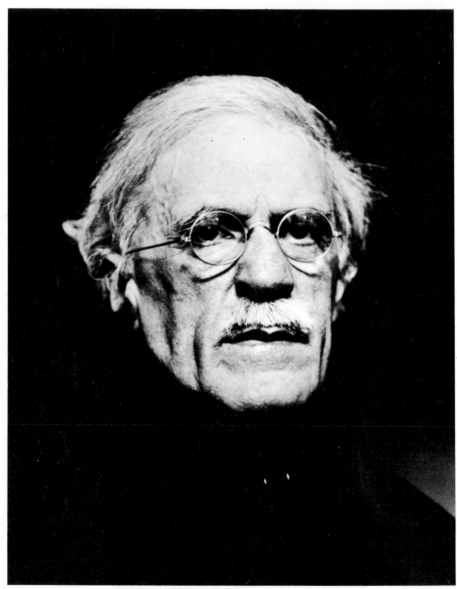

Alfred Stieglitz by Dorothy Norman, 1933

Alfred Stieglitz: An American Seer

by Dorothy Norman

An Aperture Book

DEDICATION

TO MY BELOVED GRANDCHILDREN:
HONOR, ABIGAIL, DIANA
SARAH, MARGARET, PHILIP, REBECCA

Published by Aperture, Inc.,
Millerton, New York 12546.
Aperture, Inc., publishes a quarterly
of photography, portfolios,
and books to communicate with
serious photographers and
creative people everywhere.
Book design by Peter Bradford
and Wendy Byrne.

Library of Congress Catalog Card No. 72-5048
ISBN: 0-89381-035-5 Cloth
ISBN: 0-89381-036-3 Paper
Manufactured in the
United States of America
109876543

TABLE OF CONTENTS

LIST OF PLATES

LIST OF ILLUSTRATIONS

AUTHOR'S NOTE

The reflections by Alfred Stieglitz included in this volume are directly quoted from conversations we had between 1927 and 1946, unless otherwise noted. With the exception of the summer months and other rare intervals, we met almost daily. I was able to go over with Stieglitz what I wrote down. I have left his sentence structure and grammar intact except where a certain clarity was in danger of being sacrificed. Since Stieglitz often recounted the same experiences with varying emphasis, a few statements may differ slightly from previously published versions. I have chosen passages most relevant to the development of this book and have included much source material not hitherto available.

Stieglitz recounted details to me concerning the Photo-Secession Galleries and The Intimate Gallery. I often visited The Intimate Gallery and was closely associated with An American Place throughout its existence. Stieglitz gave me permission to print our conversations and the stories he related, what he wrote and published, as well as much pictorial material.

Because of their basic intent, these pages barely touch upon Stieglitz's personal life. They are concerned primarily with the evolution of his career. No attempt has been made to write a definitive biography, nor a technical study of Stieglitz's photography. What I have stressed, above all, is the spirit in which Stieglitz worked and lived. I urge the reader to seek out and look well at his original prints. *New York, Spring, 1973*

I. First Encounters with Stieglitz (1926–1927)

It was his presence. His magnetism. The way he saw it, said it, spoke his life out loud. Confronting the world without mask. Removing barriers. Drawing forth buried truths. It was not immediately clear to me. But then what Alfred Stieglitz said so moved me, I wrote it down before I knew his name or saw his photographs.

Having recently come to live in New York, I was astonished to find so little of the great revolutionary European art I had loved as a student at the Barnes Foundation in Merion, Pennsylvania. Because the paintings and sculpture there had transformed my world, I longed to see more of them. I was especially eager to discover contemporary American work of similar stature. It was inconceivable that all first-rate artists of the period lived abroad or were dead. If there were men and women of genius suffering from neglect in the United States, they should be supported.

Simply because I had torn from an art magazine a page on which its name was listed I walked, one day, into a small and shabby, unpretentious room called The Intimate Gallery. On its walls were watercolors by a painter unknown to me—John Marin. His was the first work I had not seen before that aroused my interest since my arrival in New York. The name sounded French, when I so longed for it to be American. I had never before bought a work of art, but I had a great desire to have one Marin in particular. Could I, I wondered, acquire it? Having no notion of its cost or even whether it was for sale, I turned to question the man in charge of the gallery. He was surrounded by people to whom he spoke without pause.

Too shy to interrupt his monologue, when at last I caught his eye, I raised my hand slightly to attract his attention. Owners of other galleries tended to rush forward at the slightest display of interest, in the obvious hope that a sale might result, but not so here. Since my gesture was ignored, I departed feeling frustrated and sad.

Haunted by the Marin paintings, I soon returned to The Intimate Gallery. Although a new exhibition had been hung in the interim, a number of pictures the size and shape of those I already had admired were stacked behind cardboards. Because the unknown man of my previous visit was again talking with visitors, I carefully tilted the boards forward. The hidden paintings were indeed Marins but, to my dismay, a thunderous blast shot out at me: "Kindly do not handle the pictures!" The man at once resumed the conversation in which he had been engaged, without making any effort to show me what I wished to see. He continued, instead, to describe in an exasperated tone how corner drugstores throughout the land would soon be displaying "so-called works of art" at a "dime a dozen" which act, he declared, must be looked upon as the "last straw."

If the man would pay more attention to what was taking place in his own gallery, I thought, instead of complaining about hypothetical and irrelevant questions, art might be better served than it was at the moment. And, assuming that art was made more accessible to the people-at-large, would that not be desirable? Unnerved and antagonized, I went away again.

As I opened the door of the gallery on my third visit, a hostile young girl was asking the still nameless man to explain the pictures on exhibit. He replied that if she went through the world asking about the meaning of a painting or a poem or a bit of music, she might learn something about the individuals questioned but, in the end, only her own experience could reveal what she sought to comprehend. It was inevitable, too, he observed, that people should see works of art differently at various periods of their lives.

"I am told," said the girl, with a touch of sarcasm, "that you look upon the work you show here as Art with a capital A. If I cannot understand what it means, and it is significant to you, I do not see why you are unable to explain it."

"Art with a capital A is of no interest to me," the man said with detached calm and then shifted his emphasis: "Imagine that I find myself looking at a mountain and you stand beside me. Suppose that what I behold fills me with wonder. How, I should like to know, am I to tell you what I see and feel, if there is no basis for understanding between us?" "That is ridiculous," countered the girl.

The man continued with his own train of thought, "Or suppose you kiss someone. Even if the kiss lacks all life, still it will be called a kiss. Or, if you ask another, 'Do you love me?' and the reply is 'Yes,' if what is said fails to stem from a deep inner need, how describe it in relationship to the meaning of the word 'love,' when spoken in a living manner? And if you do love in a profound sense it is unnecessary either to use the word or to define it. Communication beyond words will inevitably be involved as in touch itself. It is the same with regard to the relationship between a person and a picture.

"Do you ask what the rain means," the man looked far into space, "or the wind? Do you ask what a thunderstorm means? You might as well ask what life itself means."

Without having experienced any transition from being irritated at the man's habit of talking when I wished to see pictures, I found myself listening to him with mounting interest. There was something mysteriously refreshing and satisfying about the simple, impersonal—yet personal—way in which he spoke. "You will discover," he remarked, "that if the artist could explain in words what he has made, he would not have had to create it." I noticed for the first time the deep-set, dark, piercing eyes.

Without obvious intent the man again shifted the conversation, this time from the abstract realm of art to the concrete details of the

girl's life. "How old are you?" "Seventeen." "What do you do?" "I study art." The strident tone softened. "What made you decide to do so?" "Why, because. . . ." One could detect a youthful and anguished defenselessness, as attention was directed, in public, from the work on the walls, to details of the girl's own undeveloped career. "What does your mother do?" "She is a housewife." "Your father?" "He is a doctor." "Do they care about art?" What was the man attempting to prove with his relentless, though gently spoken queries? "Do they often look at what you yourself do?" The girl confessed, with a certain reluctance, that her parents' preoccupation with art was slight; that they were far too busy to look at what she created, except at rare intervals.

"My dear child," said the man, "when you are grown up, when you are plagued by a thousand cares and worries and realities of life, as I am certain your mother and father must be every day, you may understand them in a way you cannot do now. You may realize something, too, about yourself, as about the pictures on the walls—as about all art—that eludes you at this point in your evolution."

For a moment the girl remained silent. She walked to the corner of the room, turned her face to the wall and wept. When she was able to stem her tears, she remarked with touching humility, "I understand something right now that I never did before."

The man's face remained expressionless. He crossed the room and sat down in a large uncomfortable looking chair. His face had the most composed quality and he had the most relaxed way of sitting in a chair I had ever witnessed. I became aware of his finely carved, slightly blue-tinged lips—their almost imperceptible quiver.

When the girl had departed, the man said, "That is the third time this week that a young woman has stood here weeping. It is most significant." I had no idea why it was significant, but I realized that I had not had a similar experience in enormous, depersonalized New York. Curiously it was more the naturalness of the man's behavior than its singularity that moved me. It was the sole occasion on which I had heard an older person communicate with someone younger about art without using tutorial, pedantic language; without failing to take into account the potential growth or development of the other. Most extraordinary of all, the man's way of functioning in the everyday world resembled the spirit of modern art, with its power to strip away nonessentials.

When everyone else had left, the man asked me whether I liked the pictures. To my surprise I found I could speak without inhibition and with a clarity I had never before achieved. Without transition and with unabashed candor, he questioned me about the most intimate details of my life. Despite my youthful reserve, what he asked did not seem at all shocking. I wondered why no one else had ever inquired about such crucial matters. I had the intuition that one could speak

to this man without fear, about anything in the world. I soon discovered that many others felt precisely as I did. It was clear that nothing more was expected of me than that I speak the truth.

And so our conversations began, and so it was that I made a vow to share my experience of Alfred Stieglitz.

Upon discovering that Stieglitz was a photographer—I did not even know at the time that there were first-rate photographs—I looked often at his prints. As I did so and listened to him speak, I concluded that he was, above all, a photographer in whatever he did, no event being complete for him until he had made a portrait of it in word or in image. Hence this book combines what he said and what he photographed with other relevant written and pictorial material. It traces the evolution of his career, including his fight for photography and the public introduction of modern art in the United States, beginning in 1908. It relates how Stieglitz functioned and influenced our way of seeing, whether or not we are aware of it.

As I questioned Stieglitz about his ideas and events in his life, I found he could reply only in relation to his own complex vision. He was unable to speak of the simplest facet of experience unless it revealed some larger meaning—made one incident or another come alive for him. Once there was a quickening—a point he did wish to make—he opened his heart and spoke by the hour, without reserve or apparent thought for anything other than what he was saying.

It was the same when he photographed. A particular face or object moved him. If what he saw was intimately related to what he was experiencing, he would take up his camera. His silences could be as unsettling as his enthusiasms were overwhelming. He discussed or photographed, retold or re-photographed, now from one angle, again from another, until for the moment there were no further nuances of interest.

Asked to explain either his own photographs or art created by others, Stieglitz referred, with delight, to the Chinese saying that a single picture equals a thousand words, although he would at times employ some two thousand words to tell why the observation so pleased him. Or he might show a painting in silence to answer what had been asked. More often than not he responded to questions with queries of his own or with paradoxical statements, not to confuse, but because of his distaste for generalization.

Stieglitz tended to speak of happenings in his life by way of parable, or to recount casual incidents to illuminate theoretical problems. In both cases he sought to indicate what mattered to him most: the split second of wonder, the subtle mystery of life unfolding, rather than any misleading, oversimplified diagram of it. His belief that the essentials of life defy simple explanation led him to devote himself to art in all its manifestations.

12

As he matured Stieglitz discovered with dismay the glaring discrepancies between the world's eloquent pronouncements and its everyday acts. He asked repeatedly how it was possible to reconcile the glib slogans about the goals of the American Revolution and Civil War he had heard as a boy, with what occurred directly before his eyes: "Because what was promised stirred me, but then was nowhere to be found, I decided I must create a world of my own in which the preachments made in my youth might be put into practice. I have spent my life trying to discover what people really mean when they speak; when they claim to believe in one thing, yet do another; declare one set of values in public, another in private; make pompous resolutions, yet fail to live up to them. I have wanted to destroy labels since they constantly get in the way. People become so satisfied with the label, they seem not even to notice whether what they are talking about is, in fact, happening."

Stieglitz feared that words, unless spoken with utmost probity, tend to conceal and distort rather than reveal, especially when used in doctrinaire or abstract fashion. He pleaded that some clear correlation should exist between what is said and done. "To know what you do, not what you think or say you do, or should do. Only through the quality of your own clarity and acts can you free either yourself or others. The act came first and then the word." Yet action itself could be of little significance unless accompanied by a readiness to take responsibility for the consequence of one's deeds; to pay the price for acts and inaction alike.

Mistrusting dogma, Stieglitz had the greatest respect for words employed with sensitivity by the true artist. He claimed that "all true things are equal to one another" and wrote as he conversed, with the same intensity he lavished upon his camera work. The necessity "to see" for Stieglitz was at the root of his passion for photography: "To see the moment is to liberate the moment."

Photography signified to him something far more than using a camera. It became "an obsession, an open sesame." It represented "an entire philosophy and way of life—a religion." Consistent dedication to the medium culminated in an untiring quest for truth, a search that leads to being truthful—to the act of truth, committed with reverence and without fear, of which all art is a symbol: "If we are not truthful, we cannot help one another. Where there is no conscience, there can be no art. The goal of the artist is to be truthful and then to share his truthfulness with others."

Involvement with photography, with art in all forms, stemmed further from a sense of awe and wonder: "When I make a picture I make love. If what is created is not made with all of oneself, in sacred spirit—with the ardor of the first pristine kiss—it has no right to be called a work of art.

"My most important function is to challenge: We must examine

our own motives, our selves, before making extravagant claims about abstract beliefs or judging the behavior of others. To grow stricter with oneself, more tolerant of others."

Stieglitz's credo, "If you do not see all of it, you do not see any of it," involved the total web of life: proportion, harmony, rhythm, relationship; the world within and the world without; what man makes and feels; what he does to and about others, nature, himself. If ugliness is permitted to predominate, how can we say that we *see?* Are not all forms of debasement—human violence, desecration of the waters, earth, air—results of *non-seeing?* Stieglitz's crying out against every affront was as much part of his function as photographer, as was his celebration of what he affirmed.

II. The Early Years

Edward Stieglitz, father of Alfred, was born in Germany in 1833. He grew up on a farm, loved nature, was an artist at heart. He earned his living from early boyhood. Legend has it that, independent and strong-willed, he ran away from home at the age of sixteen because his mother insisted upon starching his shirts after he had begged her not to.

The year 1848 in Europe was one of economic, political and social upheaval. Dreams of reform were followed by frustration and repression. Like so many of his enterprising young compatriots of modest means, Edward set sail for the United States. Not from choice, but because a job was available, he became an apprentice in the making of mathematical instruments. After serving briefly as a lieutenant in the Civil War, he decided to settle down so that he could support a family. He put up a thousand dollars and became a partner in a woolen business, which at once prospered.

In 1862 Edward married warm and outgoing Hedwig Werner, who also had been born in Germany and was brought to America at the age of eight by her parents. Hedwig's family boasted members of a literary turn of mind and several rabbis. She and Edward, cultivated and broad-minded, shunned materialism and show. They valued integrity; loved people, beauty, the arts, literature, music. Nietzsche, Goethe, Heine and Schiller were their gods.

Edward delighted in flowers, fishing, horse racing, thoroughbreds. He owned a first-rate saddle horse and rode well. Tall, slender, aristocratic in bearing, he was energetic, passionate and ambitious. Paul Rosenfeld has described him as "always well groomed and very much the cavalier . . . with his proud carriage, his fine head and luxuriant mustaches." Hedwig, beloved by all who knew her, was "cultured, soft, hospitable, generous."[1]

Edward and Hedwig settled in Hoboken, New Jersey, where
14 Alfred—the first of six children—was born on January 1, 1864, one

year to the day after Abraham Lincoln's epoch-making Emancipation Proclamation took effect.

Despite Edward's success during the second half of the nineteenth century, financial panics of the period inevitably worried him. His ability to establish himself in a strange land and move to increasingly commodious homes made it difficult for younger members of the family to comprehend the manifold problems he faced. In addition to rearing and educating their children, Edward and Hedwig helped to support numerous relatives, friends, artists. Except when temporary business reversals distressed him, Edward was the soul of generosity: "Our house was filled with guests, forever guests, expected and unexpected, from all classes of society, but mainly musicians, artists and literary folk, rather than business people. We had many books and pictures.

"Our dining room in Hoboken was in the basement. (Fashion had not as yet decreed the first floor back as such—not that my parents were guided by what others did.) The room was simple. I had my hobby horse there and while the men would drink, talk and smoke, I loved to sit on my horse, riding and listening to the conversation. This was when I was four until I was about seven years old. I remember hearing my father relate with great gusto how, frequently, he and his friends would sit, not knowing what time of day it was. He would draw the blinds and say, 'No one will disturb us.' No one did, until the servants came and said it was necessary to set the table. Then the men went upstairs until supper was served at seven o'clock. My father loved fine wines. My mother saw to it that much good food was provided.

"My parents' way of life doubtless left a lasting impression on me. They created an atmosphere in which a certain kind of freedom could exist. This may well account for my seeking a related sense of liberty as I grew up."

Wherever he might be, the spirit of the "open door"—whether at his galleries or in his own homes—came to have the same significance for Alfred that "open house" did for Hedwig and Edward.

Moral and ethical concepts, personal rather than political freedoms, were stressed in the Stieglitz household. Although, in Europe, older relatives had held well-defined religious convictions, neither Hedwig nor Edward could think in narrow denominational terms. Both were incapable of looking upon themselves or others from a sectarian point of view. Neither the question of "being Jewish" nor the meaning of the term was discussed. The Stieglitz children received no formal religious education. Metaphysical beliefs remained a private concern; each was permitted to follow his natural bent.

Early childhood incidents foreshadowed the emergence of Alfred the photographer: At the age of two, he insisted upon carrying

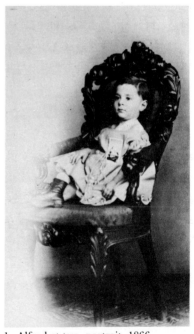

1. Alfred at two, portrait, 1866

15

about with him, in his belt, "a photograph of a beautiful boy cousin, because I could not bear to have it out of my sight. The cousin, it so happens, grew up to be one of the homeliest men I have ever seen."

There was the impassioned staring—lovesick, and by the hour—at an exquisite friend of his mother's, "the lady in black, who came often to our home. After her visits, my heart would sink. The lady in black was tall. She had dark hair, smoothed down, and white skin. While she was in the room I had a lovely but sad feeling about her. I awaited her appearance, knowing the days when she was expected. I know of no pain any more intense than the one I experienced when she departed. My heartache, I realized later, was the same as that in which all love, like all art, is rooted. I always have been fascinated by black. I believe this may well be related to my early infatuation for the lady in black. And I have always been in love."

As a boy, Alfred had a thick shock of black hair; large, dark eyes; pale, fine skin; a delicately modeled mouth and strong chin. Because he was sensitive, brooding, intense; because of his long, lean look, his pallor and his often being dressed in black velvet, his adoring mother and her friends called him "Little Hamlet."

Alfred gave himself to whatever he did with such ardor that he was a constant source of worry to Edward and Hedwig. Being the first-born, he was shown special consideration in his early childhood. Any wish he expressed—and he confessed he had many—was satisfied. He claimed that this did not spoil him and that the other children in the family seemed not to express any wishes. He found himself puzzled by his parents' often conflicting statements, made, he felt, without reason. He was distressed to find the inconsistencies of the world at large mirrored, with such precision, at home: "My mother and father would say yes concerning something one moment, no the next. I could not always discern the reasons for either my father's intermittent strictness or my mother's harrowing inability to keep within a reasonable budget. Her failure to do so never ceased to exasperate my father, who was high-strung and somewhat of an autocrat. Perhaps I should say he was very much of an autocrat. He could brook no contradiction. His word was law.[2]

"When father returned from business in the evening, my brothers, sisters and I ceased romping about at will. Father was in the house. One never knew when he would be disturbed. The slightest creaking of a maid's shoes after he had a trying day, the faintest rustling of a starched petticoat, might infuriate him.

"Yet, even while rebelling against my father and finding him vain, impatient and impossible to speak to, I admired him. Both he and my mother were extremely kind and sentimental at heart. The endless family altercations about financial matters made me recoil from all references to the subject of money. I must admit, though, had my father not insisted on a strict budget, I do not know what would

have happened to our family.

"The scenes between my parents had a powerful effect upon me. They caused me to grow up with a feeling about money as a source of release but, at the same time, as a deadly poison.

"My father would say, 'Alfred, do you need some money?' I was on an allowance. My answer was an invariable 'No.'

"One day my mother inquired, 'Why do you always say no when your father asks whether you need money?' I replied, 'You know how I hate all talk about the subject. If father has anything to give me, why doesn't he just give it, without asking if I need it? Who in the world doesn't need—or want—some money?' "

When older, Stieglitz said, "If you ask a man does he require food, and he answers no, even though the reverse is true, what then? Should you permit him to starve—even die—as proof that he is hungry, before you give what will save his life?"

No buildings stood between Central Park and the Stieglitz home in Manhattan—14 East 60th Street—to which the family moved in 1871. Approximately twenty-two feet wide, the house was spacious and modern for the period, being equipped with gas chandeliers, steam heat, fireplaces and even special taps for iced as well as hot water. "High rocks jutted up nearby, with shanties on them. Goats roamed about. Finally the rocks were blasted away and a square grass plot the size of an entire block was fenced in.

"Next to the fence, encircling the plot, was a dirt path. I found it easier to run on than pavement. I raced around the block, covering miles, as it suited me. This I did between the ages of nine and seventeen, before the family went to Europe in 1881. Since I had been taken to bicycle and horse races I did not see why I should not run long distances at high speed. I was proud of my running. I loved the hundred-yard dash, the broad jump, the high jump—to do everything as fast and well as possible. Racing was in my blood. I jumped over tables and chairs.

"My friends and I ran until midnight. I would take handicaps. I wanted to beat everybody on earth. Back of it all I probably had a feeling that the other fellow couldn't do things as well as I did. Possibly there was a shade of showing off, for vanity's sake, in my activity. But then, when I was victorious, it meant nothing to me. Really nothing. The same thing happened when I played marbles. Once I had won all the marbles on the block, this too held no interest for me, none. I gave all of them away."

Self-taught, Alfred soon played billiards better than his father, who was considered an expert. At the age of nine, he won a billiard competition against adults in Boston and became an outstanding bowler at thirteen.

A keenly developed sense of balance permitted him to ride his

high-wheeled bicycle with exceptional agility. He loved to row, swim and play tennis. Although shy, he was looked upon as the leader of any group of boys with whom he played: "I quickly tired of playing games according to the rules that came with them. I always wanted to make up new ones."

Both his feeling for balance and need to experiment, Stieglitz believed, were later important when photographing. "I have always maintained that if the fresh ways in which I have done things were natural to me, they must be for others as well. So that, in time, they would have to be accepted. I have had a sense of sport about everything I have done. When I read that Nietzsche claimed there were three types of human beings: the artist, the scientist, the sportsman, I knew his words were a key to understanding all human life."

Alfred felt deep dismay about harming or destroying any living creature, about waste and destruction in all forms.

At Lake George, New York, during the summer months, he could not understand his playmates who attempted to kill birds in the woods with guns and with bows and arrows: "I asked why this was necessary when a shooting gallery existed with plenty of targets only a short distance away. The boys said hitting a fixed mark was too

2. From Alfred's early autograph album, 1875

easy, that it was more exciting to stop birds in flight. 'In that case,' I suggested, 'why not build a moving target? Or send up a kite to hit, instead of birds?' No one agreed.

"Once in a while, birds fell to the ground wounded, or sometimes dead. I inquired what the boys planned to do with them. 'Oh, throw them away,' they said. What I was driving at did not register. You might say I was a timid soul because I did not like to hurt or kill, but I had no idea how to heal a wounded bird. Others might know how to take it home and treat it. I did not.

"Lake George was full of fish. Adults fished day and night, making great catches, but then they often threw everything away. I wondered why this was considered sport and what would happen when there were no more fish. Everyone assured me there would always be fish.

"The forests were denuded. Trees were cut down without purpose, or sometimes with a purpose. To plant young ones in their place never occured to anyone.

"I soon found that simply to hit a target was meaningless. I wanted to hit what you might call the center of the center of the target, although even that soon proved fruitless. I suppose what has always mattered to me is hitting the point beyond the center. That has been my concern when making my photographs, in my contact with the public and in personal relationships."

The artists Edward Stieglitz helped and brought home were competent but not outstanding. They, like Edward himself, were unaffected by, and no doubt unaware of, the revolution taking place in the European art world. Yet it is significant that Edward, born on a farm in Germany and now a successful businessman, should have surrounded himself with artists and become an amateur painter at the age of forty. His way of life was by no means typical of most first-generation merchants of the period in America. He lacked the means to buy masterpieces or to become a great patron, but he enjoyed the company of creative people. He bought their paintings and sculpture whenever he could and he helped to support a young German artist, Fedor Encke, among others. Encke lived in the Stieglitz house over a period of time.

In spite of meeting so many artists Alfred could not remember ever drawing a line, or ever wanting to, although he asked virtually every painter who visited his parents to draw for him and spent a great part of his allowance on pictures.

The rooms through which Alfred moved, in New York and at Lake George, were furnished in rather undistinguished Victorian fashion. The walls of his New York bedroom were covered with prints, especially those by Currier and Ives. Many of the engravings were based on the work of Louis Maurer, a friend of Edward. Louis happened also to be the father of Alfred Maurer, whose "modern" work young Stieglitz later exhibited.

"Among the pictures I loved best, before we left for Europe, was a realistic and, to me, miraculous watercolor of stamped postcards, made for my thirteenth birthday by a friend of the family, Julius Gerson. I was told it was a portrait of me."

Alfred showed the Gerson picture in an important exhibit he organized in 1937 at An American Place—"Beginnings and Landmarks"—explaining that the painting was included because it had been part of his history: "When young, I felt you could lift the postcards and stamps from the very paper on which they were painted."

Although Alfred's taste evolved in quite other directions, he never permitted this to falsify the past. The Gerson picture that so pleased him as a boy always delighted him at a certain level, regardless of

3. Painting, Julius Gerson, 1877

his growing realization that to do no more than make faithful copies of outer form bears little relationship to the creation of art.

Edward Stieglitz's insistence upon quality led him to choose only the best schools for his sons and daughters—Alfred, Flora, the twins Leopold and Julius, Agnes and Selma. He engaged the first violinist and a cellist of the New York Philharmonic as music teachers for the twins, and an excellent piano teacher for Alfred. Aunt Rosa Werner, Hedwig's sister, who lived with the Stieglitzes and was a talented pianist, often played for the family and their friends.

4. Alfred's report card, 1879

Alfred attended Charlier Institute, an outstanding private school, until it was decided he should go to a public one. His parents determined that this would be more democratic and less costly.

"At school I refused to memorize, to recite poetry or anything else by heart. My teacher of Elocution and Declamation was in a quandary about what to do. Since I was first in my class in every other subject as well as in conduct, he must have felt he could not give me a zero, so he marked me a hundred. I said this was not fair to others. He replied that he wished to be fair to me. This was when I was twelve. I have always rebelled against learning anything by heart. Due to my teacher's inconsistency I came to have little respect for what might be called academic standards."

Alfred refused to read or listen to fairy tales, but he was excited by books about the American Revolution and by those of Horatio Alger and Mark Twain. *Uncle Tom's Cabin* became a favorite. Without apparent transition he came to love Goethe's *Faust*, Byron's *Don Juan*, Shakespeare's *Venus and Adonis*, *As You Like it* and *The Rape of Lucrece*.

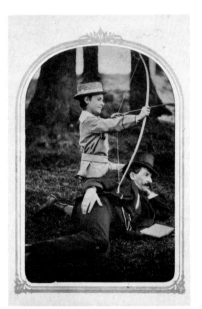

5. Alfred and his father, 1875

"When I was ten, I read *Faust*. My mother asked me whether I understood it. I said, 'I don't know what you mean by understand.' 'Then why are you reading it?' 'Two things in it attract me, Marguerite and the Devil.' 'What about Faust?' 'He doesn't interest me.'

"Marguerite and the Devil have continued to fascinate me. All thinking men must feel a similar concern about woman and the Devil. Due to something in the male and something beyond. What woman feels about the male and the Devil I do not know. People kill one another because they love one another too much. Jealousy, envy, are always at work, no matter what one does. The result is a constant. Yet everyone claims to be seeking peace."

Alfred made it a practice in his youthful letters to describe events of a day, hour by hour, in meticulous fashion, noting the exact moments at which he wrote. He recorded the most subtle variations in weather and atmospheric conditions. His sensitive reactions to almost imperceptible shifts of wind, rain, light were soon to be reflected in his photographs.

20 Clear evidence of a natural affinity with photography dates from

1872, when Hedwig took Alfred together with his brothers and sisters to have a group picture made by Abraham Bogardus, a fashionable New York photographer. "As Mr. Bogardus was about to go into his darkroom, I asked could I accompany him. He replied that if I would be very quiet I might watch him as he worked.

"I still see myself in his cubbyhole of a darkroom, while he developed his wet plate. I remained absolutely motionless, just as I had when the group was posing. I remember being told, as we left the darkroom: 'I shall not have to make another exposure. None of you moved.'

"Quite a few pictures were made of me during my youth. Of course I often saw my mother, who took great pleasure in having me photographed, show portraits to her friends, but I was far less interested in the pictures than in going into darkrooms. I wanted to know what went on in those mysterious places. Through watching what photographers did there, I learned how a properly developed negative should look."

A tintyper at Lake George where, in the mid-seventies, the Stieglitz family spent the first of many summers, made an equally lasting impression: "I was photographed by Mr. Irish, who was so decidedly cross-eyed that when he pointed to a tree and said, 'look here' and 'don't move,' it seemed he was talking about a different tree from the one toward which he pointed. But I was a good boy, very serious, and never laughed nor moved during an exposure.

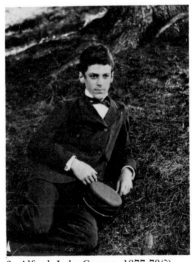

6. Alfred, Lake George, 1877-78(?)

"Pictures were taken of me with a bow and arrow, with a straw hat, and without a straw hat. I invariably accompanied Mr. Irish into his darkroom. I still see him developing his tintypes and drying them over an alcohol flame. He would take a fine camel's hair brush and dip it into some rouge with which he touched up the cheeks. I asked him why he put paint on the portraits. 'It makes them look more natural, more finished.' I objected to this: 'I don't think so. I would not do that if I were you.' It rather annoyed me to see Mr. Irish touch up his tintypes for, even at that time, I had a curiously pronounced feeling about letting a photograph be simply a straight photograph.

"Mr. Irish and I became friends."

When it came to Alfred's youthful desire to photograph at home, Edward called a halt, finding the wet plates in use far too "messy."

7. Alfred's toy racehorses, 1875

Alfred developed a lifelong interest in horse-racing after his father first took him to Saratoga in 1873. By day he played with his little leaden horses. At night he dreamed of his toy racehorses and of real ones, of everything connected with the world of racing. The first objects he took to be photographed, quite on his own, were his tiny lead horses with jockeys on them.

The youthful preoccupation with racing was related to Alfred's early admiration of thoroughbred horses. He soon became fascinated by the thoroughbred in every phase of life. He read about races throughout his life and bought books on distinctive thoroughbred horses whenever he felt he could afford it.

Preoccupied neither by his trade nor by amassing a fortune for its own sake, Edward Stieglitz felt by 1881 that he had made enough money—four hundred thousand dollars—to retire, at least temporarily, and take his entire family to Europe. He wished to give his six children everything of which he had himself been deprived, above all, "the best possible education and the finer things of life."

Before the family's departure a seemingly simple experience occurred which Alfred regarded as most significant.

"During the summer of 1916 at Lake George,[3] my mother was on the porch knitting, as she often did. I was sitting with her, looking

8. "My Parents' Home," A.S., Lake George, 1907

at the trees that surrounded us, at the lake before us. Every so often she would say something, ask me a question. I did not answer.

" 'You seem not to have changed any,' she remarked. 'Even now, when I ask you a simple question, you act as though I did not exist. You always will be mysterious.'

"I laughed and remained silent.

"My mother looked at me intently: 'Do you remember the organ-grinder who used to come to our house when you were a boy?'

" 'Of course,' I replied.

"One Saturday evening in New York, in 1875, as we sat down to supper, an organ-grinder began playing the *Miserere* from *Il Trovatore*, the *Marseillaise* and other music. I went out to him and gave him ten cents—part of the dollar I received each week from my fa-

ther for carfare and similar expenses. The organ-grinder, an Italian with a gray beard, had with him a monkey holding a tin cup. The man wanted the monkey to shake my hand to thank me, but I shrank back. I did not like to be touched.

"The following Saturday as we sat down punctually at seven, the organ-grinder once more began the *Miserere*. After going to the kitchen to ask the cook for a sandwich and cup of coffee, I went into the coldish night and gave them to the organ-grinder, together with my ten cents. Every succeeding Saturday night, except in the summer months when we were in the country, the organ-grinder appeared punctually at dinnertime. I went regularly to the kitchen and then to him. The years rolled by.

"On a bitter cold Saturday night in January, six years later, when the organ-grinder began the *Miserere*, out of tune as always, I rose to go to the kitchen. My parents said: 'Alfred, you look pale. It is such a cold night. Don't you think you had better eat your hot soup first?' I did not reply. I went to the kitchen and then to the street. The soup could wait. The organ-grinder and organ were covered with snow as were the monkey and his coat.

9. Oaklawn, A.S., 1895

"I returned to the table. My mother and father said nothing. Some weeks later my father decided we would go to Europe for a five-year stay.

"As soon as I heard of the plan to go abroad, the organ-grinder came to mind. I tried to tell him the following Saturday night that, in about ten weeks, we would be moving from our house; that we would be gone for some years. I felt he should know. On the last Saturday before our departure, we said good-bye to one another. It was all as natural as one day succeeding the other.

10. Oaklawn, A.S., 1895

"That was in 1881. Now on the porch at Lake George, my mother asked me did I recall the organ-grinder. He had never been mentioned in all of the intervening thirty-five years. Not during the time I went out to him did any of the children, nor my parents, nor my aunt who lived with us, nor any one else, ever make any remark about what occurred. So that now, my mother's unexpected questioning startled me. She wanted to know why I had not listened to her and my father on that cold night.

" 'Ma, do you know who the organ-grinder was?'

"She looked up. 'Why, of course. He was an Italian with a gray beard and he had a monkey with him.'

"I asked was she sure.

" 'Alfred, there you are with your usual mystery.'

" 'Ma, do you really want to know who the organ-grinder was? Do you want to know a secret?'

"My mother was silent.

" 'Well, I shall tell you. I was the organ-grinder. I never gave to him, nor have I ever given to anyone else, except myself.'

"My mother seemed stunned. She looked at me again. After a few moments she said, 'Did you know that from the very beginning, even when you were young?'

" 'Yes,' I replied.

"My mother continued knitting. Both of us remained silent."

III. Education in Germany
First Experiences with Photography

Edward Stieglitz was persuaded that the future belonged to the engineers. Because Alfred's teachers in New York laid special emphasis on his mathematical turn of mind, Edward expected him to become a mechanical engineer. Alfred later recalled, "The question of whether I was qualified to take courses in engineering seemed never to enter my father's head. It was assumed I would 'know what to do.' Why this was so I have never understood. As a child I did not take toys or watches apart. I was not especially good with my hands. I heard no talk of engineering at home or elsewhere. It was a closed book for me.

"When we went to Europe in 1881, my father gave me two pieces of advice: 'See that you don't get into debt,' and 'Don't be afraid to tell the truth.' He decided that, during my first year abroad, I should study in Karlsruhe, in order to improve my German. I was then to attend the Zürich Polytechnic, but after he learned that it was a coeducational institution, that the women who studied there were virtually all Russians, extremely free in their sex relations and addicted to smoking large cigars, he concluded it was no place for his son. Since there was a Polytechnic in Berlin considered quite as good scholastically as the one in Zürich, he determined I should go there instead. I was willing to make a stab at taking mechanical engineering courses."

After entering the Berlin Polytechnic in 1882, Alfred attended lectures on mechanical engineering for one year: "They meant nothing to me. I also frequented courses at the University of Berlin given by such men as Helmholtz, Du Bois-Reymond, Virchow, Hofmann and others of the same caliber. It was their names that attracted me, all those of very great men.

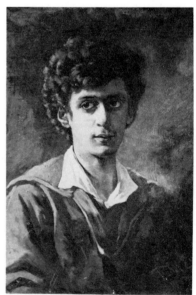

11. Alfred, Encke, early 1880s

"Not more than twelve students were present at Helmholtz's physics lectures. Next to me sat Michael Pupin, who had come from the United States—from Columbia University. I was told of his brilliance as a physicist. Helmholtz, in a low, sometimes hardly audible voice, spoke as though he were inhaling his words. I hadn't the slightest notion what he was saying. I asked Pupin, who seemed to be getting a great kick out of the classes, 'Do you understand Helmholtz? I don't.' Pupin smiled, 'Why, he is simple enough.'

24 "This did not quite satisfy me, there being nothing simple for me

about what was said. One day after a Helmholtz class I went up to him. I have no idea how I dared since I was anything but brazen. In fact, I was quite timid, but I knew I could not go on listening without learning anything. Helmholtz said in a gentle voice, 'What do you wish?' I described my dilemma and inquired whether he could not simplify his words, adding that we were not all Pupins, nor little Helmholtzes.

"In a rather sad voice, again hardly audible and scarcely letting me feel he was addressing me, Professor Helmholtz replied, 'Young man, I am making this course as simple as I can. I am discussing the ABC of physics.' I thanked him, but attended no more of his lectures.

"My experience with Helmholtz played an important role in my life. It made me realize how often we waste the time of those concerned with the XYZ of a subject before we have even mastered the ABC.

"In 1883, a chance event served as a crucial turning point in my life. I was filled with excitement as I noticed a small showcase containing photographic material in a Berlin shop window. There was a box with a lens, a small candle light with a ruby canvas hood over it, some small developing trays, plates and other equipment. I decided I must try to photograph. I bought the box which cost the equivalent of seven dollars and fifty cents; also some trays, chemicals and a ruby light. The size of the plates was thirteen by eighteen centimeters.

"The lens in the cubic box—the box was called a camera—was of the simplest kind. Its value was no more than twenty marks—four dollars—if that.

"I bought a small booklet telling about exposures, about how to develop and print. One of the first pictures I made was of a series of portraits, pinned to a drawing board, that Ernst Encke, a Berlin photographer, had made of me. Ernst was the brother of Fedor Encke, the painter who had lived with our family in New York.

"To my great delight, when the plate was fixed and I examined it in daylight, it was perfect. At no time thereafter could I have done any better with the same subject matter.

12. Early photograph, A.S., 1883

"My original darkroom, which I set up in my own quarters, was bounded on one side by a door which swung back in the corner of the room. It touched a wall at right angles to the one to which it was attached, thus forming a hypotenuse that enclosed the three-sided 'darkroom.'

"The room was relatively dark. I hung bedclothes over the door whenever the light leaked in and I pulled down the shades. The space in the small triangular section was so limited, I had to lean over a tiny chair which also served as a table. On this I placed my developing tray as well as a little red lamp with a candle in it. I had another tray containing fixing solution, a small pitcher and a slop pail under the chair. After my negatives were thoroughly fixed, I

washed them, changing the water at least two dozen times during a period of about an hour. No running water was available. The negatives dried by themselves.

"In the mornings, after developing, I prepared proofs. The man from whom I bought sensitized paper told me how to treat it. What excitement I felt while making those first proofs!

"I followed up my initial experiments by photographing, from my room, the house opposite—really a plastered wall with windows. I made exposures of the wall hundreds of times, soon realizing that every change of light presented a new problem. Looking back, it is rather strange to recall how primitive and tentative everything I did was in that early period.

"Not long after, a young man sitting nearby in an engineering course took a few photographs out of his pocket. They resembled proofs I had seen as a child. I was impatient for the lecture to end.

"When it was over I asked, 'Were those proofs you took out of your coat pocket? Do you photograph?' He replied, 'Yes. I take a course. It is part of the curriculum in engineering.'

"I rushed over to the office of the registrar and asked whether I could attend the course given by Dr. Hermann Wilhelm Vogel, a professor in photochemistry, who also lectured on aesthetic theory as applied to photography. With the registrar's approval I entered Dr. Vogel's class.

"One or two days later I heard my first lecture. To begin with, I understood little of what was said. But fortunately, each week, two periods of two hours were devoted to practical work.

"Thus my career in photography can be said to date from the day I entered Professor Vogel's course in 1883."

It was fortunate for Stieglitz that Dr. Vogel was his photochemistry instructor at the Berlin Polytechnic. The findings of this ingenious experimenter, who greatly advanced the science of photography during the seventies, had special meaning for his talented and enterprising American pupil.

In 1873 Vogel noted that, by using certain dyes in the preparation of photographic collodio-bromide dry plates, they could be made sensitive to rays of light other than blue. Plates treated in this manner were sensitized to all colors save red and so were termed orthochromatic. Later plates made responsive to all colors were called panchromatic.

Vogel's discovery was of inestimable value to photographers who "had despaired at the tendency of their material to render blue sky with such a dark deposit on the negative" that their prints showed no clouds.[1]

Stieglitz realized that to achieve the print quality he desired, the modeling of all parts of his photographs must be clear and well

defined. Orthochromatic emulsion made it far easier to attain this goal. A second advance was the introduction of platinum paper.

The British critic and editor, R. Child Bayley, has described a third step: the perfecting of the gelatino-bromide dry plate, which "did away at a stroke with three fourths of the trouble and messiness of negative making."[2] The sensitivity of the new process vastly enlarged the scope of the camera, making it feasible to photograph many subjects with a fidelity hitherto difficult to achieve. The dry plate made "instantaneous" work possible, and led to a fourth important development, the hand camera.[3]

In 1890 two resourceful experimenters, Ferdinand Hurter and Vero Charles Driffield, proved that, for a given plate, there was an optimum exposure time governed by the brightness range of the subject, the substance of the developer and the temperature at which the developer was used. In Stieglitz's view this contribution—a

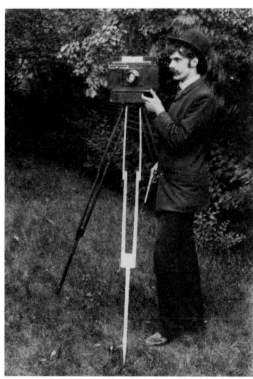

13. Alfred, Self-Portrait, Germany, 1886

fifth development of the period—liberated photographers from trial-and-error methods, thus giving them added time to concentrate on aesthetic considerations.

Despite his respect for the discoveries made by Hurter and Driffield, Stieglitz refused to rely upon purely mechanical means of developing. He preferred instead to make constant experiments. Throughout his career he varied accepted practices both when photographing and when preparing negatives and prints. He liked best to judge for himself what he should do, to follow his intuition based on ever increasing experience.

"Once I decided to concentrate seriously on photography in Berlin, I discovered that the lectures in photochemistry meant little to

me. I therefore spent most of every day doing laboratory work.

"In time Professor Vogel took me into a studio and taught me how to focus, manipulate curtains and control lighting. It seemed there were curtains everywhere. He said to photograph a plaster cast of the head of the *Apollo Belvedere*, which was draped with a black velvet focusing cloth.

"I began a series of experiments lasting for weeks. No matter how often I photographed that damned plaster cast, I seemed never to make a perfect negative.

" 'What are you doing?' Dr. Vogel asked. I described my difficulty—my inability to obtain a satisfying relationship between the white plaster and black velvet, so that the proper values of both were maintained.

" 'My God, man,' Vogel replied, 'what you are aiming at is impossible to achieve! You are searching for what might be called perpetual motion in photography. Don't you realize that, if you wish to photograph, there must be a certain compromise?' Such a concept seemed reprehensible. My refusal to accept what others said about 'compromise' and 'impossibility' played an important role for me while I was in Berlin. Being told that certain pictures could not be taken made me disregard a number of accepted practices and seek to invent new ones. In this way, I was challenged to stick at solving problems I might not otherwise have tackled with equal persistence.

"The Polytechnic moved to a well set-up new building, with the finest laboratories for both photochemistry and physics. I complained about the scheduling of special hours when the laboratories could be used. But who would be responsible for the rooms if they were open all of the time? I volunteered. As a result they were made available day and night. I worked each day as long as possible.

"I worked with the wet plate process for some time, until one day I noticed a student using a camera with dry plates. I hastened to acquire the new equipment.

"I was eager to see how fast I could take, develop and print a picture. It required thirty-four minutes. When asked what I was trying to prove, I replied that newspapers would reproduce photographs with increasing frequency, that speed would be of ever-greater importance.

"It was accepted as a fact at the Polytechnic that photographs could be made only in daylight. The cellar below our laboratory was illuminated by a weak light bulb. I made a twenty-four hour exposure of a dynamo. The negative was perfect and proved that where there is light, one can photograph. People called me that crazy American. Yes, I was a crazy American.

"The paper most favored for printing at the time was coated with albumen and sensitized by being slipped into a silver bath. It had to dry before it could be used. Once sensitized, it would keep for a few

days if stored in a dry place away from light.

"I soon found platinum paper manufactured in England, which I much preferred. When it was immersed in a hot developing bath, an image at first only faintly visible became a beautiful blue-black.

"Hypo was not required as a fixing bath for platinum paper nor was it necessary to wash the paper for long periods of time after it was developed. It could be dried over a stove very quickly without fear of damage either to paper or image.

"I had been told platinum paper was not easy to work with and it was costly. Yet it was much faster and seemed far more permanent than albumen paper. I used it almost exclusively until many years later when it became difficult to buy. I liked the print quality obtainable with it better than the hard cold prints being made of hard cold subjects in hard cold light. I did not see why a photograph should not be a work of art, and I studied to learn to make it one.

"During that early period in Berlin I began working along my own lines and had a grand time. My cameras were heavy and cumbersome. They had no shutters. I never made snapshots. I always used a tripod and exposed with great care, having no interest in shooting at random or in making shoddy, unloved prints or in careless workmanship of any variety. This was all before the Kodak[4] ('You press the button, we do the rest') and similar cameras.

"I began to photograph objects thousands of times if necessary. To others at the Polytechnic, who seemed satisfied with their first attempts, a brick wall was evidently just a brick wall. When I photographed a wall over and over again, or the white plaster cast draped with black velvet, I was trying to fathom the secrets of variations in light. I did so from an inner urge, without theory, just plain living.

"The other students had no inkling about the driving force within me. I did not realize the problems I tackled were rather deep. I was innocent of what was going on in the photographic or art world. I did nothing according to rote, nothing as suggested by professors or anyone else. It is difficult to understand at this date the passion and intensity I poured into photographing during those early hours, days, weeks and months! Photography had become a matter of life and death. I worked like one possessed, even though before long I ran up against a world not ready for true photographs.

"I gave up mechanical engineering to devote myself entirely to photography. I was eager, also, to find out what 'photography' represented in the social scheme of things.

"One of my professors asked me whether I planned to work for a degree. I said no. So far as I was concerned, it was a waste of time to study by rote—philosophy and the rest. I believed I could evolve my own philosophy from living. I sensed that the day would come when I would take up the philosophers and find that they and I had arrived at very similar conclusions about life. Not necessarily at

identical ones, but our experience of life would have been similar.

"One day in 1884 Professor Vogel asked permission to show a batch of my photographs to a group of painters. The following day he said the prints had created quite a sensation, that the artists could not believe they were photographs. I finally agreed to meet the painters. They were men of reputation, all well over forty. Some of them expressed a desire to have various pictures of mine. I was only twenty, yet their work held little attraction for me.

"One of the artists remarked, 'Isn't it too bad your photographs are not paintings. If they had been made by hand, they would be art.' The same artist said he wished he could paint the way I photographed.

"I looked at him in surprise: 'I never have had any desire to make a photograph look like anything I have seen painted.'

"Although unaware of what prompted my question, I inquired, 'Do you feel that a pair of shoes made by hand is necessarily superior to one manufactured by machinery?' The answer was 'Yes.'

"'But,' I insisted, 'suppose manufactured shoes were adequate to meet the demand of the world in general, what would shoemakers who had been making shoes by hand do if driven out of their jobs?' One of the artists exclaimed, 'That is unthinkable. No machine-made shoes can ever equal those made by hand.'

"'If machine-made shoes cost less,' I asked, 'and proved to be not only serviceable, but even more, what then? Would you wait until you had sufficient money to buy shoes produced by hand if you really needed a pair?' 'The situation you describe can never take place. Custom-made shoes must always be superior to others. They can *never* be supplanted.'

"'Suppose,' I observed, 'it should become necessary, as a matter of life or death, to compete with the machine? What then?' 'There are bound to be apprentices who will love to make shoes by hand. Their kind can never die out, no matter how many machine-produced shoes may come into being.'

"I was thinking not only of shoes, but of my photography and the painters. 'I have a feeling,' I said, 'fewer and fewer hand-made shoes will be made.'

"As I look back, there is no doubt that what each of us felt was somehow true. Perhaps I saw something fundamental having to do with the future, with the reality of the machine and its having come to stay. The question we discussed is at the root of much of the upheaval we are experiencing in the world today.

"Only too happy that my prints were admired—that they meant something to Professor Vogel's friends—I was not yet aware that all who paint are not true artists.

"This was nearly fifty years ago. If you were to ask me today whether I know the answers to the all-important questions we dis-

cussed in Germany, my reply would have to be: as little now as then; perhaps less, because I am no longer quite so naïve, or maybe more innocent—I do not know which."

The experience with the German artists had a marked effect upon Stieglitz. It intensified a boyhood preoccupation with finding out what people really mean when they speak. It caused him to write to his father that he planned to dedicate his life to seeing that photographs of distinction were accepted on the same basis as art in other already recognized forms.

"I found it difficult to understand how, with society supposed to be 'in the hands of the engineers,' machine-made objects were looked down upon. In a sense, a camera and lens are mere mechanical objects. Nonetheless, without my being one with them, what aroused admiration for my pictures could not have existed. I developed a natural respect both for well-made machines and for whatever they produce that is beautifully created.

"I have been unable to deny my cameras, or the telescope I had as a student, or any other instrument of quality. A poorly made device or object is something quite different."

"My life in Berlin was congenial, free—the freest I have ever experienced. What more could a person want than I had?

"My allowance of between twelve and thirteen hundred dollars a year was modest but so were my needs. Since I lived simply, it was possible to do and see everything that mattered.

"One hour before the opening of almost all operas, concerts and plays, students could buy tickets at a fraction of their regular cost. We were given discounts on books, rooms, the Roman Baths—a rebate even on tickets to the racetrack. Everything available to us was first rate. The museums, libraries, historical monuments were free of charge. I traveled third class on slow trains and ate well in inexpensive restaurants. I attended classes at both the University and the Polytechnic, havens of perfect freedom. I could hear any lectures that interested me on a great variety of subjects, and still have time to work at my photography in a magnificent laboratory.

"I had no desire to drink or to eat rich food. I harbored no social aspirations, and was devoted, above all, to photography. I was crazy about billiards and racehorses, but this neither complicated my life nor interfered with my work. I was interested in Woman, but not in women.

"I frequented cafés, mainly the Café Bauer, which was open day and night. There were no set times when I had to do anything. If tired, I slept; if hungry, I ate. When I wanted to read, I read.

"Even at the racetrack in Europe I thrived on the color, the movement, the jockeys on wild, rushing horses, the elements of na-

ture controlled by man. I was excited by the entire picture of life: spectators, participants, comedy and tragedy—all dovetailing, breathing! I realized that horse-racing abroad was not a 'business' in the same sense that everything was becoming 'business' in America."

Stieglitz first thought that most of the paintings by old masters looked like old leather. He raced through galleries, stopping only before those works of art that meant something to him. Tintoretto moved him, as did Rubens, especially the latter's *Hélène Fourment* and other portrayals of women.

"While in Germany, I continued to be immensely entertained by Mark Twain. I read his books aloud by the hour, to both my German and American friends. The Germans could not understand a word, but they roared with laughter in response to my own laughter and enjoyment. I could not read Dickens, but I loved Zola, especially his *Madeleine Ferat*. Also Daudet's *Sapho* and his *Tartarin* series. Turgenev introduced me to Russian literature. Pushkin came next, then Gogol. Lermontov's *A Hero of Our Times* delighted me. I did not yet know Dostoevski. I read Scheffel, later Tolstoy. The plays I admired most were those by Shakespeare, Goethe, Schiller, Ibsen, Lessing, Calderón, Echegaray.

"I was never without a piano. Among my favorite scores were *Carmen* and those of Wagner and Gluck. At times I played Chopin's Funeral March or a Tyrolese song. I loved Beethoven, Mozart, Schumann. Although never much of a pianist, I had a passion for music. Oftentimes at night I would sit bare-skinned on the piano stool and play.

"My mother's picture hung in an ornate Swiss carved wooden frame. Over it was draped an American flag twelve feet long. A friend, very poor, knowing of my feeling for my home country, surprised me one day by bringing it to me. He made the flag himself, sewing it by hand.

"To the right of the piano, before a tall glass mirror, stood my nickel-plated Columbia high-wheel bicycle."

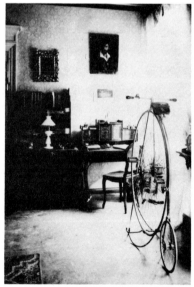

14. "My Room," A.S., 1885-86

Important technical advances in photography were achieved in Germany while Stieglitz was a student in Berlin, yet much of the foremost amateur work of the period was created in England. It must have been gratifying that, within four years after Stieglitz turned his attention to the new medium, Peter Henry Emerson awarded him first prize in the 1887 "Holiday Work" Competition of the (London) *Amateur Photographer*.

Emerson, a noted photographer and critic, was an American living in England and a leading champion of naturalistic pictorial photography. He wrote to Stieglitz, expressing sincere admiration for his pictures and emphasizing that they were the only spontaneous

work received in the entire collection. Certainly no higher praise could have been bestowed upon a young photographer at the time. All that Alfred had to say was: "I am very glad for my father. Winning the prize is tangible proof for him that my time is not being wasted. As for myself, all I can think of is how bad my competitors must be."

A lively correspondence with Emerson ensued. In one letter Emerson wrote that, although unknown to one another in the flesh, he trusted the two men were friends in spirit. Emerson mentioned

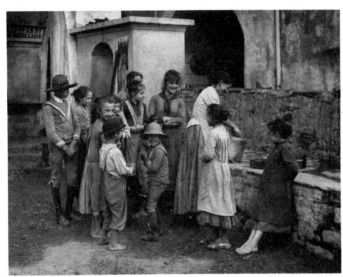

15. "A Good Joke," A.S., Italy, 1887

that he was writing a book, *Naturalistic Photography*, later published in 1889. He asked Alfred whether he would care to translate it into German, a task for which he deemed the young American highly qualified. Stieglitz agreed to go ahead, but soon realized he was not truly interested in the project.

In 1889, Alfred sent photographs to the Berlin Jubilee International Exhibition. In July of the same year his prints appeared in the first number of the *American Amateur Photographer*. He was invited to be a juror for important competitions in Germany—an honor often to be repeated in the United States. His photographs gained increasing attention both at home and abroad, winning medals in almost every exhibition in which they were entered.

Stieglitz's practice of traveling and making foot-tours during the summer months in Germany, Austria, Italy, the Tyrol and Switzerland developed a love of pastoral Europe. His pleasure was in no way diminished by the need to carry bulky, heavy cameras, plates and tripod wherever he went.

The early pictures Stieglitz made in Europe reflect an overwhelming feeling of identification with the old world, in which man's caring could still be expressed by way of his personal, loving touch upon what he fashioned. The countryside and villages, the sense of harmony observed between those he photographed and their way of

life awed him. He saw the figures in *Harvesting* as one with the soil and nature; with their task, each other, with themselves.

During the years in Berlin, love seemed all innocence and trust. In the sun-striped print of *Paula** the two photographs of mountains, lake and sky on the wall foreshadow Stieglitz's more mature *Equivalents*.

The admirer of technological innovation, who developed as an artist by way of a machine, used his modern apparatus while abroad to celebrate a non-mechanized culture. The photographs made— among them *Venetian Boy*—were unsentimental, reverent.

Much as he loved Europe, Stieglitz retained a great loyalty to America and defended his country whenever it came under attack by skeptical Europeans. When the Brooklyn Bridge was being built and a Berlin professor claimed to prove that it would certainly collapse, Alfred rose to the defense: "It was, after all, my America I was defending."

16. Berlin Exhibition, A.S., 1889

In 1890 Edward and Hedwig asked Alfred to come home. Their eldest daughter Flora had died in childbirth and they wished to have their children close at hand. They also were anxious about him, feeling that he should settle down, earn a living and marry.

"Toward the end of my stay abroad, I began to suspect that my experience there could not be duplicated in New York nor even understood. Many people said I would not enjoy life in the United States to the same extent. Still I contended that for those truly alive, life could be satisfying anywhere.

"I was so innocent while in Germany I imagined I would find all true workers in America given an opportunity to perform the tasks they were best fitted to do and thus be able to support themselves.

"I was convinced that all individuals must be busy and satisfied with their jobs. Everyone would have a roof over his head, and be as happy as the flowers and trees, functioning naturally. No one possibly would wish to destroy anyone else. All who gave themselves, with sincerity, to what they were doing would be able to live together in one spirit. There would be a widespread desire to create such

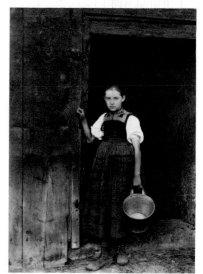
17. Little Milkmaid, A.S., 1894

an integrated social order that, no matter how complicated it might appear to be, it must operate perfectly, giving forth a sense of peace and wonder. (I still maintain this belief at heart.)

"Upon my arrival in the United States, I found the Brooklyn Bridge intact but the land of my dreams was nowhere to be discovered. I began to wonder whether I, who had refused to listen to fairy tales, preferring the *Boys of '76*, had not perhaps fallen for the greatest fairy story of them all!

*The portrait on the table, like those on the wall, are variant portrayals of Paula. The treatment of the head on a pillow also suggests Stieglitz's later work.

"I soon realized that 'photography,' as I understood the concept, hardly existed in America. The photographic scene, like much else, was disconcerting. People were without work. It was not clear where I myself would fit in.

"I found that a difference was made between the white man and the dark, the white man and the yellow, although what has always been of interest to me is the human being. Everything I saw to begin with, intensified my desire to rush back to Europe."

IV. Return to New York
Photographic Career Evolves

Stieglitz felt forlorn and at loose ends in New York: "It was strange to experience such unhappiness in my homeland among my own people; to feel no point of contact with anyone or anything. The streets were filthy. For months, despite being twenty-six years old and living with my parents, I cried every night, not from self-pity, but from a sense of overpowering loneliness. The spiritual emptiness of life was bewildering.

"My father had promised to continue my allowance of thirteen hundred dollars a year. I knew I could live on that, photograph and fight for my dream of what photography could be. I had no thought of marrying. I wanted to live simply, but my father had other ideas. He insisted on my doing something 'practical.'

"He said, 'You can sell your photographs.' 'What,' I replied, 'sell my beautiful prints? No, I will not.' Next he suggested opening a photographic gallery—meaning, of course, a commercial one. This was unthinkable. He finally arranged for me to enter the photoengraving business, an undertaking in which I had no interest. My two Berlin roommates, Louis Schubart and Joseph Obermeyer—both of them New Yorkers—became partners in the venture.

"Our firm, at first called the Heliochrome, then the Photochrome Engraving Company, gained respect for doing work of fine quality including color reproductions. Speed, however, and quantity were demanded rather than careful craftsmanship."

Various events of decisive importance soon altered Stieglitz's attitude about remaining in the United States. During the season of 1891–92 he joined the New York Society of Amateur Photographers. Because of his ability and growing international reputation, he was asked to become an editor of the *American Amateur Photographer* in 1893, a post he held without remuneration. For a time such events provided a certain focus to his life. To his surprise, early in 1893, the hand camera that had aroused his scorn became of crucial importance. It permitted him to work outdoors with far greater ease without sacrificing quality. It intensified his already strong desire to photograph the city.

"When I decided to remain in the United States, I bought an eight by ten inch camera. A good instrument, yet not to be compared with those made in England. Soon after, I was shown some four by five inch prints; their extraordinary beauty was amazing.

"They had been made with a hand camera—a box affair with a ground glass, bellows, lens and shutter, a finder in the lid and an opening in back which made it possible to look at the ground glass. There were as many plate holders as one cared to have. When I was asked whether I wanted to try out the camera, the temptation was too great to resist. In order to make a series of New York prints I had in mind—photographs I knew could not be taken with a large camera and tripod—I decided to buy the camera and master its use."

I have always loved snow, mist, fog, rain, deserted streets. All seemed attuned to my feeling about life in the early 1890s.

"On Washington's birthday in 1893, a great blizzard raged in New York. I stood at the corner of 35th Street and Fifth Avenue, watching the lumbering stagecoaches appear through the blinding snow and move northward on the Avenue. The question formed itself: Could what I was experiencing, seeing, be put down with the slow plates and lenses available? The light was dim. Knowing that where there is light one can photograph, I decided to make an exposure.

"Later, at the New York Society of Amateur Photographers, before my negative was dry, I showed it with great excitement. Everyone laughed. 'For God's sake, Stieglitz,' someone said, 'throw that damned thing away. It is all blurred and not sharp.'

" 'This is the beginning of a new era,' I replied. 'Call it a new vision if you wish. The negative is exactly as I want it to be.' What I was driving at had nothing to do with blurred or sharp. And when, twenty-four hours later, the men saw my lantern slide, they applauded. No one would believe it had been made from the negative considered worthless. I called my picture *Winter-Fifth Avenue*. It was the first photograph I had taken with a hand camera."*

One evening in 1893, Stieglitz noticed a huge poster in front of a Broadway theatre: "*Camille* was being played by a celebrated Roman actress. I had seen Bernhardt in the same role in Europe, an amazing performance.

"I disliked *Camille*, but I bought a ticket. Fortunately an aisle seat in front was available. There were no more than a hundred people present as the curtain rose.

"I seldom read programs before a performance, preferring to al-

*Edward Steichen later wrote that the picture was Stieglitz's "most exhibited, reproduced, and prize-awarded print, and was a technical achievement considered impossible" at the time it was made.[1]

low things to happen of themselves. The actors spoke Italian. I understood little of the language.

"Suddenly a figure appeared on the scene so quietly with such a face and what hands! As the woman began to speak, the tears rolled down my cheeks. I had admired Bernhardt, but had not been touched by her acting. Now the Italian woman gripped all of me. Even when silent, she satisfied everything within me.

"The emptiness of the theatre was incomprehensible. Before the last act I went to the box office and reserved the same seat for every new drama in which the actress would appear. At the end of the play I was in a daze. Reaching home past midnight, I found my mother standing at the head of the second-story stairway. 'I was worried,' she confessed. 'Where have you been?' 'Ma, don't talk to me,' I said. 'I saw a marvelous woman, a Roman actress. I have a frightful headache.' 'You enjoyed it that much,' she replied. 'You have seen Duse.' I had never heard the name before.

"'Many people consider her the greatest actress living, even greater than Bernhardt,' my mother added. I said nothing. I tumbled into bed, feeling for the first time since my return from Europe that a contact existed between myself and America.

"Some weeks later I passed another theatre on Broadway. The doors were wide open. The stage was visible from the street. I heard laughter, shouts of laughter.

"Two men were at a billiard table. I had been a fiend at billiards in my boyhood, also later in Germany. I went to the box office and asked to buy a ticket. The man at the window said, 'Walk in. It's late. The performance will soon be over.' I insisted upon paying. The man took a quarter. I laughed so hard when I saw what the two actors were doing, many people turned around and looked at me. I had never witnessed anything quite so funny, yet true. Upon leaving the theatre, I made up my mind to see, and I did, the same act every night it was given. The two performers were Weber and Fields, names also unfamiliar to me.

"A few days after *Camille*, I found myself in front of the old Post Office. The Third Avenue street railway and the Madison Avenue car systems had their terminals there, opposite the old Astor House.

"It was extremely cold. Snow lay on the ground. A driver in a rubber coat was watering his steaming car horses. How fortunate the horses seemed, having a human being to tend them. I decided I must photograph what was before me.

"The picture I made became known as *The Terminal* or *The Car Horses*. The steaming horses being watered on a cold winter day, the snow-covered streets and the stagecoach in *Winter-Fifth Avenue*, my sense of loneliness in my own country, all seemed closely related to my experience when seeing Duse.[2] And then there were Weber and Fields. America was saved for me. I was no longer alone."

At times Stieglitz felt a deep nostalgia for the hand-made, for the art of living he had witnessed and experienced in Europe. This can be sensed in his early New York photographs of isolated, old-fashioned workmen trapped, just as he was, in an ever-changing society charged with unforeseen conflicts and tensions. To his dismay he no longer found typical those who performed their tasks "with all of themselves."

He was drawn to the driver who gently tended his throbbing, steaming horses; to the solitary street-sweeper standing by a tiny

18. Typical early framing and hanging of A.S. photographs, New York, 1899

rain-drenched tree, dwarfed, nearly engulfed by the dismal structures that flanked them.

Yet he was also moved to make poetic photographs of splendid feats of engineering. Because he used his camera—still an experimental instrument—with the same daring and freshness inherent in the bold new forms he depicted, his work emerged as more modern in both substance and approach than it had been abroad. He responded to unprecedented new towers—rising, reaching, often in lonely grandeur and dignity; to great ships, massive locomotives, soaring dirigibles and airplanes.

The question of whether machine-made objects would displace those fashioned by hand became for Stieglitz part of a broader and more crucial concern. Manifold mechanized wonders aroused his enthusiasm, but they gave rise, also, to a critical apprehension. There was the double danger of machines being employed in increasingly inhumane manner with emphasis placed on mere quantity rather than quality and excellence. Still, since Stieglitz used a mechanical device with the sense of touch and integrity inherent in all art, he could not simply equate the concept of the machine with degradation of the human spirit.

Stieglitz created self-portraits—pictures of the heartache he experienced both in the presence of beauty and when faced by forces capable of destroying what was sacred to him. Man's world became

ever more complex, but so did his reactions to it. The challenges were formidable. Stieglitz confronted them without self-pity and with new power to project his maturing vision.

1890-95, Stieglitz: "During my first year in business, the Photochrome Company received not a single order. One of my partners thought we should move to larger quarters. We found a loft in a building on Leonard Street between Center and Baxter. There we were, three grown men, sitting in an office with our hats on the backs of our heads—real American businessmen but with virtually nothing to do. One day I said, 'This is nonsense for the three of us to waste our time here. Any two of us can remain. The third might just as well go out and enjoy the day.' My partners were horrified. At that I took my camera and went out.

"From 1893 to 1895 I often walked the streets of New York downtown, near the East River, taking my hand camera with me. I wandered around the Tombs, the old Post Office, Five Points. I loathed the dirty streets, yet I was fascinated. I wanted to photograph everything I saw. Wherever I looked there was a picture that moved me—the derelicts, the secondhand clothing shops, the rag pickers, the tattered and the torn. All found a warm spot in my heart. I felt that the people nearby, in spite of their poverty, were better off than I was. Why? Not because of a sentimental notion. There was a reality about them lacking in the artificial world in which I found myself and that went against my grain. Yet it was my business experience that drove me into New York's streets and so into finding myself in relationship to America.

"I loved the sloops, the clipper and other ships, with their protruding bowsprits and their sails, as they came in from the sea bringing fish and other cargo. I loved the signs, even the slush, as well as the snow, the rain and the lights as night fell. Above all there was the burning idea of photography, of pushing its possibilities ever further."

In November, 1893, Alfred married Emmeline Obermeyer, sister of Joseph, his business partner and former Berlin roommate. Joseph was Emmeline's guardian, their parents having died. He felt no less anxious to see her married to Alfred than did Edward and Hedwig or unsophisticated, adoring Emmeline herself. She confessed many years later how impressed she had been by "Mr. Stieglitz"—she invariably called him that—and his growing fame. She understood little of the true nature of his work or aspirations but, "he seemed very wonderful. His name was in the newspapers. I went to boarding school in Europe until I was sixteen. When I came back to America, after living in uniforms, I got all dressed up. I was so shy and unused to being out in the world that as I was about to go to a

19. Stieglitz, Self-Portrait, 1894

dance one evening, at the wedding of a member of our family, I began to cry. I asked my brother, 'What shall I do if a man talks to me?' I had no idea what to do or say.

"I was twenty when I married, but not really that old inside. I was very much protected. Mr. Stieglitz was twenty-nine—a finished product."[3]

Alfred was fond of Emmeline, but was convinced that one of his temperament must not be tied down. He wanted to photograph and to fight for photography. He neither had the means to marry nor was he prepared to take responsibility for a wife and children. After continued pressure, he said the most he would consider was a five year engagement. Throughout that time Emmy would be free to change her mind. The suggestion was met with strong opposition.

One Sunday Emmeline and Alfred went with friends, including Joseph Obermeyer, to a picnic at Nyack. On the return trip she fell asleep. Sitting next to Alfred, her head drooped and came to rest on his shoulder. The die was cast. Joseph felt her reputation would be ruined if Alfred did not marry her. Emmy was delighted: "I loved him."

20. The Net Mender, A.S., 1894

Emmy's family was relatively well-to-do. Her tastes were by no means simple, but she assured Alfred he would not be called upon to support her or a family. He made it clear, when he finally agreed to marry her, that he would use the money to be given him by his father—$3000 a year—to help meet their joint expenses. He was told nothing more was expected of him. The Stieglitzes were relieved that Alfred would now settle down. It seems most unusual, however, that he should have yielded to the wishes of others with regard to so important a matter: "I felt dazed. I walked in the park for hours on end, wondering what in Heaven's name I had done."

Not long after their marriage, Alfred and Emmeline went to Europe on their honeymoon, traveling to Italy, Switzerland, Germany, Holland and France. What Alfred wished most to do was photograph. Venice, whose beauty especially moved him, caused Emmy the greatest of distress. She complained about the unpleasant odors and filthy canals and she resented Alfred's natural tendency to mingle with the people. They stayed at the best hotels but Emmy, afraid of fire and great heights, was frightened of being above the fourth floor. Since both funiculars and mountains terrified her, it was difficult for Alfred to enjoy some of the most beautiful views in Europe. He had to make most of his photographic trips alone, even though at first he sincerely wanted to take Emmy with him. Her timid, conventional approach to life, her lack of interest in anything other than shopping and fashionable hotels—so different from Alfred's complex and adventurous, outgoing nature—unnerved him. He found some solace in Holland, where he made a moving

series of photographs in Katwyk. He spoke with a sense of longing about one print that shows a woman mending her husband's net: "She works quietly, hard, attempting to keep things together. All of

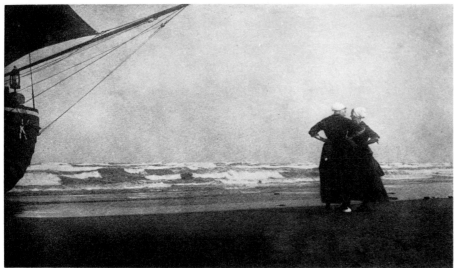

21. Gossip, A.S., Katwyk, 1894

her hopes are concentrated in her occupation. It is her life."

Both Emmeline and Alfred attempted valiantly to make their marriage work, but it was ill-fated from the beginning.

When Alfred read about the American Revolution as a child, he had felt a sense of affinity with General Nathanael Greene rather than with George Washington. Although Greene seemed ever to be beaten in battle with the English, in Alfred's view he was the victor: "He wore the British out, luring them to follow him in his rapid retreats so that, although hundreds of Englishmen were killed and taken prisoner, only a handful of Americans died or were captured. I felt there was a sense of humor in Greene's strategy. I knew that, had I lived in the days of the Revolution, I would have preferred by far to fight under him than Washington. Washington, I was told, never told a lie. He was made to appear a god and I knew I did not belong amongst gods."

Stieglitz's withdrawal from business was his first "secession". He loved fine printing, but his work at the Photochrome Engraving Company — which eventually received a few orders — was as distressing to him as it was unsuitable: "People broke their word. All I heard was 'sue me.' I felt that the only way to continue was to have a policeman on one side, a lawyer on the other. This I refused to do.

"A man on the *Police Gazette*, for which our firm did some printing, told me I was the laughing stock of New York because I delivered material to traveling theatrical troupes on credit. He advised that I be paid in advance. He was the head of a disreputable sporting house for thieves, yet the only individual, ironically, who ever dealt squarely with me while I was in business. I found that sports

of his kind never cheated me, but I was on the *qui vive* when I dealt with gentlemen.

"By 1895, our company had lost more and more accounts. I became less and less in sympathy with what I was doing. My father suggested that I withdraw. He knew I wasn't satisfied and he could no longer afford to keep me in business. I readily agreed. I had learned my lesson and have never since had a similar experience. During the entire period of five years I did not draw one cent, either as salary, dividend or interest on the money invested by my father for me. But I did come into contact with the city.

"After I left the business, my share in it was eventually turned over to the workmen. One of my partners retired not long after I did. The other continued the photogravure branch of the firm, until he also got out. So, in time, the workmen became the sole owners of the company.

"I never was particularly good with my hands. I could tell others what to do. I had a natural feeling for quality in workmanship. I could catch on to principles, ideas, processes, quickly. But I was not made to be a businessman.

"The following year I resigned as editor of the *American Amateur Photographer*. Too many concessions were demanded of me. My notices to those who submitted a certain type of photograph, unacceptable for publication: 'Technically perfect, pictorially rotten,' frightened the magazine's owner." Stieglitz maintained that for every subscriber lost as a result of his revolutionary policies, new ones of broader interests would be gained. Still further controversies made him consider it imperative to terminate his editorial position. The magazine announced that business engagements obliged Stieglitz to resign his post. In truth it was precisely from a lack of them that he had been suffering.

"Due to the advent of Eastman's mass-production methods, by the time I returned to America in 1890, it had become less exciting for the 'enthusiasts' to use their cameras, since 'everyone' was beginning to have them. As the 'enthusiasts' lost interest, feeling that the medium as a passion had no future, various New York photographic societies started talking of amalgamation.

"Within these groups, certain individuals were known as the 'dress suits,' others as 'democrats.' So far as I was concerned, all factions were in a state of dry rot. I knew that if the dress suits were willing to come to the democrats, well and good, but not the reverse.

"Efforts were made to turn the attention of those devoted to the advancement of photography toward bicycling. Anyone who could do that, I thought, no longer felt photography was of importance. For me it had not yet been born. Someone asked me what I thought

of merging the Society of Amateur Photographers with the New

York Camera Club. I said I was willing to help develop the dying and the dead into a newly consolidated organization so that it might become a living entity.

"When the committee working out the details of amalgamation invited me to be president I replied, 'In the eyes of the people I am a revolutionist and I am not a good parliamentarian. Why not choose Mr. William D. Murphy of the Camera Club and the Republican Club as president? He is wealthy, a good after-dinner speaker and a first-class presiding officer. Make me vice-president. I shall show you that a vice-president can be more than a mere figurehead and perhaps the most active member of the Club.'

"When everything was agreed upon and the new Club was set up,[4] it seemed that the entire situation was just as dead as before. I rose at an early meeting to make an announcement. I took a leaflet out of my pocket: 'You publish this Journal as a record of Club proceedings for three hundred dollars and send it gratis to members. If you make me head of the Publications Committee, let me choose the men to work with and give me three hundred dollars a year, I shall issue a real quarterly to go to members. The edition will consist of a thousand copies. We can charge outsiders one dollar a year.'

"A Camera Club member asked, 'Where will you find the rest of the money?' I explained we could take a thousand dollars worth of ads, arrange printing contracts, attend to making photogravures and guarantee that no more than three hundred dollars would be spent for printing Club proceedings. The Club would take no risk.

"My proposal was accepted. The Club came to life. Within three months Europeans in one country after another were talking about *Camera Notes*, and about New York's Camera Club. By the end of the first year the new journal sold for high prices at auction. I had a mad idea that the Club could become the world center of photography and eventually create a museum. If only others had felt as I did, wonders could have been accomplished.

"*Camera Notes* soon expanded to two hundred pages and the Club became an important center. I began to give both of them all my time and thought. The magazine was the making of the Club."

Stieglitz continued to experiment, under the most difficult conditions, photographing moving figures in rain, snow, fog, mist and at night. He told the following story about his 1898 *Icy Night* photograph: "I had had pneumonia and received strict orders to take care of myself, so that I would not have a relapse.

"My wife and I had moved to the home of my brother, Dr. Leopold Stieglitz, on East 65th Street near Central Park. One night it snowed very hard. I gazed through a window, wanting to go forth to photograph. I lay in bed trying to figure out how to leave the house without being detected by either my wife or brother.

"I put on three layers of underwear, two pairs of trousers, two vests, a winter coat and Tyrolean cape. I tied on my hat, realizing the wind was blowing a gale, and armed with tripod and camera—the latter a primitive box, with four by five inch plates—I stole out of the house. The strong wind made it seem even more bitterly cold than it was. The temperature must have been ten degrees below zero.

"Since I had screwed my camera onto the tripod, everything was ready. I succeeded in getting as far as Fifth Avenue and 63rd Street. The trees on the Park side of the Avenue were coated with ice. Where the light struck them, they looked like specters.

"The gale blew from the northwest. Pointing the camera south, sheltering it from the wind, I focused. There was a tree—ice-covered, glistening—and the snow-covered sidewalk. Nothing comparable had been photographed before, under such conditions.

22. Emmeline and Kitty, A.S., 1898

"My mustache was frozen stiff. My hands were bitter cold in spite of heavy gloves. The frosty air stung my nose, chin and ears. How to return home, with the wind blowing so violently? The Savoy Hotel was not very far away. Before venturing back, it seemed wise to have a hot lemonade and a bit of warm toast. Or it may have been a chocolate éclair. Or both.

"When I entered the café of the hotel, the headwaiter caught sight of me. 'What in the Lord's name are you up to on such a night, and at such an hour?' It must have been two o'clock in the morning. I explained what I had been doing.

"After warming up, I retraced my steps. Although the storm had increased in force, my camera remained fastened tightly to the tripod. Every ten or fifteen steps I found it necessary to stand still in order to gather strength to continue. I rarely had experienced a more terrific night. I knew it mad, on my part, to have gone out.

"After nearly an hour's struggle against the wind, I reached home and tiptoed into the house, reaching the third floor without anyone hearing me.

"The next day I went to the Camera Club to develop my plate. The exposure was perfect. Just what I wanted had been achieved. When my brother and my wife saw a proof of the picture, *Icy Night*, they asked when it had been taken.[5] After hearing what had occurred, my brother said, 'Well, if you are laid up with pneumonia again, you'll have to find another doctor. I refuse to be responsible.' My wife was horrified: 'Will you never consider me? Will you always think of photography first?'

"A few days later a member of the Orange, New Jersey, Camera Club asked, 'Stieglitz, you were out photographing on that freezing night, weren't you?' Amazed, I asked how he knew. 'A group of us from the Club went over to Central Park to take some night pictures, since you started us all on making them. The policeman in his little shelter called out, "You fellows are much too late. There was a mad

guy photographing during the storm the other night. No other human being was on the streets at the time." ' And, in unison, they had exclaimed: 'That was Stieglitz.' Yes, it was Stieglitz."

"In the early months of 1903 I stood spellbound, during a great snow storm, before the Flat Iron Building. It had just been erected on 23rd Street at the junction of Fifth Avenue and Broadway.

"Watching the structure go up, I felt no desire to photograph the different stages of its development. But with the trees of Madison Square covered with fresh snow, the Flat Iron impressed me as never before. It appeared to be moving toward me like the bow of a monster ocean steamer—a picture of new America still in the making. While snow lay on the Square, I made snapshots of the building in various lights.

"Recalling those early days, I remember my father coming upon me as I was photographing in the middle of Fifth Avenue. 'Alfred,' he said, 'how can you be interested in that hideous building?' 'Why, Pa,' I replied, 'it is not hideous, but the new America. The Flat Iron is to the United States what the Parthenon was to Greece.' My father looked horrified. He had not observed the steelwork going up. It had started from the ground but also, in part, from the top. He had neither watched the men working nor noted the amazing simplicity of the tower, its lightness combined with solidity.

"He did admire my photogravures. He remarked, 'I do not understand how you could have produced such a beautiful picture of anything so ugly.'

"Later the Flat Iron appeared rather unattractive to me, after years of having seen even taller and more extraordinary skyscrapers —the Woolworth Building shooting into the sky, and then still others. There was a certain gloom about it. I no longer considered it handsome, nor representative of the coming age, nor was I tempted to photograph it. What queer things we humans are. But now, I again have the same sensation—the identical passion concerning it—that I first experienced. I can feel the glory of those many hours and days when I stood on Fifth Avenue lost in wonder."

Various photographic salons of distinction were organized in such centers as Vienna, Hamburg, London, Paris during the early nineties. In 1895, according to Stieglitz, no exhibits in the United States could compare with those abroad. He wrote with impatience, "We Americans cannot afford to stand still; we have the best of material among us, hidden in many cases; let us bring it out."[6]

As for his own work, he won over one hundred and fifty medals in rapid succession in exhibits throughout the world. Among his most important awards of the early nineties were three Royal Photographic Society (London) medals, and those of the three Joint Exhibitions held in Boston, Philadelphia and New York. But then, once

no one could accuse him of jealousy, he attacked the entire system of holding competitions and giving prizes as infantile. He argued, too, that if there were to be juries, at least they should include photographers. The widely accepted notion that painters alone were capable of judging photographic excellence seemed preposterous.

23. *American Amateur Photographer*, 1892

The flourishing of the New York Camera Club and *Camera Notes* helped to alter the photographic situation in the United States. At the same time the prestige of those in the Club who regarded photography as a mere hobby waned. As a result they particularly resented Stieglitz because of his intransigence and growing reputation. His seriousness, dedication and warm response to fresh and unhackneyed work enraged those preoccupied with the reverse, or with smokers and bicycling.

By 1900 reactionaries within the Camera Club engaged in such petty bickering that Stieglitz withdrew as vice-president. He refused to lower his standards or excuse shoddiness in any form. In 1902 he resigned as editor of *Camera Notes*, despite the pleas of numerous colleagues that he not "leave the Club in the lurch." While wishing neither to harm *Camera Notes* and other Club activities, nor to relinquish his membership, Stieglitz felt he must strike out on his own.

Resentment against him by no means abated after his double resignation. On the contrary, as his photographic honors proliferated, envy of his influence increased to such an extent that in 1908 he was summarily expelled from Club membership without any charges being brought against him. As a result there was a searing split within the Club and some three dozen members resigned in protest, to form what they called The Camera Workers. When Stieglitz was later reinstated to membership he promptly resigned.

Following his withdrawal as editor of *Camera Notes*, Stieglitz resolved that he must never again be impeded by committees, wasteful conferences and compromise. He dreamed of publishing and editing an independent, first-rate quarterly of highest quality. He designed a dummy of what he called *Camera Work*. In choosing this title he felt he could give form to his growing belief that any faithful rendering of deepest experience, in whatever medium—expressed with a sense of wonder and sacredness—might properly be termed *camera work*.

24. *Camera Notes*, 1897

He hoped to print not only photographs, but even more articles relating to the fine arts in general than he had been able to publish in *Camera Notes*. He would include literary material he considered alive and pertinent. Without those around him fully realizing it, Stieglitz's aesthetic sensibilities had been rapidly developing. In this connection, his many conversations with the stimulating critic, Sadakichi Hartmann, had been of special value.[7]

Among the younger American photographers Stieglitz had singled out for special attention by 1902 were Gertrude Käsebier, Clarence

H. White, Frank Eugene, Alvin Langdon Coburn, Joseph T. Keiley and Eduard (later Edward) J. Steichen. It was these artists whom older conservative Camera Club members had considered excessively radical; it was their photographs and others of comparable quality Stieglitz wished to feature in his new periodical.

Prints by the painter-photographer Steichen had made an especially positive impression upon Stieglitz when they were shown at the Chicago Salon of 1900. Not long thereafter the youthful Steichen, at the suggestion of Clarence White, had stopped off to see Stieglitz in New York on his way from Milwaukee, where he had grown up, to Paris where he hoped to make his mark.

That so gifted a photographer was also a painter had great meaning for Stieglitz. He was convinced that if a talented painter gave equal importance to photography, it could be of enormous help in gaining proper recognition for the new medium. Steichen's assurance that he would not give up photographing in spite of his plan to continue painting filled Stieglitz with joy.

25. *Camera Work*, January, 1908

"I told Steichen I would publish in *Camera Notes*, and pay for, anything he might write from abroad. I also asked him whether he had put a price on his pictures. He did not know what to answer. Would he accept five dollars a print? I chose three. Steichen, much moved, again did not know what to say. But then he confessed, 'No one has paid me more than fifty cents for a photograph.' I replied, 'Never mind. I feel I am robbing you in taking your prints at five dollars apiece.'"

This meeting marked the beginning of nearly a decade and a half of close cooperation between the two men.

When Steichen and Gertrude Käsebier returned from Europe at the end of the summer of 1902, Stieglitz told them of his completed plans for *Camera Work*. He spoke, too, of his desire to devote the first issue to Käsebier, the second to Steichen.[8] He invited Steichen to design the cover of the new periodical.

The first number, prepared during 1902, carried the publication date: January, 1903. Steichen's handsome front cover and his Eastman Kodak advertisement on the back, like the typography and format devised by Stieglitz, were distinguished, uncluttered, and modern in spirit.

Stieglitz's previous experiences in editing and in the photoengraving business had developed his eye with respect to typography, printing and the making of reproductions. The Japanese tissue he used for the magnificent photogravures that graced the pages of *Camera Work* intensified both his sense of touch when making his own photographs and his awareness of print quality in general. The reproductions often surpassed the originals in richness of tonality. Stieglitz tipped in the photogravures himself, touching up gouges or

minor dust spots so that each copy would be perfect before it was sent out by registered mail.

Camera Work helped to set a new standard for bookmaking and photographic reproductions in the United States. Often termed the most beautiful magazine of the period, it gave credit not only to authors and editors but also to the printers of text and plates.

The new quarterly was an immediate and sustained success, whereas *Camera Notes* ceased publication soon after Stieglitz stopped editing it. Joseph T. Keiley, Dallett Fuguet and John Francis Strauss, who had been associate editors of *Camera Notes*, began to function in the same capacity on *Camera Work*. Later J. B. Kerfoot and Paul Haviland also served as associate editors.

Stieglitz became ever more widely recognized as an international leader in the photographic world. He was made an honorary member of various photographic societies and was called upon by "art authorities" throughout the world to choose and send American photographs to exhibits in London, Paris, Brussels, Dresden and Toronto, as well as major cities within the United States.

In 1901 he was invited to select a collection of prints for an important international exhibition in Glasgow. Not long after, Charles de Kay, founder and director of the National Arts Club in New York,[9] asked him to present his own work there. Although delighted with the idea, Stieglitz suggested that the pictures coming back from Scotland be placed on view instead. They should be supplemented by new photographs from other salons at home and abroad, together with significant prints not hitherto seen in New York. In brief, the proposed show should be composed of the "best American work created in the most modern spirit."

Before the arrangements were completed in 1902, Stieglitz made certain conditions: "I must be given a room in which pictures are exhibited as I see fit. I must be permitted to hang them without committee interference and with not a soul coming in until I am ready to open the doors. If this is agreeable, it's a go."

His terms accepted, Stieglitz was asked what the show should be called. After a brief discussion, he improvised: "Call it 'An Exhibition of Photography Arranged by the Photo-Secession.'" "What is that?" inquired de Kay. "Who is it?" "Yours truly, for the present, and there will be others when the show opens. The idea of 'Secession' is hateful to Americans. People will be thinking of the Civil War. I am not. Photo-Secession implies a seceding from the accepted idea of what constitutes a photograph. Besides which, in Europe—in Germany and Austria—splits have occurred in art circles, the moderns calling themselves Secessionists. So Photo-Secession hitches up with the art world. There is a sense of humor in the name."

At the opening, crowds appeared in spite of a storm. Gertrude

1. Sunlight and Shadows, Paula, Berlin, 1889

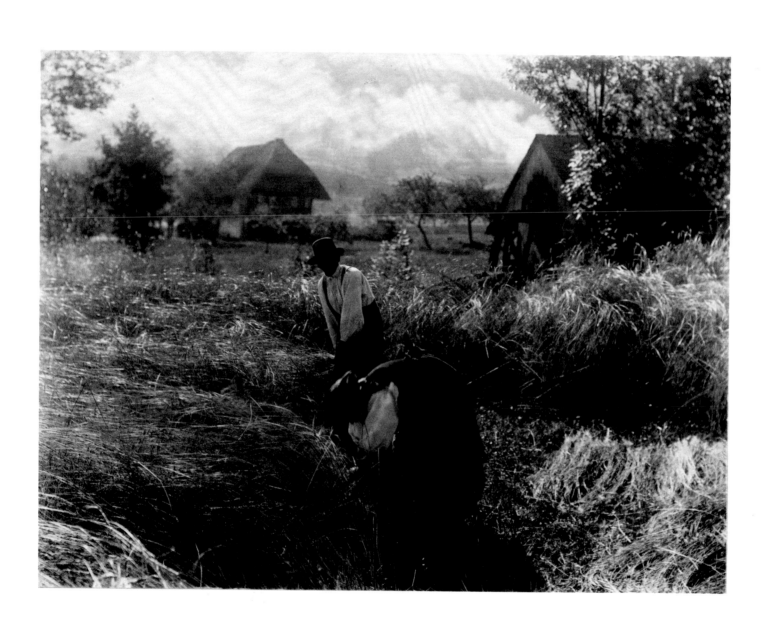

11. Harvesting, Black Forest, Germany, 1894

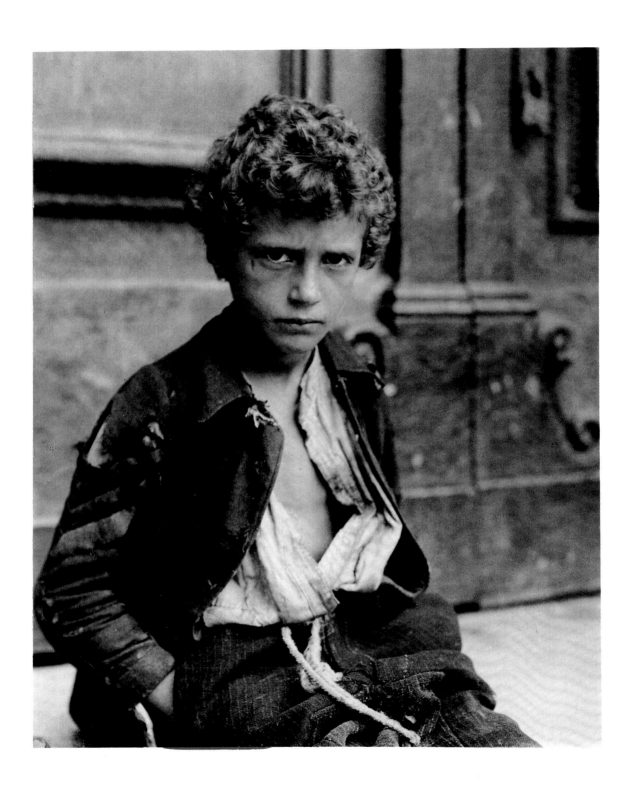

III. Venetian Boy, Italy, 1887

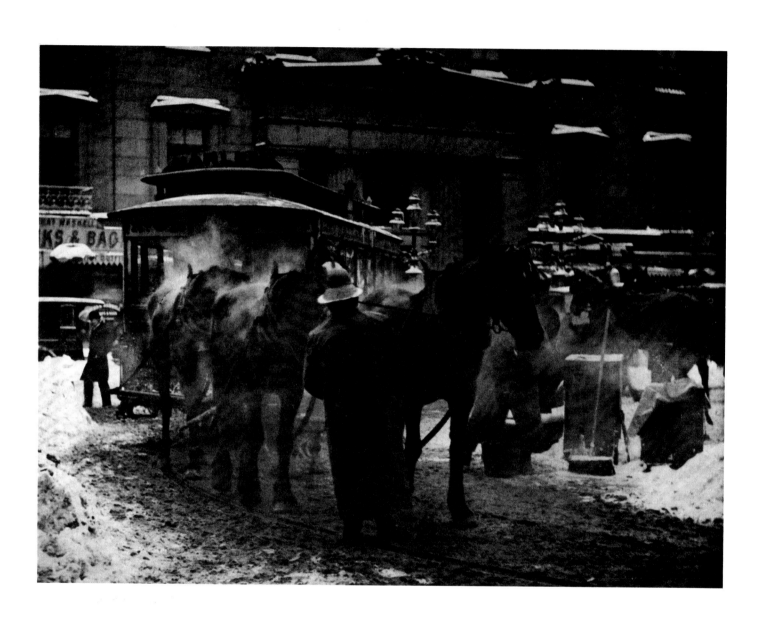

IV. The Terminal or The Car Horses, New York, 1893

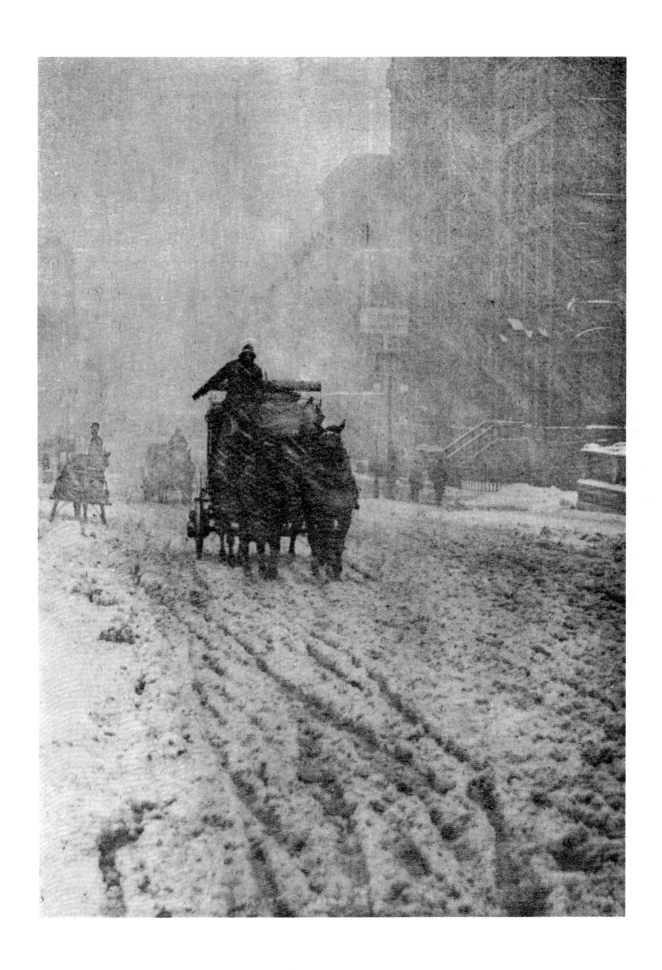

v. Winter, Fifth Avenue, New York, 1893

VI. From my Window, New York, 1900–02

VII. The Flat Iron Building, New York, 1903

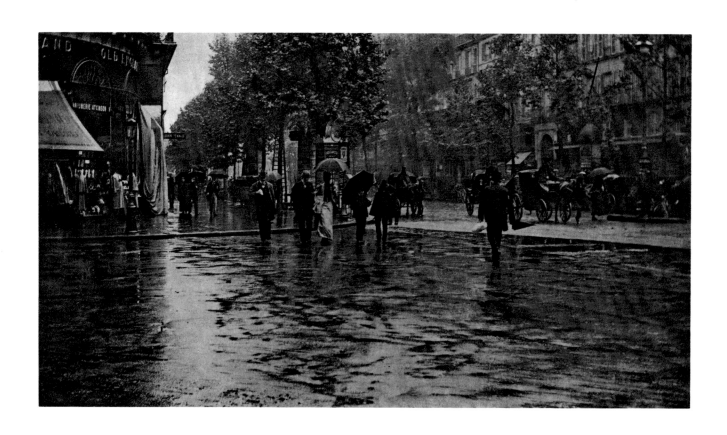

VIII. Wet Day on the Boulevard, Paris, 1894

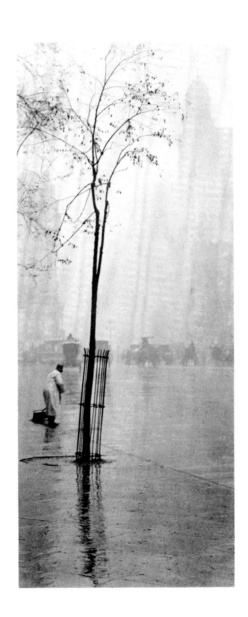

x. The Hand of Man, New York, 1902

XI. Coenties Slip, New York, 1893

XII. Sunday, Fifth Avenue and Fifty-seventh Street, New York, 1895

XIII. The Rag Picker, New York, 1893

XIV. Night, New York, 1896–97

xv. Icy Night, New York, 1898

Käsebier asked Stieglitz, "What is this Photo-Secession? Am I a Photo-Secessionist?" "Do you feel you are?" he inquired. "I do." "Well, that is all there is to it."

Later in the evening: "A man influential in the Architectural League and Camera Club, who was on several committees at the National Arts Club and who at times made a photograph of a nude that was half-way acceptable, approached me. 'Am I a Secessionist?' My answer was 'No.'"

It is difficult to comprehend at this date what caused the New York press in 1902 to single out and praise so effusively work by the Photo-Secessionists, or why a large fashionable audience, accustomed to art openings of a routine social-cultural nature, responded to the exhibit with such exceptional enthusiasm. Photographs were not, after all, widely respected at the time as art. For a small fee you could have sentimental, stilted, artificial-looking prints of yourself and those you loved made in commercial studios. You could take your own Kodak snapshots and see undistinguished prints, indifferently reproduced, wherever you looked: utilitarian documents, touched-up likenesses of romanticized celebrities and half-draped nudes or scenery in insipid imitation of etching and painting.

The National Arts Club was, to be sure, exhibiting what few New Yorkers had as yet had an opportunity to see. On its walls were, with few exceptions, photographs of fine quality and pictorial beauty, rich in tonal values, printed and mounted with subtlety on beautiful papers by men and women of sensibility—by individuals who were "amateurs" in the true sense of the word. Subject matter and material alike were respected. Whatever the shortcomings of certain pictures, the work shown was serious, honest. A new art form was clearly coming of age.

With no further formality a number of photographers who were in sympathy with Stieglitz's attitudes and who exhibited at the National Arts Club in 1902 considered themselves members of the Photo-Secession. A council was formed, Stieglitz was made Director, and principles were formulated, according to which the Photo-Secession would function.

The objectives of the Photo-Secession were to advance photography as applied to pictorial expression, to draw together those Americans practicing or otherwise interested in the art, and to hold from time to time, at varying places, exhibitions not necessarily limited to the productions of the Photo-Secessionists or to American work.

From the first, Stieglitz believed that prints by Photo-Secession members should be exhibited only when requested and as a unit; that neither any person, nor any one way of photographing should be stressed at the expense of others. He wished to make a case for

photography. He knew that each individual could benefit from seeing his own work flanked by that of the most dissimilar artists. He opposed giving in to the lowest common denominator in order to appear democratic and remained dedicated to having first-rate camera work regarded as fine art.

He never ceased opposing the institutional, the academic, the unadventurous. He rebelled against the notion that photographs should be cheaper by the dozen, realizing that each new print is a fresh experience for the creative artist. In unprecedented manner he offered to pay more than the current asking price for the pictures he acquired, although he had little money of his own. He was eager to establish greater regard for photography and to gain more adequate monetary support for those whose work he found authentic. In so doing, he set an example and was a source of unparalleled encouragement: "I was battling for fresh ideas, for a new spirit in life that went deeper than mere preoccupation with what is termed 'photography,' in either a literal or superficial sense."

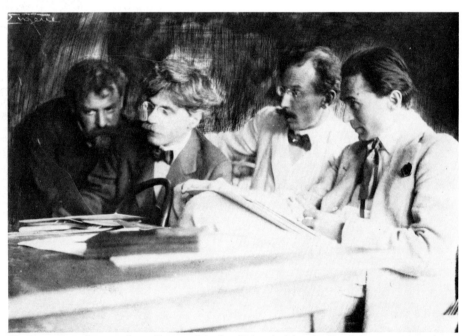

26. Photo-Secession members: Eugene, Stieglitz, Kühn, Steichen by Frank Eugene, 1905-07

As Stieglitz recounted, "General di Cesnola was the first Director of the Metropolitan Museum of Art. After a small beginning, the Museum had moved uptown into a building in Central Park and become an important institution.

"One fine day in 1902, Cesnola's secretary came to see me at the Camera Club, and told me that the General had just received a cable from the Duke of Abruzzi, the head of the international arts and decoration exhibition soon to open in Turin. The exhibit was to have a section devoted to photography. The Duke, himself a passionate photographer, had instructed his friend, Cesnola, to send over, by hook or crook, and at once, a collection of Photo-Secession photographs.

"I replied that Cesnola should designate a time and I would see him. A few hours later I sat in his office at the Museum. The General was a military-looking man, very erect, with a flowing white mustache and white hair. He confessed to me, 'I know nothing about photography but I have been told I must come to you to get what the Duke wants for Turin.'

"I described what my fight for photography had been and still was. I then informed the General he could have the collection needed for Turin if he guaranteed that when it came back, it would be accepted by the Metropolitan Museum of Art in toto and hung there.

27. Rodin-Le Penseur, Steichen, 1902

"Cesnola gasped. 'Mr. Stieglitz, you won't insist that a photograph can possibly be a work of art!'

"I asked why his friend, the Duke, was so eager to have our work in his exhibition. I said that while much in the Metropolitan, even though painted, was not necessarily art, I felt that certain photographs most definitely were and could hang next to any picture in the Museum.

"Cesnola flared, 'You are a fanatic.'

"'I am,' I agreed. 'But time will prove that my fanaticism is not completely ill-founded.'

"'No,' said Cesnola after a moment. 'I cannot accept your proposition.'

"'I respect your feelings,' I answered, 'but I respect beautifully made photographs quite as much. Please cable your friend he cannot have the prints.'

"The General stood up. 'Is that final?' 'Yes,' I assured him. 'I have no choice.'

28. J. P. Morgan, Steichen, 1903

"'I was warned that you were a madman and now I see it for myself. I accept your terms. When can the collection be here?'

"'Tomorrow,' I replied.

"And so the pictures went to Turin—the Steichens, Käsebiers, Whites, Eugenes, Keileys, Stieglitzes, Coburns and a few others.

"About six weeks later the Museum called up to notify me that the American collection had received the King of Italy's Prize and five of us were each to receive a gold medal. The prints had created a sensation.[10]

"I did not think of medals or the King's Prize but of the victory for photography. Photographs were now to be hung in the Metropolitan Museum on an equal basis with other art forms. My life work seemed accomplished. But then, before the collection was finally returned, Cesnola died. We had signed no written agreement, and even if we had, I would not have insisted on carrying out the letter. What happened took place between Cesnola, Director of the Museum, and myself. The new Director could not have understood, hence the spirit would have been lost and it is always the spirit that interests me."

"By 1904 I had been on the firing-line fourteen years in New York in behalf of photography, fighting a battle that, in my view, included everything in life. Prints by Photo-Secessionists had made the rounds of museums in Europe, arousing great interest wherever shown."

In several American cities art institutes hitherto indifferent to photography had begun to sponsor special presentations in collaboration with photographic societies—a living proof that the new medium was gaining recognition.[11] But not since the National Arts Club Show of 1902 had there been a local exhibit of any stature with which Stieglitz felt he could cooperate: "One night in 1905 Steichen and I stood at the corner of 31st Street and Fifth Avenue discussing how to remedy the situation. 'Haven't you any ideas?' he asked. 'We ought to show in the city, but where?' After a moment's silence, he added, 'There is a room in my house, a couple of rooms, in which two women artists are living. The entire building seems to be filled with the odor of their cooking. I have a feeling that renting their rooms, plus one in front, might cost no more than about six hundred dollars a year. Why not turn the space into galleries and hold Photo-Secession exhibitions there?'

29. Lady in Black, Hill, 1840s[13]

"I liked the idea, being eager that New York should see both what we were doing and outstanding prints from other countries, hung in suitable manner and surroundings. Since I knew I could rely on Steichen's enthusiasm and ability, I signed a one-year lease for the rooms at fifty dollars a month. The cost of installing electric fixtures and having the necessary carpentry done was no more than three hundred dollars."

In this modest and apparently offhand manner a vital seminal force in the American art world of the twentieth century came into being. As *Camera Work* recorded, "The most important step in the history of the Photo-Secession" was taken in November, 1905.

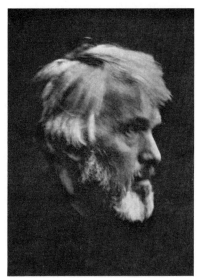

30. Carlyle, Cameron, 1867[14]

"Without flourish of trumpets, without the stereotyped press-view or similar antiquated functions, the Secessionists and a few friends informally opened the Little Galleries of the Photo-Secession at 291 Fifth Avenue, New York."[12]

"The Galleries—soon to be known as 291—were a revelation to those who came. Columns were devoted in the press to the new spirit they represented. In the course of a year masterpieces of photography, from the earliest days to the most recent, were shown."

The small and beautiful, unpretentious rooms were simply but effectively decorated by Steichen. As described in *Camera Work:* "One of the larger rooms is kept in dull olive tones, the burlap wall-covering being a warm olive gray; the woodwork and moldings similar in general color, but considerably darker. The hangings are of an olive-sepia sateen, and the ceiling and canopy are of a very deep creamy gray. The small room is designed especially to show prints

on very light mounts or in white frames. The walls of this room are covered with a bleached natural burlap; the woodwork and molding are pure white; the hangings, a dull ecru. The third room is decorated in gray-blue, dull salmon, and olive-gray."[15]

At a later date the magazine reported that, in considering Photo-Secession exhibitions, "It should be remembered that the Little Gallery is nothing more than a laboratory, an experimental station, and must not be looked upon as an Art Gallery in the ordinary sense of that term."[16]

Stieglitz's original intention was to rent the Galleries for one year. It was impossible to lease a large enough place in which all of the photographs he considered important might be hung together. He solved the problem by planning a sequence of small, select, fortnightly exhibitions, to consist of American and European work never before publicly seen in the United States.

The first show presented one hundred prints by Photo-Secession members.* The second was devoted to a collection of fifty photographs by leading Frenchmen: Robert Demachy, C. Puyo, René Le Bègue, Celine Laguarde, Georges Grimprel, Maurice Brémard, G. Bes-

31. Prints by Kühn, Henneberg, Watzek, Exhibition, A.S., 1906

son and A. Hachette. Exhibition III consisted of a series of prints by Herbert G. French of Cincinnati. Exhibition IV included the prints of Gertrude Käsebier and Clarence H. White; V those of British photographers: D. O. Hill and J. Craig Annan of Scotland, Frederick H. Evans of London.

In the sixth exhibition, work by Steichen was shown; in the seventh, photographs by the Viennese Trifolium, Heinrich Kühn, Hugo Henneberg, and Hans Watzek, as well as the Germans, Theodore and Oscar Hofmeister of Hamburg. Members of the Trifolium were the first to make greatly enlarged prints of quality or what may be

*See Appendix. Spellings are those used in *Camera Work.*

properly designated as the original photomurals.

Stieglitz singled out David Octavius Hill and Julia Cameron for special attention in *Camera Work:* "Hill and Cameron are classics. What they did has not been equaled, in spite of gumming and manipulation and all the modern tricks. They were photographers. All the great artists, even a stickler like Whistler, are intense admirers of Hill's work and Cameron's, which will live forever, since it contains the basic element of truth, character."

V. Public Introduction of Modern European Art in the United States

With startling effect, an early catalogue of the Photo-Secession Galleries announced that "Other exhibitions of Modern Art not necessarily photographic" would be held there. Stieglitz and Steichen decided to show creative work in any form that seemed meaningful, and that was rejected by conventional institutions, dealers, academies. Stieglitz also wanted to test photography against the most alive work being done in other media.

At last, there was a center where Stieglitz could function with freedom and carry on the publication of *Camera Work* with a certain ease. Before the Galleries were founded, he edited manuscripts at home and worked on the placement of reproductions far into the night. The dining room of his and Emmeline's apartment at 1111 Madison Avenue had served as general headquarters for the magazine after he became less active in the Camera Club and before the new Galleries opened.[1] Now the existence of the Photo-Secession rooms and increasing domestic tension decisively changed the situation.

32. "The Photo-Secession," 1906

At the end of the Photo-Secession Galleries' first year, Steichen decided to go back to Paris. Stieglitz called up the real estate agent: "I inquired if I could extend the lease at the same rate for two more years. He agreed, so I continued with the Galleries.

"To my dismay, jealousies soon became rampant among the photographers around me, an exact repetition of the situation I had rebelled against at the Camera Club. Various Secessionists were in danger of harming not only each other, but what I was attempting to build and demonstrate. I found, too, that the very institutionalism, commercialism and self-seeking I most opposed were actually favored by certain members."

Stieglitz wrote to one such Secessionist on February 7, 1907: "Your letter received on the 5th inst. shows me how little you understand me & what's more important the Photo-Secession. Yes, you were dropped when you sent me your business card on which was printed: *Member of the Photo-Secession.* To use the Secession for advertising purposes is about the worst offence that can be committed

by any of its members. You were notified at the time but it seems you never got the notice—to my horror I see you still using the same card. Of course you didn't know that you were doing wrong & that fact in itself proves that you are not ripe for the Secession. It is not a question of loyalty to me that qualifies you or any one else. I read your letter to me at our meeting the other night & all the members were amazed at its contents & your entire misconception of the situation. Dropping you doesn't mean that you have been punished or that I personally have lost interest in you. On the contrary. Time may prove you qualified to enter the fold again. The Photo-Secession has done tremendous work during the past two years & is very jealous of its prestige. . . . As for the indebtedness to me you may consider yourself released in full. I am not angry only sorry."

During the same year Stieglitz felt forced to express further disgust with what was occurring in the Photo-Secession: "One day a young woman appeared. I had no idea who she was. She asked me to look at her work, drawings in black and white and in color, with a view to exhibiting them. She admitted she needed money.

"The first drawing she showed me was of an interior in blue with a bit of yellow. In the foreground a skeleton was standing, in profile, and in the rafters above there was a queer little figure. One did not know whether it was an animal or a human being. It looked extremely frightened. The artist called the picture *Death in the House.* Since it illustrated exactly what I was feeling at the time and what was in danger of happening to the Photo-Secession, I decided then and there to present her work. I wanted also to destroy the idea that the Secession was dedicated solely to photography.

"The girl, Pamela Colman Smith, a close friend of Ellen Terry, Gordon Craig, Arthur Symons and W. B. Yeats, was interested in creating a 'theatre of beauty,' in music as well as in the other arts.

" 'I shall throw a bomb. Come back in four weeks and you can have your exhibition in these two rooms.' I asked what she wanted for her drawings. 'Ten or twenty dollars each,' she replied. Looking terrified, she added, 'How much will the show cost?' I explained, 'It will cost you nothing. There is no charge for catalogues, printing or postage. If anything is bought, you pay no commission. You will receive all the money that may come in.' She looked at me in amazement, unable for the moment to believe what she had heard.

"One of the first people to come to see the exhibit—it opened in January, 1907—was the critic, James Huneker. When he stated in the *New York Sun* that Miss Smith had that quality rare in either sex, imagination, this brought many people to the Galleries.

"I wrote to Steichen in Paris, telling him of my plan to present Miss Smith's work and that, at the risk of making a fool of myself, I preferred to do so rather than to go on representing a lot of con-

ceited photographers. I added that if he found anything of interest, the doors of the Galleries were open.

"Steichen cabled, 'Do you want Rodin's drawings?' I replied, 'Yes.' As late as the autumn of 1907, Steichen continued to have some difficulty in getting from Rodin what the two of them had picked out together.[2] But then he succeeded in having a collection of fifty-eight marvelous drawings brought over. Steichen was a sort of foster son of Rodin."

The drawings, far more advanced than Rodin's sculpture, were first publicly shown in the United States at the Photo-Secession Galleries in January, 1908, a year of crucial importance both in the evolution of the new center and in Stieglitz's life.

Perhaps because Rodin's sculpture was much admired, New York reviews of the Galleries' exhibit were not altogether unfriendly. Nonetheless a good deal of contempt was expressed. "Strange are the things that are done in a great man's name," W. B. McCormick wrote in the *Press*, "and under the beclouding influence of 'art': This

33. From "Sun Series," Rodin, wash drawing, c. 1900-05[3]

moral reflection is induced by the opening of an exhibition of fifty-eight drawings by Auguste Rodin in the Photo-Secession Gallery . . . which we believe are the first of their kind ever to be shown in this country. . . . For the purpose of the exhibition the members of the Photo-Secession have issued a pamphlet containing some inspired nonsense about Rodin's drawings, by Arthur Symons, who writes with equal glibness and with equal fatuity on all manifestations of art. As a matter of fact these drawings should never have been shown anywhere but in the sculptor's studio, for they are simply notes dashed off, studies of the human form—chiefly of nude females—that are too purely technical to have much general interest except that of a not very elevating kind. Stripped of all 'art atmosphere' they stand as drawings of nude women in attitudes that may

interest the artist who drew them, but which are not for public exhibition. . . . It may be all very well to talk about the 'drawing' and the other qualities of a purely technical kind in these studies. But they are most decidedly not the sort of thing to offer to public view even in a gallery."[4]

Georgia O'Keeffe wrote many years later, in different vein, "The first year I was in New York was 1908, five years before the Armory show. I was sent, like all the other students, by the instructors of the Art Students League to see the first showing of Rodin drawings at '291.' One instructor told us that he didn't know whether Rodin was fooling Stieglitz and America too by sending over such a ridiculous group of drawings to be shown here, or maybe Stieglitz knew what he was about and had his tongue in his cheek trying to see what nonsense he could put over on the American public.

"However, we should go and see the drawings, as they might be something. He even assured us that Rodin was certainly a great sculptor, but who had ever heard of anyone's making a drawing or a water-color with his eyes shut? I very well remember the fantastic violence of Stieglitz's defense when the students . . . began talking with him about the drawings. I had never heard anything like it. . . . There wasn't any place in New York where anything like [the Rodin drawings were] shown at this time or for several years after."[5]

At the beginning of 1908 Steichen wrote to Stieglitz from Paris with enthusiasm about an artist never before exhibited in the United States: Henri Matisse. Steichen asked Stieglitz whether he remembered seeing the Matisses at Bernheim-Jeune's, when he was in Paris during the summer of 1907. Calling Matisse the most modern of the moderns and "simply great," Steichen explained he had assembled a "cracker-jack" group of his drawings, as fine as that of the Rodins. Stieglitz, probably the one man in New York prepared to say an unqualified yes, agreed at once to show them: "Steichen cabled from Paris in February, 1908, that he was bringing the Matisses to New York. The Photo-Secession's presentation of the collection in April, 1908, together with the January show of Rodin's drawings, marked the true public introduction of modern art in the United States.[7] The photography I had been championing was, in reality, equally modern in spirit."

34. Nude, Matisse, 1907[6]

Camera Work said of the Photo-Secession's initial Matisse show, "The New York 'art-world' was sorely in need of an irritant and Matisse certainly proved a timely one."[8] The drawings were, in the main, greeted with derision and scorn.

Writing in the *New York Evening Mail*, J. E. Chamberlain declared, "In France they call Henri Matisse 'le roi des fauves.' A 'Fauve' is not exactly a wild beast in our sense—it may even mean a gentle fallow deer—but when the French students apply the term to an artist

they certainly mean a wild one. . . .

"No doubt this sort of thing should be treated with respect, just as adventism, Eddyism, spiritualism, Doukhobor outbreaks, and other forms of religious fanaticism, should be. One never knows when or where a new revelation is going to get started.

"But Matisse's pictures, while they may contain a new revelation for somebody, are quite likely to go quite over the head of the ordinary observer—or under his feet. . . .

"And there are some female figures that are of an ugliness that is most appalling and haunting, and that seems to condemn this man's brain to the limbo of artistic degeneration. On the strength of these things of subterhuman hideousness, I shall try to put Henri Matisse out of my mind for the present."[9]

However great the protest aroused by the 1908 Matisse exhibition in New York, as Alfred Barr has noted, "The Paris press in 1905 had in general been blinder and more violently hostile."[10]

Even in 1912, Arthur Hoeber wrote of Matisse in the *New York Globe* that some of his sculptures shown at 291, "to put it very mildly, seem like the work of a madman, and it is hard to be patient with these impossible travesties on the human form."[11] James Huneker expostulated about the same exhibition, "After Rodin—what? Surely not Henri Matisse. We can see the power and individuality of Matisse as a painter, particularly as a draughtsman, but in modelling he produces gooseflesh."[12]

35. Drawing, Matisse, 1907

Stieglitz's excitement about Rodin, Matisse and the other painters and sculptors he began to show mounted steadily. The more the public scoffed, the more vigorous his defense. Except for Steichen, few members of the Photo-Secession felt any sympathy for the revolutionary work exhibited.

Those committed exclusively to painting of the past—like most professional critics and the public at large—ranted against current innovators. Stieglitz, on the contrary, responded to their vitality with as much warmth as he felt for the fresh vision of straight photographers who refused to imitate any other medium. He sensed, too, how false was the fear of many artists that photography would render painting unnecessary. He believed instead that creative photography was rapidly releasing painters and sculptors from concern with the merely realistic or representational as previously understood. With uncanny alacrity, he called modern art anti-photography.

Associates of Stieglitz, whose preoccupations were more limited than his, failed to realize that he never stopped growing, that he refused to drop one interest when another developed; to oppose new departures because they differed from something else already accomplished and loved. What many thought was inconsistency derived from an unusual breadth of vision. Stieglitz held the firm con-

viction that past and present, like dissimilar art forms, or artists representing conflicting views and working in diverse media must be supported. All that was enriching in a spiritual sense must be permitted to coexist.

After *Camera Work* published an increasing amount of material pertaining to modern art, photographers began to cancel their subscriptions. One incensed colleague wrote to Stieglitz that he could not leave the magazine around the house for fear his young daughter might be shocked. Stieglitz, finding such parochial behavior incomprehensible, continued to print and exhibit whatever interested him, regardless of others' disapproval.

To the bewilderment of the very persons who concluded he was deserting photography, he published in *Camera Work* statements about the subject written by a number of painters and sculptors, including Rodin and Matisse. He considered this an integral part of his fight to gain enlightened consideration of the new medium.

Stieglitz juxtaposed avant-garde painting against both classics and experiments in photography, hoping that each might challenge, yet complement the other.

As in the past, he attempted to prove, demonstrate, test something of importance to himself and so, he felt, inevitably to the people at large. This was true even when he did not always, at first, fully understand or necessarily like what he presented.

As early as 1909 *Camera Work* took to task the Director of the Metropolitan Museum, Sir Caspar Purdon Clarke, for voicing the typical attitude of officialdom. "There is a state of unrest all over the world in art as in all other things," said Sir Caspar. "It is the same in literature as in music, in painting, and in sculpture. And I dislike unrest."[13]

VI. Dissolution of the Photo-Secession

"In June, 1907, my wife, our daughter Kitty and I sailed for Europe. My wife insisted on going on a large ship, fashionable at the time. Our initial destination was Paris. How distasteful I found the atmosphere of first class on that ship, especially since it was impossible to escape the *nouveaux riches*.

"I sat in my steamer chair much of the time the first days out with closed eyes. In this way it became possible to avoid seeing faces that gave me the cold shivers. But those strident voices. Ye gods!

"By the third day out I could stand it no longer. I had to get away. I walked as far forward as possible. The sky was clear and the sea not particularly rough although a rather brisk wind was blowing.

"Coming to the end of the deck I stood alone, looking down. There were men, women and children on the lower level of the steerage. A narrow stairway led up to a small deck at the extreme

bow of the steamer. A young man in a straw hat, the shape of which was round, gazed over the rail, watching a group beneath him. To the left was an inclining funnel. A gangway bridge, glistening with fresh white paint, led to the upper deck.

"The scene fascinated me: A round straw hat; the funnel leaning left, the stairway leaning right; the white drawbridge, its railings made of chain; white suspenders crossed on the back of a man below; circular iron machinery; a mast that cut into the sky, completing a triangle. I stood spellbound for a while. I saw shapes related to one another—a picture of shapes, and underlying it, a new vision that held me: simple people; the feeling of ship, ocean, sky; a sense of release that I was away from the mob called 'rich.' Rembrandt came into my mind and I wondered would he have felt as I did.

"I raced to the main stairway of the steamer, chased down to my cabin, picked up my Graflex, raced back again, worrying whether or not the man with the straw hat had shifted his position. If he had, the picture I saw would no longer exist.

"The man with the straw hat had not stirred an inch. The man in the crossed suspenders—he too stood where he had been, talking. The woman with the child on her lap sat on the floor, motionless. No one had moved.

"I had only one plate holder with one unexposed plate. Could I catch what I saw and felt? I released the shutter, my heart thumping. If I had captured what I wanted, the photograph would go far beyond any of my previous prints. It would be a picture based on related shapes and deepest human feeling—a step in my own evolution, a spontaneous discovery.

"I left my camera in the stateroom and returned to my steamer chair. My wife said, 'I sent a steward to look for you. Where were you? I was nervous. He could not find you.' I told her where I had been.

"My wife replied, 'You sound as though you were far away, in some distant world.'

"When we reached Paris, I tried at once to find out where I might develop my plate. I was given the address of a photographer who led me to a huge darkroom, many feet long and many feet wide, perfectly appointed. 'Make yourself at home. Do you have developer with you? Here is a fresh fixing bath.'

"I had brought a bottle of my own developer, and went to work at once. What tense moments! If the exposure were not correct, if I had moved, if the negative were anything but perfect, the picture would be a failure.

"I developed, washed and rinsed the plate. Held up to the red light, it seemed all right, yet I would not be sure until it had been completely fixed. At last I could turn on the white light. The negative

was perfect in every particular.

"No negative ever received more care, at least not any of mine. I washed and then dried it with the help of an electric fan until it was bone dry, replacing it in the original plate holder—not to be removed before I arrived home.

"Some months later, after *The Steerage* was printed, I felt satisfied, something I have not been very often. Upon seeing it when published, I remarked: 'If all my photographs were lost and I were represented only by *The Steerage,* that would be quite all right.' I am not certain I do not feel much the same way today."

New York's National Arts Club arranged a further exhibit of historic significance in 1908, this time one of "Contemporary Art." The show's special importance was that American paintings and sculpture were presented together with photographs.

This should have been a rewarding experience for Stieglitz, but the Club's second outgoing gesture toward photography proved somewhat disappointing to him. To be sure, prints by Photo-Secessionists were hung beside other accepted art forms, but the latter comprised pictures mainly by members of "The Eight."[1] Later dubbed the "Ashcan School," The Eight banded together in 1908, in protest against the old-fashioned attitudes of the recently merged National Academy of Design and the Society of American Artists. In principle, members of the group were no less opposed to nineteenth century vapid romanticism or the Beaux Arts tradition than were Stieglitz and the artists he favored. The Eight espoused social realism, so-called photographic portrayals of life in the slums and other unglamorized subjects. Stieglitz had intended to exhibit some of them, knowing they aroused the displeasure of powerful academicians. "When it came to a showdown, I could not see anything truly revolutionary or searching in their paintings. Their line, form and color seemed mediocre. Certainly they lacked freshness or a sense of touch. I could not feel committed to what was mere literature, just because it was labeled social realism."[2]

The Photo-Secession Galleries were notified in February, 1908, that the landlord had doubled the rent and insisted on a four-year lease. The Photo-Secession had only a small income. Dues amounted to no more than three or four hundred dollars a year. Stieglitz's original notion that membership fees alone could support the group's activities had proved to be false. His dislike of sending out bills, a persistence of the childhood aversion to monetary transactions, scarcely helped matters. Even when dispatched, his reminders about money owed were typical: "Members of the 'Photo-Secession' are expected to pay their dues, if it is within their power to do so. Those who are not in full sympathy with the present activities of the 'Photo-Secession' are in honor bound to return this bill unpaid and have their names stricken from the membership list."

Since a renewal of the Galleries' lease on the new terms was out of the question, the little Photo-Secession center, described by *Camera Work* as "unique in more than one respect—nothing like it existing in this country or abroad," had to be terminated. Thus on April thirtieth "the Galleries, stripped of their decorations, passed back into their original condition of an uninviting and dilapidated garret. A few days later the busy hands of a Fifth Avenue ladies' tailor were in full possession of the place and every vestige of the Photo-Secession atmosphere had thoroughly disappeared. During the three years of the Galleries' existence approximately fifty thousand people visited the place."[3]

But then to Stieglitz's amazement a miracle occurred, one to be repeated, with variations over the years. Individuals, without being asked and without benefit of committees or publicity, began to recognize that the way in which he functioned merited their voluntary support. They sought nothing in return.

Paul Haviland—a Harvard graduate from France—had begun to frequent the Little Galleries. During the Rodin show of 1908 he acquired several drawings. Enthusiastic about what Stieglitz was doing and sympathetic about the financial difficulties confronting him, Haviland took, on his own initiative, a three-year lease for quarters across the hall.

Stieglitz's immediate reaction was that he was too tired to carry on, that he was unable to accept the generous assistance offered. Haviland assured him he need do nothing except move into the new gallery, which was to be cleaned, painted and furnished with a simple table, chairs and benches. Continuation of the Photo-Secession Galleries would be assured.

After thinking the matter over, Stieglitz decided to accept Haviland's proposal and create a facsimile of the original rooms. Those already accustomed to coming to them would feel at home.

Before the smaller exhibition space—fifteen feet square—was opened to the public, Stieglitz, uncomfortable about allowing Haviland to carry the entire load, spoke to his friend, J. B. Kerfoot, who was associated with *Camera Work* and was literary critic for the original *Life* magazine. A three-year guarantee of twelve hundred dollars a year was required for rent, light, printing and overhead. Half a dozen men interested in photography and appreciative of Stieglitz's abilities were invited, informally, to tea at the Holland House. Almost the entire sum needed was assured at the meeting. Agnes Ernst,[4] a young woman who recently had interviewed Stieglitz for the *New York Sun*, so loved the spirit of what he did that she, too, volunteered to raise funds.

The entire guarantee was short by a few hundred dollars. After swearing not to, Stieglitz dipped into his own small capital to make up the deficit. He said that he could not permit the amount of

money involved to get in the way of doing work properly.

With the move across the hall, Photo-Secession no longer seemed an appropriate name. Although the new space was at 293 and no longer 291 Fifth Avenue—the wall between the two buildings had been removed so that the tiny elevator could serve both houses—the affectionate diminutive 291 was thenceforth used. Stieglitz found it more euphonious than 293: "I called the gallery 291. Within a week the term was commonplace amongst the frequenters of the place."

Haviland agreed that Photo-Secession was no longer an adequate title for 291's activities. It seemed almost a misrepresentation, he wrote in *Camera Work*, apparently narrowing Stieglitz's interest to photography, whereas its scope spread far beyond. The Secession's "fight had been first and foremost for recognition of photography among the arts, but now that this object had been attained, could it not legitimately bring to the fore new and interesting work in other arts, provided the men it championed worked in a medium which allowed personal expression?

"Etching, drawing, painting, sculpture, music, seem to be its legitimate province. We are dealing, not with a society, not with an organization, as much as with a movement. The Secession is not so much a school or a following as an attitude towards life; and its motto seems to be:—'Give every man who claims to have a message for the world a chance of being heard.'

"Under our social system each generation is living forty years behind its time. Our laws are written by men past their sixties, and reflect the ideas which they formed when they were in their twenties. The artists now in vogue are either dead or old men. Ibsen writes:—'The younger generation is knocking at the door,' and the older generation is trying to keep it closed before them. The Photo-Secession, through the 'Little Galleries,' has tried to help the modern tendencies to come to the front, to show the public what was being done, and not what had been done."[5]

Work by the Photo-Secession continued to attract enthusiastic attention. The Albright Art Gallery in Buffalo invited Stieglitz to organize an extensive International Exhibition of Pictorial Photography. It took place in 1910 under the management of the Photo-Secession, in cooperation with the Museum's Director.[6] Not only did the show arouse great public interest, but the Gallery made the revolutionary gesture of buying a number of the photographs on exhibit. Its official listing enumerated twenty-one acquisitions.

By the time the Albright exhibit ended in 1910, despite its success, dissension among Photo-Secessionists had reached such proportions Stieglitz no longer could contend with them. Just as the Photo-Secession had begun without formality so now, in the same manner, it gradually came to an end.

The Photo-Secession had become a world influence, accomplishing much during its brief span of life. By 1910, the values it symbolized were well established. Although new ways of seeing were inevitably evolving, the sense of quality and freshness insisted upon by its leading members remained a constant challenge.

Stieglitz went abroad for the last time in 1911. The two Paris photographs made that year differ in mood from his New York prints of the same period. They are reminiscent of his earlier European depictions of man in harmony with his world: "Paris is the only place I saw at the time that had stallions on the streets instead of geldings,[7] and women going through the streets without hats. The women were free, feminine. The men, very male, all going about their work. All simple, alive. Each one arranging his wares with love, with a sense of order, with gaiety.

"The 'good' Americans who were so good at home were charmed by the so-called naughtiness and beauty of Paris when they came with their money. They paid to have the songs, the freedom, the atmosphere, reproduced for them in cafés, and then slowly the French, through their natural desire to get money, destroyed their own freedom to be natural, finally giving the impression of unnaturalness."

Stieglitz thought of the New York he portrayed from 1893 until 1915 in terms of transition—of the old gradually passing into the new. He looked upon the photographs he made at the time as depicting not "Canyons," but "the spirit of that something that endears New York to one who really loves it—not for its outer attractions" but for its deepest worth and significance—"the universal thing in it."[8]

Stieglitz to the painter, Marsden Hartley, in 1914: "You speak of New York as an unspeakable place. It is truly that. But it is fascinating. It is like some giant machine, soulless, and without a trace of heart. . . . Still I doubt whether there is anything more truly wonderful than New York in the world just at present."[9]

VII. Public Introduction of Modern American Art
Further Exhibitions of European Art

Although Stieglitz continued, from time to time, to show European art, 291 took the important step in 1909 of holding its first exhibition of work by young Americans. In the spring of that year it showed the paintings of John Marin and Alfred Maurer.

Both artists were living in Paris, where Steichen was in touch with them. All three were members of the spirited New Society of American Artists, a group that had seceded from the conservative Paris Society.[1] It was Steichen who sent the Marins and Maurers to 291.

"When the boxes containing their pictures arrived from Paris,

XVI. The Steerage, 1907

XVII. Excavating, New York, 1911

XVIII. Old and New New York, 1910

XIX. The Mauretania, 1910

xx. A Dirigible, 1910

XXI. The Aeroplane, 1910

XXII. The Ferry Boat, 1910

XXIII. Self-Portrait, 1910

XXIV. The City of Ambition, New York, 1910

xxv. A Snapshot, Paris, 1911

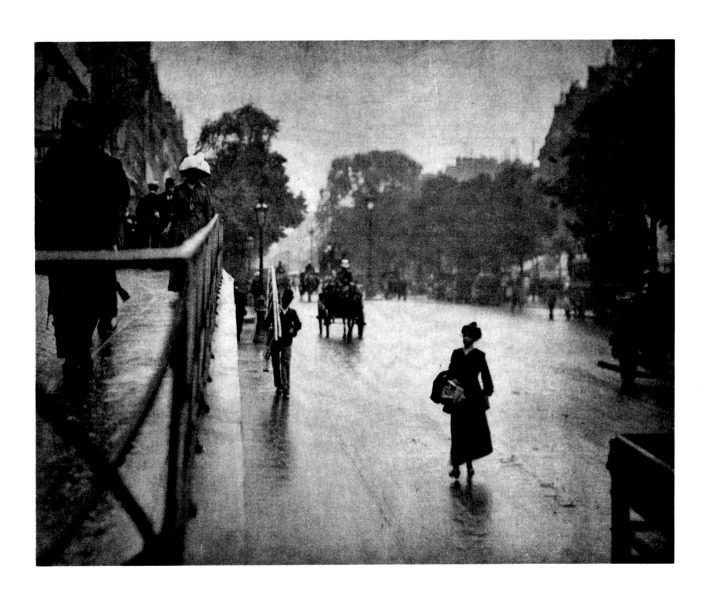

XXVI. A Snapshot, Paris, 1911

XXVII. Out of the Window, Snow on Tree, New York, 1915

xxviii. My Daughter Kitty, 1905

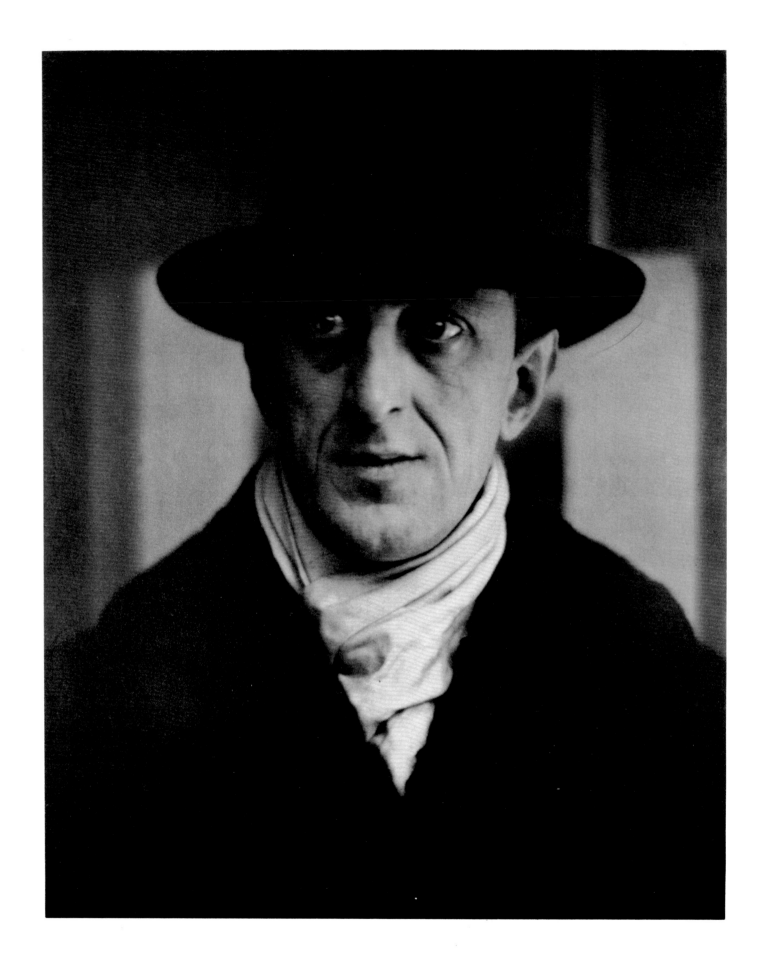

xxix. Marsden Hartley, 1915

xxx. Dancing Trees, 1921

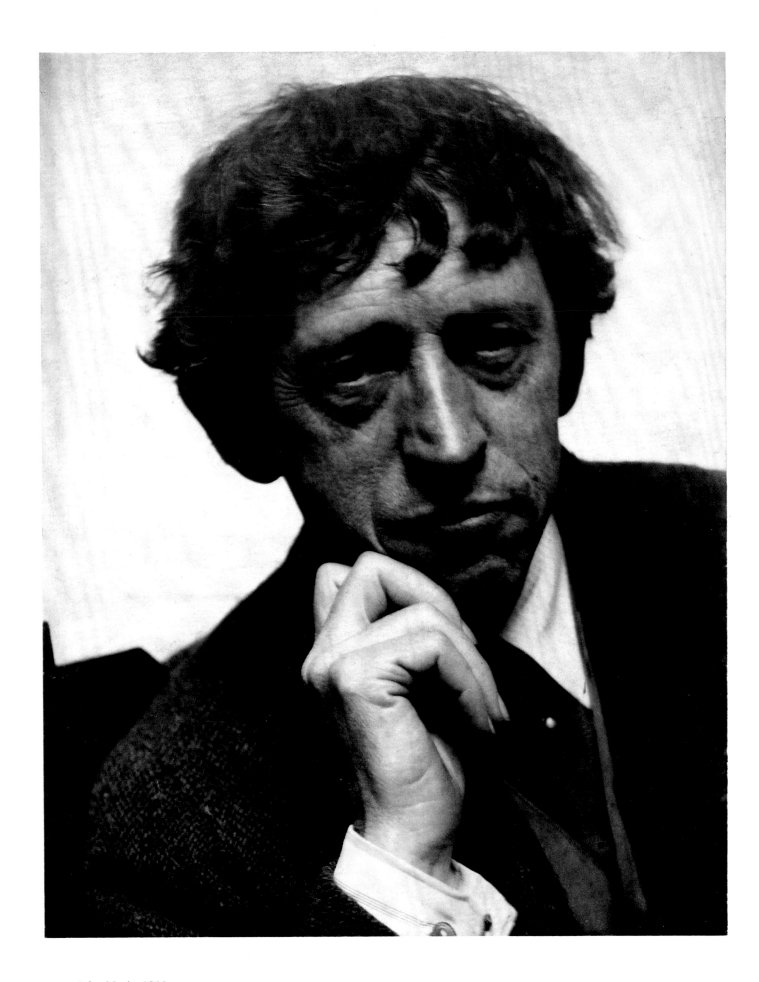

XXXI. John Marin, 1922

Charles Freer of Detroit, the art lover and eventual founder of the Freer Gallery in Washington, happened to be present. The first box contained a series of mosaic-like paintings, about ten inches square, each in little gold frames, in high-keyed, lively colors. These were by Maurer who had switched from the style of Whistler to that of Matisse, the first American to do so.

"I showed Freer some of the little paintings. He shrugged his shoulders. 'There's nothing to those.' I opened the box of Marins and took out several pictures—all watercolors—matted, unframed. Until then watercolor, even though I liked Winslow Homer, did not attract me very much, but the Marins held my attention at once. 'How about these?' 'Whistler,' he answered, 'but a long way to go.'

"Somehow this immediate sitting in judgment was irritating. 'Is that all you see?' I asked. 'That's all there is.' 'I differ with you, Mr. Freer.'

"The small, uniformly sized Maurers I hung three high, close together. What brilliant walls! The Marins were presented in a single line.

"Crowds visited the show. Alfie Maurer, for so he was known, gone red! Maurer, the first Carnegie Prize winner, a pupil of William Chase, had gone to Paris after his Pittsburgh triumph and had come under the influence of Matisse. I had met him once before he left. He was a cousin of Oscar Maurer of California who, in a minor way, was connected with the Photo-Secession, and the son of Louis Maurer—Currier and Ives artist—and a friend of my father.

"Henri, Glackens, Sloan, Prendergast, Lawson, Luks—all of that crowd, members of The Eight—came and nudged one another. They could not make out what they saw. Real revolution!

"Arthur B. Davies also appeared. He bought three Maurers. They were each thirty dollars—a hundred and fifty francs—which meant quite a bit of money in Paris.

"The exhibition was overrun with people. Maurer was the excitement, Marin the loved one. Marin's watercolors sang their quiet song while the Maurers seemed like instruments of music run riot.

"From the moment I first saw Marin's work I felt, 'Here is something full of delight.' Various artists objected to his 'not being modern.' In answer to such criticism, my sole comment was, 'His work is full of life. He is a natural singer.' "

"While I was abroad with my family in the summer of 1909, Steichen suggested I visit Marin. Upon entering his studio, I saw him standing at his press in shirtsleeves, printing etchings. On the wall hung a modest watercolor. After a few words, I asked why the work chosen for 291 was not as fine as the painting before us.

"Marin went to a drawer and pulled out an etching he had just finished. 'Man,' I said, 'why didn't you send something like that to me?' 'When my dealers,' he replied, 'Roullier in Chicago and Katz in

New York, were here recently and saw this, they threatened to discard me if I did any more wild stuff like it.'[2]

"I found nothing wild about Marin's work. His early etchings were in the Whistlerian manner, but his new phase was free, bold and distinctly Marin. It had nothing to do with Whistler. I remarked, 'Mr. Marin, you are an American. You are an artist. If I had your gifts I would see anyone in hell who tried to interfere with me.' I was startled at myself, realizing I had assumed a responsibility. I knew I would never be an art dealer, also that I would never have sufficient money to support Marin or any other artist. But somehow I had to say what I did.

"I pointed to the watercolor on the wall: 'How much do you want for that?' 'Oh, I guess a hundred and twenty-five francs will do.' 'I'll take it,' I said.

"Marin then showed me some pastels—lovely. I inquired how much he wanted for them. 'Oh, fifty to seventy-five francs.' He informed me that the best one had been bought by a well-known New

36. Brooklyn Bridge, Marin, watercolor, 1912

York theatrical man for five dollars—twenty-five francs. I observed that the man ought to be shot for robbing him. Marin laughed. After all, twenty-five francs were twenty-five francs.

"Steichen, Marin and I went downstairs to a café. I handed Marin two hundred and fifty francs. 'What's that for?' he asked. 'I can't accept your watercolor for less,' I replied.

"I had no idea then that within a matter of months, when Marin came to New York, our lives would be interwoven and the basis of a lifelong friendship would have taken root. Throughout our entire

relationship Marin and I have not had a word of difference. Each has remained free, true to himself and so true to the other."

At Marin's initial 291 exhibit, the price of his watercolors was approximately twenty-five dollars apiece. The first check, dated April 23, 1909, given to him by Stieglitz for pictures acquired at the gallery, amounted to one hundred and eighty dollars.

Although Marin's work was generally liked by the New York press critics, J. E. Chamberlain of the *Evening Mail*, upon seeing the Maurers, expostulated: "Mr. Stieglitz, the mighty hunter of the Photo-Secession, has captured another 'wild man.'" Referring to "a great gob of color" in one of the pictures, Chamberlain asked, "What is it? A bursted tomato? A fireman's hat? A red rock? A couple of people under an umbrella?"[3]

Stieglitz: "It was before the Armory Show, in 1913. Marin's new exhibit at 291 was creating a sensation. He had produced a series of several pictures, calling the group as a whole *The Woolworth Building*. The building had been erected not long before, and Marin had fallen in love with it at first sight.

"A man—well-built, well-dressed—came into the gallery soon after the Marin show opened. He went straight to the wall on which the Woolworth paintings were hung and stood, barely moving, for a long while. He looked so serious, so sad, as though he had lost his last friend. I approached him: 'Is something troubling you?'

" 'Something is,' answered the man.

" 'I suppose this kind of work startles you,' I said, 'but if you are at all acquainted with Chinese or Japanese art, these pictures should not be so very strange, even though they are not directly related to either. This series of Marins has been inspired by the Woolworth Building, a passion of his.'

"The man's expression remained sad, his face immobile. 'So this is the Woolworth Building.'

" 'Yes,' I replied, 'it is the Woolworth Building in various moods.'

"The man shook his head slightly and repeated, 'The Woolworth Building's various moods.' Whereupon he turned around and left the room, I accompanying him to the elevator. He quickly said, 'Thank you,' and disappeared.

"When I returned to the room, someone who had heard the conversation laughed: 'Stieglitz, don't you know who that was?'

" 'No, I have no idea. But the man did seem desperately sad. I wonder why.' The visitor, still laughing, told me, 'That was Cass Gilbert, architect of the Woolworth Building.'

"I never met Mr. Gilbert again. I wonder whether, had he come upon those same Marins later, would he have seen them with different eyes? Would he have enjoyed them, or would he have been still sadder?"

Marin about Stieglitz:

"Quite a few years ago . . . there got to be—a place
The place grew—the place shifted . . . the place was where this man
was. . . .
—Shift—is something that cannot be tied—cannot be pigeonholed.
It jumps—it bounds—it glides
—it SHIFTS—
it must have freedom. . . .
It seems those who do that worth the doing
are possessed of good eyes—alive eyes—warm eyes—
it seems they radiate a fire within outward.
The places they inhabit have a light burning—
a light seen from near and far by those who need this light—
and this light sometimes dim—sometimes brilliant—never out—. . . .
To realize such a place—
a very tangible intangible place was and is this man's dream."[4]

37. Woolworth Building, Marin, 1913

The American artist, Marsden Hartley, wrote later that, in 1909, the young Irish poet, Seumas O'Sheel said to him, "Do you know Alfred Stieglitz—he has a little gallery at 291 Fifth Avenue—he might be interested—let's go up and see him, and we went up the next morning.

"291 Fifth Avenue was an old brownstone house of the 'elegant' period, and had been left like so many of its kind to fate and circumstance, and had been taken over by various kinds of business enterprises. . . .

"O'Sheel ushered me eventually into a small room on the top floor of that building that opened out from the elevator, it too a tiny affair, allowing never more than three or four to ascend at one time.

"A shelf followed round the walls of this room, and below were curtains of dark green burlap, behind which many mysteries were hidden, things having to do with the progress of photography in those days.

"In the center of this small room was a square platform, also hung with burlap, and in the center of this . . . a huge brass bowl. . . .

"I was eventually presented to the presiding spirit of this unusual place, namely Alfred Stieglitz with his appearance of much cultivated experience in many things of the world, and of some of them in particular.

"Since a photographer never had to fulfill the idea of conventional appearances as the artist and poet are supposed to have done, the photographer could always look like a human being, and therefore Alfred Stieglitz looked like a very human being, and it was through this and this alone that he made his indelible impression

upon me.

"Under the nimbus of voluminous gray hair there was a warm light and a fair understanding of all things, and anyone who entered this special place, entered it to be understood, if that was in any way allowed, and the special condition for this was the sincerity of the visitor himself. . . .

"I was taken in . . . to the meaning of this place, and O'Sheel said to Stieglitz that I had come down from Maine with a set of paintings seen by no one outside of the brothers Prendergast, Glackens, and Davies, upon which these men had set some sort of artistic approval.

"Stieglitz, about whom there was a deal of glamour without trace of esthetic fakery, of which there was a great deal at that time, remarked that if I wanted to send the pictures there, he would look at them. . . .

"Certainly it was not the room, but what went on in it that mattered, just as a stage feels so empty when the play is absent. The room was, however, full when the little shows were centered in it. So much seemed to be happening.

"Stieglitz said to me, the pictures having arrived, if you will leave them a few days we can then tell you what we think of them—come in three or four days . . . and we will . . . know. This was done, and the remark then was, I don't know any more what I think of these pictures than I did at first, but if you would like it we will give you an exhibition, and you can have it in two weeks from now. I have no money and no frames, I said. We will supply the frames, was the reply, and the exhibition was far more speedily realized than I could have hoped . . . and was my initiation into over twenty years of most remarkable experience, I certainly having the right to call it unique, for here was one man who believed in another man over a space of more than twenty years, and the matter of sincerity was never questioned on either side."[5]

38. Landscape No. 25, Hartley, 1909

When Hartley first came to 291, Stieglitz was moved by his saying that he wanted to show nowhere else; that the spirit of no other gallery was of any interest to him. Stieglitz was touched, too, by Hartley's unspoiled statement that he could live on four dollars a week.

Paintings by Arthur G. Dove, another then unknown American artist, were first shown in a group exhibition at 291 in 1910. Without Dove's being conscious of it, his pictures were related to the earliest abstract work of the period.

When Dove's father later came to see his son's paintings, he protested to Stieglitz against their ugliness. He spoke with anger: "Do you mean to say that anyone in the United States is going to buy these pictures?" Stieglitz replied by taking out Cézanne reproductions, original Matisse drawings and Picassos.

"I explained to Mr. Dove the new forces at work in the world. I told him of the current trend in art and its significance. I said, 'You

do not understand. You are a business man, yet you do not realize that we are living in an unprecedented era; that even your own company will doubtlessly be superseded in time, unless you recognize the nature of the changes taking place.'"

From Notes by Arthur G. Dove: "There is no such thing as abstraction.

"It is extraction, gravitation toward a certain direction, and minding your own business.

"If the extract be clear enough its value will exist.

"It is nearer to music, not the music of the ears . . . the music of the eyes."[6]

In 1910 Stieglitz and Steichen arranged an exhibition of work by nine young American "pioneers" at 291. The major intent of the show was to demonstrate that Arthur Carles, Dove, Laurence Fellows, G. Putnam Brinley, Hartley, Marin, Maurer, Steichen and Weber were not simply "common disciples of Matisse." The gallery

39. Nature Symbolized, oil, 1911, and Cow, oil, 1914, Dove

sought to prove that each of the artists was "working along individual lines toward the realization of a new artistic ideal, the only points they have in common being a departure from realistic representation, the aim toward color composition, the vitality of their work, and the cheerful key in which their canvases are painted."[7]

Immediately after the "Young American" exhibit, a huge show of "Independent" artists—spearheaded by Robert Henri, leader of The Eight—was arranged in New York. It seems ironic, in view of Stieglitz's previous decision not to exhibit members of The Eight, that the critic and painter, Walter Pach, should have come to him to enlist his cooperation in connection with the 1910 Independent show.

Stieglitz felt he had his own job to do. He disliked the idea that the proposed exhibition was to be presented in dreary surroundings and he was certain it would represent the spirit of The Eight, rather than that of 291.

James Huneker wrote of the Independent exhibit: "Something is lacking—art; the chief devil possessing this show is the devil of empty display." As for the Young Americans, they "were actually new, not mere offshoots of the now moribund impressionists as are the majority of the Independents."[8]

In 1909 Steichen had suggested that a gifted American modern, Max Weber, who had been painting in Paris, go to see Stieglitz at 291. When Stieglitz saw Weber's work he found it outstanding, but was unable to show it at once. Weber appeared again. He told Stieglitz that he was penniless and that the artist with whom he was living had to give up his studio. Stieglitz was so stunned by Weber's plight, he invited him to stay in the rooms next to 291—the only time he took such a responsibility.

Stieglitz included Weber's paintings in the nine Americans' exhibit of 1910, gave him a one-man show in 1911 and published his writing in *Camera Work*. It was Weber who suggested to Stieglitz that he show Henri Rousseau in 1910.

Stieglitz considered Weber extraordinarily well-informed about the major developments in modern art and felt he learned a great deal from their many talks.

40. Meditating Figures, Weber, 1910

Weber, proud and sensitive, was constantly hurt by one person or another who frequented 291, even though Stieglitz went out of his way to help and protect him. One day Weber stalked out of the gallery after an imagined slight by a visitor. Although he returned from time to time and Stieglitz welcomed him warmly, Weber's illusory wounds never healed.

"Mr. Weber," wrote James B. Townsend in the *American Art News*, "is a Post-Post-Impressionist, or in other words, Matisse, Gauguin and the late Henri Rousseau—plus." His "presentments of distorted vision" cannot be called pictures, "but productions or expressions of an emotion and a vision that are not shared by other human beings."[9]

Weber wrote about the Rousseau exhibit at 291: "When I heard of the death of my friend Henri Rousseau (September 4, 1910) I suggested to Mr. Stieglitz that a memorial exhibition of [his] work . . . though limited in the number of examples and size under the circumstances, could be held. I lent my small collection of Rousseaus which I brought back from Paris. . . . No one at the time realized the significance and impact of this exhibition. Today it is known to have been the first one-man show Rousseau had ever had in the world."[10]

41. Mother and Child, Rousseau, 1906

A 291 exhibit of original lithographs by Henri de Toulouse-Lautrec in 1909 had been the first presentation of the artist's work in America. "The lithographs," wrote B. P. Stephenson, "are not for sale. They were collected with much difficulty . . . and Mr. Stieglitz exhibits them more as a protest than anything else, against that commercialism which has led so many of our men to waste their undoubted talents."[11]

The first American exhibition of original drawings, pen and ink sketches and etchings by Gordon Craig of London—whose designs for the theatre were to have widespread influence—was held at 291 in December, 1910.

42. Print, Toulouse-Lautrec, 1893

Cézanne died in 1906. In the summer of 1907, before the Photo-Secession Galleries had turned their attention to modern art, Steichen and Stieglitz were both in Paris. As Stieglitz reminisced: "Steichen proposed one morning that he and his wife, my wife and I, go to see the Cézanne watercolors at Bernheim-Jeune et fils.

"A thunderstorm was threatening, but that did not prevent the four of us from going to the gallery. As we entered, I saw what appeared to be hundreds of pieces of blank paper with scattered blotches of color on them. Each sheet must have been about eighteen by twenty-four inches. It had grown too dark because of the storm, to see almost anything, but I felt there was nothing to look at but empty paper.

43. Ninth Movement, Craig, 1909

"When Steichen suggested I price the watercolors, I asked the gentleman in charge their cost. (I learned only later that he was one of the outstanding connoisseurs in the French art business.) He replied, 'A thousand francs.' I answered facetiously, 'You must mean a dozen. There is nothing there but empty paper with a few splashes of color.'

"The man turned on his heels. I knew I had been absurdly stupid. Steichen and the ladies had gone to another part of the gallery and were laughing. To be truthful, my remarks resulted from my having been flabbergasted by the pictures.

"In the meantime, the rain came down in torrents and there were vivid flashes of lightning, followed by crashes of thunder. You cannot imagine a more uncomfortable situation.

"Steichen said, 'Why not go to the café across the street?' The rain had let up some. When we had ordered, Steichen volunteered, 'Let's play a joke on the New York critics. I can make a hundred watercolors like those at Bernheim's in a day. They were not signed. I need not sign mine. You can announce, "Exhibition of Watercolors by Cézanne."'

"I laughed and agreed, 'It's a go. Anything to try out the critics. Once they have written, I shall tell the public the practical joke we have played.'

"Steichen suddenly became very serious. He said, 'I wonder.' I replied, 'Steichen, I have never laughed before at anything I did not understand. I have a sneaking idea the joke is on us. But if you want to stick to your bargain I'll go ahead.'

"Meanwhile the storm had ceased, the sun broke through the clouds, the ladies were talking about dresses, and Steichen, very subdued, said, 'I guess I had better not.' So the matter was dropped."

"Steichen sent word to me from Paris in 1911 that he thought he could get some Cézanne watercolors for 291. I agreed that he do so. (We had shown three Cézanne lithographs in 1910.) I was naturally curious to see how the pieces of paper at which I had laughed would look to me when unpacked at 291.

"Art was not yet duty-free. However 291 had been recognized as an educational institution by the government, Paul Haviland's lawyer having prepared a document to establish its qualifications. The little gallery was permitted to bring foreign work into the United States in bond for exhibition. If people wanted to buy any of the art shown there, they had to do so abroad after it was sent back. Once the work was returned to the United States, it was dutiable.

44. The Bathers, Cézanne, colored lithograph, 1897

"After the Cézanne watercolors arrived in New York, a custom house appraiser—a fine fellow—came to 291. I told him of my experience at Bernheim-Jeune.

"The box of framed Cézannes was opened, and lo and behold, I found the first one no more nor less realistic than a photograph. What had happened to me? The custom house man looked up: 'My Lord, Mr. Stieglitz,' he said, 'you're not going to show this, are you—just a piece of white paper, with a few blotches of color?'

"I pointed to the house, rocks, trees and water. The appraiser

asked, 'Are you trying to hypnotize me into saying something is there that doesn't exist?'

"Again I attempted to indicate what was on the paper, but the man remained blind to it. The same thing happened with the other paintings. Yet to me they were as beautiful a lot as I had ever known. In fact, they were something I truly had not seen before.

"The man inquired, 'Do you mean that people will pay good money for these?' I answered, 'These pictures will become the fashion. People won't like them any more than you do, but they will pay thousands for them.'

"The Cézanne exhibit at 291 took place in March, 1911. Arthur B. Davies came in. He wanted one of the watercolors. He was the only buyer. I told him that all of the paintings had to go back to France but, since I was to be in Paris shortly, I would bring him the one he had chosen. When I returned to the United States and showed the picture to the custom house official who examined my trunks, I said it had cost two hundred dollars. The official exlaimed, 'You are crazy. You shouldn't declare anything like that. Why pay good money for what anyone could do?' 'I wish I could do it,' I answered. 'The duty will have to be thirty dollars,' said the man. 'I would have appraised it as valueless. Either you are crazy or I am.' I told him, 'The country is crazy, with its idea that art can be taxed.' The man replied, 'It is the law.' I said, 'It won't always be.'"

"One grand morning in the summer of 1911, I went with Steichen to see Matisse in Paris. Matisse's studio was large, simple, rather bare-looking. He resembled a professor of mathematics rather than an artist. While he was showing me a magnificent flower piece, I said to Steichen, 'I wonder would he take five thousand francs for that.' I was surprised at myself, at my impulse. I had in mind exhibiting the painting in New York. It was a masterly affair and not over-large to hang at 291. Matisse said he was sorry he could not let me have it. What I offered was more money than he would receive, a great deal more, but he had promised a Russian patron—Shchukin[12]—that the best things would go to him. Matisse said he would paint another flower piece that I could have, but somehow I did not like the idea.

"The time passed quickly. Matisse took us down to his dining room where, to my surprise, I saw opposite his table a series of twelve Cézanne watercolors, placed next to one another in a row. 'Do you like Cézanne?' I asked. 'You see,' Matisse replied, 'while I eat my breakfast here and look at the newspaper, I am constantly contemplating these watercolors. Bernheim-Jeune took some of my work in exchange for them. They are my teachers for the present.'

"'What a fortunate man,' I thought to myself. The Cézannes were grand ones."

Marius De Zayas, the brilliant Mexican caricaturist, said of his first meeting with Stieglitz: "I had a studio in New York. I wanted to be alone. I was not attempting to get into contact with anyone in order to have my work exhibited or bought. But then, one day in 1907, a man entered my studio and stood looking at my work. He simply walked in. He did not introduce himself. I found out later he had come because an art critic had told him about me. I was working for the *New York Evening World*, also making other pictures for myself. The man asked me about what I was doing—did I wish to sell or exhibit? I replied, 'I make what you see here for myself. Just that.' 'Would you like to exhibit?' the man repeated. I said, 'No.' It was Stieglitz who had come to see me. In spite of what I said, he decided to show my work. I told him to keep all of it. I gave him everything of mine on display at 291."[13]

45. Stieglitz, De Zayas, 1910[17]

Stieglitz's love of fine caricature was the main factor that caused him to exhibit De Zayas' work beginning in 1909. He also published writing by De Zayas and was greatly stimulated by him. Since "caricature," *Camera Work* pointed out, derived from "*caricare*, to load, overload, exaggerate," the word did not adapt itself to what De Zayas called caricatures. The term, the journal suggested, should rather have been spelled *charactature*, stemming from the root *character*.[14]

De Zayas was one of the first painters associated with Stieglitz to appreciate and understand the importance of his photographs. He also played a significant part in helping to obtain important work for 291, notably that of Pablo Picasso in 1911; of Georges Braque in 1914, and of primitive African art during the same year[15]—the latter sent directly from Paul Guillaume in Paris.

William B. McCormick, wrote of De Zayas' pictures in the *New York Press*: "And now Marius De Zayas has got it, quite the worst case on record. By this we mean an attack of the prevailing disease for the fantastically obscure in art."[16]

46. Stieglitz, De Zayas, 1913[18]

In a 1908 letter from Paris, Steichen mentioned to Stieglitz the possibility of having an exhibition by Pablo Picasso, to whom he referred as a "crazy galoot." In 1910 De Zayas suggested that 291 show Picasso. Stieglitz strongly favored the idea. The gallery's presentation of the young Spanish painter in 1911 was the artist's first one-man show in America. It included eighty-three early and recent drawings and watercolors; charcoals, pen and ink drawings, etchings —Picasso's complete evolution through Cubism. Both the press and the public in New York were contemptuous.

Even Steichen, from Paris, expressed certain reservations about sending the Picassos—one of the few times, thus far, he and Stieglitz differed about an artist. Nonetheless, as *Camera Work* noted, Steichen joined De Zayas and Paul Haviland's brother, Frank, "in so choosing the limited number of drawings which could be accommodated in the

Little Galleries that they should adequately represent the different stages leading to his latest productions. Indeed we may here state that this method of presentation and its underlying purpose is characteristic of all the Little Galleries' Exhibitions. They are essentially demonstrations of development, rather than either exhibitions of final accomplishment or 'shows' in the popular sense."[19]

From a newspaper account of a Picasso drawing that Stieglitz bought, as reprinted in *Camera Work*, No. 42–43: "[At the extreme of Picasso's subjective range there is a drawing] happily left without other title, which was for a time shown in the Photo-Secession gallery. It has been called a glorified fire escape, a wire fence and other sarcastic names. It is almost pure pattern. It is undoubtedly rhythmic in high degree. There is a curious fascination about it. Based probably upon a human figure, it is still pretty thoroughly abstract. Its owner, Mr. Stieglitz, declares in all sincerity that when he has had a tiring day in. his gallery or elsewhere he goes home at night, stands before this drawing in black and white, which hangs over his fireplace, and gains from it a genuine stimulus."[20]

47. Nude, Picasso, 1910[21]

This, the first Cubist picture publicly shown in the United States, was bought by Stieglitz for sixty-five dollars. It was the storm center of 291's 1911 exhibition.

Hamilton Easter Field[22] paid twelve dollars[23] for a pencil drawing made when Picasso was twelve, the only other item acquired from the same exhibit. Stieglitz declared it a pity that the "pictures of Picasso's evolution shown at '291' were not kept together, as I had suggested to Bryson Burroughs of the Metropolitan Museum . . . they should be. He saw nothing in Picasso and vouched that such mad pictures would never mean anything to America. At the time the collection could have been had for $2,000."[24]

Arthur Hoeber of the *New York Globe* described 291's 1911 Picasso show: "The display is the most extraordinary combination of extravagance and absurdity that New York has yet been afflicted with, and goodness knows it has had many these two seasons past. Any sane criticism is entirely out of the question; any serious analysis would be in vain. The results suggest the most violent wards of an asylum for maniacs, the craziest emanations of a disordered mind, the gibberings of a lunatic!"[25]

From a Stieglitz letter to Hoeber about Picassos exhibited slightly later at 291: "If you had looked very carefully you would have found two pieces of genius, not only his pasting of a newspaper clipping, but the clipping itself; it was one of your own art criticisms."[26]

291 had led the way in showing modern art in America, but Stieglitz was well aware the gallery lacked the space in which to exhibit larger pieces by the era's foremost artists. He therefore tried to broaden the arena in which the art he favored could be seen. An ex-

ample of his efforts was a letter addressed to the editor of the *Evening Sun*, on December 14, 1911, expressing the conviction that the Metropolitan Museum "owes it to the Americans to give them a chance to study the work of Cézanne and Van Gogh; although deceased, their work is the strongest influence in modern painting. I firmly believe that an exhibition, a well-selected one, of Cézanne's paintings is just at present of more vital importance than would be an exhibition of Rembrandts. Believe me, the conclusion has not been arrived at through any snap judgment nor without the most careful study and thought. Without the understanding of Cézanne — and this one can get only through seeing his paintings, and the best of them — it is impossible for anyone to grasp, even faintly, much that is going on in the art world today.

"The study of Van Gogh is nearly [as] essential. . . . Should the Metropolitan desire to extend the scope of the exhibition, it might include the work of Matisse and Picasso, two of the big minds of the day expressing themselves in paint. No dealer can fully realize the purpose I have in mind. The dealer would not show anything in which he had no interest. And the things he would be free to take an interest in are limited. . . . His intentions would be suspected. On the other hand, there can be no question of the Metropolitan securing the loan of the best pictures of these masters. I happen to know they can be had.

"I hope that you will use your influence toward the realization of such an exhibition at the Metropolitan, or if not there, at least in some prominent art institution."[27]

The continued deadness of the Metropolitan at the time, in contrast to the freshness of exhibits at 291, haunted Stieglitz to so great an extent that he found walking through the museum "ridiculous, trivial, superfluous." Admitting that this might be a reflection of his own state of mind, he declared that he needed bigger, truer things than were housed together in an atmosphere that repelled him: "An atmosphere breathing of a cemetery dedicated to the dead rich. A cemetery still in use. Something instinctively abhorrent to me since my childhood. And never more strongly than today. How one longs for a deserted country cemetery, which through its very desertion has come back to life — natural life."[28]

48. Sculpture, Picasso, 1909

From a Stieglitz letter to the author, art historian and critic, Sadakichi Hartmann, dated December 22, 1911: "I have undoubtedly had the most vital year in my career. . . . It has been one crescendo culminating with a most remarkable three weeks spent in Paris. There I had long and most interesting sessions with Picasso, Matisse, Rodin, Gordon Craig, Vollard, Bernheim . . . finally winding up with two days at the Louvre which in reality I *saw* for the first time. Then too I saw the various Salons. . . . All this I did in the company of De Zayas or Steichen, or both. De Zayas has developed

most remarkably and is a big fellow. Steichen too is growing fast. What a pity you couldn't have been with us. You would have thoroughly enjoyed the treasures we were privileged to see. In short my experiences were most unusual and I think they came at the psychological moment. Paris made me realize what the seven years at 291 had really done for me. All my work, all my many and nasty experiences, had all helped to prepare me for the tremendous experience. Think of it, several hundred Cézannes, any number of Van Goghs and Renoirs—these are the three really big modern painters. Matisse is doing some beautiful work, but somehow or other it didn't grip me. Possibly he is ahead of me! Picasso appears to me the bigger man. I think his viewpoint is bigger; he may not as yet have fully realized in his work the thing he is after, but I am sure he is the man that will count. It was a great pity that you missed his little show at 291. It was possibly the most interesting yet held there, and that is saying a great deal, when one remembers what a remarkable series of shows have been held there; undoubtedly the most remarkable ever held in this country as far as art is concerned. We have certainly shown the quintessence of many big men's work. Europe has nothing similar to our place. There have been greater, larger exhibitions there but there never has been such a series with such a definite purpose. When I came back from Europe it took me about three weeks to reconcile myself to New Yorkers—New York itself was as wonderful as ever. I felt the way Tannhaeuser must have felt when he returned from the Venusberg and lost his patience listening to his colleagues theorizing about love. There is certainly no art in America today; what is more, there is, as yet, no genuine love for it. Possibly Americans have no genuine love for anything; but I am not hopeless. In fact I am quite the contrary. . . .

"I am glad that my pictures gave you some pleasure. . . . It's a pity I can't afford more time for this branch of work; but daily I realize, more and more, that in sacrificing my own photography I have gained something I could have never possessed in any other way—and that is certainly a bigger thing; a bigger thing than merely expressing oneself in making photographs, no matter how marvelous they might be."[29]

In 1909 Steichen had taken Stieglitz to see the Michael Steins in Paris. "The rooms we entered were full of antique furniture—Italian. The walls were hung with Matisses and other paintings. I was shown many things, most of them new and all exceptionally wonderful to me.

"We stayed several hours. The next day Steichen said, 'Now we shall go to Leo Stein. His place is the real center. All the American artists, students who are up to date and many others go there. He has special evenings.'

"In the afternoon we drove to 27 rue de Fleurus and I found

myself in a huge room. Paintings covered the walls from floor nearly to ceiling; a bewildering lot, mainly ultra modern. There was statuary—much, again, completely new to me.

"Books and papers covered a long table, very long, at which sat a bald man with eyeglasses and whiskers. Elsewhere in the room I noticed a woman, dark and bulksome.

"Steichen introduced me to the man, Leo Stein, and to the woman, whose name I did not hear. No one else was present.

"Although the sky was cloudless, burning blue, it was one of those chilly June days that went through my bones. I stood, wrapped in my cape, some distance to the left of Stein; Steichen, in the other corner, to the right, partly hidden from him. The woman half reclined on a chaise longue.

"Leo Stein began to talk. I quickly realized I had never heard more beautiful English nor anything clearer. He held forth on art. He must have spoken for at least an hour and a half. He described Whistler as decidedly second-rate and Matisse, whom he had championed a few years before, also as second class—a better sculptor than painter, even better than Rodin. He relegated Rodin, like Whistler, to the second or third class. Steichen blanched, two of his idols having been thrown on the garbage heap by Stein, who backed up his statements with what appeared to me—I really a great innocent—profound logic.

"While Stein ran through the gamut of art, old and new, I listened, spellbound. I then said, 'Mr. Stein, why not write down all you have said? It is the most wonderful thing, in a way, I ever have heard about art. If you should find no one to print it, I am ready to publish anything and everything you might send in *Camera Work*.'

" 'But Mr. Stieglitz,' Stein replied, 'you see I am trying to evolve a philosophy of art, and I have not entirely succeeded in closing the circle. Until I have done so, I shall not write.'

"Just before leaving, I asked, 'Will you please tell me where you place Rubens and Renoir?' He was taken by surprise. 'That is the rub,' he answered. 'I like them both. They are great favorites of mine. But they seem not to fit into the philosophy of art I have thus far evolved. That worries me.' He bade us goodbye. I thought to myself, 'Stein will not be able to solve his problem about Renoir and Rubens until he has fallen in love.' Steichen, completely limp, turned to me, 'I had better stop painting. If Rodin and Whistler amount to nothing, where do I come in? I would rather have you and Stein approve of my work than any other people in the world. In Stein's eyes I must be out of the picture.'

" 'Do you paint for yourself,' I asked, 'or to please others? What has Stein, or what have I, to do with your paintings?' Then I added that what was most remarkable about the visit to Stein was the woman. She had appeared to understand everything the man said

and oftentimes smiled a knowing smile. But she never spoke a word.

"Two years later I was in Paris again. Steichen suggested we go to the Steins. The salon there was more frequented than ever. I refused, knowing that such a gathering could mean nothing to me. Also, I wanted to keep the picture of Leo Stein clear and definite, the way it had been during my first encounter with him."

"In December 1911, or perhaps it was January 1912, a huge woman leading a huge Boston bulldog entered 291. She had a portfolio filled with manuscripts under her arm. It was a funny sight to see the woman with her bulldog and bursting portfolio in that tiny room.

" 'Mr. Stieglitz?' the woman inquired. 'Yes,' I replied. 'I have some manuscripts here. I have taken them to every publisher in town. Invariably I have been told that only one man in this country is crazy enough to be interested in anything like them. Since everyone mentioned your name, I came to you. Will you look?'

"I told the woman I was not a publisher. I did print a magazine, *Camera Work*, dedicated to an idea but not a money-making affair. I asked was what I had said clear.

"She answered, 'Yes, I know you are not in business of any kind, neither art, nor publishing, nor otherwise. But I know, also, that you have been instrumental in introducing both Matisse and Picasso to America. Here are two articles about them.'

"The woman handed me a manuscript about Matisse. After having read not more than thirty or forty words I asked to see the one on Picasso. Again I read thirty or forty words. The Matisse piece seemed to be about fifteen hundred words, the Picasso perhaps eight hundred.

" 'I don't know the meaning of all this,' I remarked, 'but it sounds good to me. I think I can use the articles. I had planned to publish a number of *Camera Work*, showing the pictorial evolution of Matisse and of Picasso, but I didn't know where to find literary matter that would go with the pictures. What you have brought somehow fits into the volume I have had in mind.'

"I explained how I would print the usual thousand copies of *Camera Work*, a Special Number to be dedicated to Matisse and Picasso, and would include the two manuscripts I had read. I added I could pay no money for them but, instead, I would be willing to give the author one hundred of the thousand copies printed.

"The woman asked, 'Can't I show you some of the other writing I have brought, by the same person?'

" 'No,' I replied. 'The two pieces serve a certain end. And I am sure that, once the Special Number of *Camera Work* appears, you will have no trouble in finding publishers who will print the rest of what you have in your portfolio.'

"The woman agreed, 'I'll leave the two manuscripts with you. I am sure it will be all right. Just go ahead with what you plan to do.'

"I was delighted. Wouldn't the literary people sit up and take notice, just as the artists previously had been forced to do at 291 about Matisse, Picasso, Cézanne, Henri Rousseau and the rest?

"The visitor[30] questioned me further, 'Don't you want to know the writer's name? Don't you want to know anything about the author? Her name is Gertrude Stein. She is an intimate friend of mine. You must have met her.'

" 'How should I have met Gertrude Stein?' I asked. 'Why, she is the sister of Leo Stein and I know that you know him.'

" 'My God,' I exclaimed, 'so that is who was on the chaise longue in Leo Stein's Paris studio, wreathed in a sort of semi-Mona Lisa smile, while Leo held forth for over an hour on art, with Steichen and myself as listeners.'[31]

"Miss Stein later wrote to me that she was genuinely pleased her pieces were to appear. She asked me to take extreme care that no punctuation would be added in printing them since she had put in all that she wanted. To introduce anything more she said, would make everything wrong.

"The Special Number of *Camera Work* came out in 1912.[32] It created a great stir, primarily amongst writers. Stieglitz certainly was cracking a joke this time! A lunch was arranged to which I was invited. And wasn't I taken to task? 'Stieglitz,' I was told, 'you cannot make us believe that there is the slightest value in that gibberish you have published.'[34]

"I answered, 'I have had to listen to similar charges all along the line about the art introduced at 291. It has always been the same story in no matter what field.' "

49. Gertrude Stein, Picasso, 1906[33]

One of the writers especially distressed by the 1912 Special Number was John Galsworthy. Stieglitz commented: "I had read a chapter by Galsworthy on art that I felt would make a splendid leading article for the next number of *Camera Work*. I wrote to him asking for permission to reprint it. I also sent a copy of the Gertrude Stein-Matisse-Picasso issue published not long before, as well as a Number Thirty-six containing a large number of my own pictures and a Picasso reproduction.

"In due time I received a delightful note from Galsworthy giving me permission to reprint his writing, provided that his publisher, Scribner's, agreed, which they did.

"The Galsworthy piece already was set up when a second letter arrived in which he retracted his article. To my consternation I found that when he had received the Stein-Matisse-Picasso number he was incensed. He wrote with regret that although he found my photographs beautiful, he could not stomach Gertrude Stein, and that he

neither admired nor credited with sincerity the Matisses and Picassos reproduced. He felt the childishness of Miss Stein's articles should not be tolerated in the interest of letters.

"I was boiling. Here was this humanitarian, pleading for justice and tolerance—this socialist—retracting his word, and in such intolerant spirit.

"If Galsworthy's article had not already gone to press, I would have been tempted to keep blank the pages that were to contain his essay and print a statement explaining why. I was amazed that a man of Galsworthy's caliber should seem so small, but the ways of the gods are undoubtedly peculiar.

"Posthaste, in answer to a further letter I sent him, I received a reply stating, 'Go ahead, use my article.' It is in *Camera Work*."

The way in which *Camera Work* reprinted criticisms of 291's exhibitions proved to be of great historic importance. Stieglitz the photographer succeeded in bringing the critics face to face with the pronouncements they made in successive seasons, with the many occasions when they reversed their opinions, and with the development of public taste and sensibility.

Although antagonism to 291's many daring "firsts" was widespread, a few discerning writers did, from time to time, react favorably to its exhibitions.

Hutchins Hapgood spoke out approvingly in 1912: "We have a background of support now on politics and sociology for the insurgent and . . . unconventional. It is time . . . we should have some respectable and official recognition of . . . art that is unacademic, untraditional, personal. We need hospitable circles where such art may develop; such salons, for instance, as that of Alfred Stieglitz, where for several years the voice of freedom has been quietly shouting in the wilderness, where art could stand on its head if it wants to, provided it is animated with a sincere desire to see straight, to feel beauty and form directly, without an undue regard for convention, tradition, and authority."[35]

Charles Caffin, who became one of the more advanced critics of the period, wrote in *Camera Work:* "It is alien to usual experience that a man should promote exhibitions without any idea of gain or even of pleasing the public. That his motive should be, on the one hand, to give the public a chance of seeing what he thinks it ought to be pleased to see and will be able to see nowhere else in New York—at least until the example set at the . . . Gallery [291] has been followed, as in the case of Rodin's and Matisse's drawings, by the Metropolitan Museum—seems like an amiable form of lunacy. That he should be on the lookout for evidence of honest individuality in young unknown painters and strive to encourage it by exhibitions which display the weakness as well as the strength of the be-

ginner—what can this be but sensationalism?

"No one more than Mr. Stieglitz recognizes that there is a danger of this sort of thing degenerating into sensationalism, or is more afraid of it. Accordingly, he tries to balance one exhibition with another; off-setting, for example, the startling radicalism of a Picasso with the stable conservatism of an Octavius Hill. . . . For years, Mr. Stieglitz has taken the advanced position that photography is entitled to be considered a medium of pictorial art, and has been ridiculed by the critics of painting. Now that the latter are foaming in impotent bewilderment at the vagaries of modern painting he offers

50. Article about 291's Children's Art Exhibition, 1912

as an antidote the sanity of the photographic process. After claiming for photography an equality of opportunity with painting, he turns about and with devilishly remorseless logic shows the critics, who have grown disposed to accept this view of photography, that they are again wrong."[36]

In a 1912 newspaper interview Stieglitz referred to 291 as an idea based on revolt against all authority in art, "in fact against all authority in everything, for art is only the expression of life. . . . In short we are in sympathy with everything that is alive and interesting.

"Some people accuse us of demolishing old theories only to build up new theories of our own. They misunderstand us. We insist on remaining relaxed and not theorizing. We see things happening before us just as a chemist sees them happening before him in his laboratory. In fact, I have always refused to call these rooms a gallery. They are more like a laboratory in which we are testing the taste of the public. In the seven years that we have been here, we

have had 167,000 people in these rooms. (The 'rooms' consist of one fair sized studio and a small hallway.) Sometimes we have had as many as 150 in a day, and yet we have never done a bit of advertising.

"This work is a reflection of the social unrest that pervades the whole country. People are getting tired of the shibboleth, 'Because this always has been it always should be.' There is nothing so wrong as accepting a thing merely because men who have done things say it should be so. A genius is born and strives against existing rules until he overthrows them. Then people make rules founded in accordance with the ideas of that man, and when a new genius is born the fight between individuality and established custom begins all over again."[37]

From a Stieglitz letter of 1912: "I find that contemporary art consists of the abstract (without subject) like Picasso, etc., and the photographic. . . . Just as we stand before the door of a new social era, so we stand in art, too, before a new medium of expression—the true medium (Abstraction)."[38]

In 1912, 291 held a show of drawings, watercolors, and pastels by untaught children, two to eleven years of age. The first exhibit of its kind to be presented in the United States, it revealed the relationship between what untaught children had made and, in Stieglitz's view, "much of the spirit of so-called Modern work."

Abraham Walkowitz, a young artist who had become associated with 291, brought the children's pictures to Stieglitz from an east side settlement house. Their directness and innocence at once aroused his enthusiasm.

A mother whose daughter's work was to be included in the children's exhibit was so outraged by the Matisses shown at the gallery, she refused to permit her child's paintings to be hung.

When Stieglitz showed Walkowitz's own art later in the same year, *Camera Work* lauded it as "the manifestation of a man who has given expression to a spirit of freedom which he has found in his contact with society."[39] Arthur Hoeber, in the *New York Globe*, pronounced an opposing view, calling Walkowitz "as weird as the worst of them."[40]

In 1916 Walkowitz wrote of himself: "I am seeking to attune my art to what I feel to be the keynote of an experience. If it brings to me a harmonious sensation, I then try to find the concrete elements that are likely to record the sensation in visual forms, in the medium of lines, of color shapes, of space division. When the line and color are sensitized, they seem to me alive with the rhythm which I felt in the thing that stimulated my imagination and my expression. If my art is true to its purpose, then it should convey to me in graphic terms the feeling which I received in imaginative terms."[41]

Stieglitz's sharp insight concerning which artists—whether abroad or at home—were breaking new ground was increasingly evident. It is extraordinary that in 1912, the same year Vasily Kandinsky first published *The Spiritual in Art* in Germany, *Camera Work* printed an excerpt in translation: "Always moved, and always tempestuously torn by a compulsion for self-expression, Picasso throws himself from one extreme of means to another. If there is a chasm between the methods, Picasso takes a mad leap, and there he is on the other side to the astonishment of the enormous mass of followers. Just when these think they have reached him, the wearying descent and ascent must begin again for them. That is how the latest French movement of Cubists arose. Picasso strives to achieve construction by numerical proportion. In his last work (1911) he arrives by a logical road to an annihilation of the material, not by analysis, but a kind of taking to pieces of each single part and a constructive laying out of them as a picture. At the same time his work shows in a remarkable way his desire to retain the appearance of the material things. Picasso is afraid of no means. If he is disturbed by color in a problem of pure line form, he throws color overboard and paints a picture in brown and white. And these problems are the high watermark of his art. Matisse—Color. Picasso—Form. Two great highways to one great goal."[42]

51. Abstraction, Walkowitz, 1915

The single Kandinsky shown at the Armory Show of 1913—his *Improvisation No. 27* of 1912—was bought by Stieglitz who said at the time there was a very definite reason why he decided to obtain it for 291, although he had little money and none to waste. He wanted to save it for New York because, from a certain point of view—that is considering the future development of a certain phase of painting—the Kandinsky was possibly the most important feature in the whole Armory exhibition.[43]

VIII. Pre-World War I Period

In 1913 the newly formed Association of American Painters and Sculptors organized the now legendary International Exhibition of Modern Art, promptly dubbed the Armory Show because it was held at the Sixty-Ninth Regiment Armory on Lexington Avenue at 25th Street.[1]

Arthur B. Davies, President of the Association, made the Armory exhibit possible and transformed what was to have been a presentation of progressive American art into one of international proportions. The scope of the exhibition was indeed vast, tracing as it did the evolution of French painting from Ingres through Delacroix, Corot, Daumier, Courbet. It included work by Impressionists and Post-Impressionists, Expressionists, Cubists, Orphists, as well as painting and sculpture by numerous contemporary Americans.

Stieglitz was invited to be an Honorary Vice-President of the exhibition, as were such diverse figures as Claude Monet, Auguste Renoir, Odilon Redon, Augustus John and Boston's Mrs. John Lowell Gardner. Stieglitz played no part in choosing art for the show, but before it opened he begged the public in an impassioned article in the *New York American*, not to miss the glorious affair about to take place: "If you still belong to the respectable old first primer class in art, you will see there stranger things than you ever dreamed were on land or sea—and you'll hear a battle cry of freedom without any soft pedal on it.

"When the smoke has cleared away you'll go back to your habitual worship of eternal repetitions of mere externals of people and things that cram all the museums and galleries—but you won't feel happy. The mere outside of things won't satisfy you as it used to. And maybe the idea will dawn upon you that some genius will rise with power to prove that art is being revitalized."[2]

Extraordinary as the Armory Show was, Stieglitz's high hopes for it rapidly vanished. He became disturbed by what he called its three-ring circus atmosphere,[3] so contrary to that of 291, even though a number

52. The Armory Show, 1913[4]

of the artists he exhibited were represented in the mammoth display. He was equally distressed when he discovered the undertaking was an isolated effort, not to be succeeded by related exhibitions.[5]

The public's precipitate excitement, after the 1913 show, about the art it had been ignoring or deriding struck Stieglitz as having more to do with fashion or snobbism than with firm conviction. He never denied his own initial blindness to Cézanne, but when people behaved as though they had always favored work they had not, before it was popular or prestigious to possess, he became dismayed.

The mushrooming of commercial galleries and what he felt to be investment-minded collectors in the wake of the exhibition repre-

sented a final irony. He had sincerely hoped that the art on view would gain authentic adherents in terms of a spiritual force, not as a material commodity. "Work," he fumed, "isn't art until enough noise is made about it, until someone rich comes along and buys it." It saddened him that so little attention was paid to the American artists he admired. They had, of course, been influenced by recent

53. "The First Great 'Clinic to Revitalize Art'," by Stieglitz, *New York American*, 1913

developments abroad, yet by now each had found his own distinctive style. How, asked Stieglitz, could the country expect to produce first-rate creative figures if they lacked support?

Although he continued to present freshly conceived European art, he soon came to feel that he must concentrate his attention more intensively upon the artists he respected in the United States. He knew they needed all the sustained help they could obtain. He would do everything in his power to protect them, "not in the name of chauvinism, but because one's own children must come first."

During the Armory exhibition Stieglitz hung his own photographs at 291—the only one-man show of his prints that he held there—to see how they might measure up to the art included in the larger, highly publicized show. Writing in the *New York Tribune*, the habitually conservative Royal Cortissoz asserted: "The Photo-Secession Gallery is filled with photographs by Mr. Alfred Stieglitz. It is interesting to see them there, but we cannot forbear noting that if any

worker with a camera might have claimed admission for his prints at the Salon of the Independents it is Mr. Stieglitz. Visitors at the Armory, when they are studying Matisse and the rest, may well recall that it was in the Photo-Secession Gallery that so many of the 'revolutionaries' were first introduced to the New York public."[6]

In 1913 the talented and energetic young painter, Francois* Picabia, appeared at 291. A close associate of Marcel Duchamp and Guillaume Apollinaire, he had come to New York from Paris to see the Armory Show, in which his work created a stir. Despite their very different temperaments, he and Stieglitz responded to one another with warmth from the moment they met.

Stieglitz's reaction to Picabia's pictures was so positive that he offered to give him his initial American one-man exhibition in March, 1913, immediately after the Armory Show closed. Stieglitz also felt that Picabia was the first artist to come from Europe who understood the underlying significance of 291—the breadth and complementary nature of its photographic and non-photographic activities. It is perhaps as surprising that Stieglitz was delighted by Picabia's satirical sense of humor and sophistication as that Picabia was impressed by Stieglitz. The relationship between the two men of diametrically opposed temperaments proved to be highly productive.

As a result of his enthusiasm about Stieglitz, Picabia publicized, with characteristic verve, his belief that 291 represented something in no sense duplicated in Europe. Much could be learned abroad, he realized, from its manner of functioning—from Stieglitz's entire approach to modern art and life.

54. Crossing Atlantic, Picabia, 1913

Camera Work published Maurice Aisen in 1913, on "The Latest Evolution in Art and Picabia": "The unrest which is in a latent stage with [the] minority is precipitated by [his] paintings and grows into a conviction before their indisputable evidence that existing facts do not fit any longer into their original conceptions. The old moulds are too small for the new interpretations and, because in all evolution nothing is static and all things evolve out of themselves, the man of today realizes finally that something is forcing him to grow more inwardly from something inevitable and irrevocable."[7]

As photographer, Stieglitz began to turn his penetrating gaze more often toward those close at hand, rather than to the passing stranger. Colleagues and others of sensitivity—artists, writers, the elevator operator—were depicted by his camera. Stieglitz was not interested in photographing celebrities—the famous, the established. His portraits began to have added depth, intensity; to reveal what people were to become rather than what they already were.

*Later called Francis

When Stieglitz photographed people he expected from them the same patience that he demanded of himself. He preferred to wait, no matter how long, for the "living moment;" to take pictures again and again, rather than to compromise in order to simplify matters either for himself or for others.

He preferred to photograph in brilliant sunlight, but with the sun hidden behind clouds while he made his exposures, or on gray days, when the light was especially intense.

Konrad Cramer has described the manner in which Stieglitz photographed him in 1911: Stieglitz's "equipment was extremely simple, almost primitive. He used an 8 × 10 view camera, its sagging bellows

55. Picasso, Braque, African Sculpture, A.S., 1914-15

held up by pieces of string and adhesive tape. The lens was a Steinheil, no shutter. The portraits were made in the smaller of the two rooms at '291' beneath a small skylight. He used Hammer plates with about three second exposures.

"During the exposure, Stieglitz manipulated a large white reflector to balance the overhead light. He made about nine such exposures and we then retired to the wash room which doubled as a darkroom. The plates were developed singly in a tray. From the two best negatives he made four platinum contact prints, exposing the frame on the fire escape. He would tend his prints with more care than a cook does her biscuits. The finished print finally received a coat of wax for added gloss and protection."[8]

Among the important artists whose sculpture was seen in America for the first time at the 1913 Armory Show was Constantin Brancusi: "His work," Stieglitz recalled, "attracted quite some attention. Toward the end of the year, or a bit later, Steichen wrote from Paris that he had met a sculptor working at Rodin's studio. He saw him there often, but now the man, Brancusi, was on his own and had made some magnificent things. Should he bring them over?

"Naturally I felt elated at the idea. The examples Steichen brought with him were truly wonderful. 291's 1914 Brancusi exhibition was small, but Steichen arranged it beautifully. Several sculptures were acquired, including one I bought after the show ended.

"Certain original Brancusis in bronze, marble and wood had not been seen before in America, some of the pieces having appeared only in plaster at the Armory—casts which Steichen told me had as much quality in relationship to the originals as a shoddy reproduction does to a fine original photograph."

W. B. McCormick described the Brancusis at 291 in the *New York Press:* "Curious this exhibition is, even for the Photo-Secession Gallery, that has sheltered more strange forms of art in its lifetime than any other gallery in this city. . . . Just why, in one of [the] marble heads, [Brancusi] should represent his original with a swollen face and a goitre is not easy of solution."[9]

Stieglitz was fully in accord with De Zayas' suggestion that he show African art. When the exhibition finally took place at 291 in 1914, De Zayas called attention to how art in its researches had discovered African forms. He described the direct influence primitive art was having on "our comprehension of form, teaching us to see and feel the purely expressive side and opening our eyes to a new world of plastic sensations." He wrote that African art had "reawakened in us a sensibility obliterated by an education, which makes us always connect what we see with what we know—our visualization with our knowledge, and makes us, in regard to form, use our intellect more than our senses.

56. De Zayas, A.S., 1914

"If through European art we have acquired the comprehension of form, from the naturalistic point of view . . . [African] art has made us discover the possibility of giving . . . expression to the sensation produced by the outer life, and consequently, also, the possibility of finding new forms to express our inner life. . . . The introduction of the plastic principles of African art into our European art does not constitute a retrogradation or a decadence, for through them we have realized the possibility of expressing ourselves . . . without the recurrence of direct imitation or fanciful symbolism."[10]

The 291 exhibition of African sculpture in 1914 marked the first time such material had been shown as art in America.

De Zayas observed at another time that when "studying the ethnographical collection at the British Museum I was impressed by an object invented by an artist from Pukapuka or Danger Island in the Pacific. It consisted of a wooden stick to which a few circles made of some vegetal material were fixed by pairs right and left of the stick. It impressed me particularly because it reminded me of the physical appearance of Stieglitz. I say 'physical' because the resemblance was also spiritual. The object, said the catalogue, was built as a trap for

catching souls. The portrait was complete, and it caught my soul, because from it I developed a theory of abstract caricature . . . which I exposed together with a few caricatures called 'abstract,' together with a few others which were of the 'concrete' style. . . . I had previously made a caricature of Stieglitz with the caption 'L'Accoucheur d'Idées.'[11] These two caricatures expressed my understanding of Stieglitz's mission: to catch souls and to be the midwife who brings out new ideas to the world."[12]

The art by which Stieglitz was surrounded as a child at Lake George and in New York, like the design of the magazines he edited prior to *Camera Work*, offered no clue to what he would later foster in photography, painting, sculpture and typography. The manner in which work was shown at 291 and Stieglitz's fresh approach to photographing space relationships at the gallery were often as startling as they were unpredictable. Compare his own 1914 photographs of exhibits at 291 and their arrangement with the picture and presentation of the Armory Show.

In 1909 Steichen had written to Stieglitz about sending over work by the Polish-born artist, Elie Nadelman, who was attracting attention in Paris. 291 planned to exhibit his drawings in 1910 but, as *Camera*

57. Sculpture, Nadelman, A.S., 1915-16

Work explained, before it could do so, it was necessary to return them to Europe for an exhibition there. It was not until 1915 that the gallery held his first American one-man show of sculpture and drawings, arranged by Nadelman himself.

Camera Work printed what Nadelman wrote for the proposed catalogue of 1910: "I am asked to explain my drawings. I will try to do so, although form cannot be described. Modern artists are ignorant of *the true forms of art*. They copy nature, try to imitate it by any possible means, and their works are *photographic reproductions*, not works

123

of art. They are works without style and without unity.

"It is form in itself, not resemblance to nature, which gives us pleasure in a work of art.

"But what is this true form of art? It is significant and abstract, i.e., composed of geometrical elements.

"Here is how I realize it. I employ no other line than the curve, which possesses freshness and force. I compose these curves so as to bring them in accord or in opposition to one another. In that way I obtain the life of form, i.e., harmony. In that way I intend that the life of the work should come from within itself. The subject of any work of art is for me nothing but a pretext for creating significant form, relations of forms which create a new life that has nothing to do with life in nature, a life from which art is born, and from which spring style and unity.

"From significant form comes style, from relations of form, i.e., the necessity of playing one form against another, comes unity.

"I leave it to others to judge of the importance of so radical a change in the means used to create a work of art."[13]

IX. The War Years

The years between 1914 and 1917 were largely tense and tormented ones for Stieglitz: "Much of the enthusiasm that had existed at 291 gradually disappeared because of the war. Close friends seemed to fall by the wayside. I could not turn 291 into a political institution, nor could I see Germany as all wrong and the Allies as all right. The work going on at the gallery, I felt, was universal.

"Colleagues tried to prove to me that Beethoven was no German, that all the cruelty in the world came from Germany and that every Frenchman and Englishman was a saint. I was truly sick at heart."

Because attendance at 291 decreased, as did subscriptions to *Camera Work*, deficits mounted. Stieglitz found it impossible to have satisfactory reproductions made either abroad or in the United States. His domestic situation, never too happy, steadily worsened.

Various 291 co-workers either joined the armed forces in France or traveled abroad. De Zayas went to Paris in May 1914, where he saw much of Picabia, looked at art, scouted for work that could be shown at 291. He found no center abroad to compare with Stieglitz's gallery. Of special interest to De Zayas were members of the advanced group then associated with Guillaume Apollinaire, who were publishing the second series of *Les Soirées de Paris*.

The impact of modern art had been enormously revitalizing in Europe and the United States during the first years of the twentieth century. After the outbreak of World War I, even more revolutionary forces erupted. The new forms symbolized a tearing apart of a

world grown insensitive to the need for social and political change for spiritual rebirth. Much art of the war period may now seem minor in comparison with the serious crises that had to be surmounted. Yet the artists' commentary, however slight in form, provided clues to larger realities demanding attention.

A new avant-garde spirit developed in Europe, as within the group associated with Stieglitz. During January, 1915, Paul Haviland and Marius De Zayas came to him: "We and Agnes Meyer feel 291 is in a rut. The war has put a damper on everything."

"They believed we should publish a monthly magazine dedicated to the most modern art and satire. I always had hoped there would be a magazine in the United States devoted to true satire, but it was a form of expression sadly ignored. Americans seemed afraid of it. Afraid of caricature. They enjoy cartoons, everlasting cartoons. Was there a place, I wondered, for real caricatures in the United States? Had not De Zayas made some grand ones, and were they not shown at 291? They had evoked little response.

"Haviland's and De Zayas' proposition met with my fullest approval. Perhaps the publication envisaged might bring some new life to 291. The two men, together with Mrs. Meyer, were ready to act at once. When they asked if *291* could be the magazine's title, 291 its headquarters, and whether I would participate in establishing and publishing it, I agreed.

"Agnes Meyer wanted to know how we were to determine what should be published in *291*. What was the policy to be? Was the majority to rule? Since we were four, I inquired what would happen in case of a tie? *291* was founded on a new idea, so why think in terms of obsolete methods? If any one of us considered something worthy of publication, that should be sufficient reason to incorporate it. If we didn't have that much faith in one another, why begin?

"Meetings, minutes and endless discussions were anti-291. Agnes Meyer felt elated about my approach as did De Zayas and Haviland. The difficult problem of majorities and discussions being so simply solved, each of our meetings lasted less than ten minutes.

"We decided the magazine would appear monthly and that each number would cost a hundred dollars to publish. When I was asked to be one of three guarantors assuming responsibility for the payment of bills—the two others being Haviland and Agnes Meyer—I assented.

"Instead of *291* being the sheet originally contemplated, it became, more or less, a deluxe affair. Haviland, De Zayas and I had rather expensive tastes—that is, we wanted good paper and ink, careful printing and mailing. I realized that by the end of a year each guarantor must doubtless foot a liability of at least fifty per cent more than the original estimates. Regardless, we went ahead. The result was what counted."

291 first appeared in March, 1915. Shortly thereafter Picabia, conscripted in the French Army, was sent on a minor mission to the Caribbean. When his ship stopped in New York, he calmly disembarked. Excited by what was being done with *291*, he wanted to participate at once. Beginning with the second issue, a number of his drawings are to be found in its pages. Among others included were Apollinaire—whose picture in type, an "Idéogramme," appeared in the first issue; Picasso, Braque, Ribemont Dessaignes, Max Jacob, Marin, Savinio. Katharine Rhoades, whose paintings 291 showed and who was much involved with the gallery's activities at the time, was also a contributor as were Agnes Meyer and Haviland. Picabia's influence was great, but the main burden of editing was carried by De Zayas and Stieglitz.

58. Picabia, A.S., 1915

Like the gallery 291, the new publication was a protest against the academic and the stereotyped. Its format was necessarily different not only from that of *Camera Work*, but of other existing periodicals. Those who produced it were affected by free verse; by Cubism, Futurism and Expressionism; by the typographical and poetic experiments of Apollinaire. They were preoccupied by the unconscious, above all by the war.

Much contained in the short-lived, innovative *291* had been foreshadowed in the pages of *Camera Work*, which had for several years been publishing iconoclastic material by De Zayas. The irrepressible Benjamin de Casseres had protested against indifference toward the arts: against mediocrity and hollow respectability, brute power and lack of moral fibre. He wrote about the unconscious in Number 36, October, 1911. Sadakichi Hartmann made typographical experiments in Number 38, April, 1912. During 1912, too, Stieglitz had published Gertrude Stein. The witty *Vers L'Amorphisme*, from "Les Hommes du Jour"—at times attributed to Picabia[1]—appeared in Special Number, June, 1913.

59. Hodge Kirnon, A.S., 1917(?)

Paul Rosenfeld described the atmosphere of the gallery 291 while *291* was being published: "Behind the curtain, in the back room, *Camera Work* was edited; and here De Zayas, Paul Haviland, Agnes E. Meyer, Picabia, Katharine N. Rhoades, and Stieglitz collaborated upon the brilliant Apollinarian experiments with typography called *291*. Mats were cut; frames tried; bathroom water ran over photographic plates; and Marie, the stenographer, who was studying singing, addressed some envelopes, played the typewriter, and listened wonder-eyed. A scientific spirit was alive: people were making serious study of the components of expression, and Stieglitz was watching, with the zeal of a psychological experimenter life as it flowed into his retort and out again, observing its patterns, proving his intuitions, 'registering' the psychic reactions of America of the business man, the artist, the woman, everybody who happened in."[2]

126 Rosenfeld wrote about Picabia's cover for *291*, Number 5–6, in the

first issue of the *Seven Arts:* "There is a design of Picabia's — one of those in which he has attempted to express himself in symbols abstracted from mechanical devices — in which a kodak lens springs out from the body of the camera toward the Gothic characters that form the word 'Ideal.' At the side of the drawing stands the legend 'Ici, c'est ici Stieglitz — foi et amour.' A plastic epigram, if you will. But one that might well serve as the motto of a personality unique in America. Faith and love, love for art, faith in its divine power to reveal life, to spur action, to excite the creative impulse, those are the dominant characteristics of Alfred Stieglitz."[3]

Twelve numbers of *291* in all — six single and three double ones — were issued. "Before the periodical ceased publication in 1916, Haviland and De Zayas suggested that a double number be devoted to photography, featuring *The Steerage.* Since hundreds of people, rich and poor, had been wanting prints, Haviland and De Zayas claimed it would help photography and the basic ideas with which we were concerned if I had five hundred proofs of the photogravure pulled on Imperial Japan paper. The regular edition could be bought for two dollars. The price for the deluxe thin paper Japan tissue edition was available on request. Both versions were printed under my direction and at my expense. Using *The Steerage* as their theme, Haviland and De Zayas each wrote an essay on photography.

"I agreed to have *The Steerage* appear in *291*, to see what the American people would do if left to themselves. I made no attempt to solicit orders nor to sell the magazine.

"About one hundred people subscribed to the regular edition, eight to the deluxe. Aside from that, how many copies do you think were bought? Make your estimate as low as your imagination will permit. None!

"Once *291* came to an end, and the gallery 291 closed in 1917, I didn't know what to do with the nearly eight thousand copies of the publication that remained. I called in a rag picker. It was wartime. The cost of paper was high. Perhaps my gesture was a satirical one. The rag picker offered five dollars and eighty cents for the lot, including the wonderful Imperial Japan *Steerage* prints.

"I handed the money to my part-time secretary and said, 'Here, Marie. This may buy you a pair of gloves — or two.'

"I kept the greater part of the deluxe edition but, in time, I destroyed most of that. I had no feeling whatsoever about the transaction, except that it was another lesson. I asked myself why an official of a Berlin museum had been willing to pay a hundred dollars for a print of *The Steerage*, while my American friends did not want one at the cost of two dollars, even though they had been at me to let them acquire a copy! People wondered why I did not give the gravures away if they were sold at so low a figure. But wasn't I doing exactly that, in setting such a price?"

60. Picabia cover, *291*, 1915

The periodical *291* was proto-Dada in many important respects. The magazine represented a symbolical effort to break with what was deadening and destructive in the past; to dismantle artifice, puritanical restriction and blind repetition. It juxtaposed awareness and humanism against unfeeling mechanization; love against sentimentality and the facilely synthetic. It was satirical, scoffing at self-delusion and hypocrisy. The publication, which gave voice to much that was being felt by sensitive artists and writers in other countries, had a decisive influence on later Dada.

Picabia, together with his wife Gabrielle Buffet, founded *391* in Barcelona in 1917, a publication directly and admittedly modeled upon *291*.[4]

61. Picabia drawing, *391*, 1919

Marcel Duchamp told me that he found it difficult to define Stieglitz: "He was not a collector, but a teacher—a great man, with great judgment. A force. He abandoned the worldly conception of art. He helped American artists more than anyone else. He was primarily a humanist. He was not interested in aesthetic problems. He believed passionately that America should have its own artists. He felt his influence could force the issue.

"He saw my *Nude Descending a Staircase* at the Armory Show in 1913. At the time he did not like my work just because it was in that exhibition. He thought I must be a fraud because of my success there. When we met in 1915 we got on very well, at once. From then all went splendidly between us. He had my 'ready-made' R. Mutt figure at 291 when it was pushed aside by the Society of Independent Artists in 1917. He also photographed it."[5]

62. Marcel Duchamp, A.S., 19⟂

Stieglitz: "In 1915 I felt I should close 291 principally because of the war. At just that point De Zayas decided, with the help of Picabia and Agnes Meyer, to open what he called the Modern Gallery. All three believed 291 had done sufficient experimenting and should go into business. All objected to the idea of others reaping the benefit of what I had done for so many years. Mrs. Meyer claimed that people were afraid of asking to buy anything at 291, because of the unconventional, challenging way in which I ran it. I failed to understand why I should conform to business methods or be concerned about what 291 and business had in common.

"Just as I had wanted to assist my friends to publish *291*, so I was eager to help them found the gallery they had in mind. They insisted that I be associated with the new venture. If the spirit of the gallery 291, they said, were kept alive, then the living artists in whom they believed would gain increased financial help.

"De Zayas' Modern Gallery was duly announced in *291*. I went there at times to help him out. I permitted him to show three of my prints. I cooperated in every possible way. But then, after a while, I

found it impossible to feel directly involved and decided to withdraw completely. I had no choice but to continue with 291 on the same basis as I had in the past."

Stieglitz had become fully aware of the paradoxical behavior of colleagues who proclaimed that the excitement of 291 had diminished, yet wanted to capitalize upon his work; who could not proceed without his collaboration, support or prestige, yet often operated in a spirit contrary to his own.

De Zayas' Gallery, although it presented some excellent exhibitions, was relatively short-lived.

In 1916 Stieglitz planned to have an exhibition of pictorial material created by the psychically disturbed, and to publish writing about it in *Camera Work*. His interest in the unconscious already had been demonstrated in the quarterly and in the magazine *291*.

At the beginning of 1916 he wrote to Mabel Dodge: "I spent an evening with Brill[6]. . . . I had hoped that he would have sufficient drawings, etc., to make an [exhibition]. But he had in mind an article for *Camera Work*, illustrated with a few things—very extraordinary . . . done by a certain patient of his, and other things done by children. The whole was to be published in *Camera Work*. I told him to go ahead and get his idea into form, and to give me the material. . . . I see a great possibility of bringing out an interesting number devoted to the question that you . . . Brill, myself, as well as some others seem to be especially interested in just at present."[7]

To Stieglitz's disappointment, the issue of *Camera Work* did not materialize. Those who were to contribute articles failed to do so.

Stieglitz wrote in 1916: "I have done . . . some photography recently intensely direct. . . . A whole series. . . . All interrelated. . . . All platinum prints. Not a trace of hand work on either negative or prints. No diffused focus. Just the straight goods. On some things the lens stopped down to 128. But everything simplified in spite of endless detail. . . . The first time in years I have really had much time for my own work."[8]

The appearance of Georgia O'Keeffe's pictures and then of Miss O'Keeffe herself radically changed the course of both Stieglitz's life and hers.

"One afternoon in November, 1915, I was standing in the semi-dark room, back of 291. In walked a young Columbia student, Anita Pollitzer. I had noticed her four years before; how she had planted herself in front of the Picassos—radiant, a hundred per cent alive, intelligent, unafraid of her own emotions. Now she said, 'I had to come. I may be crazy. I have a package here, a roll of drawings I

received a few hours ago with the request to show them to no one. But I had to bring them here for you to see.'

"Feeling more dead than alive, I took the drawings—charcoals, each about eighteen by twenty-four inches—from their mailing tube. On the tube there was a six cent stamp. Examining the first drawing, I realized I had never seen anything like it before. All my tiredness vanished. I studied the second and the third, exclaiming, 'Finally a woman on paper. A woman gives herself. The miracle has happened.' I looked at a few more of the charcoals, becoming even surer of what I saw.

"I turned to Miss Pollitzer. 'You will leave these pictures with me.' 'No,' she said, 'I cannot do that. I really had no right to show them to you at all.'

"'They belong here. I shall keep them and, having scrutinized them at least three times every day for a period of four or five months, if I feel the same way I do now, I will show them.'

63. Paintings, O'Keeffe, 291 Exhibition, A.S., 1916-17

"She left the drawings. I asked no questions. I had no idea who the artist was. Day in, day out, I pored over the pictures. I became more and more convinced they should be given to the world.

"They created a sensation, when exhibited on the walls of 291 in 1916. There were two distinct camps—one deeply moved, as though before a revelation; the other, consisting of many professional artists, horrified at my showing such work after having presented Matisse and Picasso, Cézanne, Marin, Dove, Hartley.

"Then a girl appeared—thin, in a simple black dress with a little white collar. She had a sort of Mona Lisa smile. 'Who gave you permission to hang these drawings?' she inquired.

"'No one,' I replied. Still with a smile, she stated very positively, 'You will have to take them down.'

"'I think you are mistaken,' I answered. 'Well, I made the draw-

ings. I am Georgia O'Keeffe.' 'You have no more right to withhold these pictures,' I said, 'than to withdraw a child from the world, had you given birth to one.' She seemed rather surprised.

"I took her into the little gallery and asked where a particular charcoal—all of the drawings were abstract—had come from. She told me, 'I often get headaches and this is the picture I see.' That corroborated something I knew. I pointed to another. 'And what is the origin of this?' She began to talk, but after a few words she drew herself up straight and challengingly said, 'Do you think I am an idiot? I refuse to say anything more.'

64. Blue Lines No. 10, O'Keeffe, 1915

"We had lunch together. I begged that when she finished her next batch of drawings or paintings she should please pack them up carefully and send them to me, express, collect. I would take care of them.

"She left. Occasionally we corresponded. Months later, at Lake George, I received a mailing tube with a six cent stamp on it. I recognized the handwriting. In the tube were watercolors—incredible things. I was aghast that anyone could be so careless as to send such wonders in a roll, with six cents postage.

"When Arthur Dove saw the O'Keeffe watercolors he said, 'Stieglitz, this girl is doing naturally what many of us fellows are trying to do, and failing.'

"This was the beginning of what people know as O'Keeffe."

Pictures by O'Keeffe were first shown at 291 from May to July in 1916, together with those of Charles Duncan and René Lafferty; in the autumn they were exhibited with work by Hartley, Marin, Walkowitz and S. Macdonald Wright. From April 3 to May 14, 1917, O'Keeffe had her first one-man show at 291.

William Murrell Fisher wrote about O'Keeffe's paintings and drawings in *Camera Work:* "Here are emotional forms quite beyond the reach of conscious design, beyond the grasp of reason—yet strongly appealing to that apparently unanalyzable sensitivity in us through which we feel the grandeur and sublimity of life. . . .

65. Photograph, Strand, 1916

"Quite sensibly, there is an inner law of harmony at work in the composition of these drawings and paintings by Miss O'Keeffe, and they are more truly inspired than any work I have seen; and although, as is frequently the case with 'given writings' and religious 'revelations,' most are but fragments of vision, incompleted movements, yet even the least satisfactory of them has the quality of completeness. . . . Of all things earthly, it is only in music that one finds any analogy to the emotional content of these drawings—to the gigantic, swirling rhythms, and the exquisite tendernesses so powerfully and sensitively rendered—and music is the condition towards which, according to Pater, all art constantly aspires. Well, plastic art, in the hands of Miss O'Keeffe, seems now to have approximated that."[9]

Stieglitz had hung his own photographs at 291 in 1913 as a foil to the Armory Show. In 1916, during the Forum Exhibition of Modern American Painters at the Anderson Galleries, he presented prints by a young American photographer who greatly interested him, Paul Strand. Stieglitz described in *Camera Work* Number 48 how there had been no photographs on view "in the interim, primarily because '291' knew of no work outside of Paul Strand's which was worthy."

In praising Strand as a "new worker," Stieglitz made it clear he was not referring simply to a "new picture-maker. New picture-

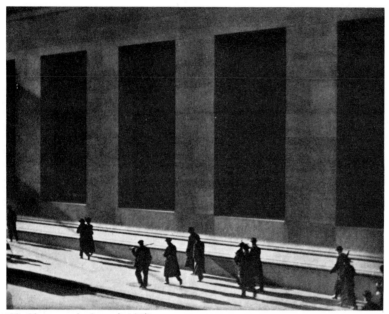

66. Photograph, Strand, 1917

makers happen every day, not only in photography, but also in painting. New picture-makers are notoriously nothing but imitators of the accepted; the best of them imitators of, possibly at one time, original workers. For ten years Strand quietly [has] studied, constantly experimenting, keeping in close touch with all that is related to life in its fullest aspect; intimately related to the spirit of '291.' His work is rooted in the best traditions of photography. . . . His work is pure. It is direct. It does not rely upon tricks. . . . In the history of photography there are but few photographers who, from the point of view of expression, have . . . done work of any importance. . . . By importance we mean work that has some relatively lasting quality, that element which gives all art its real significance."[10]

Strand's prints, to which two issues of *Camera Work* were promptly devoted, brought new life to 291 for Stieglitz, as did O'Keeffe's paintings. The work of both artists gave him fresh hope that further exhibitions of significance could be held and additional numbers of *Camera Work* printed.

In 1916 De Zayas wrote to Stieglitz that photographs of paintings by Gino Severini, the Italian Futurist, had been brought to him at

the Modern Gallery. Since he had no interest in showing Severini — in mixing Futurism with the work he was exhibiting — he suggested that Stieglitz might wish to present the paintings, as yet unknown in New York. Stieglitz, already familiar with Severini's canvases through photographs and with his writing, was quite willing to do so. As usual, there would be no charge for the space at 291 and no commissions on sales. De Zayas, pleased by Stieglitz's decision, wrote that because "Futuristic tendencies" would now be seen by the people of New York, the public no longer would "take every manifestation of modern art as Futurism."[11]

The exhibition was held in March, 1917. After the United States entered the war, Stieglitz wrote to Severini on May 6, 1917, expressing his despair that he had been waiting, waiting, "for the moneys due you on your pictures. I have been urging the purchasers to let me have them so that I could forward them to you, telling them of your needs. But things over here are in a very unsettled condition. The War has disturbed the American equilibrium tremendously. And the American optimism, for which it always has been so famous, has also received a rude shock. . . . The pictures looked very well in the little rooms. And I am sure you would have enjoyed how they were presented. From every point of view the exhibition was a success." And then with his usual generosity: "Not wanting to let you wait any longer . . . I am herewith enclosing a draft for 2280 francs. The balance will follow as soon as I get the money."[12]

67. Charcoal, Severini, 1913

In 1917, 291 exhibited the "Synchromism" of S. Macdonald Wright. Wright's intent was to "create an art which stands half way between music and architecture."[13]

Wright later wrote: "To give . . . an idea of [Stieglitz's] character. . . . In 1917 . . . [he] asked me to exhibit. I was not only delighted to be one of his 'young ones,' but I hoped that a . . . New York show would prove financially beneficial — and did we need money in those days! Stieglitz asked me my prices and I told him that things being as they were, I'd sell the whole show for $500! He told me he'd get it for me. He did. He sold several things, how many I forget, and when the thing was over, we had a chat during which he gave me a check far beyond what I had asked. I insisted that all the works left were his — I'd made a bargain and he had bettered it, and I was fully satisfied. He refused. He told me that such an arrangement was highway robbery and that he wasn't a highway robber. I took my works home, knowing that Stieglitz had never asked even a minimal commission. . . . Afterwards Stieglitz bought several works — some of which he sold at a large profit — not profit to him but to me, for the check he received he endorsed and sent me, asking that I give him another canvas. Today he owns probably eight or a dozen of my works of that day, every one of which he has

68. Synchromy, Wright, 1917

bought, in spite of the fact that I have offered him one or all the paintings I have done, without cost."[14]

Camera Work announced in 1917, in all good faith, that it would introduce its "readers to examples of Georgia O'Keeffe's work."[15] It stated that three further exhibits would be held at 291: One of Strand's photographs; another of portraits and a series of photographs taken out of the back window of 291 (covering ten years of work) by Stieglitz; a third, one of recent oil paintings by Alfred Maurer. It became impossible, however, either to present the shows listed or to continue with *Camera Work*.[16] The war, financial and other difficulties—uncertainty about the future—the entire situation finally took its toll.

Stieglitz later wrote: "I am supposed to have a huge following and many friends. You'd be amused if you knew the facts. I printed 1000 each of 50 issues of *Camera Work*.—To begin with, before a number was seen by anyone, on my name only I received 647 subscriptions!—The magazine became a classic, and when No. 50 appeared I still printed 1000 copies although only 37 subscribers were on my books! A wonderful record.—And a significant bit of American History.—My sense of humor was my dividend."[17]

291's last exhibit was devoted to new work by O'Keeffe—watercolors, drawings in charcoal, oils and a piece of statuary. "The Galleries began clean," said Stieglitz, "and they ended clean." 291 closed in June, 1917.

After *Camera Work* and 291 no longer existed, Stieglitz paid ten dollars a month to the building's agent, so that he might be permitted to come there whenever he wished and have a mailing address for the period of a year.

The rooms in which Stieglitz huddled against the cold became a kind of no-man's-land. No art was formally on view, yet people continued to find their way to him, to seek him out; to show him their work and talk with him as they had in the past. "It was the winter of 1917-18. A winter of coal famine, the coldest New York had experienced in years. For weeks the thermometer was below freezing, for days below zero.

"I sat in the desolate, empty, filthy, rat-holed, ill-smelling little space that originally was part of 291. Or I walked up and down in my overcoat, my cape over the coat, hat on, and still I would be freezing. There wasn't a trace of heat even though there were two radiator openings in the walls.

"I had nowhere else to go—no working-place, no club, no money. I felt somewhat as Napoleon must have on his retreat from Moscow. But it turned out that 291 had a great friend—S. B. Lawrence, the interior decorator—whose quarters, in which there was a coal stove, were next to mine. Lawrence said to me one day, 'Mr. Stieglitz, if you and your friends wish to get warmed up a bit, just come over to

me if I am not busy.'

"The invitation led to an over-running of this kind man. He never complained. He rather liked the odd-looking people who turned up—artists and their friends being apt to look rather odd to others.

"The world seemed sad and gray. There was not only the war but also labor unrest. The heydays of 291 were over. Yet I stuck to my post."

Earlier Stieglitz had written to Gertrude Stein: "Times are terrifically hard over here. . . . Then too, one must remember that there is no real feeling for art, or love for art, in the United States as yet. It is still considered a great luxury: something which is really not necessary. And all this in spite of the so-called interest in old masters and the millions spent for them by people like Altman and Morgan. Was not Altman the landlord of our little '291'? Did he not double the rent virtually on the day on which he bought the property and incidentally bought a new Rembrandt? Did he ever know that '291' was fighting tooth and nail, single handed, in this vast country of ours, for the very thing he thought he loved?"[18]

X. After 291

During the war years Stieglitz experienced sadness but also ecstasy. From their first meeting Stieglitz and O'Keeffe exhilarated, released and inspired one another. He began to photograph her during her visits to New York. In 1918 he asked her what she would rather do than anything else in the world. "Paint," she replied. Since she could not afford to give up her teaching, Stieglitz—although he had little money himself—offered her a year in which to realize her dream. She accepted.

"O'Keeffe," Stieglitz explained, "had no more idea that she would remain in New York than I did." Their relationship swiftly blossomed. They fell deeply in love.

Stieglitz made portraits of O'Keeffe like one possessed. He spoke of photographing again, just to satisfy something within himself: The work "is straight. No tricks of any kind. No humbug. No sentimentalism." He called his prints so sharp you could "see the pores in a face," yet they were abstract. He made a series of about one hundred pictures of "one person"—heads, ears, toes, hands, torsos; something he had "had in mind for very many years."

The prints, Stieglitz felt, were "clean-cut, heartfelt bits of universality in the shape of woman." His magnificent series of O'Keeffe, what he called a composite portrait, made photographic history.

In 1923 Stieglitz held a large one-man exhibition of O'Keeffe's work at the Anderson Galleries. It aroused warm public response. O'Keeffe wrote for the show's catalogue: "I grew up pretty much as

everybody else grows up and one day seven years ago found myself saying to myself—I can't live where I want to—I can't go where I want to—I can't do what I want to—I can't even say what I want to—. School and things that painters have taught me even keep me from painting as I want to. I decided I was a very stupid fool not to at least paint as I wanted to and say what I wanted to when I painted as that seemed to be the only thing I could do that didn't concern anybody but myself—that was nobody's business but my own.—So these paintings and drawings happened and many others that are not here.—I found that I could say things with color and shapes that I couldn't say in any other way—things that I had no words for. Some of the wise men say it is not painting, some of them say it is. Art or not Art—they disagree. Some of them do not care. Some of the first drawings done to please myself I sent to a girl friend requesting her not to show them to anyone. She took them to 291 and showed them to Alfred Stieglitz and he insisted on showing them to others. He is responsible for the present exhibition.

"I say that I do not want to have this exhibition because, among other reasons, there are so many exhibitions that it seems ridiculous for me to add to the mess, but I guess I'm lying. I probably do want to see my things hang on a wall as other things hang so as to be able to place them in my mind in relation to other things I have seen done. And I presume, if I must be honest, that I am also interested in what anybody else has to say about them and also in what they don't say because that means something to me too."

Stieglitz's marriage to Emmeline came to an end in the early twenties. He and O'Keeffe were married in 1924.

Georgia O'Keeffe stated in 1922: "To me Stieglitz portraits repeat in a more recognizable form what he expresses with the photographs of trees, streets, room interiors, horses, houses, buildings, etcetera. Devoid of all mannerism and of all formula they express his vision, his feeling for the world, for life. They are aesthetically, spiritually significant in that I can return to them, day after day. . . .

"If a Stieglitz photograph of a well to do Mid-Victorian parlor filled with all sorts of horrible atrocities jumbled together makes me forget that it is a photograph, and creates a music that is more than music when viewed right side up or upside down or sideways, it is Art to me. Possibly I feel it is Art because I am not clogged with too much knowledge. Or is it Stieglitz?"[1]

In 1919 S. Macdonald Wright asked Stieglitz to send him some notes on "Woman in Art." Stieglitz replied on October 9, 1919, from Lake George: "As for the Advent of Woman in the Field of Art—as a new factor I might say: Man, the male, had thus far been the sole creator of ART. *His* art—as until most recently he looked upon Woman as *His*. There is a new order in the course of development—if it is not already right with us—for those who see.

"Woman *feels* the World *differently* than Man feels it. And one of the chief generating forces crystallizing into art is undoubtedly elemental feeling—Woman's & Man's are differentiated through the difference in their sex make-up. They are *One* together—potentially One always. The Woman receives the World through her Womb. That is the seat of her deepest feeling. Mind comes second. . . .

"When Woman desired to paint—or model—she went to Man to be taught. He taught her the metier (art can't be taught)—usually very badly. He imagined too that he was teaching her what Art is—or what it should be. He led her through the Gallery of Masters—his Masters—of all Ages. She listened. She attempted to become what her teacher was to her. She was attempting the impossible not really realizing that she never could do what he did—and he really telling himself that no woman could ever produce a painting or bit of sculpture that was Art. Her creative sphere was childbearing With him his role in the production of that product was merely incidental. With her the child was the Universe—the All.

"His theory may have been right in the past—may still be partially correct—I have never agreed to it. The Social Order is changing. Woman is still Woman—but not so entirely *His* Woman. The potential child brings about its equivalent in other forms. It may be in Color & Line—Form—Painting. A need. Woman finding an outlet—*Herself. Her* Vision of the World—intimately related to Man's—nearly identical—yet different. Art is not Science—although there is Science in Art.

"In the past a few women may have attempted to express themselves in painting. Remember when I say themselves I mean in a universal, impersonal sense. But somehow all the attempts I had seen, until O'Keeffe, were weak because the elemental force & vision back of them were never overpowering enough to throw off the Male Shackles. Woman was afraid. She had *her* secret. Man's Sphinx!!

"In O'Keeffe's work we have the Woman unafraid—the child—finally actually producing Art! . . . She has the sense of Color in the modern acceptance of the word Color—it is part of her very *self*—as music is part of the Composer. Her feeling for Nature is tremendous—equally so for life. It is all very fine—& always creative—quite as creative as any man's I've met. She gets her shapes and lines from Nature—& her color too for that matter. Her experiences gradually take form in her mind—& then she puts this down on canvas or paper. And we have pictures or whatever you wish to call them which are different from anything we have ever seen. They make us *feel* a bigness—something that Art always does—a religious intensity—and satisfy our aesthetic sense. You know to what test I put her drawings & paintings last year—the one simple black & white one was unanimously ranked as *Art* by those we concede know—if

any one does know. And several of the color things were virtually universally accepted too. In short if these Woman produced things which are distinctively feminine can live side by side with male produced Art—hold their own—we will find that the underlying aesthetic laws governing the one govern the other—the original generating feeling merely being different. Of course Mind plays a great role in the development of Art. Woman is beginning—the interesting thing is *she has actually begun*."

People continued to gravitate toward Stieglitz, first at the vacant little rooms on Fifth Avenue, next in 1918 at the studio in which he and O'Keeffe lived and worked, then at his brother's house on East 65th Street and at the Stieglitz family home at Lake George during summers. Herbert J. Seligmann has described the days following the termination of 291 and the way in which Stieglitz's talk was "directed in various planes of exposition to two or ten or twenty people, draped on the couch, occupying what chairs there were, sitting in ranks on the floor. People came, departed, stayed till the early morning hours. . . .

"For some reason those who wrote, painted, photographed, and many who did none of these things, felt impelled to bring their works, or if not their works then their human problems. . . . Perhaps it was because they felt he was the only person in America, if not in the world, who would receive them in a disinterested—a photographic—spirit, for very nearly . . . what they actually were. . . .

"When he went to supper, as for a time he did regularly at the Chinese restaurant on Columbus Circle, there would be from two to a dozen people accompanying him. There had been ruptures of friendship, people had gone out of his life never to return. Some did turn up out of the past.

"A nucleus of workers was again building."[2]

When Van Wyck Brooks' *America's Coming of Age* appeared during 1915, the slender volume formulated a number of beliefs paralleling those of Stieglitz about the problems and challenges facing the artist in America.

Both men protested against unthinking adherence to outmoded ways of thought, against the pedantic and the puritanical; against the abandoning of artistic conscience in order to reach a wide public for mere financial gain. Each spoke with passion about what Brooks termed the need to stir the "vast Sargasso Sea" that was America, "a prodigious welter of unconscious life, swept by ground-swells of half-conscious emotion." America, Brooks proclaimed, contained "an unchecked, uncharted, unorganized vitality like that of the first chaos. . . . a welter of life which has not been worked into an organism, into which fruitful values and standards of humane economy have not been introduced." Thus the country remained "innocent of

those laws of social gravitation which, rightly understood and pursued with a keen faith, produce a fine temper in the human animal."[3]

Neither man cared about innovation for its own sake. Neither was a chauvinist, or blind to America's creative figures of the past. Both knew that European culture had been of enormous importance for the new world, but now young Americans must find their own way in all the arts. They must develop their own disciplines, speak with a sense of reality and deepest inner meaning, in their own voices.

The short-lived but important journal, *The Seven Arts*, with which Brooks became associated, was established in New York in 1916. Those who founded it and many of its contributors began to feel increasingly close to Stieglitz. Waldo Frank, one of the publication's first editors, wrote to him at once to enlist his interest. Stieglitz gave the new venture every encouragement and tried to make certain it would be as widely distributed as possible.

Paul Rosenfeld, writing in the first issue under the pseudonym of Peter Minuit, commented upon Stieglitz's work at 291 in glowing terms. Other *Seven Arts* authors with whom Stieglitz had a special affinity, at one time or another, were Leo Stein, D. H. Lawrence, Randolph Bourne, Marsden Hartley, Sherwood Anderson, Willard Huntington Wright, Theodore Dreiser.

In 1917 *The Seven Arts* was forced to cease publication, its attitude being so antiwar that the subsidy it had managed to acquire was withdrawn. This left its founders and certain of its writers largely without an organ through which they could speak freely. They became homeless, much in the same manner as was Stieglitz, their joint dilemma drawing them even closer together.

Sherwood Anderson wrote of the literary situation in America in January, 1919, that even *The Little Review* had become "too dreadfully inartistic and bad. I can't stand appearing there any more, and there is no place else to appear. There never has been a time in America when the literary artist was so completely stranded high and dry. Politically-minded men have outlets of a kind. For example, I think the *New Republic* covers its field very well indeed, and there is in addition the *Dial* and the *Nation*, both very good things. With the death of *Seven Arts*, however, the door was closed to anything like subtlety in writing in the country. . . . The big story here is the story of repression, of the strange and almost universal insanity of society. The story does not need to be an unpleasant one to right-minded men and women, but it must be boldly and subtly told and make its audience slowly. That means an endowed magazine devoted solely to good writing, and who is to put up the money for it? . . . Who knows to what depths modern prose writing has sunk, and who gives a damn? The outlook is . . . discouraging."[4]

Stieglitz sent word to Herbert Seligmann in similar vein, that he regretted not being able to publish *Camera Work* in such a period.

"There is really no *free* & *fearless* publication," he added, "of any kind today in this country. — Perhaps we'll have to issue an Occasional Leaflet after all."[5]

Stieglitz persuaded certain of the young writers who gathered around him after *Camera Work* and *291* no longer existed to take the initiative and print their own work without payment, subsidy or dependence upon the approbation of others. He wanted them, under all circumstances, to be true to their belief in whatever they wrote; to their faith in what they wanted to say. The result of his challenge and encouragement was a little magazine, *MSS.*

Those responsible for printing *MSS* wanted also to assist others producing literature, music, painting, in vital, experimental forms. A new school of criticism—one of generous acclaim and sympathetic defense of adventurous, not yet accepted talent—was developing with ever greater assurance. *MSS*—simple and unpretentious as it was—contained sensitive writing by such authors as Anderson, Frank, Rosenfeld, William Carlos Williams, Seligmann, Kenneth Burke, among others. In its pages the avant-garde music of Edgar Varèse and Arnold Schoenberg was greeted with enthusiasm. One of the most important numbers, "Can a Photograph Have the Significance of Art?", contained statements by a number of leading figures in various disciplines.

69. Cover, *MSS*, Number 4, 1922[6]

Leo Stein wrote to Stieglitz from Italy, December 4, 1922: "If truth were told I should rather see your photographs than any paintings I know of. . . . Your kind of photography seems to me essentially nearer the best of painting, the Giorgiones the Rubens the Renoirs—not of course in aspect but in spirit—than any contemporary painting that I know."[7]

Sherwood Anderson paid homage to Stieglitz. In 1924 he "gratefully dedicated" his *A Story Teller's Story* "To Alfred Stieglitz, who has been more than father to so many puzzled, wistful children of the arts in this big, noisy, growing and groping America."[8]

70. Paul Rosenfeld, A.S., 1922

After 1918 Stieglitz went regularly to Lake George during the summer months. His letters reflect exaltation about O'Keeffe, the lake, the surrounding countryside; about his photographing with renewed intensity.

He had a sense of awe before the beauty to be found everywhere: the "white, white, white—soft and clean," the everchanging colors, forms, moods. Each day he discovered something new at the root of the simple things around him—the unbelievable dignity of barns, trees, ground, of hills and sky.

The little building in which he developed and printed was primitive in the extreme. His wooden darkroom was often cold. It leaked. He had to plunge his hands into icy, "gritty" water. Plates became

fogged, emulsions were bad. The electric light was turned off without warning. Films "raised the devil." Paper was poor—its quality steadily deteriorated, it was never twice the same. Ninety-nine times out of a hundred, to achieve a "real print" became an unspeakable ordeal.

One of the many writers who visited Stieglitz at Lake George in the 1920s was Jean Toomer, author of *Cane*. He wrote of the experience: "Quite early [Stieglitz] must have found the places on this earth which belonged to him; and he must have recognized that he belonged to them. Or, for all I know, he may have felt he was an essential stranger on this planet; hence, that all regions were, on the one hand, equally alien, and, on the other, equally meaningful as locales where one could see the cosmos in epitome. . . .

"He will sometimes tell you that he feels uprooted. From one point of view this is true. He has not had a fixed establishment. . . . Yet I do not feel he is suspended or unplaced. Always I feel he is rooted *in himself* and to the *spirit* of the place. Not rooted to things; rooted to spirit. Not rooted to earth; rooted to air. . . . Wherever he is, *he is*. I cannot picture him elsewhere. I cannot envisage him going anywhere. . . .

"If he is at The Hill at Lake George, I do not have the feeling that he has come from New York or that he may be going there. No, here he is, capable of sustaining and fulfilling himself with what is present. Now and again he may walk to the village, but even this short going seems foreign to him, and he usually does it with an air which makes one feel he is walking with an illusion of Stieglitz in a black cloak.

"He lives in his house, the house with uncurtained windows, bare gray-white walls, deep chairs, tables, uncovered blue-white lights, and in this house he creates an atmosphere. A delicacy, a sensuousness, an austerity.

"No ornaments anywhere, nothing that isn't used. No 'oughts' or 'ought nots'. . . . Just life. . . .

71. Leo Stein, A.S., 1917

"I wondered when he would begin photographing. . . . how he would be when working. In due time he began. A natural happening. His working tempo was but a quickening (though what a quickening!) of his usual tempo. . . . Work and life were the same thing, and life and art. No casual observer would have thought that anything 'great' was going on. His camera was in evidence. Out he would go with it. In he would come. And soon the large table in the front room was filled with his materials and prints. It was that simple—and that real.

"Only it wasn't simple at all. The search for truth and reality is a complex search, the attempt to extend consciousness is a difficult attempt, the effort to determine and demonstrate by experiments the possibilities of a comparatively new instrument and medium is intricate and it must be sustained—and all of these he was doing

with and through the camera while I looked on at the apparent simplicity of it.

"Though at various times to various people he has told, so to speak, the partial history of this or that photograph, the full genesis of his pictures is unknown, and perhaps it is just as well. Like himself, his photographs are explicit in themselves, direct communicants with one's feelings. A genius of what is—this is Stieglitz, and this is why he uses a camera."[9]

By 1921, Stieglitz had made many photographs not yet publicly shown. Mitchell Kennerley, who headed the Anderson Galleries, the famous auction house, and who had watched Stieglitz's development for years, suggested to him that he place on exhibit his entire photographic evolution. As a result two huge rooms at the Galleries were soon filled with a large Stieglitz retrospective. It created a sensation: "People came again and again. At times, hundreds crowded into the rooms. All seemed deeply moved. There was the silence of a church."

From Stieglitz's Catalogue for his 1921 show: "The Exhibition is photographic throughout. My teachers have been life—work—continuous experiment. Incidentally a great deal of hard thinking. Any one can build on this experience with means available to all.

"Many of my prints exist in one example only. Negatives of the early work have nearly all been lost or destroyed. There are but few of my early prints still in existence. Every print I make, even from one negative, is a new experience, a new problem. For, unless I am able to vary—add—I am not interested. There is no mechanicalization, but always photography.

"My ideal is to achieve the ability to produce numberless prints from each negative, prints all significantly alive, yet indistinguishably alike, and to be able to circulate them at a price not higher than that of a popular magazine, or even a daily paper. To gain that ability there has been no choice but to follow the road I have chosen.

"I was born in Hoboken. I am an American. Photography is my passion. The search for Truth my obsession.
"PLEASE NOTE: In the above STATEMENT the following, fast becoming 'obsolete', terms do not appear: ART, SCIENCE, BEAUTY, RELIGION, every ISM, ABSTRACTION, FORM, PLASTICITY, OBJECTIVITY, SUBJECTIVITY, OLD MASTERS, MODERN ART, PSYCHOANALYSIS, AESTHETICS, PICTORIAL PHOTOGRAPHY, DEMOCRACY, CEZANNE, '291', PROHIBITION. The term TRUTH did creep in but may be kicked out by any one."

72. Dorothy True, A.S., 1919

In 1919 Stieglitz made a double-exposure portrait of a young woman named Dorothy True—a print widely imitated. The superimposing of images was accidental, Stieglitz thinking he had taken two separate photographs, one of Miss True's head, another of one of her

142

legs. He was delighted by his error, which demonstrated to him how the combination of high-heeled shoe, exposed calf and short skirt could reveal character, quite as much as did the expression of a face.

Stieglitz made his photograph of Miss True after World War I, when suffrage was about to be granted to women in the United States and short skirts were first worn. He hoped the print might serve as a commentary on the era. He had no plan to make a sensational picture, but once he saw what had occurred, his sole preoccupation, as always, was to "use the moment with all of myself."

XI. The Equivalents

The year 1922 marked the beginning of a new and important phase in Stieglitz's photographic career. He wrote at the time from Lake George of how "one of America's young literary lights believed the secret power in my photography was due to the power of hypnotism I had over my sitters, etc.

"I was amazed when I read the statement. I wondered what he had to say about the street scenes—the trees, interiors—and other subjects, the photographs of which he had admired so much: or whether he felt they too were due to my powers of hypnotism. . . . What . . . had [been] said annoyed me. . . . I was in the midst of my summer's photographing, trying to add to my knowledge, to the work I had done. Always evolving—always going more and more deeply into life—into photography. . . .

"Thirty-five or more years ago I spent a few days in Murren (Switzerland), and I was experimenting with ortho plates. Clouds and their relationship to the rest of the world, and clouds for themselves, interested me, and clouds which were most difficult to photograph—nearly impossible. Ever since then clouds have been in my mind most powerfully at times, and I always knew I'd follow up the experiment made over thirty-five years ago. I always watched clouds. Studied them. Had unusual opportunities up here on this hillside. . . . I wanted to photograph clouds to find out what I had learned in forty years about photography. Through clouds to put down my philosophy of life—to show that my photographs were not due to subject matter—not to special trees, or faces, or interiors, to special privileges, clouds were there for everyone—no tax as yet on them—free.

"So I began to work with the clouds—and it was great excitement—daily for weeks. Every time I developed I was so wrought up, always believing I had nearly gotten what I was after—but had failed. A most tantalising sequence of days and weeks. I knew exactly what I was after. . . . I wanted a series of photographs which when seen by Ernest Bloch (the great composer) he would exclaim: Music! music! Man, why that is music! How did you ever do that? And he would point to violins, and flutes, and oboes, and brass, full

of enthusiasm, and would say he'd have to write a symphony called 'Clouds.' Not like Debussy's but *much, much more*.

"And when finally I had my series of ten photographs printed, and Bloch saw them—what I said I wanted to happen happened *verbatim*.

"Straight photographs, all gaslight paper, except one palladiotype. All in the power of every photographer of all time, and I satisfied I had learnt something during the forty years. . . .

"Now if the cloud series are due to my powers of hypnotism I plead 'Guilty'. . . . My photographs look like photographs—and in

73. From Lake Como, A.S., 1888

[the] eyes [of pictorial photographers] they therefore can't be art. . . . My aim is increasingly to make my photographs look so much like photographs that unless one has *eyes* and *sees*, they won't be seen—and still everyone will never forget them having once looked at them."[1]

After 1922 Stieglitz used the word *Equivalents* to describe his photographs of clouds, his *Songs of the Skies*, his *Songs of Trees*.

He said, "My cloud photographs are *equivalents* of my most profound life experience, my basic philosophy of life." In time he claimed that all of his prints were equivalents; finally that all art is an equivalent of the artist's most profound experience of life.

Stieglitz held two exhibitions of his prints at the Anderson Galleries in 1923 and 1924. The photographs, like those in the 1921 show, were vivid public reminders of his mastery.

Stieglitz wrote in the Catalogue for his 1923 Exhibition: "ART OR NOT ART THAT IS IMMATERIAL THERE IS PHOTOGRAPHY I CONTINUE ON MY WAY SEEKING MY OWN TRUTH EVER AFFIRMING TODAY"

Of his 1924 Exhibition: " 'Songs of the Sky—Secrets of the Skies as revealed by my Camera', are tiny photographs, direct revelations of a man's world in the sky—documents of eternal relationship—

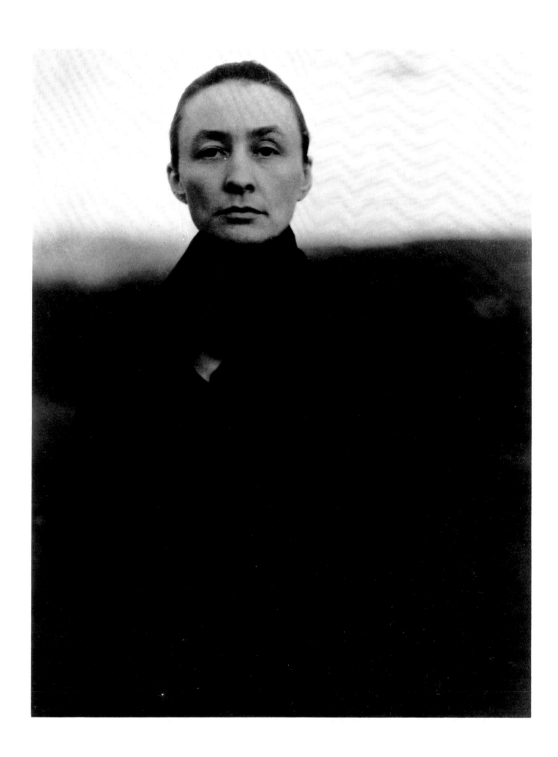

XXXII. Georgia O'Keeffe, 1920

XXXIII. Hands with Thimble, 1920

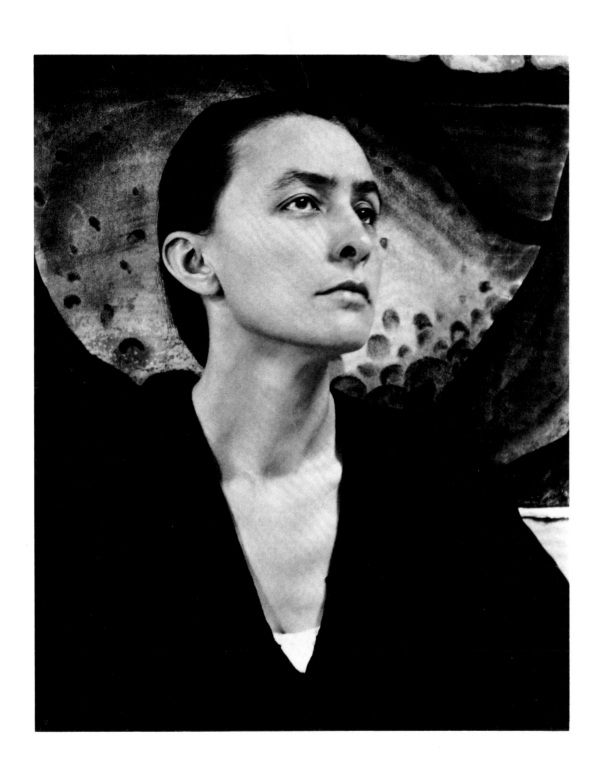

xxxiv. 1918

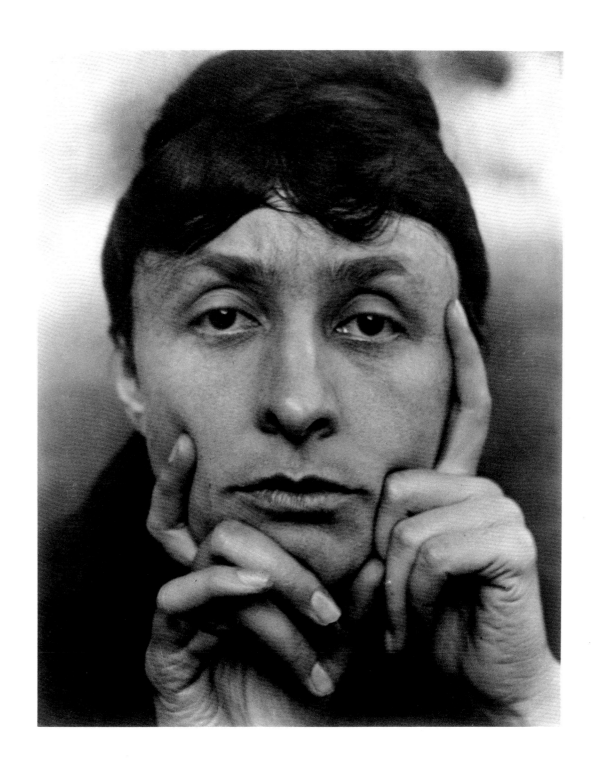

xxxv. 1918

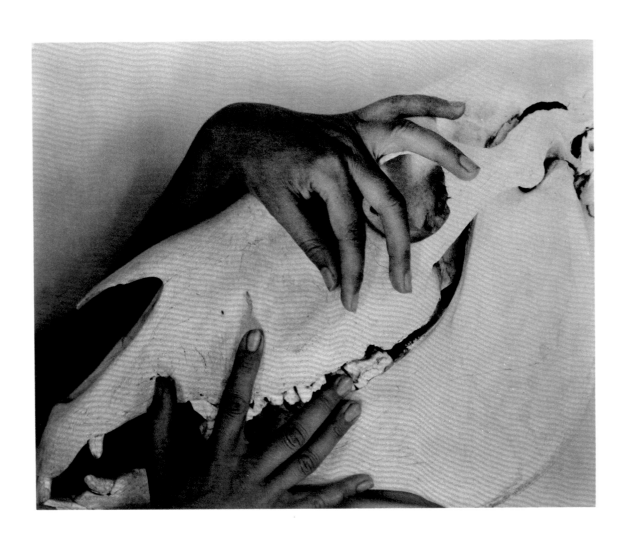

XXXVI. Hands with Skull, 1930

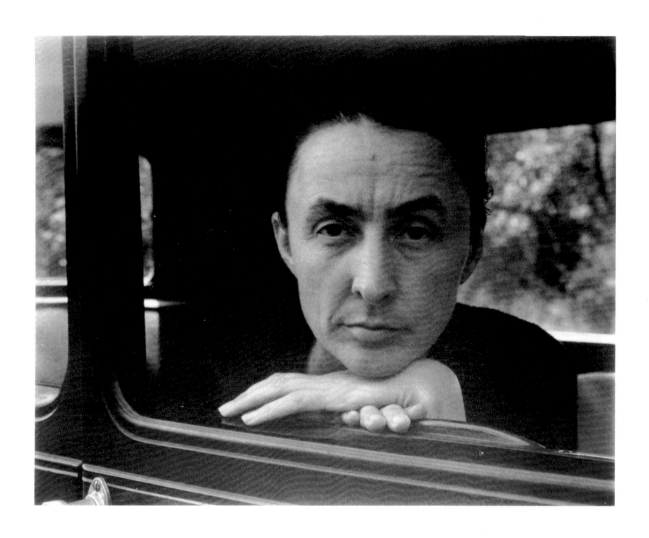

xxxvii. 1931

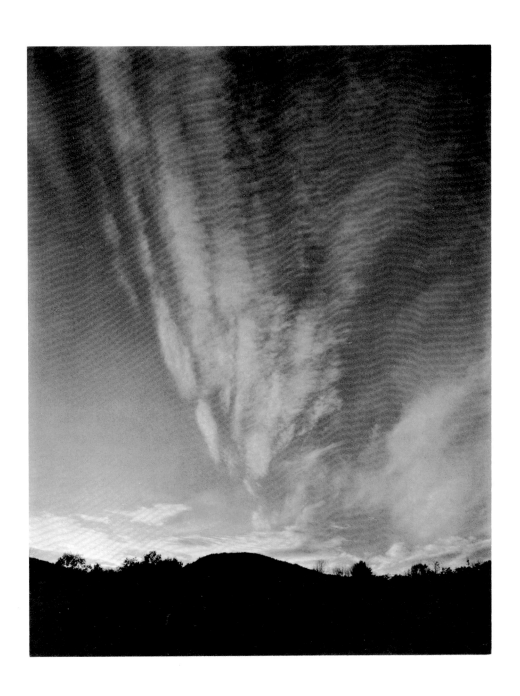

xxxviii. Equivalent, Mountains and Sky, Lake George, 1924

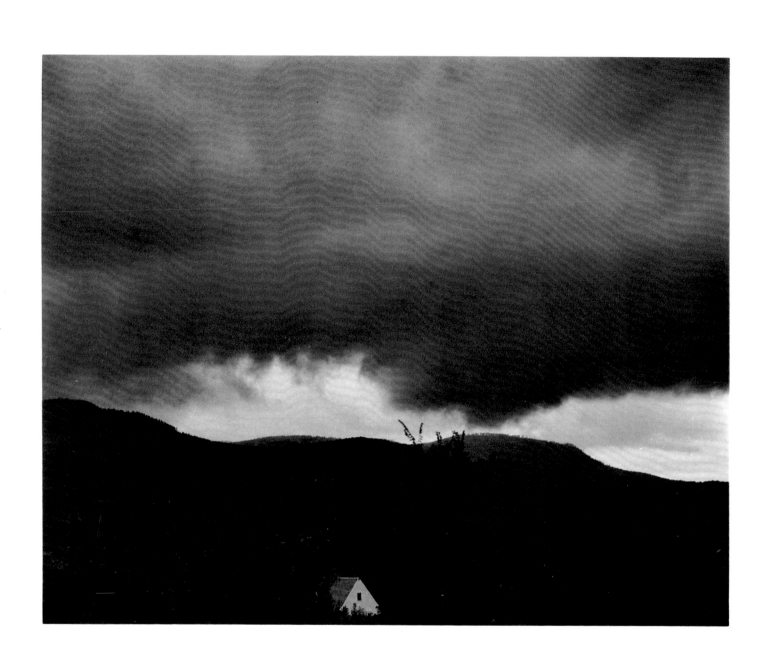

xxxix. Equivalent, Music No. 1, Lake George, 1922

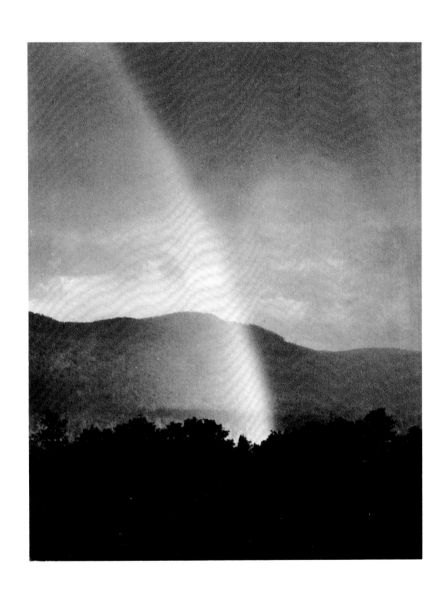

XL. Rainbow, Lake George, 1920

XLI. Equivalent, 1927–29(?)

XLII. Equivalent, 1931

XLIII. Equivalent, 1929

XLIV. Equivalent, 1936

XLV. Equivalent, 1926

XLVI. Equivalent, 1930

perhaps even a philosophy. 'My' camera means any camera—any camera into which his eye may look."

"I have found that the use of clouds in my photographs has made people less aware of clouds as clouds in the pictures than when I have portrayed trees or houses or wood or any other objects. In looking at my photographs of clouds, people seem freer to think about the relationships in the pictures than about the subject-matter for its own sake. What I have been trying to say through my photographs is communicated with greatest clarity in the series of *Songs of the Sky*. The true meaning of the *Equivalents* comes through without any extraneous pictorial factors intervening between those who look at the pictures and the pictures themselves."

Stieglitz said of his Equivalents: "My photographs are a picture of the chaos in the world, and of my relationship to that chaos. My prints show the world's constant upsetting of man's equilibrium, and his eternal battle to reestablish it."

"I simply function when I take a picture. I do not photograph with preconceived notions about life. I put down what I have to say when I must. That is my role, according to my own way of feeling it. Perhaps it is beyond feeling.

"What is of greatest importance is to hold a moment, to record something so completely that those who see it will relive an equivalent of what has been expressed.

"If I have done something and consider it well done, I am glad it exists; if it is not well done, I am sad. That is all that I feel. I can do nothing because another does it, nothing that fails to stem from a deep inner need. I clarify for myself alone.

"I want solely to make an image of what I have seen, not of what it means to me. It is only after I have created an equivalent of what has moved me that I can begin to think about its significance.

"Shapes, as such, do not interest me unless they happen to be an outer equivalent of something already taking form within me. To many, shapes matter in their own right. As I see it, this has nothing to do with photography, but with the merely literary or pictorial."

During 1923 Ananda K. Coomaraswamy[2] urged Stieglitz to make some of his prints available to the Boston Museum of Fine Arts. According to Stieglitz: "Coomaraswamy and John Lodge—both curators of Oriental art—were eager to have their ultraconservative trustees open the museum's doors to photography, by way of my prints. But, in usual fashion, the question of the museum's 'not having any money' was raised. Neither Coomaraswamy nor Lodge was primarily concerned with either American art or photography. Yet,

because of their initiative my prints were to hang in one of America's foremost museums next to black and white work by Goya, Dürer and others of that caliber. I would be able to see whether or not the photographs maintained their identity in such company. Since this idea interested me, I finally agreed to give some of my prints to the museum. I made a condition that they must be exhibited once every five years. I said my own mounts, each differing by the slightest variation with respect to color and size, must not be changed. Boston did not insist on frames, but I did. I wished to protect my prints; to have them presented in my way and no other."

When informed that the museum wanted 'to have standard sizes and mounts for his prints, Stieglitz told Coomaraswamy he could not agree. He felt he had worked out such a right way of making his prints and mounts one, that changing anything in their relative sizes would alter the spirit of what he had done and rob his work of its life and significance. "Photography," he wrote, "is still 'on trial.' "

Believing he had earned the privilege to have his prints in *his* sizes and without additional mats, Stieglitz noted, "Unless the prints are in the museum *right* they are worse than wrong. This work of mine is really something new. I know that, after 40 years of intensest work & thought & great sacrifice. It is the beginning of photography as expression & not merely photographs or pictures in the 'pictorial' sense."[3]

XII. The Intimate Gallery

From time to time Stieglitz attempted to have a few paintings by the Americans he exhibited handled by art dealers even while 291 still existed. Not only did he have recurrent premonitions that he might be unable to maintain the gallery, but friends insisted that the work he showed would bring far higher prices if sold by conventional business methods. Although Stieglitz disagreed, he decided to experiment, especially after 291 closed in 1917.

"Marin's exhibitions at 291 were popular and crowded from the beginning. I warned him when he decided to stay in America and do his work here, 'You will have a hard time, also a pretty lonely life. There are no cafés, no little Parisian girls. Everything is different in New York. While 291 exists you will be all right, but I have no idea how long it can last. Do not count on it or on great wealth.'

"Marin married. He lived modestly, using no more than twelve hundred dollars a year. He continued to paint and his pictures were wanted. He never inquired, 'Has anything sold?' He has questioned nothing in all the years of our relationship nor have I questioned him. We have completely trusted one another.

"When I first knew Marin in Paris, the only money he had was

what he earned from his etchings. Almost no one bought his water-colors and his few oil paintings.

"Charles Daniel opened a gallery after the Armory Show. He fell in love with Marin's work at 291. After some time I thought I would permit him to exhibit some of the paintings. Daniel wanted to take Marin over and to have me set prices. I suggested five or six hundred dollars a picture, promising Daniel he would receive twenty-five per cent commission. He replied, 'Do you think Americans are crazy?' 'Then don't show Marin,' I said.

"At 291 the collector Ferdinand Howald paid four hundred dollars for a Marin as did Agnes Meyer. John Quinn purchased three paintings for twelve hundred. Daniel said that was ridiculous. I retorted, 'Then we shall make each picture six hundred.'

"'You would think the sun rose and set on Marin,' Daniel sputtered. 'You want him,' I answered.

"One day Daniel announced that Howald wished to buy some Marins, including a painting I was eager to acquire myself. I proposed, 'Why not mark that one a thousand dollars?' Daniel and his assistant were horror-stricken. Their faces grew red. 'You will be paid twenty-five per cent commission,' I reminded them, 'and remember, I refuse to accept anything. Let Howald have another picture for six hundred.'

"Daniel informed me Howald was ready to spend three thousand dollars. When he came to the gallery, I was present. Howald gave without a word what Daniel asked for the watercolor we both had selected. He thought it a grand one. I remarked, 'You are lucky to pay so little for it. If I were in the art business, the price would have been three times as much. But Mr. Daniel is afraid—afraid of you.'"

"When I arranged an exhibit at the Montross Gallery, in 1921, showing the evolution of Marin's work, I found Mr. Montross as fearful as Daniel. He printed a list of over two hundred and fifty Marins. On it I marked prices from fifty to sixteen hundred dollars. The paintings hung in a large and a smaller room, even in space at the entrance to the gallery. What a magnificent show!

"Montross had said Marin's work ought to be presented in elaborate gold frames, that I should persuade friends to give them to him. Montross believed that the pictures could be sold only if they were hung in such frames on the red plush walls of his gallery.

"Montross examined the prices I listed. He blurted out, 'I have the greatest respect for you. But sixteen hundred dollars! No one will buy.' 'Then no one will buy,' I replied. 'I wish I could.'

"The following day Montross developed tonsilitis. Mr. Philip Goodwin, the architect and collector, appeared. He had acquired a Marin from me for twelve hundred dollars, the first painting by an American he had bought. At the time I asked, 'Do you think the cost too high?' 'I do not.' 'Nor do I. It is a record price, but if I had

money you would not get the picture at all.' Now, after looking around, Goodwin singled out an extraordinary sailboat. 'How much is that?' 'Don't faint,' I warned. 'Sixteen hundred dollars.' 'I will take it.' I turned to the salesman. 'Please call Mr. Montross and tell him. It may make him feel better.' The salesman smiled. 'It will be the best medicine he could have.' "

"Since I was not willing to waste the rest of my life fighting with Daniel and Montross, I took away the paintings I had left with them and decided to raise a Marin Fund. This was in the early '20s. For every hundred dollars a person might donate to the Fund, he was to receive an equivalent of two and a half times as much in Marins; in return for greater sums, a larger number. I succeeded in obtaining a guarantee of about fifteen to eighteen hundred dollars a year from Paul Strand and his father, from Paul Rosenfeld and others. If any individuals ever received their money's worth, they were the subscribers to that Fund. Marin was protected for three years."

"There is a myth current about Marin and his prices. Always, they say, an old man stands in the way. It is impossible to deal with him — the old man being myself. What is meant by deal I do not understand.

"In 1922, since I was living at my brother's house, people interested in seeing Marins came to me there. One day a banker appeared. He looked at a number of paintings and selected two handsome ones. I suggested a price for them that he agreed was fair both to Marin and himself. Then he stood staring at other pictures.

"At last he said, 'Stieglitz, why not be practical? Why not go into the art business? In that way you can protect Marin and, incidentally, yourself.'

"I had heard all this before, mostly from bankers or brokers, all quite as successful on Wall Street as the man before me. I told him I was not interested in entering the art business or any other; that it was not my nature to be practical in his sense, and as for Marin, he managed to live and paint.

" 'What would Marin like to do next?' the banker inquired.

" 'If somebody came along,' I replied, 'and gave him five thousand dollars a year for three years, he could take his wife and boy to the Southwest or Rockies to paint. If anyone took that chance, I would guarantee him first choice of Marin's work for each of the three years, Marin to have second choice, the contributor third, Marin fourth, until all the paintings were apportioned.'

"The banker then asked cautiously, 'How many pictures does Marin make in a year?' 'Sometimes forty or fifty, but no set number. He may paint more, or perhaps fewer.' The man pondered. 'I see no reason why I should not give him the amount you suggest each year for three years, in view of such a proposition.'

"After remaining quiet for a few moments, thinking over what he had just offered to do, he added, 'But if I should give Marin such a

sum, what guarantee would I have that he would do any painting at all? Artists are very peculiar human beings.' When I became aware of the banker's unbelievable suspicion, I said, 'Forget all about it. Marin will have to follow his natural course.'

"Eventually, on his own, Marin went with his family to Taos, New Mexico, for the summer. After five months, he returned to New York with sixty to seventy magnificent watercolors for some of which he received as much as three thousand dollars. My first thought was, 'How lucky for Marin the banker did not underwrite him;' my second: 'How impractical the banker!' "

"At the beginning of the twenties Hartley appeared on the scene in New York one evening and went with O'Keeffe and me to the Chinese restaurant at Columbus Circle. Hartley startled me by sticking his right palm under my nose — a penny in the palm.

"He said, 'This is all that stands between me and starvation. I know it isn't fair to you to do this, but I am desperate.'

"Hartley had gone to Europe in 1912. He lived in Paris and Berlin until the War brought him home. After his return he visited New Mexico, seeming always to have to travel, yet always being plagued by financial difficulties.

"O'Keeffe and I were having a very difficult financial problem ourselves. What was I to do? 'What have you in mind?' I asked. 'I would like twelve hundred dollars,' said Hartley. 'With it I'd go to Florence, write a book of hate, have a hundred copies printed handsomely and send them to a hundred Americans I know and know of. Then I'd commit suicide.'

" 'Hartley,' I answered, 'you have about two hundred or more paintings in the vault. Are you ready to give them up in exchange for twelve hundred dollars?' 'Yes.' 'Remember, when they are gone, you will have burnt all your bridges behind you. You won't have a single picture left.'

"The next morning I went to Daniel, who had bought some Hartleys in the hope of becoming his dealer. After relating the story of Hartley, I inquired, 'Would you be willing to give him twelve hundred dollars for two hundred of his paintings?' Daniel's chief patron was Howald, who had several Hartleys in his collection as well as quite a few Marins.

"Daniel's reply was that nobody wanted Hartleys. I was amazed. There was a handsome Hartley flower piece hanging on the small wall of the gallery. Daniel had paid sixty dollars for it. 'How much are you asking for that picture, Daniel?' 'Four hundred,' he said naïvely. 'And you can't risk paying twelve hundred, as a dealer, for two hundred paintings? I do not understand.'

"I left. Around the corner was Montross. He and Macbeth were then the two deans of art dealers for American artists. Montross had

been a regular visitor at 291. He was interested in Hartley. I described the situation, saying nothing about Daniel. Montross nodded his head: 'Yes, I believe in Hartley but nobody wants his paintings.'

"There was a large New Mexican landscape by Hartley before me. Montross was asking twelve hundred for it, yet he said he did not see how he could raise the same sum to buy two hundred Hartleys.

"I went straight to Mitchell Kennerley, head of the Anderson Galleries. I told him what had occurred. 'Why not have a Hartley auction?' I suggested.

"'A few minutes ago,' Kennerley replied, 'Jimmie Rosenberg was here and said he would like to have one.' Rosenberg was a wealthy lawyer who painted and wrote for pleasure.

"Kennerley continued, 'If there could be an auction of work by the two men in one evening, it would be a go with me. But I don't see how to handle so many paintings by Hartley in so short a time.'

"'We'll manage,' I assured him. 'It'll be a great event. Here is James Rosenberg, ready to turn his paintings into money so they can go out into the world. And here is Hartley wanting almost nothing for his life work so as to prepare himself to commit suicide.'

"Kennerley hesitated. When I told him I would write a foreword for the Hartley section, and O'Keeffe and I would hang his pictures, Kennerley agreed. He was ever the sport, the real article. I explained the plan to Hartley. He said, 'I don't want to see my paintings. I won't attend the sale.'

"With the help of men at the Galleries, we plastered the walls with one hundred and seventeen Hartleys. There were pictures right up to the ceiling. It was an exhilarating room. People came in droves—collectors, art critics and artists amongst them. Even the artists—and others—who had denied Hartley before now seemed to feel he was a versatile and fine painter.

"The auctioneer, Mr. Chapman, said, 'Mr. Stieglitz, we'll not get through before one or two o'clock in the morning.' I disagreed. 'We'll be out of here by eleven.'

"When Kennerley asked me would any pictures be sold, I smiled: 'There's a great surprise in store for you.'

"The men of the Galleries, a wonderful lot of human beings, were all keyed up, as on the day of a race. The room was packed. Standees were rows deep in the hall. Everybody seemed to be present.

"I had placed a few of my friends close to me and instructed them to do some bidding. I marked catalogues for them. After the auction began at eight o'clock, the Rosenbergs went quickly. Then the first Hartley was put up for sale.

"At five minutes before eleven all the Hartleys had been sold.

166 Hartley was present. He sat there and clapped at tense moments,

particularly when one of his paintings went for a good price.

"Daniel represented Mr. Howald, his chief customer. 'Poor' people who had been wanting Hartleys for years acquired them for ten and fifteen dollars. To keep things moving, I bid myself. Dr. Albert Barnes, who was in the company of William Glackens, got some handsome Hartleys for about one hundred and fifteen dollars.

"When all was over, the paintings had brought in the sizable amount for the period of five thousand dollars.[1] The entire sum went to Hartley, Kennerley refusing to take any commission. Even complete strangers stood around shaking hands. 'How did you do it?' Chapman said, 'I can't believe it.'

"Both Daniel and Montross were greatly impressed. As we came out to the street we could hear voices expressing disbelief that such an auction could occur in America.

"Henry McBride, the critic, was all aglow. Hartley, aquiver, came to me: 'I wish my mother were alive so that she could know this.' The artists, like everybody else, seemed happy. There was no jealousy or envy that night.

"Why was I so cocksure when the auction began? I'll tell you the secret. I had bids amounting to over three thousand dollars in my pocket from at least thirty people who couldn't come that evening. They sent me checks to buy paintings. One man gave me three hundred dollars to buy a particular picture, another the same amount for several he had pointed out.

"Some of us thought this might be a beginning for the American artist—for the unsupported ones of real talent, possibly genius. Whether the evening bore fruit or not, I cannot prove, but it was unique in the annals of American art history.

"Hartley returned to Europe. He did not write his book of hate and he is still amongst the living."[2]

In 1921 Stieglitz reacted strongly to an exhibition of Modern French Masters at the Brooklyn Museum. He wrote at the time: "It is more than thirteen years since '291' . . . introduced the 'revolutionists' to the United States. . . . It [is] ever an enigma to me why the museums of Greater New York were so backward in their official recognition of the 'New'(!) which had long since been officially accepted in many of the important museums of Europe. . . . American trustees seemed entirely lacking in their sense of responsibility to the interested public—and particularly in their responsibility to the younger generation.

"But the miracle was about to happen. The Brooklyn Museum announced the opening of its Exhibition of Modern French Masters representing the Post-Impressionists and their Predecessors!"

When Stieglitz arrived at the Museum, it was difficult to find the exhibit he had traveled to see: "Where," he asked, "was the French

art? We had come for that. Why the feeling of repression in the Museum? The half-gloom? Was it to protect the pictures?" But then there was a feeling of sudden liberation, "a glimpse of light beyond As if out-of-doors—free—enjoying actual light—the feeling of a great reality—a world truly released—a warm sun—an affirmation of life. Could it be true? And in a museum? And an American one at that. Truly a revelation. Everything seemed right. Intensely alive. The luminous walls. Space. Pictures all part of the livingness. An absence of ostentatious frames. No 'masterpieces.' With but few exceptions not even an 'important' picture. Yet most every picture not only worth looking at, and into, but returning to. I stood in the centre of the room and felt a great hope.

"Several rooms full of experiment—minds capably working out their problems—souls unafraid and singing their song within, their power ever extending. Matisse, Picasso, Cézanne, Derain, Degas, Renoir, Lautrec, Gauguin—who always seems to irritate me, an idiosyncrasy I suppose. The Matisses brilliant. A supreme colorist. How he achieves white light with color—achieves a reality. New Picassos, some of his latter period. Early Italians and Ingres seem to be exerting their spell on him. Derain always gracious—austere. Cézanne, water colors and oils. Several handsome pastels by that keenest of minds, Degas. Renoirs of different periods. A beautiful small still-life by Manet. A powerful Courbet. How gigantic and true Courbet always is!

"But in the main it was the spirit of the work that held me, together with its presentation. And it was the presentation that liberated it—made it free. A perfect unison. . . .

"I took another deep breath amongst the French pictures. I left the building a much delighted man—and very grateful to the Brooklyn Museum."[3]

In 1920 Katherine Dreier and Marcel Duchamp asked Stieglitz to be a director of the Société Anonyme.* He respected them, as he had De Zayas but, as always, he found it necessary to follow his own path. He was not inclined to show his photographs at the Montross Gallery when asked to do so. The aims of those who urged him to participate in still other activities never entirely coincided with his own.

In view of his experiences with commercial galleries, Stieglitz concluded that a 291 was more needed than ever, but he saw no way of setting up a new center. When, by 1925, he became increasingly restive, he went to Mitchell Kennerley at the Anderson Galleries: "Kennerley had been very kind to me from 1918 on. I told him about

*The Société Anonyme—Museum of Modern Art was founded in 1920 under the leadership of Katherine S. Dreier (President), Marcel Duchamp and Man Ray to advance the cause of living, vital art of the period.

the amount of work in storage by Marin, Dove, Hartley, O'Keeffe and myself. I spoke of my interest in Charles Demuth's painting and about Strand's photographs. I asked, 'Will you let us have the top floor of the Galleries for several weeks, so that the work of these Seven Americans can be presented?' Since Kennerley was willing, a fine exhibition of that name took place in the spring.

"The walls were covered with paintings and photographs never before shown, an overwhelming demonstration of accomplishment. When the pictures were taken down, I decided it was ridiculous to have them returned to storage vaults. Still not having found any dealer ready to carry on in the spirit of 291, I again went to Kennerley. I inquired, 'Is there a room in the building I can rent for exhibition purposes?'

"I wanted a center where the Seven Americans, plus X, the Unknown, whoever that might be, could be shown regularly. One corner room was available, about twenty-six by twenty feet. It was one-third windows and door, and had a high ceiling. The walls were covered with stamped black velour. The floor was black, the woodwork dark oak. We made no changes except to cover the walls with white cheesecloth.

"The rent was eighteen hundred dollars a year. Kennerley told me a lease was required, but we could move out at a moment's notice and he would not hold us to any formal agreement.

"Eighteen hundred dollars a year! Would the public support the seven artists, plus X, to the tune that they might live and pay for the rent of The Intimate Gallery?* Like 291, the Gallery was not a business, but a place of contact between the artists and public. There was not overmuch space. Pictures hung on the walls, stood on the floor, lay on shelves. They were everywhere.

"The Gallery, which opened with a magnificent Marin show in December, 1925, was an immediate success. It attracted a great audience—students, artists, collectors, real connoisseurs and, naturally, some curiosity seekers. Those were extraordinary days, with constant discussions. The Gallery—the Room, as it was called by those who frequented it—had its own character. The artists were well-supported. The rent, printing and other expenses came out of receipts.

"During its few years of existence, the Room reflected a beautiful group spirit, not only on the part of those whose work was exhibited, but of those who helped in its life. It was visited by approximately a hundred thousand people."

In 1927 Stieglitz wrote to Peyton Boswell, Publisher and Editor of the *Art Digest*, in answer to a request that The Intimate Gallery place an advertisement in its pages: "If the Intimate Gallery were a profes-

THE
INTIMATE
GALLERY
ROOM 303
ANDERSON GALLERIES BUILDING
489 PARK AVENUE AT FIFTY-NINTH STREET, NEW YORK

announces its Eighth Exhibition—November 9 to December 11, 1927
FORTY NEW WATER-COLORS BY JOHN MARIN

The Intimate Gallery is dedicated primarily to an Idea and is an American Room. It is used more particularly for the intimate study of Seven Americans: John Marin, Georgia O'Keeffe, Arthur G. Dove, Marsden Hartley, Paul Strand, Alfred Stieglitz, and Number Seven (six + X).

It is in the Intimate Gallery only that the complete evolution and the more important examples of these American workers can be seen and studied.

The Intimate Gallery is a Direct Point of Contact between Public and Artist. It is the Artist's Room. It is a Room with but One Standard. Alfred Stieglitz has volunteered his services and is its directing Spirit.

The Intimate Gallery is not a Business nor is it a "Social" Function. The Intimate Gallery competes with no one nor with anything.

The Gallery will be open daily, Sundays excepted, from 10 A.M. till 6 P.M. Sundays from 2 till 5 P.M.

Exhibition I —JOHN MARIN, December 7, 1925-January 11, 1926.
Exhibition II —ARTHUR G. DOVE, January 11-February 7.
Exhibition III —GEORGIA O'KEEFFE, February 11-April 3.
Exhibition IV —CHARLES DEMUTH, April 5-May 2.
Exhibition V —JOHN MARIN, November 9, 1926-January 9, 1927.
Exhibition VI —GEORGIA O'KEEFFE, January 11-February 27.
Exhibition VII —GASTON LACHAISE, March 9-April 14.

Hours of Silence: — *Mondays, Wednesdays, Fridays, 10-12 A.M.*

74. Intimate Gallery, 1927

sional place or I a professional in any sense, your valued *Art Digest* would undoubtedly receive an advertisement. . . . Although you hear occasionally of pictures having been procured in the Gallery, the primary function of Room 303 is in no way connected with money.

"I have always held that the relationship between artist and public has been a false one since the so-called art dealer has become the go-between—particularly when the artist is still alive. I believe that certain pictures should find homes instead of owners. For instance, in order to become guardian of the 'Shelton-Sunspots' one woman offered to give O'Keeffe an annuity of $1200 a year for five years.

75. Eggplant and Tomatoes, Demuth, 1926

Another woman a three year annuity at $1000 a year for a red canna. Other pictures have found homes in a similar way. Some people gave money outright. And although quite a few pictures went at what the world might call 'high' figures it might be well to add that people of very small means also were considered. Some pictures found homes at as low as $75. This all may interest you. It may not. I'm simply letting you know."[4]

Stieglitz admired Charles Demuth's paintings from the moment he first saw them during the 291 period. After including his work in the 1925 "Seven Americans" exhibition, he showed it at The Intimate Gallery and later at An American Place.[5]

Charles Demuth wrote: "I have been urged . . . to write about my own paintings. . . . Why? Haven't I, in a way, painted them? . . . Across the final surface—the touchable bloom, if it were a peach—of any fine painting is written for those who dare to read that which the painter knew, that which he hoped to find out, or, that which he—whatever!

"Across a Greco, across a Blake, across a Rubens, across a Watteau, across a Beardsley is written in larger letters than any printed

page will ever dare to hold, or, Broadway facade or roof support what its creator had to say about it. To translate these painted sentences, whatever they may be, into words—well, try it. With the best of luck the 'sea change' will be great. Or, granting a translation of this kind were successful what would you have but what was there already, and as readable

"Paintings must be looked at and looked at and looked at—they, I think, the good ones, like it. They must be understood, and, that's not the word, either, through the eyes. No writing, no talking, no singing, no dancing will explain them. They are the final, the 'nth whoopee of sight. A water-melon, a kiss may be fair, but after all have other uses. 'Look at that!' is all that can be said before a great painting, at least, by those who really see it."[6]

The sculptor Gaston Lachaise had an important one-man show at The Intimate Gallery in 1927. The Museum of Modern Art later credited Stieglitz with having done "a great deal to help the sculp-

76. The Mountain, Lachaise, 1924

tor's position and to justify him before the New York world of art. Stieglitz's propaganda for Lachaise came at an excellent time, for Lachaise was being bitterly attacked for his innovations."[7]

The poet E. E. Cummings wrote with enthusiasm about an earlier version of Lachaise's *The Mountain* in 1920: "It is not the slightest exaggeration to say that, to any one genuinely either cognizant or ignorant of Art As She Is Taught, this thing was a distinct shock. . . . Merely to contemplate its perfectly knit enormousness was to admit that analysis of, or conscious thinking on our part about, a supreme aesthetic triumph, is a very pitiful substitute for that sensation which is impossibly the equivalent of what the work itself thinks of us. It is difficult to conceive any finer tribute to 'The Mountain' than the absence of 'criticism' which it created. . . .

"Its completely integrated simplicity proclaims 'The Mountain' to

171

be one of those superlative aesthetic victories which are accidents of the complete intelligence, or the intelligence functioning at intuitional velocity. Its absolute sensual logic as perfectly transcends the merely exact arithmetic of the academies as the rhythm which utters its masses negates those static excrements of deliberate unthought which are the delight of certain would-be 'primitives.'"[8]

The doors of the Metropolitan Museum of Art remained closed to photography. William Ivins, curator of prints at the museum, often asked Stieglitz during the twenties why he would not give some photographs to the Metropolitan, primarily prints of his own. "Invariably I reminded Ivins that the museum bought paintings, sculpture, etchings and other things. If photographs were deserving, they too should be acquired with museum funds.

"At this Ivins balked and nothing happened. Finally he and Robert de Forest, president of the museum, appeared at The Intimate Gallery. They were fully aware that the Boston Museum, one of the country's most conservative and possibly best museums, owned a collection of my photographs. The two men informed me that the Metropolitan would also recognize photography if I would present it with some of my work, similar to the prints I had given to Boston.

"Again I heard, 'There is no money.' I should have a heart. Framing the prints for Boston had cost me three hundred dollars. Were I to give a collection to the Metropolitan it would mean another outlay of the same amount. I had very little money, little time for my own photography, and few prints to give away. I said I would consider the matter and let them hear from me.

"I was very ill at the time. Suddenly the thought struck me that prints should go to the Metropolitan. In this way the museum would be opened to photography. That was, after all, my chief aim. De Forest and Ivins had assured me that in no other way could they plead the case for starting a photographic section in the Print Department.

"I decided to offer the prints in the names of people who at various times had sent me moneys to be used for the work I was doing at 291 and The Intimate Gallery. I had given the moneys received to painters, sculptors, literary people, a dancer and other workers in the arts. I also had presented a full equivalent of my own prints to the donors.

"Eventually I wrote to Ivins that I was ready to act, not because the museum wanted my prints, but because it was opening its doors to photography. I felt, too, that those who had helped what I was doing should be recognized publicly for their generosity.

"In due course I was informed that the trustees would accept the collection and install it in the museum."

In May, 1928, Stieglitz explained to Mr. David Schulte, who had

made a most generous contribution to him for his work at The Intimate Gallery, that he had in mind contributing a small group of his rarest prints to the Metropolitan Museum: "Most of my photographs exist in one example only. Sometimes two or three. I would like to present this little collection in various names from people who have been thoughtful of me as a person believing in workers, in human beings. . . . I wonder would you permit me to give seven of my finest prints to the Museum in your name if the Museum should decide to accept Photography as a medium of art and expression. . . . I have written before how I feel about what you have done. My brother has informed me that he has the certificates[9] for me. I want you to know that I accept this gift in the spirit in which it has been given and I can assure you that it will enable me to continue my work with a bit of pressure released. And I will be able to do things for men that I have been wanting to do and couldn't."[10]

By the end of 1928, Ivins wrote to Stieglitz of his happiness about what had occurred "so quietly and calmly, as tho' it were a matter of course. It makes me feel," said Ivins, "as though a great victory had been won without the discharge of a single gun, because that means so much more than any amount of carnage possibly could."[11]

On December 30, 1928, Stieglitz informed Dr. Coomaraswamy: "The Metropolitan Museum has opened its sacred halls to Photography. . . . My photographs have performed the miracle! — I suppose Boston helped pave the way."

FROM MY NOTEBOOKS: THE INTIMATE GALLERY 1927–29

To visit The Intimate Gallery day by day is to watch a unique drama unfold. In other galleries individuals come to look at works of art—possibly to buy, possibly not. That is true here but Stieglitz is not preoccupied with profit. Many who have commercial galleries are also concerned about the fate of those exhibited. But members of the public are looked upon as potential buyers. With Stieglitz this is not so. It makes a difference. Those in business tend to woo the public. Stieglitz challenges it. When he makes a special effort to win support for artists who are in need, he has no thought of personal gain.

Since people often wish to see Stieglitz as much as what he shows, wherever he happens to be becomes a gathering place in which human discourse can develop freely, intimately. Hence the title of the gallery. Stieglitz may greet people or not. At times he continues a conversation with someone who has just left, with a visitor who enters and has no clue to what has been said.

He explains his way of functioning as often to those who are baffled by him as to those who find his way of life moving. He does not have to be appreciated. Talking, for him, is a means of self-clarification. The often uninterrupted flow of his words can be as exhausting at times to some as it is exhilarating to others.

Stieglitz makes no appointments. There is no admission fee to the little gallery. Anyone seeking immediate answers, neat conclusions, formal lectures, is bound to be disappointed. Stieglitz rarely knows the names of those with whom he speaks, nor does he try to find out. There is no guest book, no mailing list.

Ask the price of a picture. You are told, to your amazement, that you must name what you are willing to pay: "Don't wait to be sold something. Don't bargain."

Simply to say you love a particular work, or understand it, may subject you to a harangue: "You say you love it but what will that give the artist who made it? A loaf of bread? A crumb? What do you mean, you 'understand?' Art is beyond understanding. You say you care. Go home and *do* something about it.

"Yes, you can buy pictures here, but we do not sell them. There is a difference."

"Why," I ask Stieglitz, "do you allow people to go away bewildered by what you say and do? His reply: "If a person profoundly needs something and is truly seeking it, he will find it. I make nothing easy for people. I neither advertise nor do I have the gallery listed in the telephone book."

"Why," I continue, "did you express such fear during my first visit that before one knew it, works of art would be found in every corner drugstore in the land, at a dime a dozen? Especially since you have devoted yourself to seeing that art is made available to all, and not just to a privileged few?"

Stieglitz: "Of course I do not wish to see art reserved for the few. What I object to is leading people to imagine they are in the presence of art, when they are given diluted imitations having nothing to do with the spirit of an original work. It was, you must understand, about insensitive, dime-a-dozen reproductions I was speaking. I do object to the making and selling of pseudo-facsimiles, devoid of the sense of touch to be found in a true work of art. Just as I rebel against the unconscionable way in which most copies of art are sold, without the artists who have made the originals receiving a penny by way of royalties.

"My primary role has always been to challenge, to test. The manner in which I do so is of little importance. The moment alone dictates what I must do. I have no theories, no plans. I want nothing, expect nothing from anyone. I play no games. I am simply the moment. But I am the moment with all of myself and anyone is free to be the moment with me. To me, all lived moments are equally true, equally important. Only in being true to all moments can I be true to any. If others are not free to behave in similar spirit, I know the consequences.

"I am not in a hurry. There is no place else I am planning to go. I do not try to be in more than one place, to accomplish more than one thing at a time. I am doing what is essential to me. That is all."

"What," I persist, "made you speak with that young girl as you did when I first came here?"

"Please understand how the public visits this Room, as it goes elsewhere, in the so-called name of art. Or consider why I asked you not to handle the pictures. Have you any idea the way people come here and insist upon treating the lifework of an artist without any thought they might damage or soil it?

"People become so insensitive they dare to lean against the walls and even against pictures. They are willing to ruin works of art they claim to love without thinking about what they are doing and while exclaiming how much they 'care' about the very objects they have already harmed.

"Do you realize what it means to be here day after day and listen to what is said before pictures? To hear a person deny something one year and affirm it the next, without any memory of his previous rejection?

"Have you any notion what it is like to see the critics—even the best of them, on whose words the public waits and the life of the artist all too often depends—view a new work and, within five minutes, pass judgment on it? Would they dare, within the same span of time, to judge a Shakespeare? They would not. But they feel free to do so in the case of the living artist, especially if the artist happens to be American.

"And what, after all, can one tell others about something they have not experienced on their own? Is it possible to play music to the deaf, to show colors to the color-blind?" And then with brooding self-challenge: "I suppose, if you care enough, you can do even that."

Although Stieglitz proclaims again and again that the artist comes first and only then the public, he cares deeply about the quest of each individual who walks through the doors of his laboratory-centers in search of art. He is equally concerned about the fate of a maid who brings his lunch, a nurse who tends him during an illness, those who maintain the buildings where he works or lives. He has a special feeling about anyone who possesses a sense of quality, in whatever the field. To all alike he says, "Tell me your story." To all alike he tells his own. He tests the life-experience of others against his, his against theirs. He says again and again: "My payment for what I have done is in listening to people's stories based on their own experience; the possibility of bringing out the best within them; the beautiful moments."

"I dislike what goes on in the name of professional art, literature, politics, religion. I detest the professionalized American Scene. What matters to me, essentially, is what is put down with all of oneself and that in time *becomes* art."

Through holding annual presentations of work by artists, Stieglitz hopes to confront them with their own evolution. He believes that for the artist to see his own work on walls, in public, year after year, is to be able to assess it as in no other way.

"Exhibitions as such," he explains, "do not interest me. Unless they add something, I see no reason for having them. Because new departures have been made in the work I have shown, the critics, as well as most of the public, have invariably ridiculed it at first."

"When an artist finds his own truth, he will discover that it fits in with traditional truths, with those that have endured over a long period of time. Originally, whether or not the artist reveals a truth that happens to be traditional is never a question that concerns him. If he says what he must, from the depths of his own experience, it will automatically be in the great tradition of truth. It is this that I mean in spirit when I say that all true things are equal to one another."

"I do not see why first-rate photographs, watercolors, oils, sculpture, drawings, prints are not of equal importance; why one must differentiate between so-called major and minor media. I have refused to do so in the exhibitions I have held.

"People constantly attempt to compare, to label, when what matters is to see what is before one, in its own right.

"People forever ask if one likes this picture better than that; this medium better than that; the full-blown blossom better than the bud; Beethoven's Ninth Symphony better than the First. If Beethoven had not written his First Symphony, he never would have been able to compose his Ninth.

"It is as though there were a great Noah's Ark in which each species must be separated from every other, and relegated to its separate cell. Finally each grows so self-conscious that when all are taken out and thrown together again, they fall upon and kill each other."

Stieglitz uses the term *Equivalent* in manifold ways. While abhorring abstract theory, he is fascinated by trying to discover basic laws of life. He believes he has discerned something of vital significance in what he calls the law of equivalents: "The Golden Rule is meaningless as exhortation. Because we automatically evoke in others a precise equivalent of what we project, what matters is to love one's neighbor more than oneself, to do more for others than for oneself."

When I first meet the great authority on traditional Indian art, Ananda K. Coomaraswamy, in 1928, I ask him what he feels about Stieglitz's photographs. Coomaraswamy replies: "He is the one artist in America today whose work matters. His photographs are in the great tradition. In his prints precisely the right values are expressed. Symbols are used correctly. His photographs are 'absolute' art, in the same sense that Bach's music is absolute music."

I have a related view of Stieglitz's Songs of the Sky, which seem to celebrate, in

subtle variation, forces of light triumphant over those of darkness; affirmation beyond anguish. They symbolize what is at once sacred and what wounds the sacred core of our being, what is vulnerable yet when confronted and transformed becomes life-enhancing. Profoundly erotic, the prints both express and transcend the personal.

I want to know why Stieglitz does not write his autobiography. "Everyone," he says, "has his blind spot. The very root of our character is in what we do not know about ourselves. Unless we become conscious of what our blind spot is, there is bound to be falsification in whatever we may write in autobiographical vein. But if we were truly aware of all there is to know about ourselves, we could not go on living."

At another time: "If I could put down in words what I feel, when I see the fine line of mountains and sky at Lake George as they touch, I would be able to write my autobiography."

XIII. An American Place

The rumor persisted in the late 1920s that the Anderson Galleries building, in which The Intimate Gallery was located, would soon be torn down.[1] I asked Stieglitz what he planned to do, to what kind of place he intended to move. He smiled: "It is quite simple. I should like to present work with proper respect, in fitting surroundings. There must be no noise, no sound. If questions are asked about anything, an automatic shotgun will go off. The body of the one speaking will be caught in a basket. Perhaps there can be a button to press, so that if anyone says, 'What does that painting mean?' the picture can be made to utter such absurd replies the questioner will look shocked and say, 'Why what in the world is the matter with that picture?' There will then follow a silence. Whereupon I shall state: 'But what do you mean by what is the matter? Nothing is the matter.'

"My real delight," Stieglitz added, "would be to exhibit what I feel worth showing, and then say to the public, 'You cannot buy this at any price, under any circumstances.' What I wish to demonstrate above all is that there are certain things that cannot be bought, cannot be touched."

It was necessary to vacate The Intimate Gallery in the autumn of 1929. The stock market boom, which reached its height in October, was followed by Wall Street's disastrous crash. Because Stieglitz had decided not to have another gallery, pictures again went into storage.

A few of those closely associated with his activities—O'Keeffe, the Paul Strands and myself, in particular—felt that, irrespective of his decision, he must have a place. He must be available to those from all parts of the world who wished to see and speak to him. He must be able to show his work and that of others who interested him. The Intimate Gallery had become too cramped. We wanted him to have

XLVII. Apples and Gable, Lake George, 1922

XLVIII. Barn, Lake George, 1920

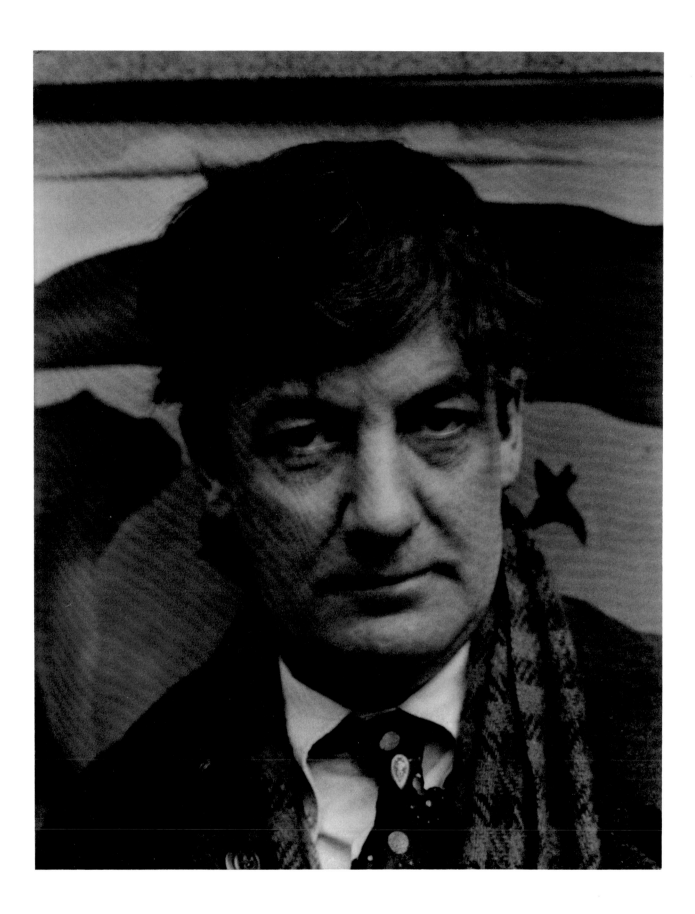

XLIX. Sherwood Anderson, 1923

L. Equivalent, 1922

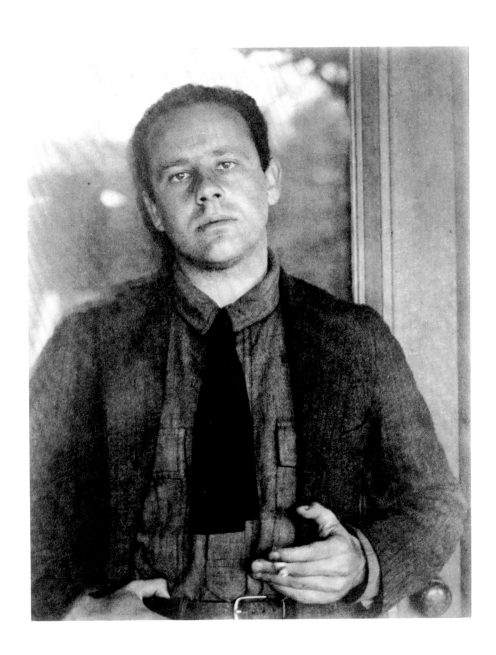

LI. Paul Strand, 1917

LII. Tree, 1933

LIII. Waldo Frank, 1922

LIV. Grasses, 1933

LV. Spiritual America, New York, 1923

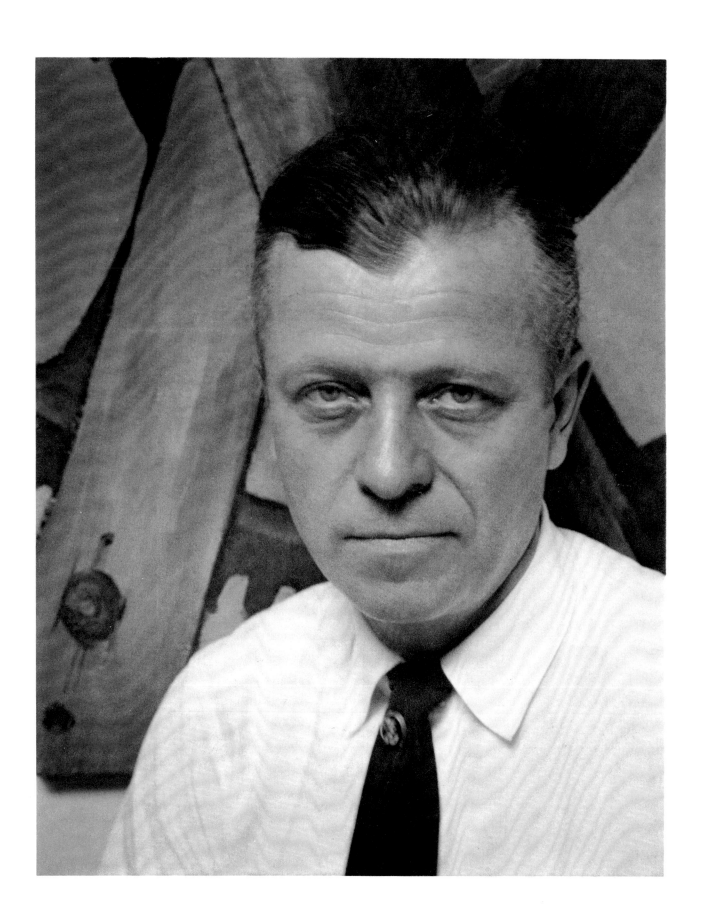

LVI. Arthur G. Dove, 1915

LVII. Grape Leaves and Porch, Lake George, 1934

LVIII. House on the Hill, Lake George, 1933

LIX. From the Hill, Lake George, 1931

LX. Barn, Weathervane, Lake George, 1934

LXI. Old Tree, Lake George, 1927

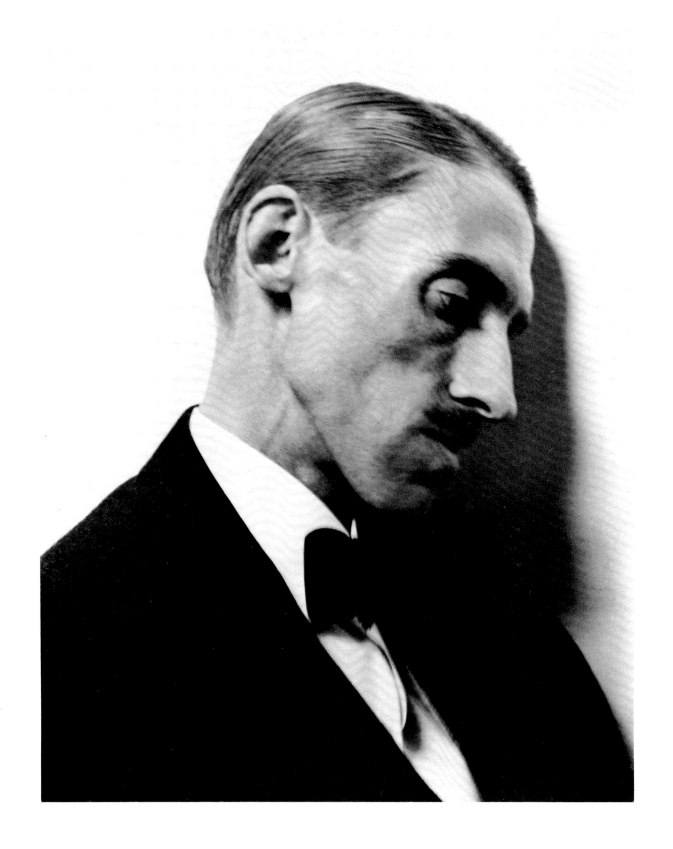

LXII. Charles Demuth, 1922

more space and, at long last, a New York darkroom of his own, in which he could develop and print during the winter months, instead of only in the summer at Lake George.

At just the time when The Intimate Gallery had to go out of existence, Stieglitz heard that a Museum of Modern Art was to be established in New York. He felt strongly that modern art should continue to be shown in uninstitutionalized manner. When someone objected, "But you must have a program," Stieglitz replied, "Yes. You must—in institutions. But I am interested in vision, not a program. I never have had an organization behind me and little public support or subsidy for what I have done. I have always refused to work hampered by committees, boards, trustees."

After much persuading, Stieglitz was prevailed upon to allow us to raise funds for a new center. He stated that he did not wish to know the names of donors. He refused to sign the lease for the quarters we rented on the seventeenth floor of a new office building, 509 Madison Avenue, or to participate in making any arrangements relating to them. This had nothing to do with his avoiding responsibility. He wished to remain free to speak out and act, without feeling obligated to contributors; without being put in a position of having to sell art so that the new gallery's rent might be assured.

Stieglitz decided to name his final laboratory-center An American Place. The word "place" was unpretentious. It might at last dispel the notion that he was interested only in "art," as generally understood. He felt no need to explain the title. The aliveness of what might happen there must give the Place its meaning.[2]

"When you enter An American Place," I wrote soon after it opened, "the first thing you sense is the quality of light. The space is divided into well-proportioned rooms of varying sizes. There are thresholds without doors, the areas leading one into the other without barrier. The rooms are painted in luminous shades of gray, and in white. The walls reflect the light coming through large, partly shaded windows, so that with the white ceilings and bare, uncovered gray painted stone floors, there is an ever-changing glow. Light and place are as one even after dusk, so discreet and sensitive is the use of electric bulbs.

"At times there are pictures on the walls and on shelves. The door to the Place is open to all.

"What, other than pictures, brings people to this unadvertised center? Why is the quality of light so significant, as though it had some special meaning, the way light in a cathedral with its unearthly, strange, concentrated quality seems to have special significance? The bare, clean walls might be, save for the pictures, laboratory, hospital, model workshop walls. Even when there are no books, no art, no cameras, no people; when nothing whatsoever appears to be happening, the character of the Place is not limited or changed.

"Founded when Stieglitz was nearing seventy, An American Place bears a close relationship to the previous galleries over which he has presided. It is an embodiment of the manifold aspects of a tradition, created by and identical with the work and the dream that continue to be Stieglitz. Within this tradition, the scientific, experimental concerns of the laboratory, the sacred ones of the cathedral, the aesthetic ones of museum and workshop, all play their role. Each is an integral part of the whole."[3]

The Seven Americans plus X of The Intimate Gallery formed the nucleus of those exhibited at the Place from 1930 to the year of Stieglitz's death in 1946.* This period was one of intense concentration "on seeing through what had been begun," on making "the American people further aware of their responsibility toward their own living artists."

With the move from small to more spacious quarters—despite no advertising and the toll of the depression—public interest in the Place and in Stieglitz increased. The austerity of the rooms at 509 struck a warm and responsive chord in the audience.

During the winter months Marin painted in Cliffside, New Jersey, during summers primarily in Maine. Dove lived close to New York on Long Island but recurrent illness prevented him from coming to the Place as often as he would have liked. This was true of Demuth also, whose home was in Lancaster, Pennsylvania. Plagued for many years by diabetes, he died in 1935 at the age of fifty-two. Strand lived in New York. Hartley, who was in and out of the city, loved to come to the Place and his work was shown there for some years.

O'Keeffe's paintings and Marin's received the most favorable reviews and were the most sought after. Times were especially difficult for Dove and Hartley during the depression even though Stieglitz always saw to it they had adequate financial support.

An independent spirit, O'Keeffe needed both privacy and to travel. Although she first saw New Mexico in 1917, it was not until 1929 that she began to summer there. She made a number of trips elsewhere, but her stay in Taos changed "the whole focus of her life." Overwhelmed by the extraordinary beauty of the desert country, she decided to spend almost half of each year in New Mexico, the remainder with Stieglitz in Lake George and New York.

Between 1930 and 1932 Stieglitz arranged important exhibitions at the new gallery of work by Marin, O'Keeffe, Dove, Hartley, Demuth and Strand.

Saturday afternoons at the Place had a special quality. More visitors came to see the exhibitions than at other times and Stieglitz's little

office frequently seemed even more crowded than the larger rooms. Creative figures, both American and foreign — including artists he showed and those he did not — wended their way to see him. Discussions could become heated, conversations were animated.

O'Keeffe, Hartley, Demuth, Rebecca and Paul Strand were often present. Marin came religiously each week during the winter months. The moment he appeared the Place came alive differently than at other times. When 509's major stars were present, although self-consciousness soon vanished, young substars were tempted to play to the gallery — to Stieglitz and Marin, above all. The wordless understanding between the two men of such different temperaments was marvelous to observe. It was during the summer months that Marin's words flowed toward Stieglitz in the vivid letters he could write to almost no one else.

During a single month Herbert Read, Frieda Lawrence and J. Middleton Murry might arrive from England, Victoria Ocampo from Buenos Aires. Waldo Frank brought Ocampo — at another time Charlie Chaplin — to meet Stieglitz. The Italian art critic, Lionello Venturi, fell in love with Marin's paintings. Gertrude Stein and Alice Toklas, on their celebrated visit to the United States in the thirties, promptly headed toward An American Place. Lewis Mumford came to review exhibitions and remained to listen and talk to Stieglitz about literature, art, life in general.

Many of those associated with *Camera Work*, 291, *MSS*, The Intimate Gallery reappeared: the by-now famous Sherwood Anderson; the ever-enthusiastic Mabel Dodge Luhan; Paul Rosenfeld, William Carlos Williams, Alfred Kreymborg, Gorham Munson, Herbert Seligmann. Hart Crane rushed in to read from his manuscript of *The Bridge* before it went to the publisher. He had written some time before how he felt Stieglitz "entering very strongly into certain developments" of the poem. Marcel Duchamp could be rather silent but smiled his assorted appreciations. Dorothy Brett, the painter, close friend of D. H. Lawrence and Katherine Mansfield, held her tin hearing aid to an ear; later an electric one rested on her lap. When bored by anyone she lowered the metal device and also with equal visibility, turned off the current of her more sophisticated instrument. Edward Steichen, after an absence of many years, was still one of the few photographers also interested in art in other media. Beaumont and Nancy Newhall and David McAlpin spoke excitedly about the founding of a department of photography at the Museum of Modern Art and sought Stieglitz's advice. Edward Weston, Ansel Adams, Eliot Porter and many other younger photographers paid their respects to Stieglitz and his prints, and brought their own for him to see.

Catherine Bauer overflowed with ideas about modern housing and city planning. The Stettheimer sisters — Florine, Ettie and Carrie — would appear on their rare outings. You might find the stage designer,

Lee Simonson, the composers Edgar Varèse, Ernest Bloch or Aaron Copland. There was a host of writers, among them E. E. Cummings and Marianne Moore, Jean Toomer, Evelyn Scott, Carl Van Vechten, Gerald Sykes, Jerome Mellquist. Over the years you could witness a generation of collectors being educated to think first of the precarious position of the artist in America rather than of their own efforts to acquire the most for the least.

Members of the emergent Group Theatre — Harold Clurman, Clifford Odets, Stella Adler, Paula Miller — admired pictures and stayed on to discuss the enterprise they were in process of founding.[4] Stieglitz's love of fine craftsmanship and his emphasis on working toward a common end, without regard to a star system, had an important influence on them.

77. American Place, A.S. script, 1932

In 1932 Stieglitz presented his own photographs — both early and recent. He wrote that the prints shown were "made with material available to everyone. I have used no special or artificial means. . . . No tricks. I loathe the materials with which I have been working, but I have tried to show what anyone who really cares can do with them."

From the catalogue of Stieglitz's 1934 exhibition at An American Place: "In my time, many many years ago, when I was young and photographing nearly daily, never dreaming of painters or paintings or artists or exhibitions, I made thousands of negatives and prints. This was before the kodak had been invented or the film either. Even the detective camera as the first hand cameras were called had hardly come into being. I used glass plates, 18 × 24 centimeters. . . . I dragged [my] heavy outfit over Alpine passes and through streets of many European villages and cities, never exposing a plate until I was sure it was worth the while to risk one. There was no random firing as is so often the custom of today. Those were still pioneer days in photography. . . . In the course of time I either destroyed all my early negatives, or they were lost or damaged beyond use. For years I believed that all were gone as well as most of my early prints.[5]

"Last summer as I was rummaging through the attic in Lake George, to my great surprise, I found twenty-two of the old negatives, many in imperfect condition, scratched and battered. . . . At once I began to make prints from them, naturally being most curious to know what they would look like today when printed on commercial paper instead of platinum which I had used exclusively for the first thirty-five years of my career.

"When I saw the new prints from the old negatives I was startled to see how intimately related their spirit is to my latest work. A span of fifty years. Should I [exhibit in spite of] my distaste for showing publicly. . . . There was Photography. I had no choice."

196 During the same year Stieglitz said again, "Personally, I like my

photography straight, unmanipulated, devoid of all tricks; a print not looking like anything but a photograph, living through its own inherent qualities and revealing its own spirit. But should any one want to go to his own particular photographic hell in his own particular way—manipulated, hybrid or what-not—I say: 'Go to it. But go to it for all you are worth, the harder the better, insisting on your right of way without necessarily disregarding all traffic lights. And if you must disregard even those, I say: Go ahead full speed!'"[6] In 1937 he reiterated his belief in straight photography and was positive he would never change his position,[7] which he never did.

Stieglitz said in the thirties: As for reproduction, "I feel that if the spirit of the original is lost, nothing is preserved. My work might be reproduced if properly interpreted, that is, the spirit might be preserved. Of course, some of the things can't possibly be reproduced for obvious reasons. Above all, the reproductions must have a clean feeling—an absolute integrity of their own."

By 1933 the first three-year guarantee-fund for the Place was spent and it looked for a while as though, due to the growing severity of the depression, there might be some difficulty in continuing.

After much persuading on my part, Stieglitz permitted me to try to raise a new rent fund. As the *New York Herald Tribune* reported, many persons were asked "for small amounts rather than a few . . . big subsidies," the poor being "more willing than the rich to support a gallery . . . described as being thirty years ahead of its time."[8]

Two weeks later, the art critic, Edward Alden Jewell, spoke out in the *New York Times:* "These are difficult days for art galleries and museums. . . . The courage displayed right and left—courage that can summon its grim smile in the presence of almost any sort of appalling situation—is positively caloric. . . . As for . . . An American Place, an SOS brought such cordial response . . . that. there now seems little doubt of this gallery's being able to make the grade. If worse comes to worst, says Alfred Stieglitz, 'I'll take half a room,' and should worse climb to the ultimate and catastrophal worst, there is always the friendly street corner (. . . glancing back a cool few thousand years one remembers Socrates)."[9]

Stieglitz was to be seventy on January 1, 1934. Paul Rosenfeld and Waldo Frank came to me some months before to discuss the possibility of doing a collective volume about him in honor of his birthday. Lewis Mumford and the educator, Harold Rugg, also were asked to be editors. All were enthusiastic about the project.

We invited twenty others to contribute to the book. A publisher at once sent us a contract. The volume was to be profusely illustrated and published in 1934. We agreed that any piece one of the editors liked, no matter what the others felt, should be included.

Contributions arrived promptly from Europe and from various regions of the United States. We had no idea how anyone would receive much recompense for his labors. This proved to be no problem, since all were writing and editing as a labor of love in tribute to Stieglitz. We were eager that the book should appear without delay, hopefully during his seventieth year.

We took manuscripts and illustrations to the publisher. To our horror he was frightened by the number of pages and reproductions about which we had told him in advance. He reneged on our contract for what he now termed too expensive an undertaking. We refused to be discouraged and completed the book as though we had a publisher.

At the end of the summer Stieglitz and I met at An American Place, not yet open for the season. A writer, who liked to talk with Stieglitz, stopped by to see him.

I spoke of the sad plight of the book, which we planned to call *America and Alfred Stieglitz*. The writer had heard that the Literary Guild was looking for an art volume—preferably illustrated—for Christmas distribution to its members.

I called Carl Van Doren, chief editor of the Guild, who invited me to bring the manuscript to him at once. As he turned pages and looked at illustrations, he was delighted. After he read and liked the book, the Guild accepted it without its having been submitted by a publisher, which was contrary to usual procedure.

Because Doubleday, Doran was associated with the Guild, both organizations distributed *A and AS*. No one at Doubleday, to our knowledge, had time to read the volume, it was placed in production with such speed. The first bound copy arrived during November, 1934. The Literary Guild edition consisted of 30,000 copies—in the midst of the depression—a joyous irony in view of the first publisher's timidity.

The design of the book, being a rush job, lacked typographical distinction. The reproductions were small and undistinguished. We presumed that Stieglitz would be infuriated. Instead he said, with generosity, that under the circumstances such considerations did not matter, that the illustrations were unpretentious and served as a valuable record. Carl Van Doren wrote to Stieglitz: "I must tell you how much I have enjoyed what the editors call a collective portrait of you but what is quite as truly a unified portrait of the generation which has been, and continues to be, so deeply indebted to you. The book at once clarifies and elevates the whole issue of art in America. Here is a record such as the subject of the record deserves." He added on the volume's jacket: "There was bound to be, sooner or later, a book on the Age of Stieglitz."

Leading reviews appeared in both the Sunday *New York Times* and *Herald Tribune* Book Review Sections as well as other publications.

Despite the book's generally warm reception, various critics objected

that those who had written for it admired Stieglitz too much! It was assumed the contributors must form a "clique," the truth being that not all of them knew one another and that those who were acquainted agreed about almost nothing save their spontaneous respect for Stieglitz. Even with regard to that seemingly unifying factor, there were constant altercations about *why* he was of importance.

Francis Henry Taylor, later Director of the Metropolitan Museum of Art, stated in his *Atlantic Monthly* review: "Stieglitz is really a great man . . . probably he has been right in the matter of contemporary aesthetics more often than any other critic and 'patron'. . . . Stieglitz was the champion of the new and the difficult to understand, a law unto himself with courage that is vouchsafed to few of us in the arts."[10]

A man who heard that the book had been voluntarily undertaken by a group remarked to Stieglitz: "Isn't working together for some-

78. Stieglitz at Marin Exhibition, An American Place, Adams, 1940

thing in which everyone believes the essence of what you have been teaching all these years?"

Stieglitz: "Teaching? You cannot teach such a thing. It is not until a need presents itself—until individuals feel it within—that anything meaningful can happen. Things must sprout—happen—of their own accord, or they can have no significance."

Stieglitz held a show of important work from his collection at An American Place in 1937, entitled, "Beginnings and Landmarks: 291—1905-1917." In an interview published in the *New York Herald Tribune*, he explained that the retrospective was "based on potentialities, not finished and developed work;" that it included much "that was new and often sensational when we first exhibited it. . . .

It represents a democracy of art, for here works of many different mediums are shown together, as they were together in the spirit of their creation.

"Photographs, oils, charcoals, etchings, lithographs, pencil work—all [were] treated equally. . . . The medium of a work doesn't matter—it's what you see there before you that counts. . . . Nothing here is for sale. This is a museum now. But I am nearly seventy-four. And what is going to happen to all this if I should die tonight? There is not an institution in the country prepared to take this collection. I don't mean to take it in my name—I don't care about that—but to preserve the value that is here. That's the thing. Broken up, these individual items would be interesting and valuable. But together they are more than that. The whole is greater than the sum of its parts."*[11]

79. Emil C. Zoler, A.S., 1917

Paul Strand's prints had been shown at An American Place in 1932. The only two younger photographers Stieglitz exhibited there were Ansel Adams in 1936 and Eliot Porter in 1938.

Stieglitz wrote with enthusiasm to Adams about his work: "The photographs took my breath away. So much so that my impulse was to telegraph to you and cry out hallelujah, or should I say 'Yodel'. . . . The photographs are a grand lot. Such prints! Really magnificent."[12]

To Porter: "I have your letter. . . . I think I know how you feel about me. *Men* really don't have to thank each other. Still I must thank you for having given me the opportunity to live with your spirit in the form of those photographs that for three weeks were on our walls.—And 'our' includes your."[13]

Emil Zoler, a young and idealistic painter, had appeared at 291 in 1909. Moved by the spirit of what took place there, he began to visit it with regularity; later he served as a loyal and helpful co-worker at The Intimate Gallery and An American Place for many years, his life revolving around Stieglitz.

Andrew Droth came to work for Stieglitz at the Place for six weeks in 1934. He remained there until after Stieglitz's death. Although delicate in health, Andrew framed and mounted pictures, packed and mailed art and books, performed myriad services with scrupulous care and devotion.

Stieglitz said of Andrew, "He is my mainstay—devoid of all intellectualities and curiosities. He doesn't smoke or drink—is absolutely prompt and reliable—a first-class workman. What I'd do without him I don't know. No one can replace him."

Zoler's work habits and sense of time differed notably from An-

drew's. Andrew arrived early in the morning and left promptly at four in the afternoon, having labored with diligence all day. Zoler rushed into the Place at just about the hour of Andrew's departure. His rapid strides and furtive glances of greeting seemed intended to reassure all present that he was about to perform some unique service for which everyone had been breathlessly waiting. He then disappeared down the hallway outside the Place to shave. In about three-quarters of an hour he returned. When the weather became warm he would ask Stieglitz every day whether he wanted some chocolate ice cream from the neighboring drug store. This was one of the few treats Stieglitz allowed himself.

Zoler disappeared again, only to return what seemed hours later with vanilla ice cream, which Stieglitz detested. The error discovered, Zoler would storm, day after day, "That stupid fellow! I *told* him chocolate." He would put tops of containers back with professional zeal and vanish for several more hours.

Zoler was not officially employed by Stieglitz. Any insinuation that he was made Zoler furious. In earlier years he had wanted to become a painter. For quite some time, he mounted and packed pic-

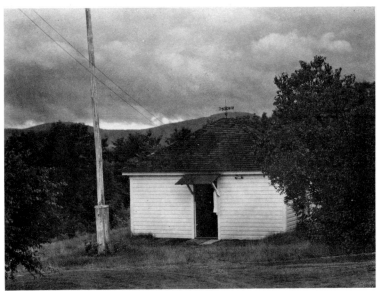

80. Little Building, A.S., Lake George, 1930

tures, lifted heavy objects and was otherwise helpful. He had a fine eye for art, was an excellent craftsman and an eternal romantic. Stieglitz always gave funds to Zoler, often took him home to supper and sometimes invited him to Lake George.

Zoler long promised to make beautiful leather portfolios for Stieglitz but these, like his paintings, failed to materialize.

"This is the little house I develop and print in. It was originally meant for the entrance to a hothouse—the hothouse went to pieces and this remained. I use it. It's well built. So it's here that some things happen!—Aug. 11/30." (A Stieglitz note to the author from Lake George, written on back of original photograph.)

Stieglitz's manner of portraying Lake George—an area he loved from early childhood—was transformed over the years. An indication of how his vision developed is to be discerned when one compares his more youthful Lake George prints with those created during his maturity.

He lamented with anguish the disintegration of magnificent and lovingly fashioned barns; the ruthless cutting-down or neglect, of the great towering trees—he called them old heroes—that he had watched with awe since childhood.

Stieglitz depicted a rapidly changing New York from his windows—skyscrapers rising higher and higher before the buildings in which he lived and worked. There was no longer the opportunity, nor the desire to photograph from the streets below.

Gazing from An American Place window Stieglitz remarked, "If what is in here can stand up against what is out there, it has a right to exist. But if what is out there can stand up against what is in here, then what is in here does not need to exist."

Again he said, "Man is faced by inevitable choices. He is forever being asked, in one way or another, whether he believes in white or in black. But how is he to choose the one above the other? The very fact that the question is asked proves there is no absolute answer.

"How conceive of black without white? Why reject either, since both exist? Indeed, it is at the very point at which black and white form a positive manifestation of life that I am most aroused.

"There is within me ever an affirmation of light. Thus, no matter how much black there may be in the world, I experience tragedy, beauty, but never futility. I am aware of the duality, the ambiguity of world forces forever at work. Yet it is when conflict hovers about a point, a focal point, and light is in the ascendancy, that I feel the necessity to photograph."

"Just as I love when there is a rightness in loving for me, so I photograph when I have a positive reaction to what I see. Otherwise, I am silent.

"If what I experience and express has the universal power to move others, then what I am and do will be life-giving. If not, I shall simply have spoken. I shall have spoken, however, with passion and with deepest caring. Nothing more.

"Each thing that arouses me is perhaps but a variation on the theme of how black and white maintain a living equilibrium. That only few significant moments occur during years of seeing is as natural as that there should be but few personal crystallizations of love, as against a vast and constant impersonal love.

"Whether my work is beautiful I do not know, any more than I

know if Einstein's theory of relativity, as conceived in his spirit, is truer or more beautiful than it would have been in the hands of someone who might have come upon the same formula, and have been unmoved by its wonder."

XIV. The Final Years

By the time An American Place opened I no longer merely desired to aid Stieglitz. I had become, as he phrased it, an "integral part" of the Place in the natural course of events. He continued to answer my questions about the years before I knew him. I kept a record of what he told me in my notebooks and wrote down whatever conversations at the Place were of interest to me. I was permitted to read the material in Stieglitz's disorganized files and I put them in order. In time I helped prepare catalogues and took care of numerous other details involved in running the new and expanded laboratory-center. As always happened, either one worked with Stieglitz in perfect trust or not at all. No questions were asked. If you were not ready, on your own, to undertake what you did in Stieglitz's behalf or if you could not sense what was right for him, you had better do nothing at all. I could not say I had any exact position, nor did I have any desire to have one. No matter what you wanted to do for Stieglitz, it seemed always that he did more for others than anyone possibly could do for him and he asked for nothing.

His inner strength was formidable. He found his own direction in photography as in everything else he did. He was never a follower but rather a leader, even while making no attempt to be one.

FROM MY NOTEBOOKS: AN AMERICAN PLACE 1929–46

1929: In evolving the most austere mounting and framing of his prints or choosing to have An American Place undecorated. Stieglitz has no intention of being modern. Neither does he make any effort to be consistent.

In the office at the Place he has an old dilapidated chair, left over from The Intimate Gallery. That it is poorly made and ugly—out of harmony with its surroundings—does not bother him, yet he refuses to use a new and shiny wastepaper basket someone has given him. If objects are to be bought, they must be undecorated; furniture must be simple and unfinished.

He cannot bear to see a piece of mounting paper with a single blemish, a book marred by a thumbprint. But if there are imperfections in a work of art, often they are what give it life for him, provided that he believes in the artist.

When told he is contradictory Stieglitz replies: "Contradictory? Of course. There are contradictions in everyone truly alive. If seen in proper relationship, however, they may, in reality, not be contradictions at all. Static consistency is contrary to life. Any conclusion is for me a dead thing—unaesthetic, a tombstone. Where there are no contradictions there is no life."

1930: Stieglitz's skin has become tissue-paper fragile. The silvering hair accentuates the penetrating dark eyes. When he laughs, is mischievous, he looks twenty years younger.

Except during the summer months, he wears without variation the same type of black Loden cape adopted during student days in Europe. He wears woolen underwear; a freshly laundered, white cotton shirt; a grayish sweater-vest; pepper and salt suit, herringbone overcoat. Now that he is growing older, there are layers upon layers of clothing to protect him against chill. Whether or not the temperature is, in fact, low has ever less importance. Often he keeps his hat and cape on indoors as well as out.

There is the flat, gray-black, porkpie hat, year in, year out. It becomes almost impossible to find a new one in all of New York. Habit, not the desire to appear eccentric, dictates what Stieglitz wears. He detests fuss and shopping, has no interest in fashion, cares about simplicity and quality. It matters little to him that his clothing becomes shabby, but it must be clean.

His ties are invariably black. Everything gives the impression of being black and white even when it is grayish. Stieglitz puts on and wears his clothes almost absentmindedly. He is without affectation, has natural dignity, never tries to attract attention. He is totally unaware that passersby stare at him when he appears in public lost in reverie, or talks to companions, without stopping—concentrated, intense.

1931: Other than black and white, Stieglitz loves red, a touch of red. Especially red roses. He loves flowers but claims he has never felt himself worthy of either picking or photographing them. He tells me I have great courage to photograph flowers.

He has been teaching me how to photograph. All he will say at first is to shut down my lens as far as possible, take the longest exposures I can and then just go ahead: photograph, photograph, photograph.

Stieglitz's way of telling me how to develop negatives and make prints in An American Place's darkroom first startles, then makes me roar with laughter until I understand.

He lifts a bottle of developer to the weak light, reads the directions printed on it and repeats exactly what they say: "Use three parts water to one part developer." The label indicates that the water should be a certain temperature. Stieglitz: "Forget about that. You will soon sense how hot or cold it should be and how your negatives should look." He advises that I keep on shaking the pan in which the dark, mysterious, slippery little rectangles lie. I must then place them in hypo for a certain time and finally wash them much longer than you are supposed to. A similar procedure is followed when he tells me how to print.

Frightened and shy to begin with, I find it a source of wonder to discover how the discipline of having Stieglitz stand behind me, wordlessly watching, makes me measure what I do against what I feel I should do. His method of teaching is, above all, to encourage. My awkwardness soon vanishes because he is so generous and involved, yet never explains what is right or wrong. I know that everything is up to me.

Seeing Stieglitz photograph, develop and print, looking at his photographs, train my eye more than anything else. Influenced by him at first, I then work with independence and am relieved when I realize that, subconsciously, I am unable to photograph anything I think he would. I cannot believe his effect on others can be any less positive than it is on me.

Stieglitz cares profoundly about technique, even when, at times, he says the reverse, trusting that others will follow through on their own. "I rebel," he says, "against the overemphasis often placed on technique, not because I have no respect for it. I take craft for granted, assuming the true artist will master it. The artist is one thing all the way through. Talent controls one, genius one controls."

How does Stieglitz create the illusion of such momentous intensity while sitting quietly, his words never hurried—talking, talking, talking? And then, as suddenly, silent. The intensity equal.

If you record what he says literally, it often does not sound the same when you read it back. The timbre of his voice is gone. Only a single phrase may continue to be moving, but it makes the entire writing down worthwhile.

Stieglitz does not smoke, drink, gamble. He appreciates good food, but pays little attention to what is placed before him. For many years his chief meals consisted of what he tells me he has always preferred: "Mutton chops, baked potatoes, a chocolate éclair, some toast or Zwieback; hot water with lemon and sugar—sometimes a trace of tea to discolor the water. Apple sauce." He eats less and less as he grows older.

1932: Stieglitz is in a reminiscent mood: "All relationships I have had, exhibitions I have held, publications or catalogues I have issued—all things I have ever said or done—are closely related. Thus nothing I have undertaken or experienced can be judged, or even considered separately without, at the same time, taking everything else into account."

He recalls an encounter: "A woman found one of the exhibitions at 291 very exciting. She asked me what else she ought to see in New York. I confessed I had no

No formal press views
No cocktail parties
No special invitations
No advertising
No institution
No isms
No theories
No game being played
Nothing asked of anyone who comes
No anything on the walls except what you see there

The doors of An American Place are ever open to all

Please do not take away.

AN AMERICAN PLACE
509 MADISON AVE., N. Y. C.

81. An American Place announcement, Stieglitz handwriting, 1930s

idea. The woman insisted; could I tell her where Mr. Stieglitz's gallery was. She had heard he had the finest things in the city but she couldn't find him listed anywhere.

"I informed her that Mr. Stieglitz had no gallery. The woman became very angry and said I was mistaken. She had been distinctly told he did have a gallery and that she must go there.

"Irritated, I raised my voice: 'Well, I ought to know. I am Mr. Stieglitz and I tell you he has no gallery.'"

"For eleven years the doors of 291 were always open. Nothing was locked. People asked me how I could permit this. My reply was that I refused to fill my mind with keys; to spend my energy on wondering whether people were stealing, when I needed it for more important things.

"I also felt that if anyone had wanted to enter 291 by force he could have, since the locks used were of the most ordinary kind. But nothing was stolen. The works of art we had were so unpopular no one thought of them in terms of monetary value. This was true before the Armory Show in 1913 and for quite some time after.

"I said that if anything were taken, the gallery automatically would have to close. I meant that sincerely. I was affirming my faith in the fundamental honesty of human beings. People of all classes frequented 291—the hopelessly rich, the desperately poor and all in between—individuals who might have been tempted to steal elsewhere.

"Part of the trouble with what I am doing now at An American Place is that, al-

though the door is open between the other rooms and my so-called office, most of those around me have been forced to look upon their work as their sole means of livelihood. In consequence, I must lock doors when I leave.

"The idea of art being property is something to which I have never become accustomed. Art belongs to the people. Until they recognize this and voluntarily support the artist in terms of what they derive from him year after year, there will be this mess of property for the artist. The people will be deprived of what they need but have found no way of procuring or securing for themselves.

"It is because I refuse to permit what I do to be turned into property, yet am forced to see the things around me so transformed that I am constantly misunderstood. As a result, what I am doing must, in time, be destroyed."

A writer who has professed both great idealism and veneration for Stieglitz and the artists he exhibits steals a number of paintings from the Place and sells them. Others who learn of the incident are shocked. Stieglitz is entirely forgiving. He has long talks with the writer, which help him to seek professional advice to overcome his kleptomania.

Stieglitz: "I have had the possibility of great riches, but they have never meant anything to me. I have wanted little which is in reality much. I have wanted to be free to do what the moment calls upon me to do. That is what I call real freedom. How many have that? I have worked hard in my lifetime even though I have never known what it is to 'earn' a living. But at least I feel I have earned the right to live.

"Work must come first. It becomes more and more the essential thing for me. Time is an awful thief—a cold-blooded one, if one permits it to be."

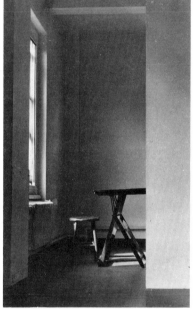

82. American Place, Norman, 1946

1933: Stieglitz veers between relentless self-examination and a tendency to believe that his shortcomings must be understood, accepted. When he hurts someone, he claims that is life and that he must be trusted. When he is hurt, he is outraged. He acts as though those inflicting his wounds have no capacity for true caring.

If you are close to the Place and leave it even briefly, to satisfy needs beyond it, this indicates to him that you have no feeling whatever about it. Since he recognizes every instant in the same spirit, at times he appears to cause the most profound and the most superficial events to seem equal. If those near him rebel against his manner of reacting, he is astonished.

But then he quickly recovers his equilibrium, contending, "There is far too much concentration on the black spot on white in life, instead of the white spot on black. Even when people find that ninety-nine percent of oneness exists between them, they will still insist upon complaining about the one percent that eludes them. That is why they so often succeed in destroying the ninety-nine percent that does exist. I prefer to concentrate on the white spot on black."

Paul Rosenfeld calls Stieglitz to ask how he would define his criterion of excellence. Stieglitz laughs: "I wouldn't. You might as well question the sun, the moon, the stars. They *are*. They *exist*. How is it possible to say what is the most excellent when values are forever changing, when Bach and Beethoven in one age are considered great, in another not? All we can do is stand before a work, honestly. If it endures, satisfying the most conscious people over a long stretch of time, perhaps it can be included among the great."

83. American Place, Norman, 1936

1934: The telephone rings at the Place during exhibition hours. A number of people are present. Stieglitz picks up the receiver: "No. Thank you. There is really no need for you to come here to help me. Please go right ahead with what you are doing. But thank you very much." A young man has phoned for whom Stieglitz is a heroic figure. Stieglitz turns toward the visitors: "People are very kind. Very. But how often they fail to realize what they are doing. They think that offering to help is the same as helping. If the friend who called truly could and wanted to do something for me, he would be here as part of the natural, inevitable course of events beyond choice or asking. Or I would feel free to ask him to come here whenever necessary.

"I know only too well what occurs when people say they want to help me. They become so interested in the alive side of the Place they pay no attention to its everyday, humdrum needs. They fail to see that, in order to participate in what is occurring here, it is necessary to function in a certain way. The sporadic, the half-measure, the not-completed can lead only to chaos. Then who is to straighten out the disorder that is created? Ultimately I must do it.

"I take it for granted that my young friend has an independent life to lead. He has gone through his apprenticeship here, which has led him out into the world. So why should he return now and do what he calls helping? The very fact he asked means that he already is too busy to have come even for the duration of our conversation.

"This Place requires constant concentration at every moment. There must be complete continuity, responsibility, dedication, for assistance to mean anything. Since I am here all day, everyday, including weekends, from morning until night, others may feel that these rooms are something of a jail. They may be, but I have to behave as I do. When someone says he wishes he could act in similar fashion, this is not true, otherwise he would."

At another time: "People come here. They feel the spirit of what is being done. They respond to its beauty. If they want to become involved in what I am doing, I warn them about the heartaches in store for them—for anyone who is sensitive, who cares. I warn them, but they do not hear me. They can see only the beauty."

1935: A painter has written an article without giving proper credit to 291 for presenting his pictures when he was unknown. He now complains that Stieglitz shows favoritism because Marin and O'Keeffe attract more public attention than he does. Stieglitz does nothing to make this occur. It is a natural situation.

Behind Stieglitz's back, the artist attempts to arrange shows of his work at other galleries, rudely ignoring Stieglitz's long-term and successful efforts—against the greatest odds—to gain support for him.

Under the surface, the relationship between the two men daily becomes more strained, yet the artist placidly continues to come to An American Place, exclaiming that it is the only gallery in which he feels at home. Stieglitz knows just what has been happening, but never makes the painter feel uncomfortable.

Then one day Stieglitz remarks: "It is only an insider who can destroy the Place."

Stieglitz: "What is not generally understood is that if one artist I exhibit sells three thousand dollars' worth of pictures and needs only two thousand, whereas another has received only thirteen hundred and needs two thousand, I feel I have a right to subtract seven hundred and eleven dollars from the first and give it to the second for the time being. The artists agree to this. They name minimum prices acceptable to them for their pictures at the time of exhibitions. I often ask a good deal more, depending on the circumstances. Part of what is received, when more than expected, goes toward upkeep of the gallery, part to others who are in need. If someone does not trust this way of functioning, he does not belong here.

"When Marin has not been able to pay framing bills, I have laid out the money required and taken pictures in exchange. I could say to him now, kindly pay me back and I will return your pictures. I cannot spend energy on that kind of dead exchange nor does Marin expect me to. Each feels life is too short. I never sell what I buy or am given, but I protect it. I am keeping things together that will go to the public in a much more meaningful way than if they were separated."

1936—FROM CONVERSATIONS OVERHEARD AT AN AMERICAN PLACE

A woman and Stieglitz stand before a painting. She explains that she has been at the gallery several times looking at the picture and feels she must have it. Stieglitz asks why.

"I am certain that if I could hang it in our room, my husband would understand, through seeing it, something I have been trying to tell him unsuccessfully for years.

The painting expresses just what I want to say but can't communicate."

"My dear woman, don't you realize what you would be doing? Don't you see that whenever anyone attempts to force something to happen through external means—something that doesn't occur of its own volition—exactly the reverse results? What you will accomplish is to drive your husband even further away. Let me ask you this: Have you ever tried to imagine what it is in your husband that keeps him from understanding what you want him to hear? Did you ever concentrate on finding out what, perhaps, he has wanted to say to you when you fail to reach him?"

A woman stands before paintings by Dove. When she inquires whether he is successful, Stieglitz asks, "In what sense?"

"Do his pictures sell well?"

"What does that have to do with art? The number of pictures liked or sold tells one nothing about the stature of an artist. Thank God, when people look at a rose and marvel at its beauty, they don't have to think about it in terms of an investment."

A number of visitors are at the Place. Stieglitz has been discussing the difficulties the contemporary artist must face. A young girl asks plaintively, "Is there no chance for the artist?"

Stieglitz: "There is one law that, if passed, would be the first to be obeyed by everyone—the Prohibition of Art. A great sigh of relief would be heard throughout the land, as though people were saying, 'Now we don't have to bother with that anymore.' Their burden would be lightened, with no loss felt. Art could be forgotten, it being clear that finally no one really cared about it; that seeming to want it was only the remains of a superstition."

Other visitors laugh. There is a twinkle in Stieglitz's eyes despite the serious implications of what he has said. The girl looks shocked: "I shouldn't feel like that." "No," Stieglitz replies, "not now perhaps, for you are young. When you are older and married, have children and other responsibilities, you too will feel that way. You will see whether or not you'll lift a finger for art. That will be the only proof of your caring."

Sad and eager, the girl inquires, "What can I do so that it won't be that way?" "Nothing," replies Stieglitz, "except what you are doing."

A woman of about fifty looks at a Marin exhibition in bewilderment. She turns to Stieglitz: "Is there someone who can explain these pictures to me? I don't understand them at all. I want to know why they arouse no emotion in me." Before Stieglitz quite realizes what he is saying, he replies, "Can you tell me this: Why don't you give me an erection?"

He walks back into his office. The woman acts as though she isn't quite sure she has heard him correctly. She seems afraid to leave at once. She walks around the Place for a while, stares at the pictures, then flees.

The president and director of a large museum come to discuss with Stieglitz an exhibition of American paintings they plan to hold. They say that Marin and O'Keeffe are to be included. Stieglitz, sensing the way in which the institution functions, asks whether it hopes to show the most representative pictures possible, or to have paintings loaned by wealthy owners?

The president, looking angry, points out that he and his trustees want as many wealthy people to appear in the museum's catalogue as possible.

Stieglitz: "But the best Marins may still be in his possession and the best O'Keeffes in hers. Won't you include the very finest procurable art, irrespective of ownership?"

The president grows increasingly impatient: "Mr. Stieglitz, your way leads nowhere. We want a better building for our museum. We need the names of the rich if we possibly can get them."

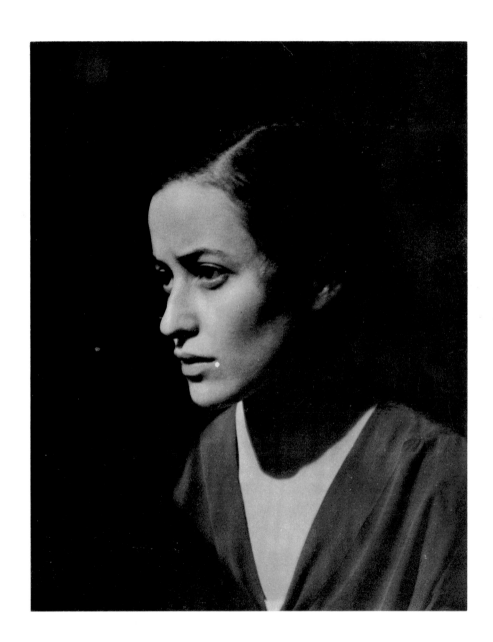

LXIII. Dorothy Norman, 1931

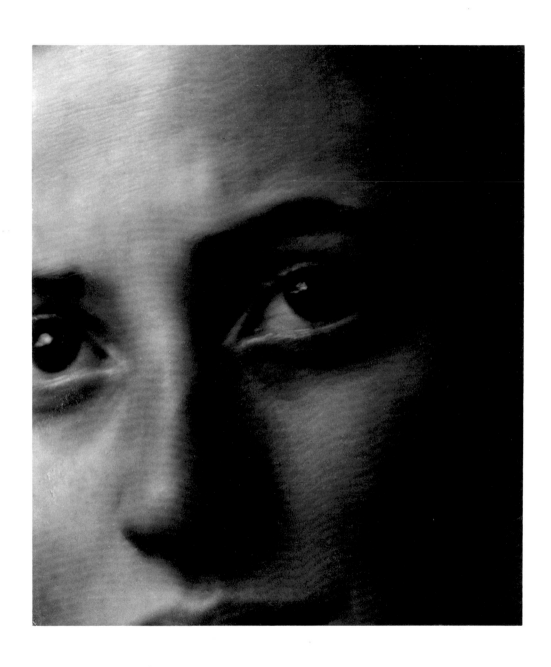

LXIV. 1930

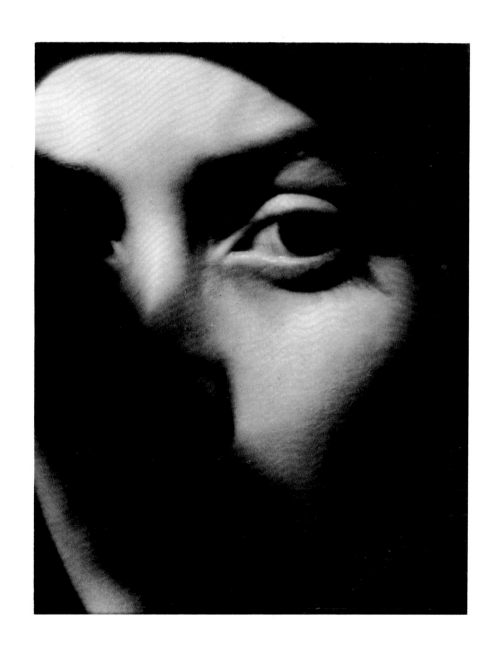

LXV. 1931

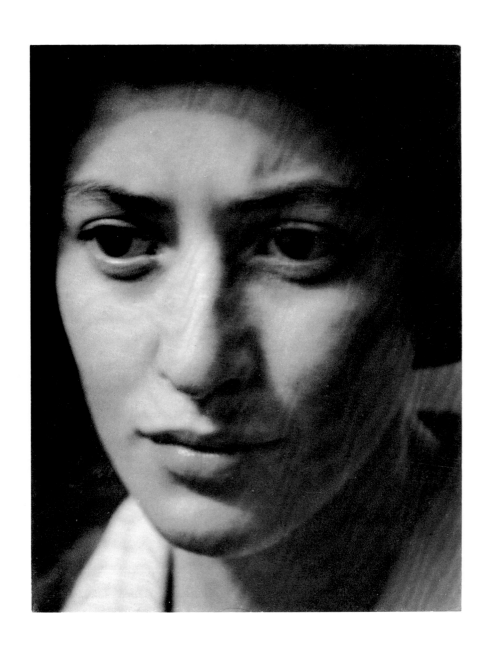

LXVI. 1931

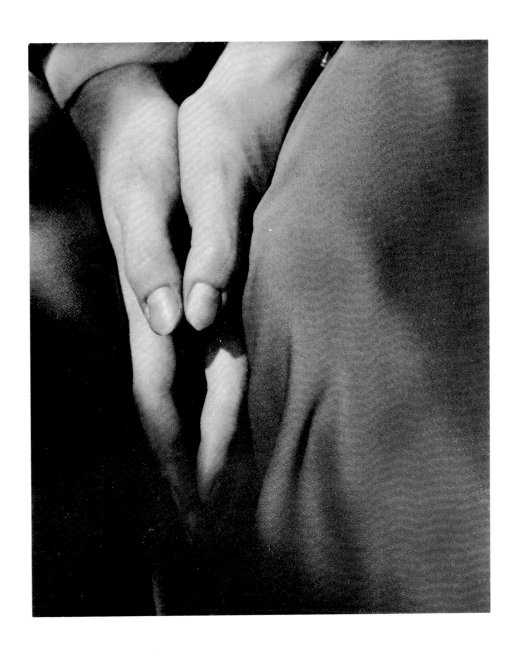

LXVII. Hands, 1932

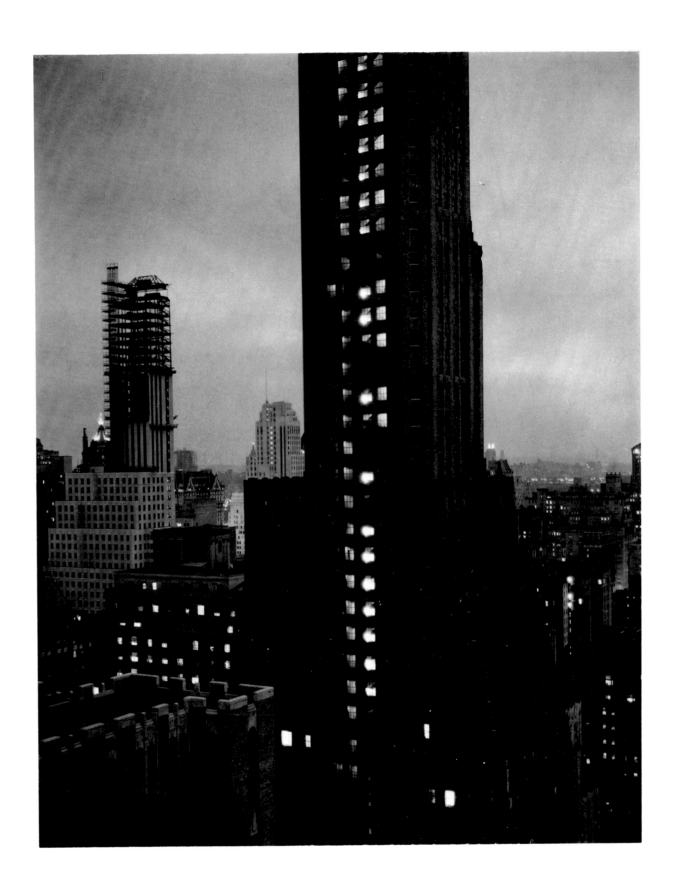

LXVIII. Evening, New York from the Shelton, 1931

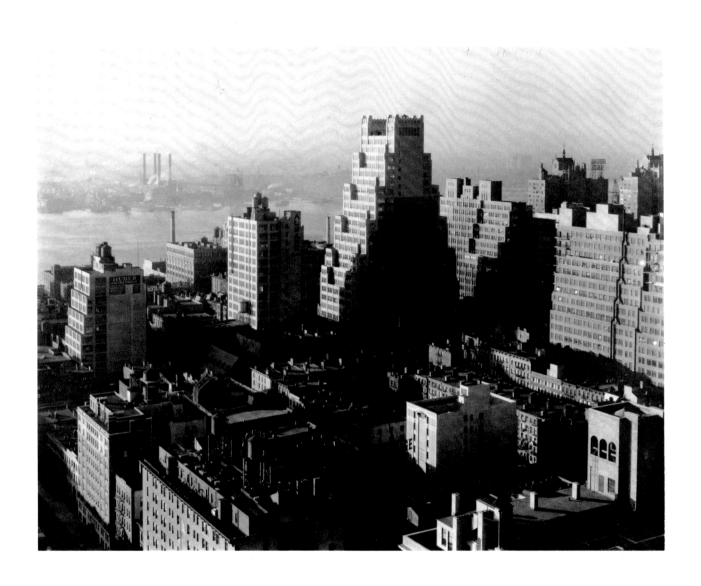

LXIX. From My Window at the Shelton, New York, 1930

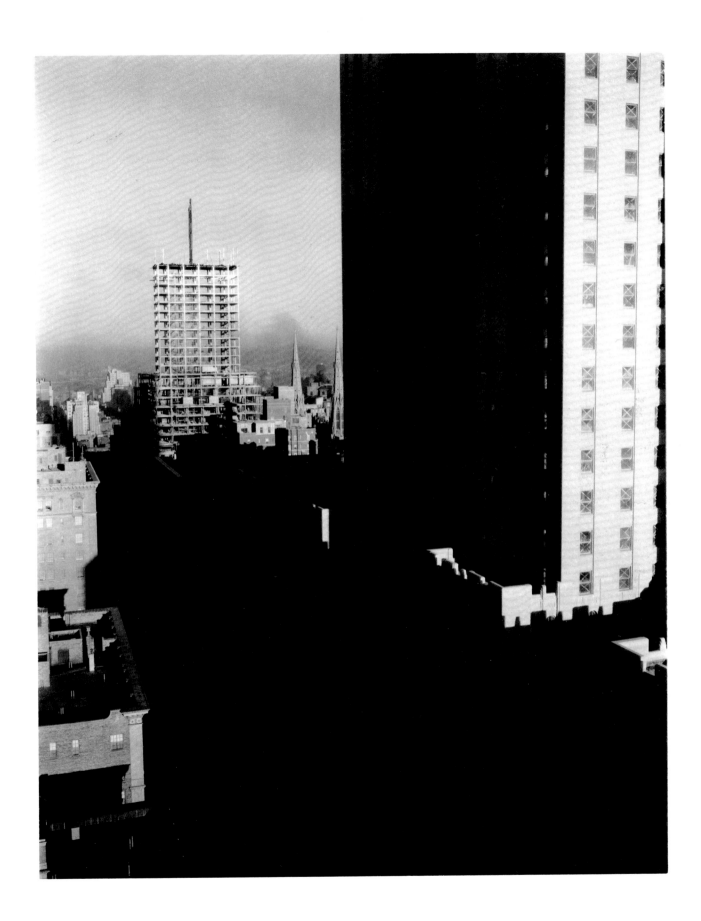

LXX. Looking Northwest from the Shelton, New York, 1932

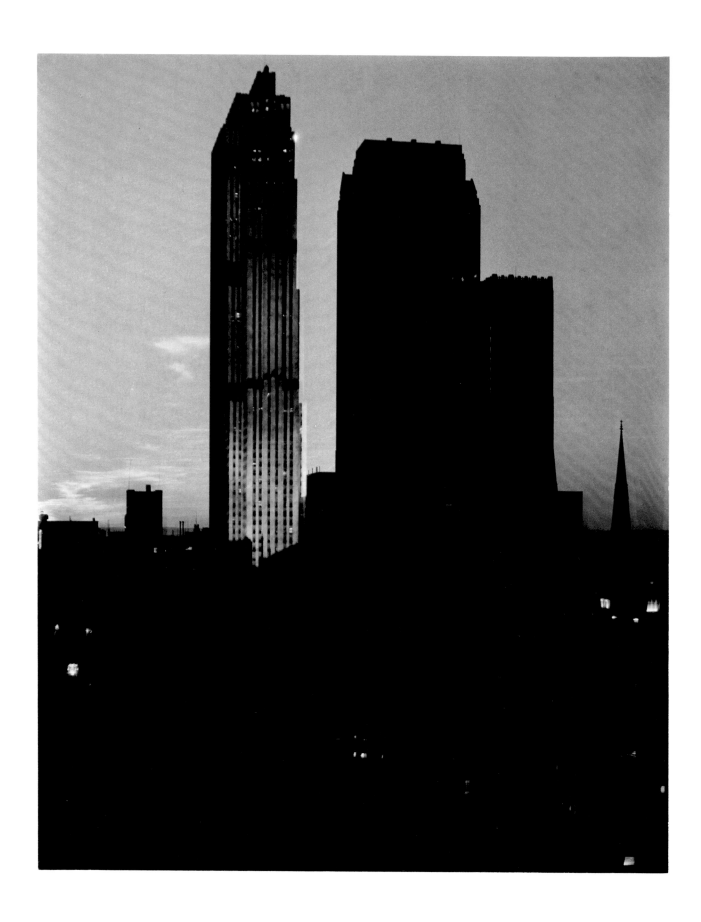

LXXI. New York Series, 1935

LXXII. New York Series, Spring, 1935

LXXIII. Hedge and Grasses, Lake George, 1933

LXXIV. Poplars, Lake George, 1932

LXXV. Tree, Lake George, 1937

LXXVI. Dying and Living Poplars, Lake George, 1932

LXXVII. Equivalent Series 27c, 1935

Stieglitz: "Is this being true to your trust?"

The president stalks out of the room.

A man who has overheard the interchange says to Stieglitz: "Your way of doing things is impractical. It can't work."

Stieglitz: "And I say that the world is in a sorry mess as a result of what you call the practical. If you want to know how I see it, the world is being forced to move closer to my way of doing things rather than I to the world's."

A woman a good deal younger than he is tells Stieglitz the anguish she is undergoing. He replies, "You see, in a sense, I am happy I have lived to be my age, before meeting you at yours. I not only understand all too well what you are going through, but just because I am as old as I am and have had experiences similar to yours, I easily could suggest shortcuts you might take in order to avoid what you otherwise must suffer. But, having reached my age, I know that if I were to mention such shortcuts to you, and you were to follow my advice, everything you would do in its name would go wrong."

1937 — STIEGLITZ OBSERVATIONS

"Whatever you do to satisfy yourself will fulfill those in the world who are like you. What takes form within you will be felt outside of yourself. But if you try to satisfy someone else, you will serve neither that person nor yourself. Thus you will never know any peace. That is the difference between aesthetics and ethics, between the creative and the doing of 'good deeds.' The subconscious pushing through the conscious, trying to live in the light, is like the seed pushing up through the earth. Whatever does not function in such manner is bound to be sterile."

"My daughter once said, 'I wish father would speak of things about which people know something. He is always talking about art and life.' "

"People, even complete strangers, constantly ask me to look at their paintings or photographs or writing. What am I to do? I hate to stand in judgment. Yet I am expected to react. If I cannot follow up my saying with doing, what right have I to speak?

"My first impulse is to state that I will not look at work, but when a person seems woebegone and persists, despite my 'No,' something rises up within me and I can no longer refuse.

"If work seems alive, if there is even a spark of life in it, I am sad, for I know what suffering a pure spirit must undergo. If what I see is dead for me, who am I to say it is bad? A person may be doing something for which he is not equipped. I know the struggle that must be gone through then, too. If I cannot suggest how to remedy the lack I feel, again I am sad. If people only knew what happens when they ask one to look and to pass judgment."

"I say that the world in which one believes is a greater reality than the one that exists."

"I have always been a great believer in *today*. Most people live either in the past or in the future, so that they really never live at all. So many are busy worrying about the future of art or society, they have no time to preserve what *is*. Utopia is in the moment. Not in some future time, some other place, but in the here and now, or else it is nowhere."

"Unless you have respect for a clean wall, you will not be able to see a picture. But the picture itself must stand the test of being seen against the cleanliness of the wall."

"I maintain that if one takes care of 'Photography,' 'Art' will take care of itself."

"What I would like is that when I die, photography should say of me, 'He always treated me like a gentleman.'"

1941–1945: During World War II a woman telephones Stieglitz from one of the city's museums: "You know, Mr. Stieglitz, we are doing a great thing. Have you heard about it?" Stieglitz tells her he has not, that he hears nothing about anything.

"Well," she explains, "you know there are many empty rooms now at our museum. Most of our priceless treasures have been sent to the Middle West for the duration of the war. They will be safe there. As a result we are planning to use a number of rooms for a large exhibit of art by living Americans. Prizes as high as five thousand dollars are being offered. But you haven't sent us any pictures. You surely will let us have some, won't you?"

Stieglitz replies that he will not. The woman responds: "You mean to say you are not going to support us?"

"I mean exactly that. I think what you are planning is simply horrible. You are doing just what I have been fighting against for years. No wonder there is no respect for the artist."

"But Mr. Stieglitz, suppose I were to go directly to the artists whose work you show? They might feel they would let us have something. What then?"

"Well, please get in touch with them. Why bother me?"

The woman implores him: "Don't you think they will let us have something?"

"I don't think at all. Or, if I do, I think your museum's idea is plain awful."

84. Stieglitz, Strand, 1929

"I wonder," Stieglitz remarks after the conversation, "what the museum officials have in their minds. If their most precious treasures have been sent away because of the war, and rooms are to be filled instead with art by living Americans, what is their attitude toward it? Do they feel its being bombed would be of no significance?

"It is during just such a period as this that all art should be made available to the people."

Stieglitz is upset the moment anyone about whom he cares has so much as a common cold. Surely it will develop into pneumonia and the pneumonia will prove fatal. He rushes for a bottle of iodine when he, or anyone, is wounded by a pinpoint yet reacts strongly against hysteria about large issues. He refuses to participate in air raid drills and will not move an inch when asked to engage in them: "I insist upon remaining on the job. I do not believe in leaving what I am doing for a single instant."

He dreads sending works of art out on loan for fear they will be damaged, soiled, but during the entire period of the war he refuses to protect any works of art at the Place by storing them in more trustworthy vaults. Any artist he shows may do so, but he will not. "Let all the art in the world be destroyed. It will arise again, for the art spirit is inherent in man."

One day in 1943 a woman approaches Stieglitz: "I am preparing a book on abstract art. I should like to know about American abstract art of the early period before the Armory Show. I don't wish to exclude American abstract artists, the way so many writers do when dealing with the original abstract movement. I was told you know more about the subject than anyone else. I wonder if you would tell me about the evolution of abstract art in America."

85. Stieglitz, Man Ray, 1912

Stieglitz: "I do not label things in that way. In fact, I do not label anything. I dislike labels."

Woman: "But I want to write a book about the abstract art movement because it is one of the most important developments of the twentieth century. Abstract art has, after all, gone in a certain definite direction. It's about this I wanted to talk to you."

Stieglitz: "What direction?"

Woman: "Well, that is what I want to learn from you."

Stieglitz: "So far as I am concerned, in one sense, all art, all living work, whether in painting or literature or in any other medium, is abstract. The idea of life, of life itself, is abstract in the deepest sense. I just cannot label things the way you do."

Woman: "But, after all, you have to have labels."

Stieglitz: "My dear woman, use all the labels you will, and then go to Sears Roe-

buck after the war. Ask for what you have labeled and they will tell you, 'We don't have those things any longer. We have only the labels left. The war has wiped out all of the objects for which you are looking.' You might say, 'Well, why not give me the labels, at any rate.' And I say to you, I do not know what good they will do you."

Woman: "Well, they would of course be valuable for purposes of identification."

Stieglitz says nothing.

Woman: "This is such an interesting conversation."

Stieglitz says nothing.

A museum curator tells me of borrowing a painting from Stieglitz for an exhibit: "He warned me to be careful so that it wouldn't be harmed. And then the picture was dropped. The frame was damaged. Everyone trembled in fear of what would happen. I said, 'I shall simply take the painting to Stieglitz and say what has occurred. You'll see, everything will be all right.' That is what I did. I hid nothing. I was, of course, tremendously upset. Stieglitz knew it. But because there was caring, he wasn't at all disturbed. Everything with him depends upon how one behaves, how one feels. That is what matters—what influences the way in which he reacts. He couldn't have been nicer about the entire incident. I have always found him completely fair."

A well-known author who has written about Stieglitz with great respect tries to bargain with him about a picture, apparently thinking that their friendship will help. The writer fails and looks disgruntled. While Stieglitz goes to talk with someone who wishes to look at another picture, the author whispers to me maliciously (I have not hitherto heard him speak in such manner) that Stieglitz is vain, loves to talk, to hear himself talk; he enjoys being agreed with, but being disagreed with makes him feel superior too. Stieglitz is a man, says the writer, who can use only one pronoun. He does all the work for shrewd artists who can make more money through having a non-commercial-looking organization.

Meanwhile, in spite of not being well, Stieglitz carries heavy pictures from one room to another in order to show them. I am nonplussed at the author's words and am on the point of helping Stieglitz, for fear he will overstrain himself. The writer places a restraining hand on my arm: "Don't worry. He is playing his own particular game of celestial solitaire."

1946: Stieglitz: "I feel my age not with sadness nor fear, but rather with a growing sense that I am inadequate to the responsibilities I have undertaken. If I show a person's work and cannot follow it up, I become convinced I should not have presented it to begin with. I know that I should never do anything I cannot see through. I try not to.

"Young people come in and complain that I no longer exhibit new painters. They do not understand. They come here and if I am free for the moment, relatively well and those around me are relatively well also, and working, then if I give them my time, they seem to go away with something positive. If they return and I am not free, they think that, although I was interested at first, I no longer am.

"One should not start what one cannot follow through. I have known this principle all my life but, at times, I have permitted myself to be deflected, which is human, but from my point of view, inexcusable.

"I have permitted loose ends to dangle, because I always dreamed there could be a great impersonal working together. It has been proved to me that this cannot be. Thus, in my eighties, I find myself alone and I must tie all ends together myself. I must be at An American Place all day every day. I must be able to hang pictures, no matter how heavy; to carry them to those who wish to see them; to do everything myself that may arise. I dare count on no one, and must save my energy for what I have undertaken. I must start nothing new so that I can at least follow through what I have begun."

86. Stieglitz, Marin, 1935

Stieglitz has been very ill. Someone tells him how well he looks. Stieglitz: "That is quite wonderful. It would be superb to die, and upon entering Heaven, have the Lord greet one with, 'My, but you are looking well.'"

A visitor asks Stieglitz about his attitude toward life. Stieglitz: "Man, can't you figure it out for yourself? I am trying to sustain life at its highest, to sustain a living standard for the artist, to permit every moment to live, without isms, fashions or cults attached. This Place is a living center even when it is deserted. I do not claim this in a vacuum. People tell it to me. Otherwise what I say would have no meaning. Everything connected with this Place and with what you see here is rooted in its vital center. I don't hold exhibitions as they are held elsewhere, to make money or so that art can lie in state. There are no pictures here just because they are pictures. What is at stake is nobility, but how many individuals recognize that there is such a thing?"

A final note to myself at the Place: I must finish what I have set out to do: prepare something of a record of Stieglitz's life, set straight various facts that continue to be reported incorrectly; make Stieglitz's way of seeing things, telling them, more available. While doing this I feel constantly trapped. There is an outer story—long; an inner one—short. As people come to see the exhibits here or to see Stieglitz, as they talk of the pictures, or Stieglitz cuts through what is being said to tell of some simple event in his life, I want at moments to explode: "This place is born of love. This man is here all day, every day. He would stay all night. He asks for nothing. He speaks of love and truth, of the sacred and of that which transcends commonplace language. The pictures on the walls come close to him in their speaking and he fights for the artists who have made them. The pictures are, in reality, a point of contact. The biggest thing here is Stieglitz himself. No, he cannot tell the whole truth. But the integrity of his prints, of his work in all of its phases is absolute. Listen to his way of seeing: look at it. Look at his photographs one by one. Look at his love pouring out of him into them, into everything he does. That is what this is all about. What artist gives so much of himself to other artists—to everyone?

"Look again at the little picture of him as a child with the photograph tucked in his belt, listen again to the early story of his boyish staring in wonder at the lady in black. He has said it often, 'The more beautiful an experience, the less it can be told.' When he is gone, there will be no Place, even if there is art here and the space. Meanwhile his life exudes the power to make people reach out toward achieving the impossible—the point beyond the center of the center of the target. For he knows always that without losing oneself to something beyond, one is bound to be disappointed."

Those who have worked with Stieglitz over a long period of time know the continuing generosity and trust of the man. He could write today, as he did in 1923 to Sherwood Anderson: "All humans represent a Great Innocence to me— and that is the wonder I see. . . . All Innocent when I'm alone with Each—All equally wonderful. That's my madness to *feel that*. Not as theory. Not as attitude. But just to feel *that* exists and nothing more. Innocent as the trees are innocent."[1]

87. A.S. Hands, Norman, 1945

Or, under similar circumstances, he could say today what he did to Paul Rosenfeld in 1922, when Rosenfeld wanted to dedicate a book to his work: he would be delighted to accept the honor but, "We all teach each other, that's the sum total of everything. . . . I have no more to give than you have to give me."[2] Or the following year to Hart Crane: "We're all after Light—ever more Light. So why not seek it together—as individuals in sympathy in a strong unsentimental spirit—as men—not as politicians."[3]

Or again to Mabel Luhan in 1929, he wrote that his finer side had "not helped people—for I never feel the need of 'helping'—I merely let live,"[4] and in 1913 to Gertrude Stein: "I have created conditions in which occasionally something happened for others. . . . I shall continue doing this for others as long as I can."[5]

228 He still can and he still does.

During the last years of his life, there was at the Place an army cot on which Stieglitz rested and from which he often greeted and spoke with visitors. Heart attacks occurred with ever greater frequency. Stieglitz dreaded neither pain nor death but missing a single day at his post. Whatever the physical or spiritual agonies he suffered, his enthusiasms remained infectious to the end, his extraordinary sensibility maintaining the power to make any center over which he presided come mysteriously alive. He never ceased to inspire nor to challenge. It was those devoid of the capacity for awe, those bent upon destruction and bargaining—the coldly objective, theoretical and negative—who aroused his ire. But then he never pretended to be a saint.

88. Stieglitz, Norman, 1935

When Stieglitz went to Lake George during the summer of 1945 at the age of eighty-one he spoke again and again of missing An American Place in spite of the joy of breathing pure air. He missed the Place's pristine quality. Young America continued to come there and to interest him greatly, deeply. He liked its reactions. He liked what he saw and heard.

He wrote and said often that he hoped when he died the walls at An American Place would be bare, clean. Yet his most fervent wish was not to live if it were no longer possible to have the Place open both day and night, to be available at whatever the hour for those who needed what he was or represented.

Until the week of his death in July, 1946, he was "on deck" at An American Place. It so happened the walls were bare when he died.

Stieglitz added his words and his song to the great tradition. In putting down what moved him, he revealed himself. In giving a portrait of himself to mankind, he became mankind, as he became the organ grinder, the streetsweeper and tree and wet New York; the footprints in the snow and the rain itself; the arc-lit streets and the artists he showed. The woman with the all-giving body, staring into eternity; the woman with eyes looking straight into you—seemingly withdrawn. There have been the exact proportions and tensions. The anecdote, the parable, the deed in their variations have proceeded in classic line. Ahead of his time, he was timeless.

No black without white, white without black. No life without death. There has been the purity of a hunger to give life, the strength of imparting strength, translated into concrete form. Job blessing the Lord who bestoweth and taketh away. Because the man so respected his medium and himself, because he saw deeply with love, his work lives.

Stieglitz said of himself: "At least it can be said of me, by way of an epitaph, that I cared."

1833 Edward Stieglitz, father of Alfred born Hanover Münden, Germany. Came to America, 1849; became apprentice in making of mathematical instruments. Fought in Civil War; subsequently entered woolen business.

1844 Hedwig Werner, mother of Alfred, born Offenbach, near Frankfurt am Main, Germany. Brought to America by parents at age of eight.

1862 Edward Stieglitz and Hedwig Werner married, December 21.

1864 Alfred Stieglitz born, Hoboken, New Jersey, January 1. Within next seven years two brothers and three sisters born: Flora; twins, Leopold and Julius; Agnes, and Selma. Stieglitz family lived first on Washington, then on Garden Street, Hoboken.

1871 Family moved to 14 East 60th Street, Manhattan.

1871–79 Alfred attended private school, Charlier Institute, New York City, then public school.

1872 Showed first interest in photography.

1874 During summer, Edward Stieglitz took Alfred to Lake George, New York, for first time.

1875–80 Edward brought family to Fort William Henry Hotel, Lake George. Subsequently, rented cottage outside grounds of hotel and then cottage on opposite side of lake.

1879–81 Alfred attended City College, New York.

1881 Edward Stieglitz retired from business; took entire family to Europe. Alfred studied at Realgymnasium, Karlsruhe, Germany.

1882–90 Studied at Berlin Polytechnic and University of Berlin. Took mechanical engineering courses.

1883 Bought first camera. Entered Professor Hermann Wilhelm Vogel's classes in photochemistry. Began to concentrate on photography; abandoned engineering.

1880s Took courses in anthropology and history; attended lectures by noted scientist-professors at University of Berlin, including Hermann von Helmholtz, Emil Du Bois-Reymond, Rudolf Virchow, Karl Liebermann and August Wilhelm von Hofmann. Traveled and photographed exten-

sively in Italy, Germany, Switzerland, Austria. His roommates in Berlin were from New York: Joseph Obermeyer and Louis Schubart.

1885 Began to contribute articles to German photographic publications.

1886 Edward and Hedwig returned to America with daughters. Alfred and brothers remained in Europe. Julius studied chemistry, Leopold medicine.

1887 Alfred's first official recognition in photographic world: won first prize (silver medal and two guineas) in "Holiday Work Competition" of The Amateur Photographer (London). After this date won more than hundred and fifty medals in rapid succession, whereupon fought system of awarding prizes.

1888 Alfred, Leopold and Julius came to America for summer. Visited family at new summer home, Oaklawn, Lake George. Returned to Europe to continue studies.

1890 Alfred called back to America by parents in July, after death of sister Flora in California. Entered photoengraving business with Joseph Obermeyer and Louis Schubart. Alfred resided in New York City for remainder of his life.

1891 Joined Society of Amateur Photographers.

1893 Married Emmeline Obermeyer (born, New York, 1873). Became an editor of American Amateur Photographer. Beginning at this time his experimental work advanced both art and science of photography. (When Stieglitz returned to New York from Europe in 1890 he lived with his parents at 14 East 60th Street. After his marriage, he and Emmeline first stayed at the Savoy Hotel, then at the home of Alfred's brother, Leopold, on East 65th Street. Next they rented an apartment at 1111 Madison Avenue.)

1894 Summer trip to Europe. Invited to become one of first American members of Linked Ring (advance-guard British photographic society).

1895 Withdrew from business. For some years Alfred and Emmeline spent summers in Long Branch, West End, Elberon, Edgemere, Deal and other resorts near New York City. Alfred went occasionally to Lake George.

1896 Resigned editorship of American Amateur Photographer. Society of Amateur Photographers amalgamated with New York Camera Club.

1897–1902 Edited Camera Notes. Organized numerous group photographic exhibits.

1897 Picturesque Bits of New York, portfolio of photogravures by Stieglitz, published by R. H. Russell, New York.

1898 Daughter, Katherine, born to Alfred and Emmeline.

1899, 1901 Two portfolios, American Pictorial Photography, published by New York Camera Club under Stieglitz's supervision.

1899 Exhibition of his photographs presented at Camera Club.

1900 Resigned as vice-president of Camera Club.

1902 Resigned as editor, Camera Notes. Accepted National Arts Club invitation to arrange group exhibit of photographs. Founded Photo-Secession and planned independent publication, Camera Work.

1902–10 Organized Photo-Secession exhibitions shown in United States and abroad.

1903–17 Published and edited Camera Work: first issue dated January, 1903.

1904 Summer trip to Europe.

1905 Photo-Secession Galleries founded. (See Appendix for complete list of exhibitions.)

1907 Summer trip to Europe.

1908 Photo-Secession Galleries became known as 291. Public introduction there of European modern art in United States. Stieglitz expelled from Camera Club, reinstated, resigned.

1909 Modern American art shown at 291 for first time. Summer trip to Europe. Edward Stieglitz died.

1910 International Exhibition of Pictorial Photography, arranged by Photo-Secession—its final formal undertaking—Albright Art Gallery, Buffalo.

1911 Stieglitz made last trip to Europe in summer.

1912 First to accept for publication writing by Gertrude Stein.

1913 Honorary Vice-President, International Exhibition of Modern Art (Armory Show), 69th Regiment

231

Armory, New York City. Held retrospective exhibit of own photographs at 291 (his only one-man show there) during Armory Show.

1915-16 Magazine *291* published under Stieglitz's auspices.

1916 Stieglitz met Georgia O'Keeffe for first time.

1917 Gallery 291 and *Camera Work* terminated.

1918 When O'Keeffe came to New York in 1918, she and Stieglitz used studio belonging to his niece, Elizabeth Davidson—Leopold's daughter—until 1920, then lived in Leopold's house on East 65th Street until 1924. Moved to studio apartment at 38 East 58th Street, then to Shelton Hotel, next to apartment at 405 East 54th Street, finally to one at 59 East 54th Street. Beginning in 1918 Stieglitz and O'Keeffe spent summers at Lake George, which Stieglitz continued to do until 1945. After 1929 O'Keeffe spent approximately half of each year in New Mexico.

1921 Stieglitz held one-man show of own photographs at Anderson Galleries.

1922 Hedwig Stieglitz died. Soon thereafter Oaklawn was sold, but house and property on hill were retained by Stieglitz family.

1922-23 Publication *MSS* issued under Stieglitz's auspices.

1923 Stieglitz held one man show of own photographs, Anderson Galleries. Katherine Stieglitz married Milton Stearns, Jr. of Boston.

1924 Stieglitz and Georgia O'Keeffe married. Stieglitz held exhibit of own photographs, Anderson Galleries. Royal Photographic Society of Great Britain awarded him Progress Medal "for services rendered in the founding and fostering of pictorial photography in America, and particularly for his initiation and publication of 'Camera Work,' the most artistic record of photography ever attempted." Boston Museum of Fine Arts "opened its doors" for first time to photography—the prints of Stieglitz—on same basis as other recognized art forms.

1925 Stieglitz founded The Intimate Gallery. (For complete list of exhibitions, see Appendix.)

1928 Metropolitan Museum of Art's first acquisition of photographs as a fine art: prints by Stieglitz.

1929 The Intimate Gallery closed. Stieglitz established An American Place. (For complete list of exhibitions, see Appendix.)

1931 Published *Letters of John Marin*, edited by Herbert J. Seligmann, An American Place.

1932 Held one man show of own photographs, An American Place.

1932–37 Published various pamphlet series, *It Must Be Said, It Has Been Said*, etc., An American Place.

1933 Published *Dualities*, a volume of poems by Dorothy Norman, An American Place. Metropolitan Museum of Art received important

segment of Stieglitz's collection of work by other photographers.

1934 *America and Alfred Stieglitz*: A Collective Portrait, edited by Waldo Frank, Lewis Mumford, Dorothy Norman, Paul Rosenfeld, Harold Rugg; published by Doubleday, Doran and Company (Literary Guild Selection). Stieglitz exhibited own photographs, An American Place.

1935 Cleveland Museum of Art received anonymous gift of Stieglitz photographs.

1937 Stieglitz received Townsend Harris medal, for "conspicuous post-graduate achievement," from Associated Alumni of City College. After this date, due to repeated illness, made few photographs and was able to do little printing.

1940 Awarded Honorary Fellowship by Photographic Society of America.

1941 Museum of Modern Art's first acquisition of photographs by Stieglitz.

1942 Museum of Modern Art exhibition of its Stieglitz photographs.

1944 Selections from Stieglitz's collection of paintings and photographs, "History of an American. Alfred Stieglitz: '291' and after," shown at Philadelphia Museum of Art, arranged by Carl Zigrosser and Henry Clifford.

1946 Stieglitz died, July 13, New York. (His ashes were buried at Lake George near an undesignated pine tree on the family property.)

APPENDIX

A. EXHIBITIONS HELD AT THE GALLERY OF THE PHOTO-SECESSION, 291 FIFTH AVENUE, NEW YORK—1905–17

Dates*	Photographic Exhibitions	Non-Photographic Exhibitions
November 24, 1905—January 5, 1906	Members' Work: Jeanne E. Bennett, Alice Boughton, Annie W. Brigman, John G. Bullock, A. L. Coburn, Sydney Carter, Mary Devens, W. B. Dyer, J. M. Elliot, Frank Eugene, Herbert G. French, W. F. James, F. D. Jamieson, Gertrude Käsebier, Joseph T. Keiley, M. R. Kernochan, J. B. Kerfoot, C. A. Lawrence, Helen Lohman, William J. Mullins, Jeanne E. Peabody, Fred H. Pratt, W. B. Post, Landon Rives, H. C. Rubincam, Eva Watson-Schütze, Sarah C. Sears, Katharine A. Stanbery, Mary R. Stanbery, Eduard J. Steichen, Alfred Stieglitz, W. P. Stokes, J. F. Strauss, Orson Underwood, Mary Vaux, S. S. Webber, Clarence H. White, W. E. Wilmerding, S. L. Willard	

Dates*	Photographic Exhibitions	Non-Photographic Exhibitions
January 10–24, 1906	French Work: Maurice Brémard, G. Besson, Robert Demachy, Georges Grimprel, A. Hachette, Celine Laguarde, René Le Bègue, C. Puyo	
January 26–February 2, 1906	Herbert G. French	
February 5–19, 1906	Gertrude Käsebier, Clarence H. White	
February 21–March 7, 1906	British Work: D. O. Hill, J. Craig Annan, Frederick H. Evans	
March 17–April 5, 1906	Eduard J. Steichen (c)	
April 7–28, 1906	Austrian and German Work: Heinrich Kühn, Hugo Henneberg, Hans Watzek, Theodore and Oscar Hofmeister	
November 8, 1906–January 1, 1907	Members' Work	
January 5–22, 1907		Drawings: Pamela Colman Smith
January 25–February 12, 1907	Baron A. de Meyer, George H. Seeley	
February 19–March 5, 1907	Alice Boughton, William B. Dyer, C. Yarnall Abbott	
March 10–April 10, 1907	Alvin Langdon Coburn	
November 18–December 30, 1907	Members' Work (c)	
January 2–21, 1908		Drawings: Auguste Rodin
February 7–25, 1908	George H. Seeley	
February 26–March 11, 1908		Etchings and Book-Plates: Willi Geiger; Etchings: D. S. McLaughlan; Drawings: Pamela Colman Smith
March 12–April 2, 1908	Eduard J. Steichen (c)	
April 6–27, 1908		Drawings, Lithographs, Watercolors, Etchings: Henri Matisse
December 1–30, 1908	Members' Work	
January 4–16, 1909	J. Nilsen Laurvik (c)	Caricatures: Marius De Zayas
January 18–February 1, 1909	Alvin Langdon Coburn	
February 4–22, 1909	Baron A. de Meyer (c)	
February 26–March 15, 1909		Etchings, Dry-points, Book-Plates: Allen Lewis
March 16–27, 1909		Drawings: Pamela Colman Smith
March 30–April 17, 1909		Oils: Alfred Maurer; Watercolors: John Marin
April 21–May 7, 1909	Eduard J. Steichen	
May 8–18, 1909		Oils: Marsden Hartley
May 18–June 2, 1909		Japanese Prints from the F. W. Hunter Collection: Shiba Kokan, Suzuki Harunobu, Ippitsusai Buncho, Katsukawa Shunsho, Kitagawa Utamaro, Toshiusai Sharaku, Utagawa Toyokuni, Katsushika Hokusai
November 24–December 17, 1909		Monotypes, Drawings: Eugene Higgins
December 20, 1909–January 14, 1910		Lithographs: Henri de Toulouse-Lautrec
January 21–February 5, 1910	Eduard J. Steichen (c)	
February 7–25, 1910		Water-colors, Pastels, Etchings: John Marin
February 27–March 20, 1910		Drawings, Photographs of Paintings: Henri Matisse

233

Dates*	Photographic Exhibitions	Non-Photographic Exhibitions
March 21–April 15, 1910		Paintings, Sketches: Younger American Painters: G. Putnam Brinley, Arthur B. Carles, Arthur Dove, Lawrence Fellows, Marsden Hartley, John Marin, Alfred Maurer, Eduard Steichen, Max Weber
March 31–April 18, 1910		Drawings: Auguste Rodin
April 26, 1910–indefinitely		Caricatures: Marius De Zayas
November 18–December 8, 1910		Lithographs: Paul Cézanne, Auguste Renoir, Edouard Manet, Henri de Toulouse-Lautrec; Drawings: Auguste Rodin; Paintings and Drawings: Henri Rousseau
December 10, 1910–January 8, 1911		Drawings, Etchings: Gordon Craig
January 11–31, 1911		Paintings, Drawings: Max Weber
February 2–22, 1911		Water-colors: John Marin
March 1–25, 1911		Water-colors: Paul Cézanne
March 28–April 25, 1911 (extended)		Drawings, Water-colors: Pablo Picasso
November 18–December 8, 1911		Water-colors: Gelett Burgess
December 18, 1911–January 15, 1912	Baron A. de Meyer	
January 17–February 3, 1912		Paintings: Arthur B. Carles
February 7–26, 1912		Paintings, Drawings: Marsden Hartley
February 27–March 12, 1912		Paintings: Arthur G. Dove
March 14–April 6, 1912		Sculpture, Drawings: Henri Matisse
April 11–May 10, 1912		Work: Untaught children aged two to eleven
November 20–December 12, 1912		Caricatures: Alfred J. Frueh
December 15, 1912–January 14, 1913		Paintings, Drawings: Abraham Walkowitz
January 20–February 15, 1913		Water-colors, Oils: John Marin
February 24–March 15, 1913	Alfred Stieglitz	
March 17–April 5, 1913		Studies: Francois Picabia
April 8–May 20, 1913		Caricatures: Marius De Zayas
November 19, 1913–January 3, 1914		Drawings, Pastels, Water-colors: Abraham Walkowitz
January 12–February 14, 1914		Paintings: Marsden Hartley; Bronze: Arnold Rönnebeck
February 18–March 11, 1914		Drawings: Untaught Children (Second Exhibition)
March 12–April 1, 1914		Sculpture: Constantin Brancusi
April 6–May 6, 1914		Paintings, Drawings: Frank Burty
November 3–December 8, 1914		African Sculpture
December 9, 1914–January 11, 1915		Drawings, Paintings: Pablo Picasso, Georges Braque; Archaic Mexican Pottery, Carvings; "Kalogramas": Torres Palomar
January 12–26, 1915		Paintings: Francis Picabia
January 27–February 22, 1915		Paintings: Marion H. Beckett, Katharine N. Rhoades
February 23–March 26, 1915		Water-colors, Oils, Etchings, Drawings: John Marin
March 27–April 17, 1915		Work: Children (Third Exhibition)
November 10–December 7, 1915		Paintings, Drawings: Oscar Bluemner
December 8, 1915–January 18, 1916		Sculpture, Drawings: Elie Nadelman

234

Dates*	Photographic Exhibitions	Non-Photographic Exhibitions
January 18 – February 12, 1916		Water-colors: John Marin
February 14 – March 12, 1916		Drawings, Water-colors: Abraham Walkowitz
March 13 – April 3, 1916	Paul Strand	
April 4 – May 22, 1916		Oils: Marsden Hartley
May 23 – July 5, 1916		Drawings: Georgia O'Keeffe; Water-colors, Drawings: Charles Duncan; Oils: René Lafferty
November 22 – December 20, 1916		Water-colors, Drawings: Georgia S. Engelhard, Ten Years Old; Paintings, Drawings: Marsden Hartley, John Marin, Abraham Walkowitz, S. Macdonald Wright, Georgia O'Keeffe
December 27, 1916 – January 17, 1917		Water-colors: Abraham Walkowitz
January 22 – February 7, 1917		Paintings: Marsden Hartley
February 14 – March 3, 1917		Water-colors: John Marin
March 6 – 17, 1917		Paintings, Drawings, Pastels: Gino Severini
March 20 – 31, 1917		Water-colors, Drawings, Oils: S. Macdonald Wright
April 3 – May 14, 1917		Water-colors, Drawings, Oils: Georgia O'Keeffe

*Dates of exhibitions have been taken from 291 catalogues and compared with issues of **Camera Work** published after the exhibitions had closed.
(c) = color photographs included
Note: Among the artists whose work could be seen at 291 at various times, although it was never formally exhibited or catalogued: Kandinsky, Manolo, Felicien Rops, Théophile Steinlen, and Man Ray.

B. STIEGLITZ COLLECTIONS OF PHOTOGRAPHIC BOOKS (1923) AND OF PHOTOGRAPHS BY OTHERS (1933)

Stieglitz's photographic books and his collection of photographs by others were "given" to the Metropolitan Museum of Art in 1923 and 1933, respectively. There were moments when his dislike of being burdened by "property" he had no means of protecting overwhelmed him. He seemed at such times to blame the entire world for "not caring," often making extreme threats and performing drastic and uncharacteristic acts when he sensed that something precious to him was endangered.

Stieglitz: "Through the kindness of Mitchell Kennerley, after 291 closed, my library containing innumerable books on photography—rare ones—was housed in the Anderson Galleries in a small room given to me for the purpose. When Kennerley needed the space at the end of 1922, I ordered all the books thrown on the street, to be carted away.

"Carl Zigrosser, of the Weyhe Gallery, passed by at just that time and so discovered what was happening. He telephoned Mr. William Clifford, the Librarian of the Metropolitan Museum, to tell him what I was doing.

"Zigrosser came rushing back to me. He asked me to wait before having the books removed. The Metropolitan, he said, was sending down its wagon to get them, so that they could be installed in the Museum library. I laughed, 'Do with them whatever you like.' So the books went to the Metropolitan. I have never been in its library, so have never seen them there."

By 1933 Stieglitz had filled vaults in the Lincoln Storage Company with the large and important collection of photographs he had been buying for years: "The collection included work by such Americans as Steichen, Clarence White, Frank Eugene; by Robert Demachy of Paris; Henneberg and Watzek—both Viennese; Heinrich Kühn of Innsbruck; Craig Annan of Glasgow; Baron de Meyer and quite a few other representative photographers of the period.

"When buying prints, always the best of their kind, I hoped some day to give them to a photographic working center. I had the dream for years that there might be a museum devoted to photography in all of its manifestations.

"Finally I saw no sense in paying storage bills year in, year out, once I no longer had hope there could be a place in which the collection would function as I believed it should, in order to be of living significance.

"One fine day I went to the Lincoln Warehouse to see about taking the collection from the vaults. On my way back, again by coincidence, I ran into Zigrosser. I told him it was my intention to destroy the entire collection, probably the most important of its kind in the world. (It did not include my own prints.) The pictures I had accumulated with such idealistic intent had become meaningless to me. Zigrosser asked would I mind if he again phoned the Metropolitan Museum.

"The photographs had hardly been deposited at An American Place when the assistant to William Ivins, Curator of Prints at the Metropolitan, appeared. (Ivins was in Europe.) The woman who came had no authority, but said she believed the Museum would cart away the collection and gladly receive it.

"I told her if she would see to it that the prints were out of my sight within forty-eight hours, I did not care what was done

with them. But it must distinctly be understood that the collection was not a gift of mine to the Museum. If taken, the pictures must be looked upon as having been salvaged from the garbage heap.

"Twenty-four hours later Ivins' assistant phoned that a wagon was coming and that the Metropolitan would take the prints. I wrote a letter reiterating what I had said, that under no condition was the collection to be looked upon as a gift from me.

"The photographs were called for, all but a few that I still have, including the famous print of J. P. Morgan by Steichen. I sighed with relief when the collection was gone, even though another dream had come to an end.

"Imagine my surprise when about a year later I received a handsome parchment diploma from the Metropolitan announcing that I had been made a Fellow of the Museum in perpetuity.

"Wondering what the phrase meant, I looked it up in the Museum's book. I found it referred to a person who gives the Museum a donation of at least five thousand dollars and that such a Fellowship can be handed down to a successor. I laughed.

"The Museum had refused to take me at my word. What would it have given me, I wonder, had I offered the collection at the Museum's own valuation? That question will always remain unanswered."

C. SOME SPECIAL EXHIBITIONS ARRANGED BY STIEGLITZ AT THE ANDERSON GALLERIES — 1921–25

Dates	Artists
1921	Stieglitz — Photographs
1923	Stieglitz — Photographs O'Keeffe — One Hundred Pictures
1924	Simultaneous Exhibitions of Stieglitz Photographs and O'Keeffe Paintings
1925	Seven Americans: Marin, O'Keeffe, Demuth, Dove, Hartley, Strand, Stieglitz — Paintings, Photographs

D. EXHIBITIONS HELD AT THE INTIMATE GALLERY, ROOM 303, 489 PARK AVENUE, NEW YORK — 1925–29

Dates	Exhibitions
December 7, 1925 — January 11, 1926	John Marin
January 11 — February 7, 1926	Arthur G. Dove
February 11 — April 3, 1926	Georgia O'Keeffe
April 5 — May 2, 1926	Charles Demuth
November 9, 1926 — January 9, 1927	Marin
January 11 — February 27, 1927	O'Keeffe
March 9 — April 14, 1927	Gaston Lachaise (sculpture)
November 9 — December 11, 1927	Marin
December 12, 1927 — January 7, 1928	Dove
January 9 — February 27, 1928	O'Keeffe
February 28 — March 27, 1928	Oscar Bluemner
March 27 — April 17, 1928	Peggy Bacon (pastels and drawings)
April 19 — May 11, 1928	Francis Picabia
November 14 — December 29, 1928	Marin
January 1 — 31, 1929	Marsden Hartley
February 4 — March 17, 1929	O'Keeffe
March 19 — April 7, 1929	Paul Strand (photographs)
April 9 — 28, 1929	Dove
April 29 — May 18, 1929	Demuth

E. EXHIBITIONS HELD AT AN AMERICAN PLACE, ROOM 1710, 509 MADISON AVENUE, NEW YORK — 1929–46

Dates	Exhibitions
December 1929 — January, 1930	John Marin
February — March, 1930	Georgia O'Keeffe
March — April, 1930	Arthur G. Dove
April — May, 1930	Retrospective Exhibition: Charles Demuth, Dove, Marsden Hartley, Marin, O'Keeffe
November, 1930	Marin
December, 1930 — January, 1931	Hartley
January — February, 1931	O'Keeffe
March — April, 1931	Dove

Dates	Exhibitions
April—May, 1931	Demuth
May, 1931	Group Show: Demuth, Dove, Hartley, Marin, O'Keeffe
October—November, 1931	Marin
December, 1931—February, 1932	O'Keeffe
February—March, 1932	Alfred Stieglitz (photographs)
March—April, 1932	Dove
April—May, 1932	Paul Strand (photographs) Rebecca Strand (paintings on glass)
May, 1932	Impromptu Exhibition: Demuth, Dove, Hartley, Marin, O'Keeffe
October, 1932	S. Macdonald Wright
November—December, 1932	Marin
January—March, 1933	O'Keeffe
March—April, 1933	Dove, Helen Torr
May, 1933	Selected Early Works: Dove, Marin, O'Keeffe
October—November, 1933	Twenty-five Years of John Marin—1908—1932
December, 1933—February, 1934	Marin
January—March, 1934	O'Keeffe
April—June, 1934	Dove
November—December, 1934	Marin
December, 1934—January, 1935	Stieglitz (photographs)
January—March, 1935	O'Keeffe
March—April, 1935	George Grosz
April—May, 1935	Dove
October, 1935—January, 1936	Marin
January—February, 1936	O'Keeffe
February—March, 1936	Robert C. Walker
March—April, 1936	Hartley
April—May, 1936	Dove
October—November, 1936	William Einstein, Ansel Adams (photographs)
November—December, 1936	Group Show: Demuth, Dove, Hartley, Marin, O'Keeffe, R. Strand (paintings on glass)
January—February, 1937	Marin
February—March, 1937	O'Keeffe
March—April, 1937	Dove
April—May, 1937	Hartley
October—December, 1937	Beginnings and Landmarks: "291" 1905—1917
December, 1937—February, 1938	O'Keeffe
February—March, 1938	Marin
March—May, 1938	Dove
November—December, 1938	Marin
December, 1938—January, 1939	Eliot Porter (photographs), Demuth
January—March, 1939	O'Keeffe
April—May, 1939	Dove
October—November, 1939	Beyond All "Isms" 30 Selected Marins (1908—1938)
December, 1939—January, 1940	Marin
February—March, 1940	O'Keeffe
March—May, 1940	Dove
October—December, 1940	Group Exhibition: Dove, Marin, O'Keeffe
December, 1940—January, 1941	Marin
January—March, 1941	O'Keeffe
March—May, 1941	Dove
October—November, 1941	Group Exhibition: Dove, Marin, O'Keeffe, Pablo Picasso (collage, etching, charcoal), Stieglitz (photographs)
December, 1941—January, 1942	Marin
February—March, 1942	O'Keeffe
March—April, 1942	Pertaining to New York, Circus and Pink Ladies: Marin
April—May, 1942	Dove
November, 1942—January, 1943	Marin

Dates	Exhibitions
February—March, 1943	Dove
March—May, 1943	O'Keeffe
November, 1943—January, 1944	Marin
January—March, 1944	O'Keeffe
March—May, 1944	Dove
November, 1944—January, 1945	Marin
January—March, 1945	O'Keeffe
May—June, 1945	Dove
November, 1945—January, 1946	Marin
February—March, 1946	O'Keeffe
April, 1946	Marin
May—June, 1946	Dove

Note: In the early thirties Stieglitz showed Henwar Rodakiewicz's first experimental motion picture at An American Place: Portrait of a Young Man.

F. THE STIEGLITZ COLLECTION AND ARCHIVE—POSTHUMOUS EXHIBITIONS, TRIBUTES

Stieglitz's Collection of art was not assembled in a systematic way nor did it contain only items shown by him. By the time Georgia O'Keeffe presented it to museums after his death, as she has written, she had eliminated from it certain works, in consultation with various museum officials.

Describing how the Collection was formed, Miss O'Keeffe has noted that Stieglitz bought from the European exhibitions at 291 "because the prices asked were so low he was embarrassed to return the work. Some things he undoubtedly liked and wanted. Some were bought at the Armory Show, in 1913. Others at the first auctions of modern art, when they were going for almost nothing. American artists gave him things. He often gave Camera Work to artists when they wanted it, and they would sometimes give him a picture." At times, Stieglitz advanced money for framing and storage bills and when the artists could not repay him, he took pictures instead, with the artists' full approval.

"With the American painters, as with photographers for many years, he bought from almost every show. He felt that if he thought work worth showing, he should himself buy something from what was shown. He had very little money to spend, but he lived simply, and during the early hard years when no one else would buy, he bought."[1]

Whenever possible Stieglitz liked to demonstrate how the artists he showed had evolved. For this purpose he hoped to keep together work from successive years. He deplored having meaningful entities split up in haphazard fashion: "One does not scatter the works of a Shakespeare over the face of the earth, page by page. Why do so in the case of the artist?"

As executrix of Stieglitz's estate, O'Keeffe found his Collection too large for any one museum to hang. Since she did not wish to see a great part of it relegated to storage, and wanted neither to keep nor sell it, she decided she "had no choice but to give it to the public."

Thus, in 1949 the Stieglitz Collection of modern painting, photographs, sculpture and other works of art—both European and American—was divided. The bulk of it went to the Metropolitan Museum of Art because, in O'Keeffe's words, "Stieglitz was so definitely a New Yorker." Two other major parts were given, respectively, to the Art Institute of Chicago because of its central location in the United States, and to Fisk University, Nashville, because O'Keeffe thought it a good thing and "that it would please Stieglitz." Smaller parts of the Collection were presented to the National Gallery of Art in Washington, D. C., the Philadelphia Museum of Art and the Library of Congress. The National Gallery received the key or master set made up of the best original mounted prints by Stieglitz he had kept together until his death. His were the first photographs at the Gallery.[2]

In 1951, O'Keeffe presented to Yale University over fifty thousand letters from Stieglitz's correspondence, as well as manuscripts, catalogues, portraits and clippings. The papers—the Alfred Stieglitz Archive—are housed in the Beinecke Library in the Collection of American Literature. O'Keeffe has since given the Archive a number of original Stieglitz photographs and pictures by others from his Col-

lection.[3] Certain of his cameras and other photographic apparatus are at the George Eastman House.

In 1947, even before the Stieglitz Collection was dispersed, the Museum of Modern Art held an exhibition of a group of Stieglitz photographs and selections from his collection of paintings, sculpture, drawings and graphic art. The following year the Museum exhibited work by "The Photo-Secession Group (1902-1910);" in 1951 art on extended loan from the Metropolitan Museum's Stieglitz Collection.

The Art Institute of Chicago honored Stieglitz in 1948 by holding a memorial exhibition that included his photographs, and paintings, sculptures, drawings and prints from his Collection. The Institute showed a selection of works from its portion of the Stieglitz Collection in 1949 and, eighteen months later, exhibited forty-three Stieglitz prints—also a part of the gift from his estate.

Fisk University showed its "Alfred Stieglitz Collection of Modern Art" at the opening of the University's Carl Van Vechten Gallery of Fine Arts, in 1949. The following year the Metropolitan Museum of Art had an exhibition of "20th Century Painters—U.S.A.," which included over two hundred "oils, watercolors, drawings and more than one hundred prints" from the Museum's collections. (For the first time the Museum hung photographs, including Stieglitz's, next to prints.)

In 1951, the Taft Museum, Cincinnati, paid tribute to Stieglitz by exhibiting work shown or similar to what had been presented at his galleries. The Museum sought to evoke "a personality, and through him. . . important facets of the art of this

century from 1900 to 1925;" "to show the great vitality of '291' and the sensitive and discriminating taste of its founder." During the same year the Yale Library placed on view a selection from the Stieglitz Archive. City College of New York honored Stieglitz in 1956 by naming one of its buildings Alfred Stieglitz Hall.

The George Eastman House, Rochester, showed photographs by Stieglitz in 1957, including recent acquisitions to its Collection; in 1959, a Photo-Secession Exhibition. In 1958 the National Gallery of Art presented a selection of prints from its "key" set of photographs by Stieglitz; Pomona College, Claremont, California, arranged a "Stieglitz Circle" exhibit.

Wellesley College observed the centennial of Stieglitz's birth with an exhibition in his honor in 1964. A group of Stieglitz's prints was shown at the Boston Museum of Fine Arts in 1965.

The Alfred Stieglitz Memorial Lectures were established at Princeton University in 1967. The Alfred Stieglitz Center at the Philadelphia Museum of Art, founded in 1968, is one of the most recent tributes to bear Stieglitz's name. A complete list of exhibitions featuring his work, held since his death, is too voluminous to include.

NOTES

CHAPTER II

1. *America and Alfred Stieglitz*, pp. 60–61.
2. Family tales of Edward Stieglitz corroborate his "law unto himself" quality. He could not tolerate the scraping of a knife on a plate, the noisy sipping of soup, the audible chewing of nuts. One of his nieces became so terrified of him that, when offered almonds in his presence, she found herself swallowing them whole. Guests were ordered from the dining room for rude behavior. An artist who appeared at dinner at Lake George without a collar and tie was asked to leave Oaklawn. There is an anecdote about Edward riding on the platform of a crowded New York bus, next to a man who whistled. Edward warned the man he would throw him off the bus if he refused to be quiet. The man continued to whistle. Edward pushed him off the bus. But when the proud Edward—still quite young—requested a loan from a bank president and was asked what he could put up as collateral, he replied simply, "My face." He received the loan.
3. In the late 1880s, when Edward Stieglitz bought Oaklawn at Lake George, the odor of pigs wafted down toward the large house from a smaller farm on the hill above. This was so offensive to him that he bought the upper land as well.

CHAPTER III

1. Newhall, *The History of Photography* (1949), p. 116.
2. *America and Alfred Stieglitz*, p. 100.
3. The hand camera did not attract Stieglitz while he was in Europe, nor did he ever use the recently developed Stirn Vest Camera, generally considered admirable. "The Stirn camera was a round affair, made of metal, about eight inches in diameter. It held a round dry plate that could be revolved and would make about eight or ten small snapshots. The camera was hidden behind one's vest. Its small lens was pushed through a buttonhole. I found the entire affair distasteful, a sort of sneaking up on somebody and photographing him unawares."
4. The Kodak was introduced in the United States by the George Eastman Company in 1888.

CHAPTER IV

1. *Vogue*, August 15, 1948, p. 186.
2. In the early 1900s Stieglitz was asked to photograph Duse. He refused. She expressed a desire that they meet. He refused. It was suggested that he might wish to see her perform when she returned to America in the 1920s. He refused. He said his original experience had been so perfect, he wanted nothing to interfere with it. One day when entering a building through a revolving door, he had the impression that he passed Duse. He felt a strong impulse to return to the street to see whether it was indeed she. He resisted the temptation. The mysterious incident had so profound an effect upon him he never forgot it. He spoke of it always with great wonder.
3. From a conversation with the author after Stieglitz's death.
4. The Camera Club of New York was the result of a consolidation, effected on May 7, 1896, of the Society of Amateur Photographers (founded in 1884), and the New York Camera Club (incorporated in 1888). Stieglitz became vice-president of the Club in 1897.
5. The negative of *Icy Night* was 4″ × 5″. It "was made in January, Eighteen Hundred and Ninety-eight, at one a.m., with a Goerz Lens, Series III., full opening, and an exposure of three minutes." (*C. W.* Number 4, October, 1903, unnumbered p.)
6. *American Annual of Photography*, 1895, p. 28.
7. As early as 1899, Stieglitz printed an article by Sadakichi Hartmann, "Portrait Painting and Portrait Photography," in *Camera Notes*, Vol. III, No. 1, July, 1899, pp. 3–21.
8. Not until *Camera Work*'s twelfth issue did Stieglitz include a representative sequence of his own photographs. Although he devoted number after number to work by others, it is only in *Camera Work* Number 36 that a second series of his prints appears.
9. The National Arts Club is an association of "Painters, sculptors, musicians, writers and others who form an appreciative audience for all the arts." (*Encyclopedia of Associations*, Vol. I: *National Organizations of the United States*.)
10. The King's Prize was originally awarded by mistake to the Camera Club of New York, although the Club was in no way connected with the prize-winning collection. The error, soon corrected, was caused by the fact that Stieglitz had given his return address as the Camera Club.
11. By 1904 photographic exhibitions had been held in such leading American art institutes as the Pennsylvania Academy of Fine Arts, Philadelphia; the Art Institute, Chicago; the Corcoran Art Galleries, Washington, D. C.; the Carnegie Institute Art Galleries, Pittsburgh. Stieglitz refused to cooperate with those who arranged photographic exhibits in New York during the same year because he did not respect their standards.
12. *C.W.* Number 14, April, 1906, p. 17.
13. Exhibition catalogues of the 1840s and 1850s mention calotypes by the

Scotch painter, David Octavius Hill, as having been designed and arranged by him and executed by Robert Adamson. Hill's photographs became generally known abroad only later. See Heinrich Schwartz, *The Art Quarterly*, Winter, 1958, p. 396. The early Hill photographs, begun in 1843 as aids to his painting, were largely completed by 1847, not long before Adamson's death.

16. Julia Margaret Cameron, distinguished British photographer, portrayed a number of outstanding literary and other well-known figures during the 1860s.

15. *C.W.* Number 14, April, 1906, p. 48.

16. *C.W.* Number 30, April, 1910, p. 47.

CHAPTER V

1. Although, directly after their marriage, Emmeline accompanied Stieglitz to meetings and photographic exhibitions, she soon tired of them and became hostile to some of Alfred's most trusted colleagues. After Stieglitz showed modern art, the same pattern prevailed. Stieglitz often invited artists to his home for dinner and some of them stayed with the family in the country. Emmy increasingly resented the spending of money on those she felt were ne'er-do-wells. As a result, Stieglitz's life became more and more centered in the little rooms on Fifth Avenue.

2. For further details of Steichen's role in the early days of 291, see *Camera Work*, and his correspondence with Stieglitz in the Stieglitz Archive at Yale.

3. From *C.W.* Number 34–35, April-July, 1911.

4. As reprinted in *C.W.* Number 22, April, 1908, pp. 39–40.

5. *New York Times Magazine*, December 11, 1949, p. 26.

6. From *C.W.* Special Number, August, 1912.

7. George F. Of owned the only Matisse in New York before the 291 exhibit. Stieglitz borrowed it for the show. Mr. Of's premises were used as a mailing address for the Photo-Secession before the Galleries were founded. Of did framing for Stieglitz and various artists he showed for many years.

8. *C.W.* Number 23, July, 1908, p. 10.

9. As reprinted in *C.W.* Number 23, July, 1908, pp. 10–11.

10. Barr, *Matisse—His Art and His Public*, p. 114.

11. As reprinted in *C.W.* Number 38, April, 1912, p. 45.

12. As reprinted in *C.W.* Number 38, April, 1912, p. 45.

13. As reprinted from the *New York Post* in *C.W.* Number 26, April, 1909, p. 25.

CHAPTER VI

1. The Eight included Arthur B. Davies, William Glackens, Robert Henri, Ernest Lawson, George Luks, Maurice Prendergast, Everett Shinn and John Sloan. All except Davies and Prendergast were listed as having exhibited at the National Arts Club in 1908.

2. Thus, although an early Photo-Secession announcement of a Salon des Refusés in 1906 stated that the Galleries would present "A collection of paintings, by American painters, that have been refused at the Society of American Artists, National Academy, Carnegie Institute, and Pennsylvania Academy of Fine Arts Exhibition," the exhibition never took place.

Frank Jewett Mather, a leading art critic of the period—one far more conservative than Stieglitz—told the author that, in his judgment, "The Eight did not need the Photo-Secession Galleries. Although their work had been turned down by the current academies, it was acceptable to the popular critics of the time. Much of it was just journalism. Even though termed 'realistic,' it was so only in superficial fashion. Stylistically the Eight were followers of Edouard Manet above all—as interpreted by their leader, Robert Henri—but by the time they had adopted Manet's manner, it was well established. Their work was not innovative in the sense that the Americans introduced by Stieglitz were."

3. *C.W.* Number 23, July, 1908, p. 13.

4. Agnes Ernst married Eugene Meyer, Jr. in 1910.

5. *C.W.* Number 25, January, 1909, p. 22.

6. *Camera Work* Number 33, January, 1911 (pp. 61–63) contains a complete account of the exhibition.

7. "In Paris, I once saw two teams of black stallions pulling wagons going along side by side. The traffic was stopped. The horses were lined up in front of me. Along the curb many women were at market. The horses stood throbbing, pulsating, their pe-

nises swaying half erect—swaying—shining. I stood transfixed, wishing I had a camera. No one cared to be seen staring at the animals yet it was clear that everyone was aware of them, wanting to look. In New York such a thing would not have been permitted, all the horses in the city being geldings."

In 1923 Stieglitz photographed a gelding in New York City. He called the picture *Spiritual America*. (Plate LV)

8. From Stieglitz letter to Hamilton Easter Field, November 16, 1920.

9. From Stieglitz letter to Marsden Hartley, May 12, 1914.

CHAPTER VII

1. In the early 1900s several American painters and sculptors, who later became associated with Stieglitz, aligned themselves with "The New Society of American Artists in Paris." The young secessionists "frankly declared war on the old society of the same name." When they met in Steichen's studio in February, 1908, the governors elected were Steichen, Maurer, Max Weber, G. Putnam Brinley and MacLaughlan. Marin also was a member of the group. (Based on McCausland, *A. H. Maurer*, pp. 93–94.)

2. For a detailed account of Marin's early relationship with his print dealers, see Zigrosser, *The Complete Etchings of John Marin*, pp. 2–3.

3. As reprinted in *C.W.* Number 27, July, 1909, p. 43.

4. *America and Alfred Stieglitz*, pp. 233–34.

5. *America and Alfred Stieglitz*, pp. 236–38.

6. From catalogue of Dove exhibition, The Intimate Gallery, 1929.

7. *C.W.* Number 30, April, 1910, p. 54.

8. As reprinted in *C.W.* Number 31, July, 1910, pp. 49–50.

9. As reprinted in *C.W.* Number 36, October, 1911, p. 33.

10. From Max Weber letter to Peter Selz, July, 1958, published in catalogue of exhibition, "Stieglitz Circle," Pomona College Galleries, 1958.

11. As reprinted in *C.W.* Number 29, January, 1910, pp. 53–54.

12. Shchukin's collection of Matisses and other modern works is in the U.S.S.R.

13. From a conversation with the author after Stieglitz's death.

14. *C.W.* Number 46, October, 1914, p. 33.

15. De Zayas wrote to Stieglitz from Paris as early as 1911, in the hope that African art might be shown at 291.

16. As reprinted in *C.W.* Number 42–43, April-July, 1913, p. 51.

17. From *C.W.* Number 30, April, 1910.

18. From *C.W.* Number 46, October, 1914.

19. *C.W.* Number 38, April, 1912, p. 36.

20. As reprinted in *C.W.* Number 42–43, April-July, 1913, p. 47.

21. From *C.W.* Number 36, October, 1911. Illustration 48, from *C.W.* Special Number, August, 1912.

22. Art critic for the Sunday *Brooklyn Eagle* and founder of *The Arts.*

23. The entire amount Field paid for his Picasso, plus the frame Stieglitz had made for it, was thirty-five dollars (this according to a Stieglitz letter, dated October 21, 1911).

24. From Stieglitz letter to Edward Alden Jewell, December 19, 1939.

25. As reprinted in *C.W.* Number 36, October, 1911, p. 49.

26. From Stieglitz letter to Arthur Hoeber, December 9, 1914.

27. The Stieglitz letter was published December 18, 1911. It inspired an editorial, printed the same day in the *Evening Sun,* "An Appeal to the Purveyors of Art." The editorial began: "We are glad to publish today a letter from Mr. Alfred Stieglitz on the subject of what is commonly called Post-Impressionism. Mr. Stieglitz is entitled to speak, for what little we know of the various painters whose work is grouped under that ambiguous title is due in the main to his disinterested zeal."

28. From Stieglitz letter, May 31, 1916.

29. From Stieglitz letter to Sadakichi Hartmann, December 22, 1911.

30. It was Mrs. Charles Knoblauch who brought the Stein manuscripts to Stieglitz.

31. Miss Stein later wrote: "And then there was Stieglitz. Stieglitz tells a strange story of the early days when we were living in Paris and I had begun writing and my brother was painting and we had begun everything. According to Stieglitz, and I very well remember his being there he was there for several hours and my brother was talking and according to Stieglitz I was not saying anything and he went away with the greatest admiration and said he had never known any woman well perhaps anybody to sit still so long without talking. He still when I went to see him in New York he still told me this thing. Well perhaps I did. At any rate by that time I was writing and arguing was no longer to me really interesting. Nothing needed defending and if it did it was no use defending it. Anyway that was the beginning of my writing and by that time my brother had gotten to be very hard of hearing." (Stein, *Everybody's Autobiography,* pp. 72-73.)

32. This constituted the first public appearance of Gertrude Stein's writing in America. (Her *Three Lives,* written in 1905–06, had been privately printed by the Grafton Press in 1909.) *Camera Work* Special Number, June, 1913, contained a further article by Miss Stein, "Portrait of Mabel Dodge at the Villa Curonia;" Number 45 reprinted her Foreword for the catalogue of Marsden Hartley's 291 Exhibition in 1914.

33. The Picasso painting of Gertrude Stein reproduced was a bequest to the Metropolitan Museum by Miss Stein, who died in 1946. It was the first Picasso to be owned by the Museum. The Metropolitan's initial purchase of a Picasso was made in 1947. (The Stein portrait was reproduced in *Camera Work* Special Number, June, 1913.)

34. Miss Stein wrote to Stieglitz on August 29, 1912, that she was entirely pleased by the copies of *Camera Work* she received, that the photographs had been admirably selected and she liked his introduction. She found the whole thing "delightful."

35. As reprinted in *C.W.* Number 38, April, 1912, p. 43.

36. *C.W.* Number 37, January, 1912, p. 43.

37. From an interview with Stieglitz, *Evening Sun,* April 27, 1912.

38. From Stieglitz letter to Heinrich Kühn, October 14, 1912.

39. *C.W.* Number 41, January, 1913, p. 24.

40. As reprinted in *C.W.* Number 41, January, 1913, p. 26.

41. From catalogue of Walkowitz exhibition, Photo-Secession Galleries, February, 1916.

42. *C.W.* Number 39, July, 1912, p. 34.

43. From Stieglitz letter to a Mr. White, March 18, 1913.

CHAPTER VIII

1. In 1911 the painters, Jerome Myers, Elmer MacRae, Walt Kuhn and Henry Fitch Taylor, while discussing the economic plight of the American artist, thought of reviving the "Independent" idea which had had a hapless trial the year before at an exhibition held in a loft building on West 35th Street. After inviting a larger group of sympathetic artists to join them, they laid the foundations for the new society, the Association of American Painters and Sculptors.

2. *New York American,* January 26, 1913, p. 5–CE.

3. Photograph by courtesy of Walter Pach.

4. When the Armory Show took place and proved to be a sensation, as Milton Brown relates, "Press coverage was extensive and highly laudatory of the AAPS and the job it had done. The Show was hailed as a 'miracle', a 'bombshell', and 'an event not on any account to be missed.' It was not until the critics took over from the reporters that the bricks began to fly. They spewed venom on Matisse and ridicule on the Cubists. Marcel Duchamp's *Nude descending a staircase* became the butt of cartoon, jokes and jingles. The 'crazy' art of the Armory Show became the talk of the town and, as publicity increased, attendance skyrocketed." (Brown, *The Armory Show — 50th Anniversary Exhibition,* p. 34.)

5. Even though the Armory Show shattered the complacency of American art, the Association of American Painters and Sculptors failed to survive the exhibition's success. The Society never put on another show and "was riven by dissension." The Academy found that its death warrant "had been signed" by the exhibition, but perhaps the gravest blow of all was dealt "to Robert Henri and the Ashcan School; the former standard bearer of progressive art was in eclipse and his troops were irretrievably scattered," the Europeans having stolen the show. (Ibid., p. 35.)

6. As reprinted in *C.W.* Number 42–43, April-July, 1913, p. 47.

7. *C.W.* Special Number, June, 1913, p. 15.

8. *Photographic Society of America Journal,* November, 1947, p. 721.

9. As reprinted in *C.W.* Number 45, 241

June, 1914, p. 39.

10. *C.W.* Number 48, October, 1916, p. 7.

11. The caricature was reproduced in *Camera Work* Number 39, July, 1912.

12. From an unpublished manuscript on Stieglitz by De Zayas, who gave it to the author for her use after Stieglitz's death.

13. *C.W.* Number 32, October, 1910, p. 41.

CHAPTER IX

1. There is no specific evidence that Picabia was its author.

2. Rosenfeld, *Port of New York*, pp. 257–58.

3. Rosenfeld wrote under the pseudonym, Peter Minuit, in *The Seven Arts*, November, 1916, p. 61.

4. As late as March, 1949, Michel Tapié edited a single number of a publication called *491* in Paris. Pierre André Benoit of Alès (Gard) published *591* in 1952 and *691* in 1959. An edition of *791* was planned in France, but never issued.

5. From a conversation with the author after Stieglitz's death.

6. Dr. A. A. Brill, psychoanalyst; an early exponent of the theories of Dr. Sigmund Freud and his first translator into English in America.

7. From Stieglitz letter to Mabel Dodge [Luhan], January 20, 1916.

8. From Stieglitz letter to R. Child Bayley, November 1, 1916.

9. *C.W.* Number 49–50, June, 1917, p. 5.

10. *C.W.* Number 48, October, 1916, pp. 11–12.

11. From De Zayas letter to Stieglitz, September 11, 1916.

12. From Stieglitz letter to Gino Severini, May 16, 1917

13. *C.W.* Number 49–50, June, 1917, p. 33.

14. *Rob Wagner's Script*, September 23, 1944, p. 12.

15. *C.W.* Number 49–50, June, 1917, pp. 33 f.

16. One of the projects that did not materialize: Stieglitz wrote to Charles Sheeler on March 1, 1917, that he wanted to pick out a few of his negatives from which to have photogravures made for *Camera Work*. He also wrote an optimistic letter to Waldo Frank on February 23, 1917, saying he had signed up for another year at 291. He explained how he did not know what had made him do it, except that it was a bright sunny day when the agent appeared. A further

Stieglitz letter to Annie W. Brigman of early May, 1917, describes how things seemed so bemuddled and absolutely devoid of form that, although 291 had been busy in spite of everything, the job had become heartbreaking. Clearly, radical changes were taking place everywhere and even more radical ones were bound to come, especially at the economic level. Because of this, there were sure to be comparable spiritual changes. Stieglitz lamented the fact that people had been overfed; that things had come too easy; that troubles were looked upon as tragedies.

As late as September 18, 1919, Stieglitz wrote to Dove of his attempt to get in touch with old friends about reproductions and printing; that, "in spite of No Cash," he was mad enough occasionally to dream of more numbers of *Camera Work*. "Habits perhaps.—Hard to get rid of." Stieglitz wrote letters, even in the 20s, about his desire to publish additional issues of *Camera Work*.

17. From Stieglitz letter to J. P. Cooney, August, 1938.

18. *The Flowers of Friendship*, pp. 87–88.

CHAPTER X

1. *MSS* Number 4, December, 1922, p. 17.

2. *America and Alfred Stieglitz*, pp. 113–14.

3. Brooks, *America's Coming-of-Age*, pp. 164–65.

4. *Letters of Sherwood Anderson*, pp. 44–45.

5. From Stieglitz letter to Herbert J. Seligmann, July 6, 1921.

6. "For the cover design: apologies to 'Dada' (American), Marcel Duchamp, Man Ray, and acknowledgement to 'Anonymous.'" (*MSS* Number 2, March, 1922.) The "anonymous" individual was Georgia O'Keeffe.

7. From Leo Stein letter to Stieglitz, December 4, 1922.

8. Anderson, *A Story Teller's Story*, unnumbered p.

9. *America and Alfred Stieglitz*, pp. 297, 296, 298–99.

CHAPTER XI

1. From letter written by Stieglitz "with no idea of publication," as printed in *The Amateur Photographer and Photography*, September 19, 1923, p. 255.

2. It is noteworthy that Ananda K. Coomaraswamy, Fellow for Research in Indi-

an, Persian and Muhammedan Art at the Boston Museum of Fine Arts—a strict traditionalist—should have considered Stieglitz the most important contemporary artist in the United States.

3. From Stieglitz letter to Ananda K. Coomaraswamy, December 31, 1923.

CHAPTER XII

1. The actual sum for the Hartleys totaled $4,913.50.

2. Stieglitz arranged a second auction, held at the Anderson Galleries on February 23, 1922, which he named "The Artists' Derby." It included work by forty living American artists, among whom were: Marin, Maurice Sterne, Hartley, Demuth, Stefan Hirsch, Dove, Lachaise, George Of, Hamilton Easter Field, Robert Laurent, S. Macdonald Wright, O'Keeffe, Sheeler, Pach, Thomas Benton, Louis Bouché, Ben Benn, Preston Dickinson, Mell Daniel, Maurer, Jennings Tofel, Morris Kantor and the Zorachs.

3. From Stieglitz letter in *The Brooklyn Museum Quarterly*, July, 1921, pp. 108, 112–13.

4. From Stieglitz letter to Peyton Boswell, February 22, 1927.

5. Demuth wrote to Stieglitz from Paris as early as 1921 about French recognition of modern American art: "It is all very amazing to me to find this enthusiasm here—after knowing what we have always felt for the French, not thinking much of our own; and the great Frenchmen telling us that we are very good. It seems rather grand. It is like Baudelaire and Poe. I wish that you could be here to get the thrill of it—after the work and love you have given the painters French & American. It seems almost as though the dream were 'coming true'. . . . Sometimes it seems almost impossible to come back. . . . Then one sees Marcel [Duchamp] or Gleizes and they will say—'Oh! Paris. New York is the place—there are the modern ideas. . . .' How wonderful a time it is. I'm glad, missing the Renaissance—I suppose that I did!—that I was not called upon to live at any other time—aren't you?" (October 10, 1921.)

6. *Creative Art*, September, 1929, pp. 629, 634.

7. From catalogue of Lachaise exhibi-

tion, 1935, Museum of Modern Art, p. 12.

8. *The Dial*, February, 1920, as reprinted in *Twice A Year*, 1948, p. 303.

9. This refers to stock Mr. Schulte had presented to Stieglitz to be used for work in conjunction with The Intimate Gallery.

10. From Stieglitz letter to David Schulte, May 24, 1928.

11. From letter to Stieglitz from William Ivins, December 28, 1928.

CHAPTER XIII

1. Mitchell Kennerley had sold the Anderson Galleries to the American Art Association. Although the building was to be demolished, it still stands at the present writing.

2. According to William Carlos Williams' *Autobiography* (p. 236), Stieglitz wrote to him enthusiastically after the 1925 publication of *In the American Grain*. Stieglitz also said, stated Williams, that the book "had given him the name, An American Place, when he moved to the new site for his gallery on Madison Avenue." The gallery, however, was not founded until 1929. I was present when the Place was named. Stieglitz's original desire was to call the center simply "The Place"

which, on second thought, seemed inadequate. He thereupon added the word "American." For a more detailed correction of Williams' oft-repeated statement and its background, see Bram Dijkstra's *Hieroglyphics of a New Speech: Cubism, Stieglitz, and the Early Poetry of William Carlos Williams* (pp. 84 ff.). Stieglitz often made generous, expansive statements. But, in this case, the dates are too far out of line for Williams' assertion to be accurate, even though Stieglitz did have great admiration for *In the American Grain*.

3. A related, longer version of this description appeared in *America and Alfred Stieglitz*, pp. 126 – 28.

4. Years after Stieglitz's death An American Place Theatre was named in honor of his final gallery.

5. Many of Stieglitz's early prints were lost, given away or destroyed. Some are to be found in albums he presented to his father, now in the Stieglitz Archive, Yale University Library. When 291 closed, it was discovered that many negatives stored under the sink were hopelessly ruined.

6. *New York Times*, June 24, 1934, p. 6x.

7. Paraphrased from Stieglitz letter to

Robert Taft, November 17, 1937, quoted in Taft, *Photography and the American Scene*, p. 497.

8. *New York Herald Tribune*, April 29, 1932.

9. *New York Times*, May 15, 1932.

10. *Atlantic Monthly*, January, 1935, pp. 8, 10.

11. *New York Herald Tribune*, November 10, 1937.

12. From Stieglitz letter to Ansel Adams, December 6, 1939.

13. From Stieglitz letter to Eliot Porter, January 21, 1939.

CHAPTER XIV

1. From Stieglitz letter to Sherwood Anderson, July 30, 1923.

2. From Stieglitz letter to Paul Rosenfeld, September 2, 1922.

3. From Stieglitz letter to Hart Crane, August 15, 1923.

4. From Stieglitz letter to Mabel Dodge Luhan, July 7, 1929.

5. *The Flowers of Friendship*, p. 88.

APPENDIX

1. *New York Times Magazine*, December 11, 1949, p. 29.

2. Ibid., p. 30.

3. From press release by Yale University, February 22, 1951.

SELECTED BIBLIOGRAPHY

Published material by or relating to Alfred Stieglitz and his various activities is far too vast to list in full. Items other than books are presented in chronological order. With minor exceptions, no technical material is listed. Entries marked with an asterisk are quoted from in the text or are illustrations. The initials A.S. stand for Alfred Stieglitz.

PUBLICATIONS EDITED, PUBLISHED OR SPONSORED BY STIEGLITZ

Periodicals:

The American Amateur Photographer. Edited by A. S., Vol. V, No. 7, July, 1893 – Vol. VIII, No. 1, January, 1896. (Co-editor: F. C. Beach.) The Outing Co., Ltd., New York.

Selected articles:

"The Platinotype Process and the New York Amateur," A. S., Vol. IV, No. 4, April, 1892, pp. 153 – 55.

"The Platinotype Process with Cold Development," A. S., Vol. IV, No. 9, September, 1892, pp. 391 – 92.

"The Joint Exhibition at Philadelphia," (review), A. S., Part I: Vol. V, No. 5, May, 1893, pp. 201 – 09; Part II: Vol. V, No. 6, June, 1893, pp. 249 – 54.

"The Seventh Annual Joint Exhibition," (review), A. S., Vol. VI, No. 5, May, 1894, pp. 209 – 19.

"Exhibition of Pictorial Photography at the National Arts Club," unsigned, Vol. XIV, No. 4, April, 1902, pp. 171 – 73.

Account of Turin Exhibition award made to Camera Club in error, Vol. XIV, No. 11, November, 1902, p. 562; "Society News," Vol. XIV, No. 12, December, 1902, pp. 573 – 75 and letter from A. S., p. 575.

Camera Notes, The Official Organ of the Camera Club, New York. Managed and edited by the Publication Committee; A. S., Chairman, Vol. I, No. 1, July, 1897 – Vol. IV, No. 4, April, 1901. Edited and managed by A. S., Vol. V, No. 1, July, 1901 – Vol. VI, No. 1, July, 1902. New York.

Selected articles:

"A Few Reflections on Amateur and Artistic Photography," Sadakichi Hartmann, Vol. II, No. 2, October, 1898, pp. 41 – 45.

"Some Thoughts on Landscape and Nature," Charles H. Caffin, Vol. IV, No. 1, July, 1900, pp. 3 – 8.

"Naturalism in Photography," A. Horsley Hinton, Vol. IV, No. 2, October, 1900, pp. 83 – 91.

"The Art in Photography," W. I. Lincoln Adams, Vol. V, No. 4, April, 1902, pp. 247 – 258.

"Painters on Photographic Juries," A. S., Vol. VI, No. 1, pp. 27 – 30.

Camera Work. Published and edited by A. S. Number I, January, 1903 – Numbers XLIX-L, June, 1917. New York.

291. Sponsored by A. S. Published by "291" (A. S., Agnes E. Meyer, Paul Haviland). Number 1, March, 1915 – Number 12, February, 1916. New York.

*MSS. Sponsored by A. S. Published by "the authors of the writing which appears in it." Number One, February, 1922–Number Six, May, 1923. New York.

Collections of photographic prints:

Picturesque Bits of New York and Other Studies, by A. S. New York: R. H. Russell, 1897. 12 signed photogravures in portfolio.

American Pictorial Photography, Series I. New York: Publication Committee, Camera Club, 1899. 18 photogravures in portfolio.

American Pictorial Photography, Series II. New York: Publication Committee, Camera Club, 1901. 18 photogravures in portfolio.

The Steichen Book, Eduard J. Steichen. New York: Alfred Stieglitz, 1906. 26 plates.

Work by Pamela Colman Smith. New York: the Photo-Secession, 1907. 22 platinum prints by A. S. in portfolio. (1 special portfolio containing 29 prints and 7 regular portfolios completed.)

As advertised in *Camera Work:*

Five signed, original photogravures, by A. S. 1904.

The White Book, Clarence H. White. 1908. 23 plates.

Leaflets and booklets:

The Photo-Secession. New York: *No. 1, December, 1902; No. 2, April, 1903; No. 3, October, 1903; No. 4, February, 1904; No. 5, May, 1904; No. 6, February, 1905; No. 7, June, 1909.

Photo-Secessionism and Its Opponents: Five Recent Letters. (Four by A. S.) New York, August 25, 1910.

Photo-Secessionism and Its Opponents: Another Letter—the Sixth. (By A. S.) New York, October 20, 1910.

The Photo-Secession Exhibition Society—Constitution and By-Laws, together with Information and Documents concerning the Importation of Works of Art into the United States. New York, 1911.

A Study of The Modern Evolution of Plastic Expression, Marius De Zayas and Paul B. Haviland. New York: "291," 1913.

Publications (leaflets) of An American Place, from various series:

"It Must Be Said." No. 1. *John Marin and the Real America*, Herbert J. Seligmann. 1932. No. 2. *Outside*, Cary Ross. 1932. No. 3. *Frames, with Reference to Marin*, Herbert J. Seligmann. 1934. No. 4. *Dualities* (review), Evelyn Howard.

1933. No. 4 (bis). About "My Egypt," painting by Charles Demuth, unsigned. 1935. No. 7. *"291" Again!*, Ralph Flint. 1937.

"It Should Be Remembered." No. 1. List of exhibitions at "291." 1933.

"It Has Been Said." No. 2. *From Rainer Maria Rilke's Letters to a Young Poet*, translated by Cary Ross. 1933.

"It Might Be Said." No. 1. *Prelude to a Church*, Dorothy Norman. 1937.

Other numbers are catalogues or supplements to catalogues of An American Place exhibitions.

Catalogues of exhibitions:

Gallery of the Photo-Secession, 291 Fifth Avenue, New York. November, 1905–May, 1917.

The Intimate Gallery, Room 303, 489 Park Avenue, New York. December, 1925–May, 1929.

An American Place, Room 1710, 509 Madison Avenue, New York. December, 1929–June, 1946.

See Appendix for individual listings.

Books:

Letters of John Marin. Edited by Herbert J. Seligmann. New York: An American Place, 1931.

Dualities. Dorothy Norman. New York: An American Place, 1933.

SELECTED WRITING BY STIEGLITZ

Articles in American periodicals:

"A Plea for Art Photography in America," *Photographic Mosaics*, 1892, pp. 135–37.

"Two Artists' Haunts," with Louis H. Schubart, *Photographic Times*, Vol. 26, No. 1, January, 1895, pp. 9–12.

*"A Plea for a Photographic Art Exhibition," *The American Annual of Photography and Photographic Times Almanac*, 1895, pp. 27–28.

"The American Photographic Salon," *American Annual of Photography*, 1896, pp. 194–96.

"The Hand Camera—Its Present Importance," *American Annual of Photography*, 1897, pp. 19–27.

"Night Photography with the Introduction of Life," pp. 204–06; "A Natural Background for Out-of-Door Portraiture," pp. 210–11; *American Annual of Photography*, 1898.

"The Progress of Pictorial Photography in the United States," *American Annual of Photography*, 1899, pp. 158–59.

"Pictorial Photography," *Scribner's Magazine*, Vol. XXVI, No. 5, November,

1899, pp. 528–37.

"Modern Pictorial Photography," *Century Magazine*, Vol. LXIV, No. 6, October, 1902, pp. 822–26.

"The Photo-Secession—Its Objects," *Camera Craft*, (San Francisco), Vol. VII, No. 3, August, 1903, pp. 81–83.

"The Photo-Secession," *American Annual of Photography*, 1904, pp. 41–44.

On the New England Convention of Photographers (letter), *Wilson's Photographic Magazine*, 1911, p. 437.

On censorship (letter), *Bruno's Weekly*, January 8, 1917, p. 8.

In *Twice A Year*: "From the Writings and Conversations of Alfred Stieglitz," I, 1938, pp. 77–110.

"Ten Stories," V–VI, 1940–1941, pp. 135–63.

"Four Happenings," pp. 105–36; "Four Marin Stories," pp. 156–62; "Three Parables and a Happening," pp. 163–71; "Alfred Stieglitz Replies to 'Officialdom'," pp. 172–78; VIII–IX, 1942.

"Four Stories," X–XI, 1943, pp. 245–64.

"Six Happenings—and a Conversation," XIV–XV, Fall-Winter, 1946–1947, pp. 188–202.

"Stieglitz-Weston Correspondence," compiled by Ferdinand Reyher, *Photo Notes*, Spring, 1949, pp. 11–15.

"Alfred Stieglitz on Photography," compiled and edited by Dorothy Norman, *Magazine of Art*, December, 1950, pp. 298–301.

Articles in British periodicals:

"A Day in Chioggia," *Amateur Photographer* (London), Supplement to Vol. IX, Special Number, June, 1889, pp. 7–9.

"Cortina and Sterzing," *Amateur Photographer* (London), Supplement "Sun Pictures from Many Lands—Containing Illustrated Accounts of Holiday Tours," 1892, pp. 60–61.

"Pictorial Photography in the United States, 1895," *Photograms of the Year 1895*, pp. 81, 84.

"Pictorial Photography in the United States: 1896," *Photograms of the Year 1896*, Vol. I, pp. 43–44.

"The Photographic Year in the United States," *Photograms of the Year 1897*, pp. 29–30.

"The Photo-Secession at the National Arts Club, New York," *Photograms of the Year 1902*, pp. 17–20.

*"How I Came to Photograph Clouds," (letter), *The Amateur Photographer and*

Photography (London), September 19, 1923, p. 255.

Articles and letters in newspapers:
*Letter, *Evening Sun*, December 18, 1911.
*"The First Great 'Clinic to Revitalize Art,'" *New York American*, Sunday, January 26, 1913, p. 5 – CE.
"Is Photography a Failure?", *New York Sun*, March 14, 1922, p. 20.

Articles in booklets:
"Platinum Printing," *Picture Taking and Picture Making*, Rochester: Eastman Kodak Company, 1898, pp. 67 – 72; also in *The Modern Way of Picture Making*, Rochester: Eastman Kodak Company, 1905, pp. 122 – 28.
"The Photo-Secession," *Souvenir Portfolio* (bound), Rochester: Bausch and Lomb Optical Company, 1903, p. 3.

Forewords and statements in catalogues of exhibitions:
Foreword, The Forum Exhibition of Modern American Painters, Anderson Galleries, New York, March, 1916, p. 35.
*Three Statements: Exhibition of Photography by A. S., February, 1921; Second Exhibition of Photography, April, 1923; Third Exhibition of Photography, March, 1924; Anderson Galleries.
A Note, auction sale of pictures by James N. Rosenberg and Marsden Hartley, Anderson Galleries, May 17, 1921, pp. 11 – 12.
Statement, Seven Americans, Anderson Galleries, March, 1925.

Articles in museum bulletins:
*"Regarding the Modern French Masters Exhibition, a Letter," *Brooklyn Museum Quarterly*, Vol. VIII, No. 3, July, 1921, pp. 107 – 113.
"Two Stories," (as reprinted from *Twice A Year*, V – VI, 1940 – 1941), and "Letter to Olivia Paine of the Museum's Print Department," *Metropolitan Museum of Art Bulletin*, New York, Vol. XXVII, No. 7, March, 1969, pp. 334 – 37.

SELECTED MATERIAL PERTAINING TO STIEGLITZ AND HIS ACTIVITIES
Articles in American periodicals:
Unsigned, "Special Exhibition of Lantern Slides" by A. S. shown at Society of Amateur Photographers, (review, and list of prizes already awarded to Stieglitz), *American Amateur Photographer*, Vol. IV, No. 2, February, 1892, pp. 73 – 74.
Clarence B. Moore, "Leading Amateurs in Photography," *Cosmopolitan*, February, 1892, p. 428.
Unsigned, "Distinguished Photographers of To-day. I. – Alfred Stieglitz," *The Photographic Times*, Vol. XXIII, No. 637, December 1, 1893, pp. 689 – 90.
Unsigned (written by W. E. Woodbury, editor), "Alfred Stieglitz and His Latest Work," *The Photographic Times*, Vol. XXVIII, April, 1896, pp. 161 – 69.
Unsigned, "A Daughter of Walton," from section "Shooting and Fishing," *The American Rifleman*, Vol. 22, No. 7, June 3, 1897, p. 130.
James B. Carrington, "Unusual Uses of Photography. Part II. Night Photography," *Scribner's Magazine*, Vol. 22, No. 5, November, 1897, pp. 626 – 28.
Marmaduke Humphrey (Rupert Hughes), "Triumphs in Amateur Photography. I – Alfred M. Stieglitz," *Godey's Magazine*, January, 1898, pp. 581 – 92.
Unsigned, review of Stieglitz exhibition at the Camera Club, *Anthony's Photographic Bulletin*, Vol. XXX, No. 6, June, 1899, p. 163.
Theodore Dreiser, "A Master of Photography," *Success*, June 10, 1899, p. 471.
Theodore Dreiser, "The Camera Club of New York," *Ainslee's Magazine*, September, 1899, pp. 324 – 35.
F. H. Day, "Art and the Camera," *Lippincott's Monthly Magazine*, Vol. 65, No. 385, January, 1900, pp. 83 – 87.
Sadakichi Hartmann, "The New York Camera Club," *The Photographic Times*, Vol. XXXII, No. 2, February, 1900, pp. 59 – 61.
William Edward Ward, "The Cult of the Godlings," *Wilson's Photographic Magazine*, Vol. 37, No. 523, July, 1900, pp. 292 – 99.
Osborne I. Yellott, "The Rule or Ruin School of Photography," *Photo Era*, Vol. VII, No. 5, November, 1901, pp. 163 – 66.
Unsigned (attributed to Theodore Dreiser), "A Remarkable Art," (includes interview with A. S.), *The Great Round World*, Vol. 19, No. 286, May 3, 1902, pp. 430 – 34.
Unsigned, about A. S.'s withdrawal from *Camera Notes*, *Camera Craft*, (San Francisco), Vol. V, No. 2, June, 1902, p. 1.
Sidney Allan (Sadakichi Hartmann), "The Exhibition of the Photo-Secession" (review of exhibition at the Art Galleries of Carnegie Institute, Pittsburgh), *The Photographic Times-Bulletin*, Vol. XXXVI, No. 3, March, 1904, pp. 97 – 105.

Sidney Allan, "Advance in Artistic Photography," *Leslie's Weekly*, April 28, 1904, p. 388.
Unsigned, "The Fiasco at St. Louis," *The Photographer*, Part I: Vol. I, No. 12, July 16, 1904, pp. 178 – 79, 187; Part II: Vol. I, No. 17, August 20, 1904.
Juan C. Abel, "Editorial Comment," "Alfred Stieglitz Expelled from the Camera Club of New York," *Abel's Photographic Weekly*, Vol. I, No. 10, February 8, 1908, pp. 95 – 96.
F. Austin Lidbury, "Some Impressions of the Buffalo Exhibition," (review), *American Photography*, Vol. IV, December, 1910, pp. 676 – 81.
J. Nilsen Laurvik, "Alfred Stieglitz, Pictorial Photographer," *International Studio*, Vol. XLIV, No. 174, August, 1911, pp. xxi – xxvii.
*Peter Minuit (Paul Rosenfeld), "291 Fifth Avenue," *The Seven Arts*, Vol. I, November, 1916, p. 61 – 65.
Horace Traubel, "Stieglitz," *The Conservator*, Vol. 27, No. 10, December, 1916, p. 137.
Guido Bruno, "The Passing of '291'," *Pearson's Magazine*, Vol. 38, No. 9, March, 1918, pp. 402 – 03.
Paul Strand, "Alfred Stieglitz and a Machine," (review), privately printed, February 14, 1921.
Herbert J. Seligmann, "A Photographer Challenges," (review), *The Nation*, Vol. 112, No. 2902, February 16, 1921, p. 268.
John A. Tennant, "The Stieglitz Exhibition," (review), *The Photo-Miniature*, Vol. XVI, No. 183, July, 1921, pp. 135 – 39.
Sherwood Anderson, "Alfred Stieglitz," *The New Republic*, Vol. 32, October 25, 1922, pp. 215 – 17.
Charles Sheeler, "Recent Photographs by Alfred Stieglitz," (review), *The Arts*, Vol. III, No. 5, May, 1923, p. 345.
Unsigned, "News and Comment," (account of the Royal Photographic Society of Great Britain's award of its Progress Medal to A. S.), *The Photo-Miniature*, Vol. XVI, No. 192, January, 1924, p. 594.
Thomas Craven, "Art and the Camera," (review), *The Nation*, Vol. 118, No. 3067, April 16, 1924, pp. 456 – 57.
Guy Eglington, "Art and Other Things," (review of third A. S. exhibition and *MSS* Number Four), *International Studio*, May, 1924, pp. 148 – 50.
George Garfield and Frances O'Brien, "Stieglitz: Apostle of American Culture," *The Reflex*, Vol. 3, No. 3, Septem-

ber, 1928, pp. 24–29.

Lewis Mumford, "Alfred Stieglitz, '84," *The City College Alumnus—Fine Arts and Architecture*, Vol. 25, No. 5, May, 1929, p. 149.

Murdock Pemberton, *The New Yorker*, Vol. 5, September 14, 1929, p. 84.

*Charles Demuth, "Across a Greco Is Written," *Creative Art*, Vol. 5, No. 3, September, 1929, pp. 629, 634.

Inslee A. Hopper, "Vollard and Stieglitz," *The American Magazine of Art*, Vol. XXVI, No. 12, December, 1933, pp. 542–45.

*Francis Henry Taylor, "*America and Alfred Stieglitz: a Collective Portrait*," (review), *The Atlantic Monthly*, Vol. 155, No. 1, January, 1935, pp. 8, 10.

Carl Zigrosser, "Alfred Stieglitz," *New Democracy*, Vol. IV, No. 4, April 15, 1935, pp. 65–67.

Theodore Buckwalter, "Alfred Stieglitz and a Classic Query," *The Pocket Photo Monthly*, Vol. 3, No. 6, June, 1937, pp. 335–41.

Robert W. Marks, "Stieglitz—Patriarch of Photography," *Popular Photography*, Vol. 6, April, 1940, pp. 20–21, 76–79.

Edward J. Steichen, "The Fighting Photo-Secession," *Vogue*, Camera Issue, June 15, 1941, pp. 22–25.

Henry Miller, "Stieglitz and Marin," *Twice A Year*, VIII–IX, 1942, pp. 146–55.

Carl Zigrosser, "Alfred Stieglitz," *Twice A Year*, VIII–IX, 1942, pp. 137–45.

Unsigned, "Is Photography Art?" *Building America*, The Department of Supervision and Curriculum Development, N.E.A., Vol. VIII, No. 6, March, 1943, pp. 180–81.

Unsigned, "Speaking of Pictures," *Life*, April 5, 1943, pp. 6–7, 9.

Edward Epstean, "Memories: Photo-Engraving in New York City 1889–1900," *The Photo-Engravers Bulletin*, November, 1943.

Nelson Morris, "Alfred Stieglitz: A Color Portrait and Notes," *Popular Photography*, March, 1944, pp. 52–53.

*S. Macdonald Wright, "Art," *Rob Wagner's Script*, September 23, 1944, p. 12.

Paul Strand, "Alfred Stieglitz: 1864–1946," *New Masses*, August 6, 1946, pp. 6–7.

James Thrall Soby, "The Fine Arts—Alfred Stieglitz," *The Saturday Review*, Vol. XXIX, No. 39, September 28, 1946, pp. 22–23.

Paul Rosenfeld, "Alfred Stieglitz," *Twice A Year*, XIV–XV, 1946–1947, pp. 203–05.

Oliver Larkin, "Alfred Stieglitz and '291'," *Magazine of Art*, Vol. 40, No. 5, May, 1947, pp. 179–83.

James Johnson Sweeney, "Stieglitz," *Vogue*, June 15, 1947, pp. 58–59, 93.

Paul Strand, "Stieglitz: An Appraisal," *Popular Photography*, July, 1947, pp. 62, 88–98.

Milton W. Brown, "Alfred Stieglitz—Artist and Influence," (review of memorial exhibition at the Museum of Modern Art), *Photo Notes*, August-September, 1947, pp. 1, 7–8.

Harold Clurman, "Nightlife and Daylight," *Tomorrow*, Vol. VII, No. 2, October, 1947, pp. 53–54.

*Konrad Cramer, "Stupendous Stieglitz," *Photographic Society of America Journal*, Vol. 13, No. 11, November, 1947, p. 721.

*Edward J. Steichen, "Fifty Photographs," *Vogue*, August 15, 1948, p. 186.

Doris Bry, "The Stieglitz Archive at Yale University," *The Yale University Library Gazette*, Vol. 25, No. 4, April, 1951, pp. 123–30.

Joseph Shiffman, "The Alienation of the Artist: Alfred Stieglitz," *American Quarterly*, Vol. III, No. 3, Fall, 1951, pp. 244–58.

Dorothy Norman, "Alfred Stieglitz—Seer," *Aperture*, Vol. 3, No. 4, 1955, pp. 3–24.

Neil Leonard, "Alfred Stieglitz and Realism," *Art Journal*, 1960, pp. 277–86.

Gorham Munson, " '291': A Creative Source of the Twenties," *Forum*, University of Houston, Vol. III, No. 5, Fall-Winter, 1960, pp. 4–9.

Dorothy Norman, "Stieglitz and Cartier-Bresson," *The Saturday Review*, September 22, 1962, pp. 52–56.

David Vestal, "Philadelphia Heritage—the 1898 Salon," *U.S. Camera World Annual*, 1970, pp. 160–63.

Robert E. Haines, "Alfred Stieglitz and the New Order of Consciousness in American Literature," *Pacific Coast Philology*, Vol. VI, April, 1971, pp. 26–34.

Articles in British periodicals:

Unsigned, "Our Views," announcement of first prize for "Holiday Work" Competition to A. S., *The Amateur Photographer* (London), Vol. VI, No. 164, November 25, 1887, pp. 253–54.

Unsigned, "Our Views," announcement of first prize for "Travelling Studentship" Competition to A. S., *The Amateur Photographer* (London), Vol. XII, No. 302, July 18, 1890.

Unsigned, "Pictorial Photographers. No. III. Alfred Stieglitz," *Practical Photographer* (London), Vol. X, No. 112, April, 1899, p. 117.

Joseph T. Keiley, "The Stieglitz Exhibition in New York," *The Amateur Photographer* (London), Vol. XXIX, No. 766, June 9, 1899, p. 443.

Sadakichi Hartmann, "Mr. Stieglitz's Exit," *The Amateur Photographer* (London), Vol. XXXII, No. 823, July 13, 1900, pp. 31–32.

Unsigned, "Respecting 'Camera Notes'," *The Amateur Photographer* (London), June 5, 1902, p. 461.

R. Child Bayley, "Things Photographic in the United States of America. V. Pictorial Photography," *Photography*, Vol. XV, No. 743, February 7, 1903, p. 124.

R. Child Bayley, about *Camera Work*, *Photography*, March 26, 1904.

"The Editor Afloat," (A. Horsley Hinton), "The Work and Attitude of the Photo-Secession of America," *The Amateur Photographer* (London), Vol. XXXIX, No. 1026, June 2, 1904, pp. 426–28.

Unsigned, "New Books," (review of *Camera Work*, Special Number, 1912, especially articles by Gertrude Stein), *The British Journal of Photography*, Vol. 59, No. 2730, August 30, 1912, pp. 678–79.

"Letter to Editor" by A. S., in reply to above, *The British Journal of Photography*, Vol. 59, No. 2734, September 27, 1912, p. 757.

Ward Muir, "Alfred Stieglitz: an Impression," *The Amateur Photographer and Photographic News*, Vol. 57, No. 1486, March 24, 1913, pp. 285–86.

Ward Muir, "Photographic Days—Stieglitz and others in New York," *The Amateur Photographer and Photography*, Vol. 46, No. 1553, August 14, 1918, pp. 187–88.

C. Lewis Hind, "The Lesson of Photography," *The Photographic Journal*, Vol. 63, No. 2, February, 1923, pp. 56–63.

Paul Strand, "The Art Motive in Photography," *The British Journal of Photography*, Vol. 70, No. 3309, October 5, 1923, pp. 612–15.

Ward Muir, " 'Camera Work' and its Creator," *The Amateur Photographer and Photography*, Vol. 56, No. 1829, November 28, 1923, pp. 465–66.

J. Dudley Johnston, "Pictorial Photography—Alfred Stieglitz," *The Photographic Journal*, Vol. 79, April, 1939, pp. 200–02.

Articles in other periodicals:

Charles H. Caffin, "The Development of Photography in the United States," *The Studio*, London, Paris, New York, Summer Number, 1905, pp. U.S. 1–7.

Gabrielle Buffet, "On Demande: 'Pourquoi 391? Qu'est-ce que 391?'," *Plastique*, Paris, No. 5, Summer, 1937, pp. 2–8.

"Art Nouveau in New York—Photographie," *Du*, Zürich, June, 1971, pp. 432–41.

Articles, interviews and reviews in newspapers:

Unsigned, review of *Camera Notes*, *Commercial Advertiser*, January 4, 1897.

F. Huber Hoge, "King of the Camera," *Illustrated Buffalo Express*, January 22, 1899, pp. 1, 4.

Unsigned, reviews of exhibition of photographs by A. S., *New York Journal of Commerce, New York Tribune, New York Evening Post*, 1899.

Charles de Kay, "The Photographer as Artist," (review of A. S. exhibition), *New York Times—Illustrated Magazine*, June 4, 1899.

Unsigned, "Exhibition of Pictorial Photography," (review of exhibition at National Arts Club), *New York Sun*, March 12, 1902.

Unsigned editorial, "Photographers of the New School," *New York Times*, June 6, 1902.

Unsigned, "Camera Club Ousts Alfred Stieglitz," (includes interview with A.S.), *New York Times*, February 14, 1908, p. 283.

Unsigned, interview with A.S., *New York Herald*, Sunday, March 8, 1908, third section, p. 5.

Agnes Ernst (Meyer), interview with A.S., *New York Sun*, 1908.

Guy Pène du Bois, "Art Notes of the Studios and Galleries," (review of exhibition at the National Arts Club), *New York American*, February 9, 1909.

Baldwin Macy, "New York Letter," (includes interview with A. S.), *Chicago Evening Post*, December 22, 1911.

*Hutchins Hapgood, "Hospitality in Art," *Globe and Commercial Advertiser*, February 19, 1912.

Unsigned, "The Future Futurists," (review of exhibition at 291), *New York Tribune*, March 31, 1912, p. 4.

*Unsigned, "Some Remarkable Work by Very Young Artists," (review of exhibition at 291), *Evening Sun*, April 27, 1912.

Felix Grendon, "What Is Post-Impressionism?" *New York Times*, May 12, 1912, p. 294.

Arthur Hoeber, "Art and Artists," (review of articles by Gertrude Stein in *Camera Work*, Special Number, 1912), *Globe and Commercial Advertiser*, August 13, 1912.

Hutchins Hapgood, "A New Form of Literature," (review of articles by Gertrude Stein in *Camera Work*, Special Number, 1912), *Globe and Commercial Advertiser*, September 25, 1912.

*Samuel Swift, "Art Photographs and Cubist Painting," (review of exhibition of photographs by A. S.), *New York Sun*, March 3, 1913.

Charles H. Caffin, "A Gallery Like Our '291' in Paris," *New York American*, March 17, 1913.

Alfred Kreymborg, "Stieglitz and '291'," *New York Morning Telegraph*, Sunday Magazine, June 14, 1914, Section 2, p. 1.

Unsigned, "'291' the Mecca and the Mystery of Art in a Fifth Avenue Attic," (includes interview with A. S.), *New York Sun*, Sunday, October 24, 1915.

Djuna Barnes, "Giving Advice on Life and Pictures," (includes interview with A. S.), *New York Morning Telegraph*, Sunday, February 25, 1917, p. 7.

David Lloyd, "Stieglitz, the Pioneer Who Has Developed Photography as an Art," (interview with A. S. and review of exhibition), *New York Evening Post*, February 12, 1921, p. 12.

Unsigned, "Two 'Moderns' Sell All of their Art," (about Hartley auction), *New York Times*, May 18, 1921.

Unsigned, "'The Artist's Derby' To Be Swift Event," *American Art News*, February 18, 1922, p. 1.

Royal Cortissoz, review of exhibition of photographs by A. S., *New York Tribune*, April 8, 1923.

Royal Cortissoz, "291," (review of exhibition of "Seven Americans"), *New York Herald Tribune*, Sunday, March 15, 1925, Section IV, p. 12.

Unsigned, "Stieglitz of '291' Begins Again in Room 303," *New York World*, December 20, 1925, p. 9.

Herbert J. Seligmann, "Some Views of Modern Tendencies, Including the Acceptance of Photography," *New York Sun*, March 23, 1929, p. 34.

Unsigned, "Artist as Exile," (includes review of Marin exhibition), *Springfield Daily Republican* (Massachusetts), October 24, 1931, p. 10.

*Unsigned, "Stieglitz at 70 Facing Loss of His Art Gallery," *New York Herald Tribune*, April 29, 1932.

*Edward Alden Jewell, "In the Realm of Art," *New York Times*, May 15, 1932.

*Edward Alden Jewell, interview with A. S., *New York Times*, June 24, 1934, p. 6x.

Royal Cortissoz, "The Role of Alfred Stieglitz," *New York Herald Tribune*, Sunday, December 30, 1934, Section V, p. 10.

*Unsigned, interview, *New York Herald Tribune*, November 10, 1937.

Unsigned, "Alumni Honored at City College," *New York Times*, November 14, 1937, pp. 1, 4.

Ralph Flint, "What Is '291'?" *Christian Science Monitor*, November 17, 1937, p. 5.

Edward Alden Jewell, "Art and Alfred Stieglitz," (review of exhibition, "History of an American, Alfred Stieglitz: '291' and After," at the Philadelphia Museum), *New York Times*, Sunday, September 10, 1944, Section X, p. 4.

Obituaries: *New York Sun, New York World-Telegram*, July 13; *New York Times, New York Herald Tribune*, July 14; *New York Post*, July 15, 1946.

Edward Alden Jewell, "The Legend That Is Stieglitz," *New York Times*, Sunday, August 18, 1946, Section X, p. 8.

Henry Beckett, "Dorothy Norman Sifts Writings of Stieglitz," *New York Post*, August 28, 1946.

James Johnson Sweeney, "Rebel With a Camera," *New York Times* Magazine, Sunday, June 8, 1947, pp. 20–21, 41.

Emily Genauer, "Monument to Stieglitz Legend," (review of exhibition of the Stieglitz collection, Museum of Modern Art), *New York World-Telegram*, June 14, 1947, p. 4.

Paul V. Beckley, "Bulk of Stieglitz Art Collection Going to Metropolitan Museum," *New York Herald Tribune*, June 27, 1949, p. 1.

*Georgia O'Keeffe, "Stieglitz: His Pictures Collected Him," *New York Times* Magazine, Sunday, December 11, 1949, pp. 24–30.

Aline B. Louchheim, "'An American Place' to Close Doors," *New York Times*, Sunday, November 26, 1950, Section 2, p. X9.

Dorothy Norman, "Stieglitz's 'Experiments in Life,'" *New York Times* Magazine, Sunday, December 29, 1963, pp. 12–13.

John Canaday, "Art: A Little Something From Storage," *New York Times*, September 22, 1967.

Forewords to and catalogues of exhibitions:

Joseph T. Keiley, foreword, Exhibition of Photographs by A. S., The Camera Club, New York, May, 1899.

American Pictorial Photography, by members of the "Photo-Secession," The National Arts Club, New York, March, 1902.

A Collection of American Pictorial Photographs as Arranged by the Photo-Secession and Exhibited under the Auspices of the Camera Club of Pittsburgh, at the Art Galleries of the Carnegie Institute, Pittsburgh, February, 1904.

Special Exhibition of Contemporary Art, The National Arts Club, New York, January, 1908.

International Exhibition of Pictorial Photography, Albright Art Gallery, The Buffalo Fine Arts Academy, Buffalo, November, 1910.

International Exhibition of Modern Art, Association of American Painters and Sculptors, Armory of the Sixty-ninth Infantry, New York, February-March, 1913.

*Gaston Lachaise Retrospective Exhibition, Museum of Modern Art, New York, January-March, 1935, p. 12.

History of an American, Alfred Stieglitz: "291" and after, Selections from the Stieglitz Collection, Philadelphia Museum of Art, September-October, 1944.

Art in Progress, Fifteenth Anniversary Exhibition, Museum of Modern Art, New York, 1944.

Alfred Stieglitz: His Photographs and Collection, Museum of Modern Art, New York, June-September, 1947.

Alfred Stieglitz Collection for Fisk University, The Carl Van Vechten Gallery of Fine Arts, Nashville, November, 1949.

Climax in 20th Century Art: 1913, Sidney Janis Gallery, New York, January-February, 1951.

History of an American, Alfred Stieglitz: "291" and after. Selections from the Artists Shown by him from 1900 to 1925, Taft Museum, Cincinnati, February, 1951.

Alfred Stieglitz: American Pioneer of the Camera, Art Institute of Chicago, June-July, 1951.

Doris Bry, "Alfred Stieglitz: Photographer," Exhibition of Photographs by A. S., National Gallery of Art, Smithsonian Institution, Washington D.C., March-April, 1958.

248 *Stieglitz Circle, Pomona College Galleries, Claremont, California, October-November, 1958.

*Milton Brown, "The Armory Show in Retrospect," 1913 Armory Show, 50th Anniversary Exhibition, Armory of the Sixty-ninth Regiment, New York, April, 1963, pp. 34–35.

Doris Bry, "Alfred Stieglitz: Photographer," the Alfred Stieglitz Collection in the Museum of Fine Arts, Boston, 1965.

Dorothy Norman, "Evolving Environments of Art," Selections from the Dorothy Norman Collection, Philadelphia Museum of Art, May-September, 1968.

Carl Zigrosser, "The Complete Etchings of John Marin," (catalogue raisonné), Part I; Sheldon Reich, "John Marin: Oils, Watercolors and Drawings which relate to his etchings," Part II; John Marin: Etchings and Related Works, Philadelphia Museum of Art, January-March, 1969.

William A. Camfield, "Francis Picabia," The Solomon R. Guggenheim Museum, New York, 1970.

Lloyd Goodrich, "Georgia O'Keeffe," Whitney Museum of American Art, October-November, 1970.

Articles in, issues of museum bulletins:

"Accessions and Notes," Bulletin of the Metropolitan Museum of Art, New York, Vol. XVIII, No. 1, January, 1923, p. 19.

Ananda K. Coomaraswamy, "A Gift from Mr. Alfred Stieglitz," Museum of Fine Arts Bulletin, Boston, Vol. XXII, No. 130, April, 1924, p. 14.

William M. Ivins, Jr., "Photographs by Alfred Stieglitz," Bulletin of the Metropolitan Museum of Art, New York, Vol. XXIV, No. 2, February, 1929, pp. 44–45.

William M. Milliken, "Alfred Stieglitz, Photographer—An Appreciation," Bulletin of the Cleveland Museum of Art, Twenty-second Year, No. 3, March, 1935, pp. 32–34.

A. Hyatt Mayor, "Daguerreotypes and Photographs," Bulletin of the Metropolitan Museum of Art, New York, Vol. XXXIV, No. 11, November, 1939, p. 243.

"The New Department of Photography," Bulletin of the Museum of Modern Art, New York, Vol. VIII, No. 2, December-January, 1940–41.

"An American Collection," The Philadelphia Museum Bulletin, Vol. XL, No. 206, May, 1945.

Daniel Catton Rich, "The Stieglitz Collection," Bulletin, The Art Institute of Chicago, Vol. XLIII, No. 4, November 15, 1949, pp. 64–71.

"Photographs in the Metropolitan," Metropolitan Museum of Art Bulletin, New York, Vol. XXVII, No. 7, March, 1969.

Portfolios, booklets:

Stieglitz Memorial Portfolio. New York: Twice A Year Press, 1947.

18 Reproductions of Photographs by A. S.: Tributes—In Memoriam.

1955–1956: Year of Dedication. New York: The City College, 1956.

Dorothy Norman, Dedication Address, Stieglitz Hall, The City College, March 15, 1956.

BOOKS

*America and Alfred Stieglitz: A Collective Portrait. Edited by Waldo Frank, Lewis Mumford, Dorothy Norman, Paul Rosenfeld and Harold Rugg. New York: Doubleday, Doran and Company, Inc., 1934.

*Anderson, Sherwood. A Story Teller's Story. New York: B. W. Huebsch, Inc., 1924.

*_____. Letters. Edited by Howard Mumford Jones. Boston: Little, Brown and Company, 1953.

*Barr, Alfred H., Jr. Matisse: His Art and His Public. New York: The Museum of Modern Art, 1951.

_____. Picasso: Fifty Years of His Art. New York: The Museum of Modern Art, 1946.

Baur, John I. H. Revolution and Tradition in Modern American Art. Cambridge: Harvard University Press, 1951.

Bayley, R. Child. The Complete Photographer. Sixth Edition, Revised. London: Methuen and Company, Ltd., 1920. (Includes note by A. S., "Some of the Reasons," pp. 380–82.)

*Brooks, Van Wyck. America's Coming-of-Age. New York: B. W. Huebsch, 1915.

_____. The Confident Years: 1885–1915. New York: E. P. Dutton and Company, Inc., 1952.

_____. Days of the Phoenix. New York: E. P. Dutton and Company, Inc., 1957.

Bulliet, Clarence J. Apples and Madonnas. New York: Covici, Friede, Inc., 1930.

Caffin, Charles H. Photography as a Fine Art. New York: Doubleday, Page and Company, 1901.

Civil Liberties and the Arts: Selections from Twice A Year, 1938–48. Edited by William Wasserstrom. Syracuse: Syracuse

University Press, 1964.

Cortissoz, Royal. *Personalities in Art.* New York: Charles Scribner's Sons, 1925.

Crane, Hart. *Letters, 1916–1932.* Edited by Brom Weber. New York: Hermitage House, 1952.

*Dijkstra, Bram. *The Hieroglyphics of a New Speech: Cubism, Stieglitz and the Early Poetry of William Carlos Williams.* Princeton: Princeton University Press, 1969.

Doty, Robert. *Photo Secession.* Rochester: The George Eastman House, Inc., 1960.

Eddy, Arthur Jerome. *Cubists and Post-Impressionism.* Chicago: A. C. McClurg and Company, 1919.

Emerson, P. H. *Naturalistic Photography for Students of the Art.* American Edition. New York: The Scovill and Adams Company, 1899.

Farnham, Emily. *Charles Demuth: Behind a Laughing Mask.* Norman: University of Oklahoma Press, 1971.

The Flowers of Friendship: Letters Written to Gertrude Stein. Edited by Donald Gallup. New York: Alfred A. Knopf, 1953.

Frank, Waldo. *Our America.* New York: Boni and Liveright, 1919.

———. *The Re-discovery of America.* New York: Charles Scribner's Sons, 1929.

———. *Salvos.* New York: Boni and Liveright, 1924.

(———). Searchlight. *Time Exposures.* New York: Boni and Liveright, 1926.

Gernsheim, Helmut and Alison. *The History of Photography.* London: Oxford University Press, 1955.

Hapgood, Hutchins. *A Victorian in the Modern World.* New York: Harcourt, Brace and Company, 1939.

Hartley, Marsden. *Adventures in the Arts.* New York: Boni and Liveright, 1921.

Hartmann, Sadakichi. *A History of American Art.* New York: Tudor Publishing Company, 1934. (Revised Edition.)

Ivins, William M., Jr. *Prints and Visual Communication.* New York: Da Capo Press, 1969. (Reprint.)

Katz, Leo and Webster, James C. *Understanding Modern Art.* Vol. III. [Chicago]: Delphian Society, 1940.

Kreymborg, Alfred. *Troubadour, An Autobiography.* New York: Boni and Liveright, 1925.

Larkin, Oliver W. *Art and Life in America.* New York: Rinehart and Company, Inc., 1949.

Luhan, Mabel Dodge. *Movers and Shakers.* Vol. III of *Intimate Memories.* New York: Harcourt, Brace and Company, 1936.

*McCausland, Elizabeth. *A. H. Maurer.* New York: A. A. Wyn, Inc., 1951.

Marin, John. *Selected Writings.* Edited with an Introduction by Dorothy Norman. New York: Pellegrini and Cudahy, 1949.

Mellquist, Jerome. *The Emergence of an American Art.* New York: Charles Scribner's Sons, 1942.

Mumford, Lewis. *The Brown Decades: 1865–1895.* New York: Harcourt, Brace and Company, 1931.

———. *The Condition of Man.* New York: Harcourt, Brace and Company, 1944.

———. *Technics and Civilization.* New York: Harcourt, Brace and Company, 1934.

*Newhall, Beaumont. *The History of Photography from 1839 to the Present Day.* New York: The Museum of Modern Art, 1949. (Revised Edition, 1964.)

Norman, Dorothy. *Alfred Stieglitz: Introduction to an American Seer.* New York: Duell, Sloan and Pearce, 1960. (Also *Aperture,* Vol. 8, No. 1, 1960.)

Phillips, Marjorie. *Duncan Phillips and His Collection.* Boston: Little, Brown and Company, 1970.

Pollack, Peter. *Pictorial History of Photography from the Earliest Beginnings to the Present Day.* New York: Harry N. Abrams, Inc., 1958.

Ritchie, Andrew C. *Abstract Painting and Sculpture in America.* New York: The Museum of Modern Art, 1951.

*Rosenfeld, Paul. *Port of New York.* Urbana: University of Illinois Press, 1961. (1st Edition: Harcourt, Brace and Company, 1924.)

Rugg, Harold. *Culture and Education in America.* New York: Harcourt, Brace and Company, 1931.

Sanouillet, Michel. *Dada à Paris.* Paris: Jean-Jacques Pauvert, 1965.

———. *Francis Picabia et 391.* Paris: Eric Losfeld, 1966.

———. *391.* Paris: Le Terrain Vague, 1960.

Seligmann, Herbert J. *Alfred Stieglitz Talking.* New Haven: Yale University Library, 1966.

Steichen, Edward J. *A Life in Photography.* New York: Doubleday and Company, Inc., 1963.

Stein, Gertrude. *The Autobiography of Alice B. Toklas.* New York: Harcourt, Brace and Company, 1933.

*———. *Everybody's Autobiography.* New York: Random House, 1937.

Sunlight and Shadow. Edited by W. I. Lincoln Adams. New York: The Baker and Taylor Company, 1897. (Includes "The Hand Camera" by A. S., pp. 69–78.)

*Taft, Robert. *Photography and the American Scene.* New York: The Macmillan Company, 1938.

Wasserstrom, William. *The Time of the Dial.* Syracuse: Syracuse University Press, 1963.

Weber, Brom. *Hart Crane.* New York: The Bodley Press, 1948.

*Williams, William Carlos. *Autobiography.* New York: Random House, 1951.

———. *Selected Letters.* Edited by John C. Thirlwall. New York: McDowell, Obolensky, Inc., 1957.

Wright, Willard Huntington. *Modern Painting.* New York and London: John Lane, 1915.

ACKNOWLEDGEMENTS

I wish to express my profound appreciation to Georgia O'Keeffe, personally, and as Executrix of the Alfred Stieglitz Estate, for permitting me to reproduce certain photographs and other works of art, as well as to quote various documents, cited below. I am grateful to Doris Bry for her cooperation and courtesies in conjunction with pictorial and other material made available to me by Miss O'Keeffe.

I should like to offer special thanks to Donald Gallup who, as Curator of the Collection of American Literature at the Yale University Library, is in charge of its Alfred Stieglitz Archive. He has been so consistently cooperative that the many gracious acts he has performed are too numerous to mention. My gratitude to 1) the Stieglitz Archive for permission to include the items listed; 2) Beaumont Newhall— whose writings and work in connection with photography have long been outstanding—for his careful reading of an earlier draft of this volume; 3) Flora Stieglitz Straus, Dorothy Schubart, Mary Lescaze, Dr. Stella Kramrisch and William I. Homer, for their meticulous reading of my manuscript and their knowledgeable and perceptive reactions; 4) Bernard Karpel, Grace Mayer, Peter Bunnell and other

members of the staff at the Museum of Modern Art for their gracious aid on various occasions; 5) Michael Hoffman, George Novotny, Peter Bradford and Wendy Byrne for their kind cooperation.

My warmest thanks to Janet Dowd for her devoted and able secretarial assistance, as well as her helpful comments; to Elinor Weis for her extremely sensitive reactions and suggestions, and her indefatigable industry; to Dorothy Van Nostrand for her excellent typing.

I greatly appreciate the kind permission granted to me by the individuals and institutions listed elsewhere, to reproduce photographs by Stieglitz and other pictorial material. When, in a few cases, no credit for the use of illustrations is given, this indicates that 1) their source is unknown; 2) in the case of a few early Stieglitz prints, they have been reproduced in so many early photographic magazines, long out of print, that to mention one publication rather than another would merely confuse; 3) since more than one example of a particular work of art is in existence, no attribution to any single collection is made.

I gratefully acknowledge permission to publish material from: *America and Alfred Stieglitz*, edited by Frank, Mumford, Norman, Rosenfeld and Rugg, copyright 1934 by Doubleday and Company, Inc., reprinted by permission of the publisher; *Letters of Sherwood Anderson*, edited by Howard Mumford Jones, published by Little, Brown and Company; *The Flowers of Friendship, Letters written to Gertrude Stein*, edited by Donald Gallup, published by Alfred A. Knopf Incorporated, reprinted by permission of the publisher and editor; article by Georgia O'Keeffe in the *New York Times*, December 11, 1949, © 1949 by the New York Times Company, reprinted by permission of the *New York Times* and Miss O'Keeffe; *Port of New York* by Paul Rosenfeld, edited by Sherman Paul, published by University of Illinois Press, reprinted by permission of the publisher; *Everybody's Autobiography* by Gertrude Stein, published by Random House, Inc., reprinted by permission of the publisher; Max Weber letter to Peter Selz, from the Pomona College catalogue, *Stieglitz Circle*. I deeply appreciate the kind permission of Miss Georgia O'Keeffe for the Stieglitz Estate and of the Yale University Library to print passages from Stieglitz correspondence in the Yale Collection of American Literature; from the Alfred Stieglitz Archive, the Mabel Dodge Luhan Collection, the Marsden Hartley Collection.

Credit is hereby acknowledged to the following for their kind permission to reproduce Plates (designated by Roman numerals) and Illustrations (designated by Arabic numerals): Ansel Adams: 78. The Art Institute of Chicago, The Alfred Stieglitz Collection: 33. Fisk University, Van Vechten Gallery, Alfred Stieglitz Collection: 44. John Marin, Jr.: 36. The Metropolitan Museum of Art: 38, 49. The Metropolitan Museum of Art, The Alfred Stieglitz Collection: 47, 67, 76. The Museum of Modern Art: XXVII, LXII; 75 (Philip L. Goodwin Collection). Dorothy Norman Collection: I-XXVI, XXVIII, XXXI, XXXVIII-L, LII, LIV-LVI, LIX, LXI, LXIII-LXXVII; 4, 8, 12, 15–17, 21, 29–31, 37, 43, 45–46, 55, 60, 63, 79–80, 84; photographs by Dorothy Norman: Frontispiece; 82–83, 87–88. Georgia O'Keeffe: XXXII-XXXVII. Georgia O'Keeffe for the Alfred Stieglitz Estate: XXIX-XXX, LI, LIII, LVII-LVIII, LX; 56, 58–59, 62, 70–72. Georgia O'Keeffe and the Metropolitan Museum of Art, The Alfred Stieglitz Collection: 64. Walter Pach: 52. Dr. Leopold Stieglitz: 1, 11, 22. Edward Steichen: 27 (Collection Mr. and Mrs. Hans Hammarskiöld, Stockholm), 28. Paul Strand: 65–66, 84. Alfred Stieglitz Archive, Yale Collection of American Literature, Beinecke Rare Book and Manuscript Library, Yale University: 2–3, 5–7, 9–10, 13–14, 19, 26, 85–86. The following Illustrations are reproduced from *Camera Work*: 32, 54, 57.

INDEX

251